LET'S BECO FUNGAL!

Mycelium
Teachings
and the Arts

Based on conversations with:
Francisca Álvarez Sánchez, Carolina Caycedo, Annalee Davis, Maya Errázuriz, Juan Ferrer, Lilian Fraiji, Giuliana Furci, Sofía Gallisá Muriente, Yina Jiménez Suriel, Patricia Kaishian, Mirla Klijn & Olaf Boswijk, Lola Malavasi & Daniela Morales Lisac, Martina Manterola & Carmen Serra, Camila Marambio, Mariana Martínez Balvanera, Claudia Martínez Garay, Lina Meija & Luciana Fleischman, Tomaz Morgado Françozo & Marília Carneiro Brandão, Marjon Neumann, Maria Alice Neves, Tara Rodríguez Besosa, Raquel Rosenberg, Juli Simon, Ela Spalding, Gianine Tabja & Gabriela Flores del Pozo & Lucia Monge, Fer Walüng and Tatyana Zambrano

Yasmine Ostendorf-Rodríguez

LET'S BECOME FUNGAL!

Based on Conversations with Indigenous
Wisdom Keepers, Artists, Curators, Feminists,
and Mycologists

Mycelium Teachings and the Arts

Illustrations by Rommy González

VALIZ, AMSTERDAM

Beginnings of journeys are often veiled in mystery. Layers of ignorance are slowly unpeeled as you learn more about place, history, culture, or language. Things start making sense. My journey into the world of fungi was quite the opposite—and it's not unlikely to be similar for you. The more you learn about fungi, the more puzzling they become. Fungi throw up questions, never answers. And that's exactly what makes them so tantalizingly appealing.

Fungus is a system, an ecosystem, a rhizomatic network that sometimes, but not always, bears 'fruits' we mostly call mushrooms. We shouldn't really call them fruits though, as fungi aren't plants or animals. They are a kingdom of their own, on their own terms and with their own terms. Unfortunately, most of us humans are acquainted solely with fungi through the consumption of a tiny percentage of different mushrooms: portobellos, button mushrooms (champignons), shiitake, or maybe porcini, chanterelles, morels, or enoki if you're slightly more of a foodie, and depending on your geography. We tend to only consume the mushrooms with the best shelf-life, generally resulting in a rather limited understanding of flavors and possibilities. Your geography doesn't only dictate which mushrooms grow in your locality, it is also decisive given that some countries tend to be more 'mycophobic' (scared, or even slightly disgusted by mushrooms) while others are more 'mycophiliac' (mushroom loving and with a long tradition of using mushrooms in their cuisine or medicine). While there are literally, and without exaggerating, thousands of edible mushrooms—some of which you will get to know through these chapters—there's more to fungal life than a nice taste. The starting point for this book was my growing interest in the mycelium: the thread-like network of the fungus, which mainly operates underground, and consists of hyphae—plural for hypha, the self-learning membranes that help unify different ecosystems through the exchange of resources. Some might call them roots, or describe them as root-like, but once more we are borrowing terms from a kingdom they are not part of. Mycelium is often (but not always) mycorrhizal, meaning it is the interface for forming symbiotic relationships with the roots of plants, typically trees (but not always). These symbiotic relationships allow for the exchange of nutrients, minerals, water, and information between different (and the same) species. The fact that there are always exceptions to every rule—divergent mycelial variations or rebel mushrooms that mess up the whole categorization— makes them hard to pigeonhole. It contributes to their complexity as well as their appeal. Fungi do not like to be boxed.

Mycelium can be considered a messenger in the forest eco-system, like a chatty and curious neighbor who teases out from everyone in town the latest gossip and likes to pass on that information. To further anthropomorphize, this gossipy neighbor would also be babysitting the local kids, collecting funds for the community clubhouse, welcoming the newbies in the neighbor-hood, and making sure a hearty vegetable soup is to be found at people's doorsteps when they're ill. And that's essentially the mycorrhizal mycelium: exchanging information, ensuring resourc-es are re-distributed, expanding on collaborations, helping trees recover, and helping young plants with their chances of survival. Except the comparison with a human doesn't make sense because the mycelium doesn't consist of individuals and is instead a net-worked organism, an environmental sensor below the ground that holds knowledge about the status of soil and the health of the forest as a system. In addition, it is the carbon reservoir of nature; keeping carbon in the soil (rather than in the atmosphere) and, therefore, playing a very important role in the light of climate col-lapse. Mycelium has so many interesting and important functions and behaviors that it carries a profound usefulness as a metaphor for how to live above ground, too. Metaphors have the potential to inform our behaviors and assist us where technical language falls short, from the very pragmatic to the poetic. And that's what this book is about: a mutually beneficial system-design for humanity, seen through a mycological lens.

Though unappreciated and unrecognized for years, myceli-um received its big moment of fame when it was re-branded as the 'wood wide web' as a result of research by biologist Suzanne Simard in her book *Finding the Mother Tree*.[1] Though she had been working as a scientist researching mycorrhizal net-works since the nineteen-nineties, her work remained fairly unknown outside of the world of science for many years. It wasn't until she wrote her book, in which she compared the mycorrhizal network to the Internet and social media—a way for trees to communicate with each other—that her cross-disci-plinary fame took off. And with this fame, so did the mycelium, with this anthropomorphic approach allowing for a bigger public to relate to the network. Simard was the first to publish her evidence on how trees were exchanging nutrients through myce-lium. Her research has further evolved over the years, to the point that researchers have found that fungi infiltrate the roots of plants to such an extent that they are 'inextricable from the plants themselves', posing interesting questions about where one thing ends and another begins.

1.

Suzanne Simard, *Finding the Mother Tree: Discovering the Wisdom of the Forest*, Knopf Doubleday Publishing Group, 2021.

But that wasn't all. From an interest in mycelium grew a bigger interest in the whole fungus as ecosystem. They started popping up everywhere (excuse the pun), even reaching Netflix audiences with the beautiful visually animated *Fantastic Fungi* by Louis Schwarz. The (some best-selling) books and lectures by 'myco-kings' Paul Stamets, Terence and Dennis McKenna, Merlin Sheldrake, William Padilla-Brown, and Peter McCoy have been instrumental in educating the general public about the wonderful world of fungi. The Covid-19 pandemic also contributed to the so-called 'shroomboom'; after everyone got bored with making Instagrammable sourdough breads at home, lockdown millennials across the world started micro-dosing en masse. This book, however, is informed by 'Latin myco-queens'. Not the male (native-speaking) voices from the United Kingdom and the United States, but rather the female, non-binary and female-identifying voices from across Latin America and the Caribbean. They are people I have befriended, met on forays or hikes, worked with, and Zoomed with, people who were so generous in sharing their practices and thoughts about farming, fungi, networks, and how to design a fair world with me. Each chapter reveals a teaching, based on their stories, collaborations, movements, communities, and societies, all informed by fungi. For this book I have integrated the wisdom that shone through more than forty of these conversations, and it would not have been possible without them and I'm forever grateful for how generously they passed on their knowledge and experience with me. I distilled mine and their fungal stories, combining them into twelve teachings.

I, like many others, think there is an urgent need for systemic change, rather than taking a single-issue approach (such as just focusing on plastic straws or buying from 'sustainable brands') to the climate collapse. Multinationals and governments alike are looking at technological advancements to envision and define our future, which I find a limiting and, quite frankly, depressing idea. As my discontent with those ruling systems grew, so did my eco-anxiety. This lack of imagination, combined with the daunting amount of urgently needed systemic and behavioral change, made (pleasant) life on earth feel like a ticking time-bomb. I found hope with fungi, which approach environmental collapse in a low-tech, collaborative, holistic, and interconnected, adaptive yet pro-active way. Fungi don't let a good crisis go to waste; they are veterans when it comes to luring extinction; they have survived meteors and ice-ages, nuclear disasters, and the loss of their habitat. Crises equal opportunities for fungi, as they present a situation in which to expand on their collaborations

Merlin Sheldrake, *Entangled Life: How Fungi Make Our Worlds, Change Our Minds & Shape Our Futures*, Random House, 2020.

2.

and, therefore, increase symbiosis.[2] In times of crisis, fungi demonstrate how dominant, centralized, highly technological or exploitative power dynamics and patterns could, and should, be challenged.

Because fungi throw up questions, not answers, every chapter is phrased as a question. They do not lead to answers, but to teachings. Every teaching includes stories of the small in the big or the big in the small and are entanglements of my personal experiences, as well as the stories that have been told to me by interviewees through informal encounters, books, and overheard conversations. The interviewees are from Colombia, Brazil, Barbados, Puerto Rico, Costa Rica, Mexico, Chile, Peru, Panama, Bolivia, the Dominican Republic, and Argentina. More informally, I spoke about this subject with women from Suriname, Venezuela, Guatemala, and Trinidad. I wanted a mycelial approach to my research subject, hence why this book was written in a hybrid, rhizomatic, and non-linear way. I use the word 'women' in its broadest sense, so it includes all those who, sometimes partially or occasionally, identify as women. As the differences between the interviewees' countries couldn't be greater at times, you can imagine the same goes for their stories, too. Though his book is not chronological and you can read the teachings in any order you prefer, my personal journey started in Brazil, as described in Teaching One. I quit my job as the Head of the Nature Research Department, a new department at the Jan van Eyck Academie in the Netherlands that I had set up three years before, and moved to a biodynamic shiitake farm in Minas Gerais. This is where the love for fungi exponentially grew and my relationship to food dramatically changed.

Spending time in Latin America and the Caribbean meant agricultural, colonial, and cultural entanglements through time and space started to reveal themselves to me, leading to Teaching Two and the connected question of 'How to Review Our Collective Memory?'. Recognizing, naming, questioning, and addressing these entanglements became a form of practicing responsibility. Latin America has a long, complicated, and ongoing history of activism and uprisings connected to dictatorial regimes, which in itself holds many teachings about how people organize themselves for united protest, build community, and how to build a decentralized support network of mutual care. A history of myceliated activism. The question for Teaching Three is: 'How to Organize like a Mycelium?' and shares learned strategies for entangled protest from Chile to Mexico to Brazil.

A taboo for many people, yet a central topic for fungi is death. In

this chapter (four) the fungal teaching could not be more obvious: we need to talk about death. Fungi present themselves beautifully as enablers of new life, but indeed through rot, decay, and decomposition. So how do we re-think rot, decay, and decomposition as something desirable? Teaching Four offers tools to start talking about death by discussing (climate) grief, eco-anxiety, and the need for degeneration for regeneration.

Talking about death irrevocably brings us to the question of how to understand the closeness of toxicity, Teaching Five. And I don't mean poisonous mushrooms. I mean the toxicity that is embedded and a result of our systems and societal choices. The consequence comes to us in the form of diseases (cancers, viruses, obesity), in our polluted food, soil and air, and in ongoing colonial legacies informing how we treat each other and the natural world. Though many of us have been brought up with the idea of modernity, hygiene, and progress, this teaching is about the impossibility of purity, the traps that come with the idea of purity, and the illusion of innocence. Starring slime molds, the compost-police, swamps, and a banana peel stew.

Teaching Six looks at the senses for guidance. Though no actual answers are given, the question of 'How Can Our Imagination Shape New Worlds?' is addressed through ways to de-zombify and re-train our senses. This teaching speaks of the shared history of fungi and art, celebrates diversity and sensitivity, and discusses fungal ways of seeing, smelling, touching, hearing, and tasting. It's an ode to the arts, to creativity, and to imagination. An ode that comes with a role and responsibility, however, and an invitation for artists to become myco-ambassadors. Featuring polypore paper, mycelium bags, mountain smells, and bio-sonification.

Then the astounding bit of information was brought to me, leading to Teaching Seven, that some fungi can have more than twenty thousand mating types. While some of us basic humans are still getting used to the idea of LQBTQIA+, fungi are way beyond this limited idea of gender. It was first told to me by Brazilian mycologist Juli Simon, that fungi can produce both sexually and asexually, are non-binary, and have endless possibilities for sexual compatibilies, in which gender does not play a role. They demonstrate the amount of space and possibility we can enjoy when we break out of the limited boxes of categorizations we live by. In addition, in my conversations with Patricia Kaishian she proposed mycology as a queer discipline. Fungi made it clear they aren't plants or animals and are free from sexual categorizations, opening up a beautiful, ambiguous space in-between. And in that in-betweenness there is space for many col-

laborations outside of our boxes, to use a contemporary term; multispecies collaborations. This teaching looks at how we humans can collaborate with the natural world. How to work with water and humidity, peatbogs, forests, molds, or other natural materials and entities without being extractive? Inspiration is to be found in the collaborations between fungi and bees, fungi and ants, and fungi and termites, among others.

Fungi appeared to be able to move through different notions of time, bringing to my attention how different realities operate in different time frames. This question of 'How to Move Through Different Notions of Time' informed the teaching that addresses the importance of valuing and recognizing non-linearity, invisibility, and silence. The stories connected to this teaching were beautiful and sometimes heartbreaking, from Peruvian artist Claudia Martínez Garay telling me about the woman she saw on the road in the middle of nowhere in the Andes selling cheese (and didn't sell anything all day) to Ela Spalding describing Estudio Nuboso's project emerging from the Panamanian cloud forest, geological deep time and the rising of the isthmus—as a country Panama connects two larger landmasses and separates two bodies of water. A key fungal reference for this teaching were the spores, which, with their different dispersal strategies and eternal patience, always wait for the right conditions to sprout, sometimes a thousand years.

Not only were fungi able to play with the notion of time; they were portals to different dimensions and understandings, from the *Mycena cristinae* lighting up the dark night in the Brazilian Amazon with its bioluminescence to the *Psilocybe mexicana* with mind-opening properties. The Peruvian art collective FIBRA, in working with oyster mushrooms and their mycelium as a material for their sculptures, shared how fungi taught them that control is an illusion, and how to embrace mystery and surprise rather than fear insecurity, which informs Teaching Ten.

A prominent voice throughout the book is Chilean myco-queen Giuliana Furci, the founder of the Fungi Foundation. Her ideas were particularly influential for Teaching Eleven and its discussion of how language shapes our understanding of the world surrounding us. This teaching comes with a list of words and concepts that can guide us into the fungal paradigm, as suggested by the interviewees. Furci and her colleagues were the ones who introduced the term *funga* to add to flora and fauna. The trickle-down effect of this simple addition was seismic, opening the doors to fungal education, funds, jobs, policies, and conservation status. A powerful expression of how language creates

reality and reality creates language. Rather than just being about language, this teaching turned out to be about how communication is constant and infinite, beyond languages.

In the whole writing process, I started living with fungi as allies, allies who were changing my behavior and influencing my collaborations. I was implementing the teachings into my own life and had identified my personal fungal teacher: the mycorrhizal mycelium. The alliance that I'm running, the Green Art Lab Alliance, became more mycelial than ever before, became more decentralized, more about mutually beneficial exchange, more focused on non-monetary resources. I understood mycelium to be a methodology, a way of thinking and doing. Teaching Twelve is about how we can implement these fungal teachings into our lives, into the ways we live, work, love, organize, think, and collaborate.

It contributes to this book being written in a rhizomatic way and all the different interviews, conversations, literature references, personal stories, losing their chronological order, but naturally finding each other and connecting. Not only do I thank all the people I have spoken to for their generosity in sharing their knowledge and time, but also for their trust in being quoted outside of the context of the original interview. Their words have become spores, landing in different places, slowly forming a network together. The aim is that, throughout the book, you will get to know the people, as well as the fungi, more closely. This was a risky operation that I hope I have treated with enough care and respect, to honor their true voices. Because as much as this book is about fungi, it's a book about women who are designing new worlds. And happen to love fungi.

HOW TO BECOME FUNGAL?

Bodily and Fungal Learning

<u>TEACHING ONE</u>

Featuring:
Cordyceps, shiitake, oyster mushrooms (*Pleurotus ostreatus*), Tomaz and Marília, Jorge Menna Barreto and Joélson Bugilla, FIBRA, Lina Meija (Platohedro), Maya Errázuriz, Carolina Caycedo, black mold, *Pewenomyces kutranfy*, Olaf Boswijk & Mirla Klijn (Valley of the Possible) and Máximo Corvalán-Pincheira.

Geographies:
Mantiquera Mountains in Minas Gerais (Brazil), Wallmapu/Araucanía (Chile), Saõ Paulo (Brazil), Medellín (Colombia), Tenochtitlan (Mexico), a Peruvian myco-cave, El Quimbo, Magdalena River (Colombia).

MARI MARI

The portal into my self-declared myco-apprenticeship was being with mushrooms every day. Eating, touching, and smelling them, breathing in their spores, and always being on the lookout for them was part of my self-motivated training. I initiated a bodily re-set and relocated from the Netherlands to a remote shiitake farm in Brazil. I started an online course in mycology by Peter McCoy, known as the maker of the inspiring book *Radical Mycology, a Treatise on Seeing & Working with Fungi.* I began interviewing mycologists, farmers, artists, designers, and activists who were working in what I considered to be fungal ways—networked, cross-disciplinary, and connected to mushrooms and/or mycelium. The spores had nestled themselves inside of me many years ago. Ever since I read Anna Tsing's *Mushroom at the End of the World: On the Possibility of Life in Capitalist Ruins,* I was infected with mushroom fever. What could have been perceived as an eureka moment was really just the spores inside of me germinating. Moving to the shiitake farm was the first proper move to educate myself in the world of the fungus.

The farm was run by a young Brazilian couple, Tomaz and Marília. They lived in the main house, a beautiful high space with a big fireplace overlooking the misty Mantiquera Mountains. The flames kept us warm in the evenings. The days were hot and the nights were cold: the perfect climate for the shiitake—they love a steep temperature drop. When I

arrived at the farm, the mountains were covered with purple flowers, the blossoms of the *quaresmeira*, a tree that is named after the period in which it blooms, between carnival and Easter. What was remarkable about their house was the fact that there was Internet, an extravagance nowhere to be found on the rest of the fifty hectares of land. My accommodation was a cozy adobe hut with a compost toilet a bit further down, toward the woods, underneath a flock of mighty Araucaria trees. *Quaresma*, or Lent, is not only a season with an abundance of purple flowers, it is also the beginning of the *pinhão* season. The *pinhão* (Portuguese) or *piñon* (Spanish) is the seed that falls from the Araucaria tree in big waxy cones that look a little like solid beehives. When they reach the ground after their spectacular fall—Araucarias can grow up to eighty meters tall—the cone explodes and releases its seeds. After the fall it's just a matter of collecting the *pinhãos* from the ground and making sure the next flying cone doesn't land on your head. Though the seeds are said to resemble cockroaches as they have a hard, shiny shell and are similar in shape and size, this does not make them any less attractive or less delicious. Their nutty, creamy taste makes them a perfect snack with a drop of olive oil and salt. They are very versatile and can be turned into a flour too to make *pão de pinhão* (bread) or can be shredded over practically everything. I had first started learning about the Aracuaria as part of my residency at Valley of the Possible. Valley of the Possible is a centre for regenerative culture in the Chilean Andes that invites people to spend time in the mountains and re-think our relationship with the natural world. There I learned, amongst many other things, that the Araucaria is a protected tree, listed on the IUCN Red List of Threatened Species since 2019. The tree has a special status in Chile, where it has been part of Chile's natural heritage since 1976 and is protected by national law. The true guardians of the Aracauria, or the *Pehuén* tree as they call it, are the Mapuche people, the original inhabitants of the country. With more than one million people, they are the biggest community of indigenous people in South America, with most of them living in the central to southern part of this long-stretched country, their ancestral land. There is a deep history, relationship, and understanding between the *Pehuén* tree and the Mapuche. The Mapuche have profound respect for the tree and consider it to be sacred. The emblematic trees with their long and spiky branches are 'living fossils' as they have been around for millions of years and are known to have been part of the diet of dinosaurs in Jurassic times. The *piñones* are also very much part of the Mapuche diet. Some Andean communities call themselves Pehuenche, or the 'people of the *Pehuén*.' More specifically, the Mapuche that live in the mountains, or in Pehuénmapu as they say. In 2022, I had the honor of joining the residency program with Valley of the Possible in Pehuénmapu/ Wallmapu, also known as the Araucanía Andina region in Chile. Among many other things, we visited a Pehuenche community at the Pehuen Reserve Quinquén. Tucked away between various national parks, Comunidad Pehuenche Quinquén is located south of Lonquimay, towards the Andes

and close to Lake Galletué, the birthplace of the sacred Bío-Bío River. We went with a small group of artists, all participating in the residency. Before our arrival we had some homework: we learned to leave any agenda or extractive mindsets behind and to just come to listen and learn. We practiced a few words in Mapudungun, the Mapuche language, so that at least we could say hello ('*mari mari*') and thank you ('*chaltumay*'). After a long drive through spectacular snowy landscapes, we arrived at the community, where around fifty Pehuenche families live. We were greeted by the *lonko*, the chief of the community, and invited into the *ruka*, a traditional Mapuche house. A goat (or was it a sheep?) was roasting over a fire as we sat in a circle, still a bit uncomfortable and afraid of making social *faux pas*. A cup with *maté*, a strong herbal tea, was going round in a ceramic cup and we drunk out of a flat metal straw. Smoke was stinging my eyes and I felt a bit dizzy. I was worried it might appear disrespectful to leave and get some fresh air so instead I surrendered and let go of everything I thought I knew. Not only did they serve the *piñones* to snack on, it was the first time I tried a coffee made out of the *piñon* too. A warm and nutty flavor that I couldn't get enough of and that got me back on my feet. If you had to survive off only one plant or tree, the Araucaria would be a good pick. This tree is a monumental life-saver and a hipster might call the *piñones* a 'superfood'. The Mapuche and Pehuenche have known this since time immemorial. When the Araucaria was under threat because of excessive felling in the nineteen-eighties, Comunidad Pehuenche Quinquén played a key role in fighting for its protection. They led the movement for the legal protection of the tree, alongside the need for recognition of their territorial rights. Later, while we hike through their forest, a beautiful valley full of thickets, *lengas*, *coihue* (Nothofagus), and Araucarias, Joaquin Meliñir, our guide and the son of *lonko* Ricardo, explains to us that it has been a long process, both for the tree to have been declared a national monument and for the community to have obtained the domain titles of their ancestral lands. In the process, they teamed up with various NGOs in Chile, including WWF and CODEFF. Collaboration is crucial I hear. Walking through this valley, smelling the volcanoes, feeling the strong presence of the trees, the body hot from ploughing uphill, I recognize this is a different way of learning. I'm not learning about a place. I'm learning *in* a place. Founders of Valley of the Possible, Olaf Boswijk and Mirla Klijn, tell me later that this is exactly how their residency program started. As they walked through Cañón del Blanco, they had all these insights about what they could and should do in the area. Mirla:

> It's literally when we walked here in the valley, without Internet, without reception, just walking in the mountains, that we got all these ideas that seemed so possible, and so within reach. It's not until you sit down behind your laptop and you start writing and researching about it, that it becomes complicated. Then it's like 'how are we go-

ing to do this in this capitalist society?' 'We have
to make money and everything!' That's also where
the name comes from, Valley of the Possible.

For Mirla, one of the most profound experiences was when they walked in
the valley (to 'La Callana') and they couldn't find their way back and got
lost. Seriously lost. She recounts:
> The only thing we knew was that we had to go
> down. But we couldn't find any paths and we were
> completely lost. We went straight through the bush-
> es and the trees, just going down. We were literally
> holding on to the branches of trees and walking
> on—I'm not kidding—a humus layer THIS THICK.

She signals a dramatic half a meter with her arms.
> It was such a dreamy experience for me because
> the smell of decay was so strong and I was scared
> because we didn't know where we were going and
> it was kind of dangerous and we were holding on
> and slithering down. I was also a bit scared of
> the smell; it felt like I was walking on death, on
> graves of dead tree bodies. At the same time, I
> have dreamt about it so many times afterwards. It
> came back in my dreams and then later I realized
> a lot of perfumes actually have a smell of decay.
> It's really attractive to people. I felt such a strong
> connection to the earth, literally to the soil. I've
> never had that before. If anything, I'd like to give
> our participants of Valley of the Possible that
> same experience somehow. I don't know how—you
> can't really push them into the mountain and tell
> them to get lost—but something like that I would
> like to incorporate. The thing I felt, sliding down
> that mountain on top of this thick humus layer, is
> that this is a place where humans hardly ever go.

Mirla's words resonate with me and remind me of reading Rebecca Solnit's
Field Guide to Getting Lost, a book about the importance of getting
lost. She writes:
> Never to get lost is not to live, not to know how
> to get lost brings you to destruction, and some-
> where in the terra incognita in between lies a life
> of discovery.

A central question that keeps on coming back in her book is: How will you
go about finding that thing, the nature of which is totally unknown to you?

Perhaps what we call 'getting lost' is just the mycelial walking, or the mycelial thinking. We don't get there in a straight line; we take unlikely and unexpected turns, only to discover what we actually have been looking for—without us knowing.[1]

1.

Rebecca Solnit, *A Field Guide to Getting Lost*, Canongate Books, 2005, p. 15.

BETWEEN ENDEMIC AND INVASIVE

This bodily learning, through walking, getting lost, and activating the senses, was very much part of a botanical hike in that same Cañón del Blanco a few days later, with self-taught naturalist Miquel Moya. Miquel is part of Colectivo Atlas Nativa, a collective of naturalists that seek to spread the importance of native ecosystems through art. Slushing through melted snow, Moya was telling us, the group of participants, about how the area was highly populated before the Spanish colonists arrived, precisely because of the enormous quantity and diversity of edible plants, seeds, and mushrooms. He generously shared his knowledge, pointing out all the wild edibles we encountered and explaining which of them were endemic—only existing in Chile—which ones were native, which ones exotic, and which ones were both exotic and invasive. The rose hip and blackberries for instance—edible plants I actually love—were both abundantly available yet exotic and invasive, their spiky arms always reaching out for a suffocating embrace. The apple and chestnut trees were exotic, but not invasive. They adapted, yet weren't reproducing. The examples of the endemic plants in the region were plentiful. From about one thousand meters in altitude, not sloshing in melting snow anymore but sinking knee-deep with every step, we started encountering the native Araucarias again. In other parts, it had mostly been the pine and eucalyptus trees dominating the forest. They are being intensively cultivated because they are fast growers, which creates various problems. For instance: the eucalyptus takes a lot of the water from the ground and the pines come with a different fungal strain, changing the pH value in the soil.

Artist Máximo Corvalán-Pincheira, as part of his Fundación Mar Adentro residency, spent time at Bosque Pehuén, a conservation site also in the south of Chile, about three hours further south from Valley of the Possible, closer to Pucón. Corvalán had the opportunity to work with scientists researching the damage caused in the bark of the Araucaria due to fungal disbalance. He visited the lab where these scientists are experimenting with fungi extracts harvested from the Araucaria. Corvalán, a photographer himself, took pictures of the scientific results; he already had a keen interest in species extinction, having previously worked with DNA and the idea of memory, addressing in his work what he calls *detenidos desaparecidos* (the detained and disappeared). His artworks bring together human transcendence, life, death, and memory to tell stories about how bodies can disappear but traces of their DNA can remain forever. At the lab at Bosque Pehuén was a group of scientists from the University of California, Davis (UC Davis) working on the endangerment and potential

Máximo Corvalán-Pincheira, *Sistema,* part of the series *Padece*, 2019.
Photograph, 70 x 70 cm. Courtesy the artist.

2 0

extinction of the Araucaria. The scientists had been experimenting
with the fungi and phytophthora they had been sampling from the Arau-
caria. Phytophthora are morphologically similar to fungi, though biologi-
cally more closely related to plants. The DNA of 'true' fungi is more closely
related to animals.

In this lab in the south of Chile, the DNA of the Araucaria had been
codified for the first time. The scientists had never been able to do this
before because of all the rules and regulations surrounding the Araucar-
ia—the result of its strictly protected status as 'natural heritage'. This
made the tree hard to access and do research on, ironically meaning that
relatively little scientific research had been carried out on the tree. Only
when the species became sick and potentially endangered because of the
fungus did scientists gain access to study it and codify its DNA.

Corvalán spent time with the scientists and, in return for the generous
sharing of their knowledge, he took professional pictures of their work that
they could use and keep. He made a photographic record of their research,
which helped them to publish their results. For his artwork he blew up
the images of the petri dishes with different fungal samples and combined
them with neon lights stating three different words: 'sospechoso' (sus-
pect), 'sistema' (system) and 'padece' (suffers). Maya Errázuriz, curator
of the residency program, tells me that, interestingly, the petri dishes with
the fungi that are most damaging to the Araucaria are visually the most
beautiful and attractive looking. Errázuriz:

> The artist played with the idea of which of the
> photographs you think is the suspect/culprit of
> the 'crime' against the Araucaria, but then also
> questions whether you the viewer are the poten-
> tial suspect and doing the damage to the tree.

In addition to the lights and photographs, Corvalán took maps from differ-
ent parts of Chile and carved out pieces of these maps in the same pattern
as the fungi in the petri dishes.

It's easy to perceive this 'attacking fungi' as evil, trying to kill the
Araucaria. Yet it is of course signifying something else. Rather than evil
attackers, they are messengers; they come to tell us something about an
imbalance in our environment. They are teaching us that there needs to be
an end to the intensive logging and cultivation of the pines. That's what's
killing the forest. The same might apply to the fungi we find and loathe in
our bathrooms and on damp walls and ceilings. Spreading monsters creat-
ing dark patches and Rorschach test-like shapes. What are the black molds
in your bathroom telling you about the unbalances in your household?
What do you read here? Let's not shoot the messenger, because maybe
this is fungal learning too.

UNCONVENTIONAL EATING

Back to the farm in Minas Gerais. It did not take long before I developed a

relationship with the little creatures I was harvesting every day. My days on the farm started early, at sunrise. I was tasked with watering, harvesting, weighing, cleaning, packing, and sealing the shiitake on a daily basis. I felt incomplete when I missed a day of harvest. Often, I didn't want to cut them off the eucalyptus wood pulp mycelium block because they just looked too beautiful together, or they resembled a family. Almost every day I ate shiitake, forcing me to become more creative with preparing them. Having to be more creative impelled me to start using more of the edible plants, herbs, veggies, and fruits on the farm that I was completely unfamiliar with. A big book, the weight of a brick, was my guidance on this—containing over ten thousand plants that grow in Brazil and are not just edible but extremely nutritional, yet also unknown and unconventional—and suitably called *Plantas Alimentícias Não Convencionais* (PANC). These unconventional edible plants are generally not cultivated or consumed on a large scale, but spontaneously grow all over the country, from the Amazonian rainforest to a surprising *acte de présence* on the sidewalks of Rio, for those who recognize them. With the PANC book in hand, I realized that literally the whole farm was edible. Next to the *pinhãos* and shiitake I became a big fan of the *chuchu* (*chayote*, a type of squash), *tamarillo* (tree tomato), *physalis* (so good that I'd often gobble them all during harvesting), *ora-pro-nobis* (careful with the spikes!) and crunchy *yacon*. Every Wednesday morning, we would harvest leaves for the salad baskets, including the *peixinho* (a soft and slightly hairy leaf named after its fishy shape), *almerão roxo* (a type of red salad) and *manjericão* (Brazilian basil). Even though at least by that point I recognized these leaves as edible, I was often still oblivious to how to cook with all these new ingredients. There was a bit of pressure to deliver a good hearty meal every afternoon as, next to breakfast, lunch was the only other meal we consumed each day. In addition, it was vegan and almost all from the land. That meant that on my cooking days—twice a week—I would go out into the food forest with my little woven basket to find ingredients for lunch. This was initially a daunting task confronting me with my inability to recognize all the plants as food. With the PANC book, however, it became a fun game of hide-and-seek with food, a treasure hunt for anything ripe and ready. Deciding what to eat was not about what you feel like eating, it was dictated by weather and season and required a sharp eye and good timing. Waiting long enough for it to ripen, but getting there before the monkeys or birds did. I noticed that harvesting the food for lunch allowed smaller nearby plants to access more light and space. I was helping other plants by harvesting the abundance. It lessened competition and balanced out the forest, reminding me of Robin Wall Kimmerer's observations in her beautiful book *Braiding Sweetgrass*. She writes about the relationship between humans and sweetgrass, a type of tall, flowering grass that generally grows close to rivers and wetlands. It has an important role for different Native American groups, including the Potawatomi people, who traditionally use the grass for incense, basket weaving, and

other crafts. Their relationship with sweetgrass is reciprocal and by harvesting in a respectful and balanced way the species can actually flourish. This became clear when they noticed the growth of sweetgrass was declining in areas where it wasn't growing in conjunction with people. 'Respectful and balanced' in this case means in line with the guidelines of the so-called Honorable Harvest, which Kimmerer mentions in her book. These guidelines can be seen as an agreement between the people and the land, as about reciprocity; a protocol about ethical giving and taking. Simple things such as never foraging the first thing you see and never taking the last are crucial gestures for allowing the species to continue to prosper. In the Potawatomi cosmology (and many others), the harvest, but also fresh air and clean water, are considered gifts of the earth, and gifts need to be reciprocated. Kimmerer gives us many examples in her book of how to reciprocate the gifts of the earth:

> In gratitude, in ceremony, through acts of practical reverence and land stewardship, in fierce defence of the places we love, in art, in science, in song, in gardens, in children, in ballots, in stories of renewal, in creative resistance, in how we spend our money and our precious lives, by refusing to be complicit with the forces of ecological destruction. Whatever our gift, we are called to give it and dance for the renewal of the world.[2]

It was time to re-think gifts as something we only give to people, and that's when I started fantasizing about what I could give the Araucaria tree.

SCULPTING WITH OUR MOUTHS

As I was harvesting foods for lunch with the guidelines of the Honorable Harvest in the back of my mind, I slowly started to review my ideas about the human as a destructor of nature and saw a potential role for humanity as exactly the opposite: creating and safeguarding biodiversity just by eating the right thing. By eating unconventional, nutritional edible plants biodiversity was flourishing. By harvesting leaves, fruits, and vegetables, less dominant plants had a bigger chance of surviving. And by taking what was ripe, the overall balance was kept. If a plant became too dominant, it just meant we simply had an abundance of it to eat. The relationship between eating and biodiversity became more and more apparent as the ingredients we were using for cooking were shaping the landscape. Our mouths were literally sculpting the land. This is what Brazilian artist Jorge Menna Barreto calls 'environmental sculpture'. In his project *RESTAURO* developed for the 32nd São Paulo Biennial in 2016 with Joélson Bugilla, they turned the exhibition space into a kitchen where they were preparing foods that came from nearby food forests. That proximity of where the foods came from triggered a conversation about site-specificity, a term regularly used in the arts yet just as applicable in the context of food.

2. Robin Wall Kimmerer, *Braiding Sweetgrass: Indigenous Wisdom, Scientific Knowledge and the Teachings of Plants*, Milkweed. 2020. p. 225.

These were foods whose variety was specific to their locality. *RESTAU-RO* operated as a restaurant in collaboration with local farmers who were also working with food forests. A lot of these farmers were also part of the Movimento dos Trabalhadores Rurais Sem Terra (MST), the Landless Rural Workers' Movement in Brazil. This movement of rural workers squats land that is being unused in order to use it for organic agriculture to feed the community. Since its inception in 1984, they have organized more than 2,500 land occupations with about 370,000 families, leading to 7.5 million hectares of land now being used for growing food by and for families in Brazil. More than just growing food, it is a political movement that is fighting for the social, environmental, and cultural rights of landless farmers, including access to education, health care, and credit for agricultural production.

The 'environmental sculpture' of Menna Barreto and Bugilla is the act of conjointly shaping the landscape by eating. Placing an emphasis on education, *RESTAURO* proposed a 'Pedagogy of the Forest' which is both discursive and experiential. It generated discussions with an audience as it took the food politics of our times as a point of departure. Food is deeply ingrained with information from the land and can be read by our bodies. It can thus become a mediator in the relationship between society and environment. Jorge, a dear friend, once explained to me over a vegan lunch in Saõ Paulo: 'As the public ate in *RESTAURO*, they infused their bodies with "forestness". Our digestive systems do not begin in the mouth, but on the land we share,' he explains. Re-inscribing agriculture into culture, *RESTAURO* served over thirty thousand plant-based meals during the Biennial. Menna Barreto makes clear that we should understand our digestive system as a sculptural tool. 'We are participants in an environmental sculpture in progress, where the act of nourishing oneself regenerates and shapes the landscape in which we live.' The efforts of Menna Barreto and Bugilla made visible that somehow eating is always political. Cooking with certain recipes and ingredients contributes to biodiversity; they give back. Others do the opposite; they only take and ruin soils, water, and ecosystems. And we get even more than their nutritional value, as 'biodiversity is biosecurity'—the adage of myco-king Paul Stamets. More diversity means fewer imbalances, fewer pests, fewer viruses, fewer pandemics and epidemics. We get health and safety.

When the Spanish invaded Mexico in 1519 they thought the native people of Tenochtitlan were poor and didn't have anything to eat. The opposite was true. Not only were the Aztecs a highly cultured society, they also had advanced systems of water management and agriculture. The Spanish, however, didn't recognize their foods as food as they were unfamiliar with the plants and their ways of growing crops. They didn't recognize the ingenious interconnected systems of the *milpa* and the *chinampa,* or the advanced forms of water management in their pyramids. That which you don't recognize, you don't see. You will not appreciate

and, likely, not care. To some extent I had been an uninformed foreigner when I arrived on the farm: I had no idea what to do with most of the plants. I had never seen them before and, therefore, hadn't recognized them as edible. I had stampeded perfectly edible leaves thinking they were weeds or not even noticed them at all. How embarrassing.

MICROBIOPOLITICS

The food I was eating, the daily shiitake intake, was having a strong influence on me. At night, in my little adobe hut, I started having intense and vivid dreams about fungi. With one of the first ones I remembered most clearly, I recorded my voice re-telling the dream upon awakening. With a sleepy voice, interrupted by occasional yawns, I heard myself telling how I was in a tropical sculpture park—similar to Brazil's famous Inhotim—except all the sculptures were as tall as skyscrapers and they were all representing communist leaders. I was there with a group of family and friends, but everyone was behaving like a different animal. My ex-boyfriend was barking like a dog (not sure how to interpret that one) and my mother was an albatross and running towards a cliff to fly off—an image that occasionally still haunts me. I was an ant. But not just any ant. I was an ant infected with *Cordyceps*. There are over 400 different species of *Cordyceps*. The most famous type to us humans, the *Cordyceps sinensis*, is known to have healing powers, boosting energy and vitality. Humans can take it as a supplement (which I had indeed been doing) to boost the immune system and enhance focus. However, when an ant is infested with *Cordyceps* (*Ophiocordyceps*) it becomes a so-called 'zombie-ant'. The fungus starts dictating the behavior of the ant and the ant has no other option than to do what the fungus tells it to do: climb to a high point to die. Google any zombie-ants videos and you will find a gruesome narrative (and accompanying music) similar to a horror film. As I was ascending a huge tree, I knew that when I reached the top, just like in the videos, a bulky mushroom would sprout straight out of my forehead. It would be the end of my life, as well as the beginning for a whole bunch of spores that could flow out freely from this height. I was just the host for the fungus to reproduce.

From a microbial point of view, we humans are just that. A vehicle, a habitat, an environment. With every breath we take, we inhale spores and bacteria; with every surface we touch, we take millions of invisible guests with us. Moving to the farm in Brazil wasn't just about relating to new foods and peoples. I had to relate to my new microbes, to the bacterial, fungal, and viral organisms that I was ingesting. I felt more and more that I was becoming the food I was eating. It reminded me of the work of Heather Paxson, who writes about eating as a site for understanding the material constitution of relationality. Through this understanding, Paxson introduces the concept of microbiopolitcs, what she calls 'the creation of categories of microscopic biological agents.'[3] She illustrates what she means with microbiopolitics by laying bare the processes and perceptions in the world of artisanal raw-milk cheese-making. Food Safety regulators

3.

Heather Paxson, *The Life of Cheese: Crafting Food and Value in America*, University of California Press, 2012, pp. 158–162.

often perceive these cheeses as dangerous because of the amount of microbes involved in the process. The makers of the cheese perceive their product to be beneficial to our human health for exactly the same reason. The concept of mircobiopolitics shows that there are very different attitudes towards microbes, from people understanding them through a Pasteurian lens, which is more concerned with hygiene and fear of infection, to the 'post-Pasteurians' who embrace microbes—probiotics—as positive enhancers of digestive processes. In a post-Pasteurian worldview, we are no longer fighting the microbes, but recognizing them as part of our bodies and, therefore, of ourselves. In political terms, we have the probiotics and the antibiotics. This concept of microbiopolitics acknowledges the agency and political power of the microbes living and interacting with our bodies.

It took me some time to get to know the food on the farm and understand how it likes to be treated. Before we could eat the *feijão* (beans), the plants had to dry for months and we had to hit the dried plants with sticks on the ground so the beans came out, an intense but fun workout. Before cooking, the beans had to hydrate for twenty-four hours. Food was about time. Time for a plant to grow, time to learn to recognize the leaf, root, bark, fruit, or fungus as food, time to observe its growth and the ripening process. But also, time to harvest, to dry, to ferment, to process, to boil, to hydrate or de-hydrate. These teachings were not to be read in a book, but learned with and through the body, through spending time. In an interview with Lina Meija, director of the art program Platohedro in Medellín, Colombia, we spoke about this bodily learning. Since 2004, they have investigated contemporary issues and the defense of human rights through the liberation of knowledge, exploration, and autonomous and collective reflection. The body plays a central role in how they approach artistic experimentation, the appropriation of technologies, free communication, and alternative pedagogies. As an organization they offer support to children, adolescents, and young people, and they try to disassociate them from the dynamics of generalized violence, a daily reality for many in the community. Lina herself comes from a dance background and told me in her charming mixture of English and Spanish that: 'Our bodies aren't meant to just carry a big *cerebro* (brain) around, as intelligence and memory are really present throughout the body.' That's why, at Platohedro, her art organization, they do therapeutical work or offer psychosocial support through body-work. Lina:

> Body movements for *sanación*, for healing, recovery. In this sense we shut up the word, *la palabra*, and the mind. Usually with victims and situations of trauma, there is still hurt encapsulated in the body that needs to be let go of. And so the body transforms.

Though art is the main vehicle for working with communities and children at Platohedro, they also like to cross disciplines in recent years

have started learning about the body in collaboration with a laboratory in Medellín that works with bacteria. The project was called 'Micro-rhythms' and took viewers to a hybrid world created by sounds and light movements coming from the energy generated by bacteria. Artists Leslie Garcia and Paloma Lopez, part of the art collective Interspecifics, carried out a research and creation laboratory with a group of participants who collected soil samples from different areas of Medellín in order to feed bacterial cells and produce bioelectric energy in this way. With the audience, they created sounds and light movements coming from the energy generated by bacteria. At the Museo de Arte Moderno de Medellín, where this multidisciplinary project was conducted, an installation amplified the micro-voltage produced by the microscopic organisms and turned their oscillations into electronic signals; the language of the bacteria, if you like. The installation, consisting of a micro-voltage decoding system that uses lamps and a Raspberry Pi camera system (among other high- and low-tech gadgets), was essentially the bridge that allowed for a form of communication with the bacteria. Lina:

> We are just these huge vehicles of a whole bunch of bacteria, and they also have intelligence and desires. The body starts to resonate with them, energetically and in communication. What do the bacteria in and on our body want to eat?

She continues:

> I remember ten years ago, our young vegetarians would eat rice and egg. That was how you were vegetarian. But then they realized, through this acknowledgement of the bacteria, they weren't just feeding themselves.

Lina describes how the team's way of eating started to change. How they started to cook together. How they started to create a whole different menu. And here it becomes very mycelial because the vegetarianism started to 'contaminate' all the others. Lina:

> Just like on a tree, you'll see the lichen, but you'll also see the fungi and you see them together but sometimes they overlap. This is also how things at Platohedro started to work, to get more layered. Either a layer underneath or on top, but they started to become integral.

Platohedro shares the process in how they got to this point. Lina:

> About ten years ago, before all the experimentation with art and technology began and before the multidisciplinary, other species, gender, and the cross-critical thinking about these issues, we

had a very traditional vision of the organization
with different roles that help sustain the others:
a fundraising team, directors, communication, ev-
erything was much more separated. Yet that was
not how things worked in reality. A shift slowly
started to take place in 2014. Each program start-
ed to generate its own sustainability. It wasn't
as parasitical as before, and became more like a
multispecies community that helped sustain the
whole ecosystem. This works much better. At the
time the shift seemed slow but when you look
back it happened so fast. When you see other
organizations, they develop over years and they
have these very deeply rooted problems. Their
dirt, grounds, are contaminated by gender, hierar-
chies, a certain motionlessness... .

I get Lina's point. The configuration of the team with everyone's roles and
responsibilities entangled is crucial. Something that is only possible with a
lot of trust and respect between everyone. She continues:

The well-being of the team is so important and
the well-being of the person feeds the well-be-
ing of the organization. Everyone has a different
rhythm and we have to go through our own pro-
cesses. You can't take away someone's pain. But
that doesn't mean that we should bury the shit. It
means that we have to compost it. And then one
nurtured organism starts to open up, and then
all the other ones start to spread out as well to
become the way they want to be, and start using
the space and the co-living in a nurturing manner.
It's not the way humans have worked in the sense
of the patriarchy: 'You are because I give you.' It's
more like 'I exist because you exist and how do
we exist together?' That's a completely different
way of working. We have a way of thinking based
on *buen vivir*.

Buen vivir, also called *sumak kawsay*, by the Quechua people, can be
understood as a social philosophy that is the opposite of capitalism; it's
about leading a balanced life in an ecological sense, having a harmonic
community at the center of activity and being culturally sensitive with
each other. At Platohedro they help and care for each other, but it's clear
that no one can take the pain of others away. However, there is a genuine
interest in going deeper and not just looking at symptoms. Lina:

That's how our medicine works today: to combat

symptoms. We want to really deeply feel what's
going on with the person. That also that person
has the chance to really critically feel what's
going on, how that could be resolved. Here we
believe that everybody, everyone, every living ex-
pression, even the material, the objects, are part
of that everyone. They all have their own sense
of reality and understanding. I remember before
we studied micropolitics at Platohedro, I had
come to this notion in physics that's called 'con-
tención'. It means that when I take this glass of
coffee and I put this lighter inside of it, they will
just sit there with each other—normally—and won't
chemically react; they just embrace each other in
that volume. I brought that to the group before
we started with micropolitics. Let's just trust and
let that other person resolve. We were there with
each other, connected, in senses, understanding
the communication, not ignoring and being inside
ourselves, but also not being violent in trying to
resolve. Just to allow. I think this is also how the
forest works.

It seems that this all requires an awful amount of trust between people.
When I ask her how they got to this deep level of trust within the team, she
gives me a knowing and slightly mysterious smile like she is about to share
the big secret of life with me. Lina:
We only got to that by working on silence: of deep
listening to ourselves initially, but then also to
our participants. When we learned to be silent it
helped us to be more entangled.

Her answer makes me silent. Perhaps she did just share with me the big
secret of life.

TAKING CARE AS A WAY OF LEARNING
We learn with our body not only through food and bacteria, but also by
just spending time in the presence of fungi and looking after them. Working
with fungi or learning from fungi is a different way of acquiring knowledge
than from a book. It's not a school about theory. Writer Alexis Pauline
Gumbs proposes in her book *Undrowned: Black Feminist Lessons
from Marine Mammals* to rethink school as a scale of care. 'What if
school was the scale at which we could care for each other and
move together?' she asks. A question aligned with the methodologies
of fungal learning. It's helpful to read instructions about how to create the
right conditions for fungi to grow, but essentially how successful you are in

doing this depends on a series of factors that are specific to your time and space. Only through care, time, careful observation, touching, and smelling do these lessons reveal themselves.

The three amazing women of Peruvian art collective FIBRA, Gianine, Lucia, and Gabriela, work closely with fungi in their artistic practice. Having made various sculptures using mycelium, they have experienced closely how their own behaviors changed while working with this living material. By wanting to use mushrooms (mostly oyster mushrooms) and mycelium in their work, they learned how to take care. By spending so much time with them, trying to make them grow, talking to them and observing changes. When I interviewed FIBRA, the topic of care came up, though not without a fair amount of initial resistance to it. Care, especially in Latin America, is often automatically associated or even stereotyped as feminine behavior, as a quality of mothers. It comes with a certain softness or love that is considered misplaced in a rational, professional, and scientific discourse. Lucia explained how fungi changed her relationship with care:

> I used to be resistant of care as a thing. I felt
> that because I was a woman working with natu-
> ral things it was always obvious that 'I wanted to
> work with ecology because I'm a woman and it's
> natural for a woman to care.

As a rejection of this assumption of femininity, Lucia would say the opposite, that she didn't really care. After becoming a mother, this has changed something for her, making her think about care as a more radical act. She continues:

> With the mushrooms we have a lot of attention in
> how we take care of them so they can grow well.
> And taking care is a powerful way of learning. It's
> a form of thinking about and learning in non-tra-
> ditional environments; to care for is not a school,
> not a theory; you can only learn if you are there,
> if you show up for this other living being. There is
> something about care in fungal learning.

Gianine expands on this and explains how the care between her and the fungi has been mutual. Fungi has shaped the way she connects with herself.

> I thought I was already a grown-up and knew who
> and how I was. I knew my body and the connec-
> tions with the world and my surroundings. Some-
> how this experience of working closely with fungi
> was new and I don't know if I can really explain it
> in words. It's about different ways of connecting
> with yourself. Within the mycelium the hyphae

FIBRA Colectivo, *Desbosque 8°07′16.6″S 74°52′46.6″O*, 2022. Installation, mixed media (inkjet prints, 150 x 100 cm each; binaural sound, 10 min). Photo: Tatiana Guerrero, 2022.

31

Bodily and Fungal Learning

can always find multiple ways of going. We human
individuals have to decide to take one road or
another, but they can take both or three or even
more. You don't have to decide and you can be in
all those places. Now with FIBRA, our collective,
I can miss some parts, but FIBRA is doing it so
somehow I'm also doing it at the same time. It's
not about individualities or individual presence,
but about a collectiveness, of being one together.

When some of the other members of the collective might be working on
something, or are physically present somewhere, she doesn't have to be.
They can represent each other, represent the collective, and be in multiple
places at the same time. Just like the mycelium. Gianine:

I think it has something to do with selfishness and
authorship. We have learned in life that we have
to shine as an individual. This is something I have
never been comfortable with. The way of working
as a collective makes it possible to work without
celebrating the ego, without having to focus on
who owns the work or owns the idea. It goes be-
yond ownership... I like to think about the collec-
tive and about community and at the same time
the input the individual can have in that commu-
nity. And fungi are an amazing example of that.
They have an input in shaping the world.

Lucia:

When we were working on the sculptures, we were
in a makeshift kind of lab. This working space
we called our 'myco-cave'. It's really more a cave
than a lab. It was super tiny and really hot. It was
summer and we separated some spaces with plas-
tic and a little fan. It was the three of us with our
face-masks sweating on each other in this cave,
hoping that the sculptures were going to be OK. I
feel there's often a lot of conversation around the
conditions of the environment in which we make
and less about the condition of the makers. For
instance: how our sweat and breathing are part of
that environment.

GEO-CHOREOGRAPHIES

That it's not just the conditions of the environment, but also the move-
ment and interactions of our bodies within that environment that hold
knowledge, power, and influence, is beautifully laid out by the work of art-

ist Carolina Caycedo. She calls this 'geo-choreographies'. It was
the name of a project she did with the people affected by *El Quimbo*, the
hydro-electric dam on the Magdalena River, located in the southwestern
central part of Colombia. The term refers to the everyday gestures that are
specific to a certain geography. When I meet Caycedo in an inconspicuous
juice bar in Mexico City, she explains to me how a geography is connected
to the embodied knowledge that can be found in the gestures of the people
living with the specificity of that geography. Caycedo gives an example:

> In the geography of a river, you have the everyday
> gestures of the throwing of the net, the casting
> of the net, the crossing of the river, the paddling,
> the weaving of the net, the carving of the paddle
> and the building of the tools. This is what I call
> the geo-choreographies; an embodied knowledge,
> something that you have inherited for genera-
> tions, which has been sophisticated throughout
> the generations and through the act of doing it
> every day.

When I ask why 'choreography' over the word 'gesture' in this context, she
explains:

> It's a choreography because you repeat it. When
> you cast a net, you don't throw it in the river just
> once. You cast it two hundred times and each
> individual has their nuances, depending on who
> taught you. There are so many ways of doing
> things, even for weaving the net. It's accumulated
> knowledge because it passes through generations.
> It has to do with memory muscle, that's why it is
> a choreography.

This example clarifies how a seemingly mundane everyday gesture—
in this case fishing—can be given agency through language. The term
geo-choreography is charged with political power that can be put to use
when the river is threatened. The deeper the connection with the locality,
the stronger the agency of the geo-choreography. After all, the more spe-
cific the choreographies are to their geography, the harder it is to re-locate
them or exchange them. Nature writer Robert Macfarlane spoke about
something similar on a podcast from *Emergence Magazine* I had once
listened to, in which he refers to his book *Landmarks*. In this conversa-
tion he speaks about landscape and language and how naming the living
world and the specificities of the landscape are both a joy and a responsi-
bility. It's a way of creating intimacy and connection with a landscape, and
naming its specificities can help indicate the irreplaceability of it. He states
what's at stake when specificity is gone as landscapes described in general
terms are more vulnerable to misuse. In other words, when the ecological

Carolina Caycedo, *Mujer grande* [Big Woman] (detail), 2017. Sculpture, mixed media (Wooden mask, handmade fishing net, handmade wool hammock, nylon fishing net, fabric, dry cattails, dry plantain stem fibers, vine, rope), 216 x 66 x 157 cm. Photo: Ruben Diaz.

Bodily and Fungal Learning

complexities are not perceived, but when the landscape is simplified and
homogenized, it could more easily be considered 'no use' and, therefore,
disposable. There is no reason why that landscape should not make way
for a hydro-electric dam for instance. Macfarlane:

> The right names, well used, can act as portals
> into the more-than-human world of bird, animal,
> tree, and insect. Good names open to awe and
> mystery, grow knowledge, and summon wonder.
> And wonder is an essential survival skill for the
> Anthropocene.

Carolina Caycedo takes these words of Macfarlane to the next level, reiter-
ating not only the irreplaceable and invaluable specificities of the locality
(geography), but also the embodied knowledge that is connected to it
(choreography). She adds:

> If that river was not there, that evolution of the
> gesture would not have been possible. When the
> river is threatened and changes its form, when it
> stops being a free-flowing river, becomes privat-
> ized, and becomes a stagnated dam or reservoir,
> there will be no more fish. When there's no more
> fish, then you stop fishing. First you stop going to
> the river, it makes you depressed and you don't
> want to see the river that way, so there's an emo-
> tional aspect of it; an identity aspect. Secondly
> you stop weaving the net and you stop eating fish.
> Not just the river, but all of that embodied knowl-
> edge is threatened. The passing of the knowledge
> through generations is broken, the geo-choreog-
> raphy disappears, and that's the ultimate conse-
> quence of extractivism.

Her work makes visible not only how energy is extracted from the river
but also how knowledge is extracted from the bodies that lived with that
river. It means that fishing in a river without fish can be a political gesture
of resistance.

EMBODIED COMPLICITY

Applying the concept of Caycedo's geo-choreographies in a world ridden
not only with these environmental destructions such as hydro-electric
dams, but also the destructive forces of extreme weather caused by cli-
mate breakdown, inherently loops back to food and our body. Our bodies
hold our pain, our traumas, and knowledge that can be passed on through
generations. We are the cause but also the victims, even when we don't
want to be. The consumption of energy, medicine, and food produced by
multinationals makes us complicit even when essentially the damage is

directed towards ourselves. Eduardo Viveiros de Castro brings nuance to this in his book *The Ends of the World*:

> This is because, today, many of us (humans and the non-humans we have enslaved or colonized) are victims and culprits all at once, in each action we engage in, at the push of every button, with every portion of food or animal feed we swallow— even if it's as obvious as it is essential that we do not confuse McDonald's itself and the teenager conditioned into consuming junk food, or Monsanto and the small farmer obliged to spray his genetically modified corn with glyphosate, let alone the pharmaceutical industry and the cattle force-fed with anti-biotics and hormones.[4]

Like fungi, we don't only carry our landscapes, ancestors, traumas, knowledges, and microbes in and throughout our bodies, we embody a complicity, caused by the entanglements within a system. Being aware of this embodied complicity requires us to stop thinking in terms of us and them. When we are our landscapes, we are less likely to cut our rivers, our crucial veins, and make different decisions about the ways we source our energy. When we are our ancestors, we connect differently with an energetic world, and recognize that their spirits can be found in other living beings. When we are our traumas, we acknowledge that our healing needs take place throughout our bodies and not just in the mind, and when we are our knowledges, we connect with a bodily intuition that goes beyond every rationale. When we are our microbes, we feed beyond comfort or taste. And this we learn best by walking, gardening, cooking, dancing, feeling, moving, and perhaps by getting lost sometimes.

4. Eduardo Viveiros de Castro, *The Ends of the World*, Polity, 2016, p. 176.

HOW TO REVIEW OUR COLLECTIVE MEMORY?

Recognizing Entanglements as a Practice of Responsibility

TEACHING TWO

Featuring:

Huitlachoche, Chytridiomycosis (chytrids), Maria Alice Neves, colectivo amasijo (Martina Manterola and Carmen Serra), Mahmood Patel, Tara Rodríguez Besosa, rust fungus, *Beauvaria bassiana*, porcini, Vero Briseño, pathogens, fairy rings, Annalee Davis, Dona Ji, Fernando Laposse, Trine Ellitsgaard, Pedro Neves Marques, Patricia Kaishian.

Geographies:

Barbados (Coco Hill and Sandy Lane), Restinga area of Brazil, Mata Atlántica, wider Caribbean region, Oaxaca Mexico, Milpa Alta Mexico, Puerto Rico.

Walking through Coco Hill Forest in Barbados, the easternmost island of the Caribbean, is probably the closest you can get to catching a glimpse of what the island must have looked like before the British arrived in 1620, Mahmood Patel tells me. Patel, who is Barbadian and the guardian and owner of this site, has been spending the last decade attempting to understand and regenerate the multi-layered social and environmental complexities of this forest, which used to be a sugarcane plantation. The trauma of colonialism is not only felt by the people, but also by the land, this land. The settlers had been brutal in enslaving people to work on the plantations and were violent toward the island's grounds, species, and ecosystems by cutting literally everything down to make space for large-scale monocropping of mostly sugarcane. Some four hundred years later, the scars on the landscape and the collective memory are still very much present.

Patel aims to restore and heal the landscape of Coco Hill Forest by regenerating the soil, as well as re-introducing native forest trees—such as whitewood and fiddlewood—and edibles that the island has lost over the years, for instance cocoa, coffee, and pineapple. He is faced with numerous challenges: the soil is poor as the top layer has been washed away due to exhaustive sugarcane production, and there have been huge mudflows at Coco Hill, eliminating everything in their way and leaving behind only terrestrial skid marks. Patel has been planting coconut trees in some of

these barren strips—and with success. The roots are strong and help against erosion. The healthy young trees are now signifiers of hope and possibility for (agro)reforestation.

Swaying over the undulations—a visible consequence of the plantation as these were the sugarcane beds—we are now on a path of natural forest perfumes where we encounter ginger, turmeric, citrus, bay leaves, Bajan sage, guava, lemongrass, tamarind, and many more edible and medicinal plants. We rub leaves and inhale deeply—this forest is to be experienced using all the senses. Patel shows me the local mamey apple, sugar apple, and custard apple, although curiously none particularly look like apples. Colonial legacies remain in the language: the European reference was the apple, so the circular fruits are all named after what was known to the British settlers. Even the fruit needs decolonizing it seems.

In a sudden clearing you can note that people used to live in that part of the forest, possibly people that had initially managed to escape from the plantation and kept living there. The clues lie in the sudden increase in the variety of edible and medicinal plants, sometimes a remnant of a corrugated plate. Some areas are untouched, tranquil, and allow for a connection to deep time; incredible Jurassic tree ferns with detailed barks hint of other geological eras.

Other areas are used to try different varieties of coconut trees. Mahmood picks up a coconut, decapitates it, and invites me to drink the flavors of the forest. The husk of the coconut makes for an excellent compost, and all other old palm leaves and twigs are used for terrace farming. Nothing goes to waste and value is added to the produce by making jams from banana and ginger and by-products from the coconut crop. 'I envisage a permaculture circle here with the coconuts, ginger, and eddoe-yams,' he explains while digging up a huge chunk of fragrant ginger from the ground for me to take home. They are growing abundantly at Coco Hill. 'And can you imagine we import these from China to Barbados?'

The Caribbean island shockingly imports ninety percent of its food, including many primary agricultural goods that could be grown locally. Very few people are interested in farming in the region, among other reasons, because the profession of a farmer is haunted by historical plantations. It is physically taxing and surrounded with shame. Other farmers are not interested in an organic practice as that would be 'too expensive'. The dominant argument against organic farming is that 'the price is the problem', not that the disturbed (eco)system is, Patel tells me.

The work of Barbadian artist Annalee Davis addresses these 'post-plantation economies,' particularly of Barbados. Her work is very much informed by history and brings back stories that have been erased (for instance from archives), excluded (from pedagogical curricula), or forgotten (from the collective memory). When Davis was commissioned by the National Trust of Scotland to develop new work inside the frame-

work of their ongoing mission to face the legacies of slavery and empire, she decided to explore the shared history between Barbados and Scotland. What few people know is that in the seventeenth century not only hundreds of thousands of enslaved African people were sent to work on the plantations, but numerous Scottish, Irish, Welsh, and English prisoners and women were also banished to Barbados. For her work *A Hymn to the Banished*, Annalee Davis conducted research into the banishment of fifteen Scottish women and traditional practices around the use of plants, healing, and incantations practiced by Gaelic people in the Scottish Highlands and African enslaved people in Barbados who also brough their own traditions. She was imagining how Scottish laborers that came to Barbados and brought their traditions and practices with them might have encountered enslaved African people in Barbados and wondered if their practices rubbed up against each other, influencing one another's rituals. Scottish people and enslaved African people in Barbados both used incantations as a way to release the healing properties in plants. In an interview Annalee tells me:

> One difference between the two places is that the Scottish have transcribed their incantations in both Gaelic and English. In the Caribbean, these rituals that were praciced, were illegal, and weren't written down as a strategy of survival, but were orally transmitted. Trying to recover this kind of memory is challenging. The practice of Obeah, the collective term for these spirit-based practices in the Anglophone Caribbean that the enslaved African society engaged in, was illegal in Barbados up until the nineteen-nineties. Of course, Obeah practitioners haven't been policed in recent years but the practice was originally punishable by torture, prison and even death.

Annalee is interested in working with plants and developing small plots or living apothecaries to foreground traditional uses of plants as systems of counter-knowledge, resistance, and empowerment. Annalee: 'When thinking about memory, we need to ask ourselves: Whose memory? What kind of archives exist that can give us access to these counter-stories and buried narratives?' As a Barbadian raised on a series of sugarcane plantations, her growth required unlearning and re-learning in response to the colonial curricula which left out so much information, 'alienating us from many alternative narratives,' she tells me.

> This notion that some plants were weeds that had no value and had to be removed with chemicals or by hand, only to realize that many of these plants had profound value in terms of healing, ritual, and

resistance within Barbadian enslaved society is
knowledge that was excluded from the curriculum.

44

Annalee grew up thinking she was raised in a natural environment, only to
realize that it was a very controlled setting. The plantation was where
monocrop farming practices required the denuding of the island's biodi-
versity and in so doing has contributed to the sixth extinction or the
Plantationocene, a term signifying our human epoch, defined by ex-
traction, racialized violence, land alienation, and the loss of biodiversity. In
her text 'Innerseeing versus Overseeing',[1] Davis describes the ritual of
walking former sugarcane fields as one way to form a more intimate
relationship with a landscape that has been so heavily mediated by
centuries of the plantation—and more recently by tourism. Her approach
to reviewing collective memory is by trying to bring up other memories
forced into being dormant and controlled by the colonial project, memo-
ries that have been erased, removed, or deemed to be illegal. Davis: 'It's
about trying to probe underneath the surface of the colonial
project and recognize the chaos, trauma and potential of what
sits just below that surface.' In a work that is still in progress when we
speak, *Pray to Flowers. A Plot of Disalienation*, the words 'Un-learn
the Plantation' are embroidered into textile. When I ask her about it, she
explains:

> Un-learning the plantation is really central, in part
> because of the idea of the plot—a critical site of
> memory for enslaved society within the context of
> the plantation. These marginal pieces of land were
> given to the enslaved to eke out a living and grow
> their own food and plants for sustenance, healing
> and spirit-based practices. Barbados tends to be
> better known for exotic flower shows and exotic
> plants, but what I'm focusing on is the marginal
> pre-capitalist site of the plot within the larger
> capitalist machinery of the plantation, where the
> enslaved had agency when working with plants as
> spirit practitioners, building community and pass-
> ing on information while taking care of themselves
> and each other.

Words that echo the writings of Sylvia Wynter. I see a parallel between the
plot and the plantation, between wild mushrooms and the agricultural
field. True nutrition, medicine, and value is situated right outside of con-
trolled areas. The plot is a powerful metaphor for the underground in un-
registered spaces where important knowledge and meaning is produced.

BATTLES ON THE GOLF COURSE

Rather than being used for agroforestry or regenerative agriculture, like

1. See: annaleedavis.com/archive/
innerseeing-versus-overseeing.

Annalee Davis, *Woman Confronts a Long Annelid Parasite of History*, 2018.
Mixed media on paper, 135 x 91 cm. Photo: Daniel Christaldi.

45

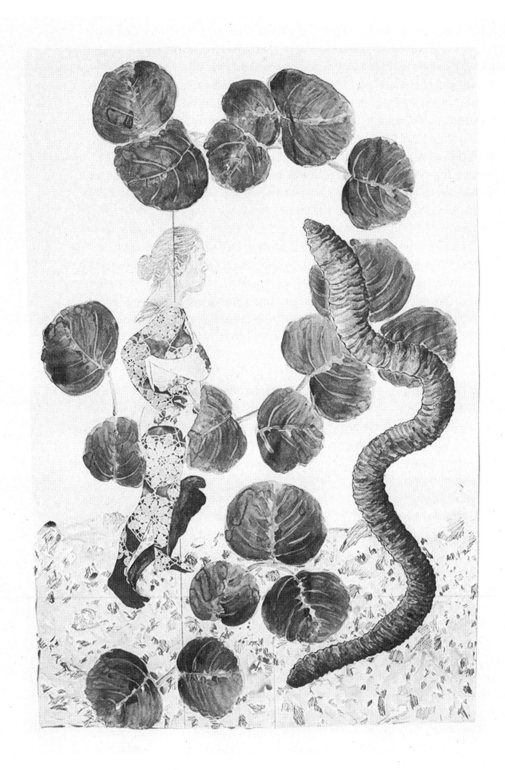

Coco Hill Forest, a lot of the former plantations have been turned into golf courses, symbolizing natural manifestations as a display of wealth through a monoculture—because, essentially, that is what a lawn is. Curator Beatriz Colomina writes in her book *Domesticity at War* about the role of the lawn in the representation of the picture-perfect American dream: 'A bright green manicured strip of grass that is as tame as nature can get controlled by poisons and gasses and kept accurately in place by fossil-fuel thirsty lawn-mowers.' Colomina highlights the peculiar advertisement and language for the domestic equipment to cut the grass, using the military logic of battles fought in the war. This same militarization of language is addressed by artist Pedro Neves Marques. In their beautiful film *A Mordida* (The Bite), we follow two parallel storylines: one that takes place in a lab in Brazil, where scientists are researching the possibility of genetically modifying mosquitos in order to stop them from spreading disease (this is real, no science-fiction!), and a second centering on the erotic and tense love story between three people.[2] The film was shot during the Zika epidemic in Brazil and in one scene Neves Marques shows a big banner that they had come across, stating '*Se o mosquito pode matar, ele não pode nascer*' (if the mosquito can kill, it cannot be born). The language against the virus was militarized and even the scientists were speaking of the mosquito causing a 'genocide', Neves Marques tells us in a talk they gave that I attended in Mexico City. The militarization of the language of biology inspired them to write this poem.

Back at the plantations-turned-lawns in Barbados, a dear friend who lives right by Sandy Lane—an area enveloped with golf courses—told me she often encounters fairy circles of mushrooms around the courses when walking her dog. I was so happy she brought them up as I've been fascinated with this phenomenon. Fairy circles are mushrooms that grow in the shape of a ring, perfect circles of mushrooms that are associated with witches because they are so mysterious. It occurs with over fifty different species of mushrooms, with the most significant one being the fairy ring fungus (*Marasmius oreades*), which also happens to be edible. Scientifically, there are several theories about how it is possible that certain mushrooms grow in the shape of a ring, and it's more than likely to do with the shape of the mycelium underground, possibly creating a lack of mushroom growth in the middle as nutrients are exhausted from the center outwards. The hyphae are busy reaching outwards to extend the network, creating the ringed-shape of mushroom growth. Other theories suggest the fairy ring begins with spores. A big enemy of the clean green golf lawn globally is rust fungus. Rust fungus causes diseases on plants and there are around seven-thousand different species of them. The powdery orange fungal substance that indeed looks like rust spreads easily. Rust fungus is considered a parasite and you can imagine the nightmares it must cause any golf-club owner: a neatly manicured green field, turned bright orange. And it's not

2. See the trailer: vimeo.com/349134759.

Pedro Neves Marques, 'The Militarization of Biology' from *Viral Poems*, 2018. Set of 21 poems, 44 x 62 cm each. Courtesy the artist and Novelio Furin Collection.

47

THE MILITARIZATION OF BIOLOGY

the militarization
of biology
is
the language
of suppression

when
the state
begins
to wane

the suppression
of language
is
the biology
of militarization

just golfers' torment; rust fungi also infuriate farmers given that they pose a threat to agriculture and have been responsible for gigantic crop losses, particularly of wheat and other cereals.

I decide to contact Patricia Kaishian, a mycologist whose post-doctoral thesis was about rust fungi. In our conversation, Kaishian first critically and clearly contextualizes how we understand 'parasites' as a judgement of value:

> The idea that there are biological laws and forc-
> es that govern any given organism is no different
> than those that govern parasites. Basically, para-
> sites are organisms that we don't like.

She explains:

> How can you definitionally separate a predator,
> like a lion who eats a prey, from a parasite? It
> becomes really difficult to really securely defi-
> nitionally separate those things. Or similarly a
> herbivore that is grazing on a plant. There is not
> actually a great definition for parasitism that
> would not incorporate all these other things that
> we don't feel comfortable calling parasites, be-
> cause they are probably engaging in behaviors
> that are similar to people.

It's true, we humans are very uncomfortable with using parasites to describe relatable behaviors and instead only really relate that term with organisms that are creepy or weird. Kaishian:

> Pathogens are a little bit similar in this; both of
> the terms have overlap and connotations around
> value assessment that break away from anything
> strictly objective and scientific. All organisms
> engage in this process of killing and using ener-
> gy that has been obtained by something else and
> using it to our own benefit.

It made me think of how, in some way, everything that we ingest becomes part of us. It informs how we are, and what we are. The micro-organisms that live in our gut have the memory of the past lives of our ancestors and their diets. If they used to eat corn, it is more likely our stomachs will tolerate that too. The diets of our ancestors are the memory of our body and how it connects us to land and food. Next to the energy that food provides, something else is being passed through that is the essence of our microbial collective memory. Though it is always 'selfish' to kill something else to eat, whether plant or animal, there is also a transfer of something else taking place there. We all consume things that are external to our bodies, which makes us heterotrophs. Some cellular organisms are self-feeding

and are known as autotrophs. They produce their own energy and nutrients using sunlight, water, or occasionally through other chemicals. Examples of autotroph organisms are plants (photoautotrophs), algae, phytoplankton, and some bacteria. Kaishian:

> Everything else that has evolved has incorporated the resources of other organisms. Maybe to the detriment of other organisms. How we talk about that actually has strong roots in social assessments and are not necessarily scientifically subjective. It's everywhere you look, once you start to appear in these ideas. Of course, with fungi they are known by most people to be pathogens, to be parasites, so there is a strong relationship with these terms and fungi. Even though most fungi are not necessarily pathogens, they are still strongly associated with that.

Kaishian's important research on parasites was conducted at Purdue University, an institution with a big and long-standing history of agricultural research. Though Kaishian speaks highly of her fellow researchers and is grateful for the support that she has received, she is also very aware of how Purdue is supported by industrial agricultural monies, including the United States Department of Agriculture , and other funding bodies that are interested in crop management and crop protection. There is a clear agenda there. Rust fungi are pathogens on a variety of plants, and highly valuable plants, socially and monetarily valuable like coffee, chocolate, wheat, soy, and corn. They are studied extensively at Purdue by scientists who receive funding from agricultural industries, Kaishian explains to me.

> Tremendously good research is happening there; I'm not at all critiquing the research. There's been really awesome scientists who studied fungi there. But the reason why we get funding is because these fungi are of interest to agriculture. And there are so many other really cool groups of fungi that are not well studied simply because they are not ironically made into an enemy.

It seems a classic case of keeping your friends close but your enemies closer. Their enemy status has brought funding upon the rust fungi, but in order for them to be eradicated. Kaishian:

> The ways in which we study organisms is very much related to how we value them socially and commercially and that translates into material knowledge of them. It's not abstract.

Basically, the fungi that are the biggest enemies receive the most funding.

Agriculture, capitalism, science, food-security, and even golf courses are all factors that influence which fungus gets the most attention. Who gets to decide who can live and who needs to die? It's a clear example of how capitalistic human interests—money—strongly influence what we study and, therefore, what we know. A financialization of what we know, what we study, informing and forming our collective memory.

When I ask Kaishian which fungus is currently the most popular in being unpopular she doesn't have to think very long for her answer. 'Right now, there's a lot of research on *Chytridiomycosis (chytrids)*.' *Chytrids* are a type of microscopic fungi that live in water and can attack reptiles and amphibians and threaten the extinction of a lot of those groups, who are otherwise also extremely vulnerable to climate change. Species from more than thirty countries in the world have been severely affected by *chytrids*, also called 'bd' after its Latin name, *Batrachochytrium dendrobatidis*. It's a skin disease that has actually wiped out hundreds of species of frogs and has already made more than ninety frog species extinct. It's equally deadly sister 'bs' (*Batrachochytrium salamandrivorans*) is responsible for the rapid decline of salamanders. Looking into where the *chytrid* fungus comes from, its roots trace back to South Korea, yet in Asia most amphibians are impervious to it. It only became a problem when the amphibians were traded internationally. To eat? To keep as exotic pets? Who knows what they were used for, but they entered the capitalist system of trade. Animal trade allowed for *chytrid*-infected amphibians to spread across the world and affect wildlife in many places, including Latin America. Particularly in Panama and Costa Rica they have suffered from a huge decline in amphibian populations. Considering all of this, who is really responsible for the mass mortality of these amphibians and where does the root of the problem lie?

Kaishian emphasizes that she doesn't think that *chytrids* shouldn't be studied and that the protection of these vulnerable amphibians is really important. But she adds that she thinks that 'all fungi should be studied.' She points out how previously no one studied *chytrids*, except a few people around the world. 'But now that they are visible pathogens that people want to eradicate, that's when all the funding comes.' It is clear that a lot of fungal research is motivated by biocontrol. And to make it even more complicated: 'If it's not to eradicate the fungi itself, then it is to use that fungi to eradicate other "pests", like other fungi or invertebrates, that are unwanted.' There are also fungi that can kill insects such as a flock of hungry grasshoppers— very handy in an agricultural setting. Fungi in the genus Beauveria are typically insect pathogens, including *Cordyceps*. *Beauvaria bassiana*, for instance, is a fungus that creates a layer of white mold on insects, a deadly disease. It is known as the white muscadine disease and wipes out termites, aphids, beetles, and flies, and is something no insect farmer wants to have on their crops. A fungus used as an insecticide. We are fighting one thing with another thing, using insects and fungi as our warriors.

Yet we forget about the problem in the first place: these 'pests' and 'pathogens' arise as a result of monocrop plantations, excessive use of pesticides, or international animal trade.

SPONTANEOUS PORCINI

Decades of monocrop plantations and industrialization, also as part of colonial endeavors, are inextricably entangled with the landscapes of today. In the Restinga, the coastal area of the Atlantic Forest in Brazil, blessed with picture-postcard white sands, water comes in and forms lakes in the middle of the sandy areas on the coast. The sandy soil makes it a harsh environment for plants, yet there are a lot of mycorrhizal fungi there, making sure the available nutrients are shared. The area is also popular with real estate companies, which are heavily exploring the area because of its beauty and proximity to water. A group of botanists and mycologists, including Maria Alice Neves, is trying to find out which fungi are there, and how they are related to which plants. In this area, it has never been researched which plants have fungi associated with them, and the multidisciplinary team is researching the anatomy of various plants in order to see how the fungus has changed the roots. They are isolating the roots in the lab to see how each plant reacts to the fungus and how that compares to the plants that don't have a fungal partner. One of the ideas of this project is to isolate and identify the pairs; to use the plants with the fungi and to carry out restoration and conservation on this area through this pairing.

This restoration and conservation in the Restinga area is needed as there is a big problem with a pine species that is invasive—it grows all over, spreading like crazy. Maria Alice Neves tells me that an NGO has been working already for twenty years to remove pines from this area. The idea this interdisciplinary team is proposing is not to just remove the pines, but to introduce native species with their associated fungi. Neves:

> One of the problems is that we don't know what's going on here, what the native fungi are, and how the fungi of the invasive pines are affecting the native diversity of the Restinga. Before the pandemic, we started a project and we are now comparing the soil and the roots in three different areas. One with the pines, one without the pines, and one where the pines have been removed for ten years already. It should be interesting to see what we find out in a few more years. It's understanding who is who in the soils of the Restinga.

Neves explains:

> We know that things are entangled, and things can entangle in a way that we can't control. What if these exotic fungi that are on the pines are more competitive and are replacing the native species?

We can't see this and it's really hard to study.
Entanglement is good, but we've done a lot of bad
things as human species that interfere with the
native species. Without doubt, we need to under-
stand better what's going on under our feet. At
the beginning they brought seedlings of the pines,
and then the fungi are already on there. The same
pines are being moved around, spreading a my-
celium that you can't take out. Any seedling that
you have, that you will plant in other places, will
have the mycelium within and around the roots.

The pines were introduced to the area to use the wood for paper, and
came with a very unexpected yet tasty surprise. Some families living in the
higher altitude of Mata Atlántica, from eight-hundred to a thousand meters
above sea level, started discovering amanita and porcini mushrooms.
Some of these pine forests are thirty to forty years old and can produce a
lot of porcini. They are precious and valuable mushrooms, especially for
Brazil, where they are not native and usually imported for the tables of
fancy restaurants. This is probably why it took a while for people to find
out porcini was growing in Brazil; people didn't expect them outside of the
context of a plate. Maria Alice Neves:

Here in the south of the country, where pines
are growing in higher elevation, it became a very
good alternative income for some families who
started collecting porcini to sell. And they sell
for a lot. There are also pines on the coast here,
where I am, but you hardly see the mushrooms. I
think because it's too hot or because the winter is
not cold enough. I saw an amanita here once, after
a really cold winter.

Cold by Brazilian standards, that is. Though the pines are there, and the
mycelium is likely to be there, it doesn't mean the mushrooms always
come up. The temperature and humidity levels need to be right for a
mushroom to pop. Neves has been giving talks teaching people how to
recognize porcini, to understand that indeed it's good to use the wood and
this delicious by-product, but that one should never cut an existing native
forest to plant pines. Not even for porcini.

THE MILPA AS A MODEL

In September 2021, I travelled to Mexico to work with colectivo amasijo, a
group of women from different parts of Mexico (Veracruz, Oaxaca, State of
Mexico, and Mexico City) united in their desire to actively reflect on the
origin and diversity of our food. I was very excited about going to Mexico,
particularly because I had fallen in love with eating Mexican food. Ironical-

ly, the most traditional Mexican dishes I had tried were in the context of snazzy restaurants abroad that appropriated Mexican cuisine. They were celebrating the handmade tortillas and beautiful maize in all the colors of the rainbow, yet for me it very quickly became clear that in Mexico the majority of people didn't eat like this at all. Quite the contrary; the bulk of the corn came from the United States and was completely modified—nothing ancestral about it. The collective explained to me that this was the result of NAFTA, the North American Free Trade Agreement between Mexico, the US, and Canada implemented in 1994. The idea behind this trade agreement was to 'modernize' and boost economies, yet it resulted in a total collapse of small-scale Mexican agriculture, which sent the majority of Mexican farmers into poverty. In her brilliant book *Eating NAFTA, Trade, Food Policies, and the Destruction of Mexico,* Alyshia Gálvez demonstrates the interconnection between NAFTA, obesity, and other health conditions and diseases in Mexico, and the disappearance of biodiversity and ancestral crops as processed foods and GMO corn flooded the market. Gálvez writes in her book:

> The winners, large corporations and industrial farms, have achieved a level of unprecedented prosperity and power at a great human cost. This leads us to ask whether traditional Mexican food-ways will be reduced to an elite, luxury experience for a few, or preserved for everyone.

Her careful and thorough research is painful to read:

> Local green markets have been replaced with supermarkets overflowing with processed foods and soda. 'Gringos' clamour for handmade tortillas, whilst Mexicans have become the world's top consumers of instant noodles.[3]

My unlearning and re-education of Mexican food started here: with a research residency with colectivo amasijo. This collective of women was born in 2016 to provide a platform for non-dominant voices: the narratives of women close to the land, stories that show the way to regeneration, and to tell of the real cost of climate change and NAFTA. As an open collective, they understand food as a network of relationships, a system. Collectively they cook to share, learn, care, conserve, relate, and celebrate the (bio)diversity of food. Their projects are aimed at making visible the interdependence between language, culture, and territory. Through these projects—that can take the form of gatherings, dinners, research, actions, ceremonies, exhibitions, markets, seminars, film, talks, or other—the collective builds structures to form a community in which taking care of ourselves and taking care of the territory we inhabit is a priority. The women of colectivo amasijo were the ones who took me to the *milpa* for the first time in my life. The *milpa* is an ancestral form of agroecology in

3.

Alyshia Gálvez, *Eating NAFTA: Trade, Food Policies, and the Destruction of Mexico,* University of California Press, 2018, pp. 9–10.

Kapachita, *Hacer la milpa es un acto de resistencia, profundamente político* [Making the Milpa is an act of resistance, deeply political], 2020. Digital illustration based on analog drawing.

54

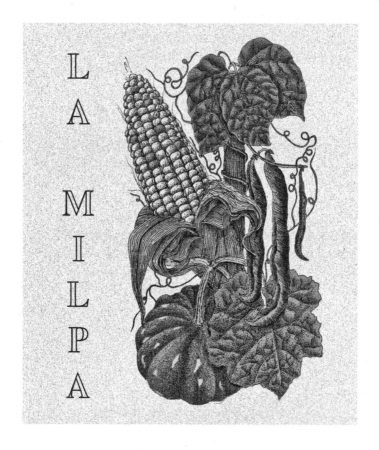

which recognizing food as a system of relationships is key. In Milpa Alta, the area in the south of Mexico City, food is still being grown according to these principles, on communal lands.

We left early in the morning and stopped along the *periférico*, the main highway where multiple little restaurants were flying colorful flags, trying to attract our attention and entice us to have breakfast there. I'm not used to highway restaurants being particularly delicious eateries, but Carmen and Martina from the collective seemed to know what they were doing when we stopped at one. As a vegetarian I was happy to see mushrooms abundantly available on the menu, including the *huitlachoche*. *Huitlachoche* (also known as corn smut) is a black fungus that grows in the *milpa*. Despite its rather unattractive appearance, it's a bona-fide delicacy. The fungus is invited to grow on the corn by opening the leaves of the *elotes* (the cobs) so the rain can get inside—thus, the right conditions are being generated for the *huitlacoche* as that moisture allows the fungus to grow. An affirmation of the diversity and versatility of the *milpa* before we had even arrived there.

As we were getting closer to Milpa Alta, the landscape started changing. We went from an abundance of mini-supermarkets selling all sorts of processed foods to an abundance of *nopales*, edible cacti. Carmen explained that all these fields used to be *milpas* too and had made way for the *nopal* after the price of Mexican corn crashed as a result of NAFTA. We went to visit farmer and academic Vero Briseño, who invited us round to her cozy home to talk about the current political challenges of Milpa Alta. She welcomed us with a refreshing green glass of, naturally, *nopal* juice. Yet before we dived into the political complexities that Milpa Alta is facing, we went to the *milpa*. At first sight, the field appeared to be a slightly chaotic potpourri of plants, with proud mama corns towering above all the other plants. On a closer look into the systematics of the *milpa* I could identify tomatoes and *calabazas* (squash) and *frijoles* (beans), using the strong corn mothers to hold on to. The corn was offering a shoulder to lean on, a little helping hand to let the smaller plants climb a bit higher, in pursuit of more sunlight. There was more complexity and entanglement in this system than at both first and second sight. Carmen told me that on early summer mornings the *chapulines* (little grasshoppers) come to feed off the *milpa*, and subsequently are being fed off themselves by people and fried with some chilies before being crunchily tucked into a taco. Just as the *huitlacoche* is a part of the *milpa*, all the other plants and animals are just as much part of this system. They all depend on each other for their existence, and could only grow alongside, with, and on each other.

Carmen Serra, whom I perceived to be the corn mother of colectivo amasijo, offering growth and sunlight to all the women surrounding her (including me), showed me the different *quelites* in the *milpa*. *Quelites* look like weeds to the untrained eye yet are the medicine of the *milpa*.

She picked some *estafiate*, a herb that is good for the stomach and liver; the bitter herb is anti-inflammatory. Carmen: 'If you drink bitter herb you come in a better mood.' Promising! We took it home to make tea from later. Despite the warnings about its bitter taste, but motivated by the promise of a great mood, I gulped it down with enthusiasm. The ends of the *milpa* are demarcated with the *maguey*, a type of beautiful big agaves. They fulfil a very important role within the *milpa* as their deep roots keep the moisture in the soil and protect again erosion. Though today agave is mostly known for being the source of Mexico's famous tequila and mezcal, the *maguey* used to be famed for a different alcoholic drink: *pulque. Pulque* is a pre-Hispanic drink made from fermenting the sap of the *maguey* brewing inside the plant. Different lobbies and regimes throughout history have tried to ban *pulque*, from the Spanish colonizers to President Porfirio Diaz at the end of the eighteenth century, to the beer and Coca-Cola lobbyists who wanted to take over that market. All those different attempts to banish the fermented drink have contributed to the disappearance of the old *maguey* plants. On top of that, the Catholic Church started using the *maguey* flower, the *quiote*, for making crosses. Though this spectacularly grand flower announces the end of *maguey*'s life, it still has a very important function both for the life cycle of the plant, and for other species. It's the seed source from where all new *magueys* grow, but also where a lot of bats and birds feed. It was such an ecocide for the *maguey* that nowadays cutting the *quiote* is banned. With the *magueys* disappearing, plastic was introduced to replace all the incredible biomaterials that the plant had previously provided. The membrane of the leaves makes for a strong plastic-like paper that is used as a container for food, called *mixiote*. The strong fibers of the *maguey*, *ixtle*, were being used for making fabric, ropes, carpets, and other sturdy biomaterials. Carmen Serra and Martina Manterola re-tell me the story of an old lady they know that used to make *ayate*, the cloth made from the fiber of the *maguey*. She was closely connected to the plant, to the point of identifying with it. She was joking with Carmen and Martina, telling them how she got married when she was twenty-four—at the time, quite late to tie the knot. Her *quiote* had already started growing out of her back, she laughed. Manterola, who comes from a family in which they used to produce *pulque*, hacienda-style, tells me she also feels a connection with the *milpa* and the *maguey*. Her family jokes about that because she never knew her grandfather, but it is clear that her love for the land is sincere and she is researching the history of *pulque*. Martina:

> Our family connection with *pulque* was very monetary; it was a big business. It's so contradictory, because they knew so much about the plant, and the whole ecosystem behind the plant, but at the same time there were slaves and monocultures, and political games.

At the time, the plant was so valuable that the price of the land was dependent on how many *magueys* were growing there. Nowadays, agaves are enjoying a comeback, mostly because of the popularity of mezcal and tequila. But *pulque* is also becoming fashionable. In addition, more and more artists are interested in using the fibers of different agaves. For a moment I'm confused and Carmen clarifies that there is a distinction between agaves for tequila (blue agaves), mezcal agaves (many different types), and *maguey* (one type of agave). Though it's technically possible to make mezcal with *maguey*, this is not typically done. Yet it's the *maguey* fibers that are mostly used for arts and crafts. Good examples are the work of Trine Ellitsgaard, 'an Oaxacan who happens to be Danish,' and Fernando Laposse, whom I dare say is a cosmopolitan artist that happens to be Mexican. Laposse, who studied at Central Saint Martins in London, made a funny installation using these *maguey* fibers as part of the Miami Design District neighborhood commission. The installation was called *Pink Beasts*,[4] and consisted of the fibers transformed into big pink sloths, hammocks, and tassels. He dyed the fibers using *cochineal*, a natural dye that has been used by the Mayans and Aztecs since pre-Columbian times, to give a beautiful red and pink color to them. The dye is made by crushing the shell of a very small insect which lives on—that's right—the *nopal*. And so we come full circle.

URBAN MEETS RURAL

In the meantime, still sipping from my refreshing green *nopal* juice, Vero Briseño speaks passionately but with great concern about the current challenges of Milpa Alta. While the lands are traditionally communal, its proximity to the rest of Mexico City has resulted in the prices of the land increasing. The fact that Milpa Alta is officially communal land, *tierra communal*, dedicated to agriculture and ecology, has meant for years that the land cannot be sold and bought. It's the only place in Mexico City that is still designated *tierra communal*. Now a new law regarding land use is being introduced to change this, allowing people to sell their land. It's a process called *lotificar*, leading to a fragmentation of the landscape and essentially to the end of the *milpa*. Working the land needs to be communal, and collective ownership means that everyone is involved in its maintenance, people as well as animals. The community, consisting of the *comuneros*, collectively make their decisions. Though there is a lot of resistance in the community to this new law and the fragmentation of Milpa Alta, local leaders are also being pressurized by the government to give up the communal lands. 'Maintaining the *milpa* has become an act of resistance,' Briseño says.

> Part of the problem is that people who live in the city don't know about what is happening in Milpa Alta, so they have no reason to protect it. People from the city don't care.

4.

Fernando Laposse, *Pink Beast*, 2019. Sculpture, agave plant fibers dyed with cochineals from an organic farm in the mountains of Oaxaca. Neighborhood Commission for Miami Design District. Made in collaboration with textile designer Angela Damman and local Yucatan artisans. Courtesy the artist.

Colectivo amasijo is trying to raise awareness about this by organizing '*mercados*', markets, bringing the people from Milpa Alta to the city to tell their story in the museum while people can buy their produce. The first *mercado* took place in September 2021, just a week after my arrival. On a Saturday morning, at the Museo de Arte Carrillo Gil, a contemporary art museum in Mexico City, women from Milpa Alta were arriving with boxes and bags full of fresh produce. They brought an abundance of mushrooms—August had only just passed and is known to be very rainy, causing a lot of mushrooms to grow. Some people even call August '*hongosto*', referring to the Spanish word for mushrooms, *hongos*. There are so many new shapes and forms for me that I draw them in my notebook and ask one of the ladies to teach me their names. They go by many. From the '*clavito*' to the '*mazayel*', one name can be even more bewitching than another. It's an interesting sight to see how the sterile white cube slowly transforms with colors and life, with flowers and herbs hanging on the wall, bright textiles on the tables, and the smell of corn mixed with mushrooms filling the space. Though at first glance these events just look like a colorful market in the museum, the gatherings are highly political. Talks and debates are held, flyers and pamphlets are handed out, and the women from Milpa Alta are connecting with and informing urban art audiences. One incident, however, demonstrated that the white cube wasn't as ready to receive the countryside as it seemed. One of the contributions for the *mercado* was a big tower made of *nopales*. There is a special way of placing and tying the *nopales* together to form a tower, a time-consuming, traditional way to transport large quantities of them. Not many people master the skill of this binding anymore as this ingenious labor-intensive practice has disappeared. There was true beauty in this tying together of the plants and colectivo amasijo knew a lady who was able to do this, Dona Ji, and invited her to the exhibition to tie and fold a *nopal* tower. She spent hours making the tower, which we all perceived to be a true work of art. After the exhibition, a few days later, Carmen received a phone call from the museum asking if they could discard of the *nopal* tower. It had started to become a bit wobbly, slimy, and smelly… Though the collective had imagined it could stay as part of the exhibition, the museum did not perceive the tower as an artwork, nor Dona Ji as an artist. Was her labor valued in a different way? Was her traditional tying not artistic or skillful? Interesting questions arose alongside the obvious issue of how to deal with slowly decaying slimy matter in the sterile white cube. Can a farmer be an artist and can art be slimy?

One of the ladies from Milpa Alta told me that she has never been to a contemporary art museum before, though they had been previously invited to ethnographic museums. There is a crucial difference in how the women are framed in the different contexts. One is providing a platform for contemporary and critical discourse, the other is archiving living and non-living entities as relics, something part of a history, the past, exoticized perhaps. Though these women might be wearing traditional clothes,

they are most definitely not just from the past. Quite the contrary: their knowledge is crucial for the possibility of a future for the city and its people. The role of the museum, both contemporary and ethnographic if you ask me, is to build the collective memory that tells stories of past and present from different perspectives and with a multitude of voices. To nurture a sociological interpretation of memory that goes beyond the individual-psychological level and thus opens a debate about whose labor we value and why. Not only to 'archive' collective memory, but to actively review it and continuously question and (re-)make it. Museums are potentially ideal platforms to recognize entanglements through time and space, to remind us of our responsibilities, to stimulate (political) awareness, to facilitate a knowledge exchange, to make the forgotten and invisible visible. And that is why these women belong in a contemporary art museum more so than in the ethnographic museum; they are at the cutting-edge of a critical discourse about the future, politics, how we want to live, and who we want to be.

COLLECTIVE AMNESIA

How colonial entanglements run through time, space, and species is powerfully demonstrated by Alexis Pauline Gumbs in her book *Undrowned: Black Feminist Lessons from Marine Mammals*. She gives the example of the Caribbean monk seal, whose extinction is entangled with, initially, Columbus and his crew entering the Caribbean territory. She writes about how the seals were curious, which made them easy to catch and kill. While the lands and people were exploited for sugarcane plantations, the seals were exploited for their oil. They were, quite literally, the lube of the sugarcane refineries. In her book, Gumbs emphasizes the importance of re-membering what has been dis-membered to acknowledge and see these colonial entanglements with both the human and, more than human, the natural world. By actively remembering, we can become aware of these entanglements, and their continued legacies on so many levels. It makes memorizing a political act. It's the act of acknowledging. Not remembering is easier, but is a form of denial of history, of entanglements through time and place. It makes remembering a responsibility. That also implies that not remembering, collective amnesia, is fertile ground for irresponsibility and repeating the missteps of history. In an interview with Roxanne Dunbar-Ortiz, the social justice activist and leading historian of indigenous struggles in the Americas, I read about how in the Greek language the opposite of truth is not a lie, but forgetting. Dunbar-Ortiz:

> What is the action you take to tell the truth? It is un-forgetting. That is really meaningful to me. It's not that the origin myth is a lie; it's the process of forgetting that's the real problem.[5]

When she wrote 'alliances without un-forgetting at their core aren't going to go anywhere in the long run', I realized there was an important remind-

5.

See: uppingtheanti.org/journal/article/06-the-opposite-of-truth-is-forgetting/.

Dona Ji, *Torre de Nopales* [Nopales Tower], 2021, installation.
Photo: Carmen Serra.

6 0

er for my work with the Green Art Lab Alliance. Within this alliance we currently work with fifty art organizations in Latin America, Europe, and Asia. Working toward climate justice had to start with remembering its entanglements with colonialism. How could we make this remembering a key collaborative activity in this diverse group of partners from so many different countries and with so many different backgrounds? Maybe our starting point for collaboration and relationships of trust could be to align our collective memory? As a practice of responsibility? Alexis Shotwell wrote that:

> We need to shape better practices of responsibility and memory for our placement in relation to the past, our implication in the present and our potential creation for different futures.[6]

CONNECTING THE DOTS

For many years, Puerto Rico has been suffering from many issues, ranging from devastating hurricanes to the problematic colonial and exploitative relationship with the United States. A positive consequence of all these complexities, however, is that people generally don't see these issues as separate from each other and are aware of how they are all entangled. Puerto Rico is all about mycelial organizing, in part because there are so many 'issues on top of issues on top of issues' that people tend to understand in the 'overall *lucha* (fight)' and how they are all connected, food activist Tara Rodríguez Besosa tells me.

> There is a strong connection between the queer and trans community, with those who are fighting racism, those that are fighting domestic abuse, and women's rights, for instance. There is an awareness that they are all connected. That is because in Puerto Rico you have a protest with the teachers today, yesterday it would have been the cops, and the day before that it was about Acts 20 and 22.

She is referring to the government acts aimed at attracting foreign investment to Puerto Rico by providing dubious tax incentives. Rodríguez Besosa:

> We are starting to realize that part of being Puerto Rican is connecting. We have so much that we want to protest and fight for and we have been separated so we do not get together. Now we're getting together and really understanding that it's all part of each other, even though it's not the same. We don't need to dumb it down into one main fight but we definitely need to understand the complexities of each struggle and each

6.

Alexis Shotwell, *Against Purity: Living Ethically in Compromised Times*, University of Minnesota Press, 2016, pp. 38–39.

That means, in practice, that a lot of people from other fields that don't
per se identify as doing farm work are coming to the protests. Tara ex-
plains the reason behind a lot of artists, screen printers, filmmakers, writ-
ers, and farmers in Puerto Rico whose work is political and nuanced and
complex. Rodríguez Besosa:

> We are really trying to connect the dots here,
> because we find that if we don't, we will not be
> able to face all these situations. That's why a lot
> of people are looking at food and farming in Puerto
> Rico as a very interesting environment. Most of the
> people that are farming are farming for themselves,
> are farming for their neighbors, are talking to their
> neighbors, and harvesting from their neighbors'
> farms or lands or trees. They are exchanging food;
> they come to a protest that has to do with other
> systemic forms of violence. I have people within
> my own collective that practice acupuncture and
> bring that into the space. I have other people that
> do drag and bring that into the space, I have peo-
> ple that do cheffing and they cook and do pop-
> ups…We are all bringing our own personal tools,
> and a lot of them are coming from the arts and oth-
> er creative practices, into food sovereignty spaces,
> which I think is really beautiful.

MEMORIZING AS AN ACT OF RESPONSIBILITY

The mycelium is the collective memory of the whole fungal organism. The
complexity of the webs that connect everything underground, turn out not
to be too dissimilar from the complexity of webs above ground. Whether
through historical, microbial, or environmental entanglements or because
of tricky trade agreements, things are not separate from each other. The
fragmentation of the landscape in Milpa Alta means breaking down the
social mycelium as well as the fungal mycelium. The message that we are
at war with nature, turning the lawn-mower into our weapon, is essentially
a showcase of a supposed human superiority over the natural world. From
golf course to monocrop, the story of the oppressed landscape as a dis-
play of power, status, and control continues. We need different narratives
of the relationship between people and the land to build collective mem-
ory. A mycelial network can be understood as a map of the history of the
landscape. How can we read this map? If anything, I imagine the pathogens
we perceive as evil are there asking us to bring an end to these misplaced
superior attitudes. When we recognize how things are globally entangled it
is more likely that different movements see the need to unite, collaborate,

and organize themselves. That means an end to single-issue environmentalism and understanding instead that your battle is my battle. My pain is connected to your pain, even when that's not immediately visible because it runs through unfair trade agreements or, even harder to perceive sometimes, activities that happened in the past. Memorizing can be an act of seeing these relations, connections, and entanglements in the here and now. It becomes an act of responsibility. This is where the arts come in, the museum as a platform for critical discourse, for bringing people together, for forming the collective memory. The healing of the people goes hand-in-hand with the healing of the landscape. Coco Hill in Barbados, Milpa Alta in Mexico, and the mycelial protests in Puerto Rico are just a few examples of agricultural ontologies that are aligned with the concept of entanglement. They reveal how our pasts might be inextricably connected, yet our future is too. What we do in one place always has an effect somewhere else. We can start contributing to the building of collective memory by making visible and acknowledging the human and more-than-human entanglements that run through time and space. We need to question and review the collective memory of the ethnographic museum as well as the contemporary art context, for these topics are just as much about history as they are about present and future.

HOW TO ORGANIZE LIKE A MYCELIUM?

Building Relationships of Solidarity and Exchange across Disciplines and Borders

TEACHING THREE

Rust fungus is a plant pathogen capable of destroying crops
and turning green lawns bright orange.

Reishi

Reishi (*Ganoderma lingzhi*) is a polypore fungus known
for its medicinal properties.

Featuring:
Mycorrhizal networks, *Physarum polycephalum* (slime mold), Raquel Rosenberg, Tara Rodríguez Besosa, FIBRA collective, shiitake farmers Tomaz Morgado Françozo & Marília Carneiro Brandão, Giuliana Furci, Sofía Gallisá Muriente, Mavi Morais, Carolina Caycedo, Camila Marambio, Maya Errázuriz.

Geographies:
Santiago (Chile), Tierra del Fuego (Chile), Chiapas (Mexico), Wallmapu (Chile), Belo Sun (Brazilian Amazon), Puerto Rico.

CHILEANS TYING THEIR ROOTS FOR STRENGTH

It had always been my dream to go to Chile. The father of my brothers was a political refugee in the nineteen-seventies who ended up in the Netherlands, where he met a tall, blond woman who was translating in the refugee center—my mother. They had two boys, my older brothers. Growing up with my brothers (Chilean father) and younger sister (same mother, same English father), we watched cartoons in Amsterdam under a Mapuche blue poncho and listened to Violeta Parra while washing the dishes. My mother's bedroom held mysterious treasures, the origin of which I never questioned; a small clay flute, a wooden frog, a weird (problematic) Indian-like red figure that dropped its pants and revealed its penis when you picked it up, a wonky, hand-painted box that said 'Valparaiso', and a brown ceramic piggy bank that I remember shaking on multiple occasions in the naive hope of encountering some rattling coins one day. The piggy sadly remained empty all its life, though even today, when visiting my mom, I can never resist the temptation to try. The curious objects were dusty remnants of her previous life with a Chilean husband. For me the objects had always been there and I had never consciously connected these domestic influences—songs, objects, stories, blankets—with the life my mother had before I was born. When I went to Chile for the first time in December 2019, I decided to visit the father of my brothers in Santiago. The instant familiarity was bewildering. He moved and smiled in that funny and erratic way

both my brothers do, which was both strange and comforting. For him, I imagined I must have been a less blond, less seventies-styled version of my mother. Though there was no blood relation or real memories between us, we immediately understood we were family.

Chile was submerged in the heat of intense social protests. Not only in Santiago but in many other places across the country, people were hitting the streets en masse to express their dissatisfaction with the neoliberal system and all its related injustices. Though the father of my brothers must have done a fair amount of protesting in his younger years—having to flee the country as a political refugee—he did not want me to join the protesting masses. He wanted to protect this freshly acquired daughter. Initially, I was hesitant too as we had both read one too many articles about the riots and how the police were using rubber bullets to shoot protesters in the eye. Hospitals were full of young people with severe eye injuries. Nevertheless, I wanted to express my solidarity somehow, so I ended up going to some of the events. I was deeply moved (and star-struck) by a talk by the Chilean artist Cecilia Vicuña, someone whom I had admired for years. With a few friends we met in town among the protesters and it was impossible not to feel the air charged with frustration and an appetite for change. It was powerful and overwhelming to experience how many people were fed up, how many of us wanted the same change. We went to the Plaza de la Dignidad, the heart of the protests, where my eyes started watering, itching, and hurting from the remaining whiffs of teargas in the air, a reminder that the fight was real. Hundreds of tear gas canisters had been used by the police and security forces, an excessive measure against generally peaceful protesters. A reconstruction of the use of tear gas was done by Forensic Architecture in collaboration with the Chilean medical-activist initiative NoMás Lacrimógenas, revealing the health risks caused by the number of canisters found (596!) and many other details that formed evidence for a grievance filed against the country's military police to Chile's Human Rights Commission.[1]

At the center of the Plaza's roundabout, the head of the statue of Spanish conqueror Pedro de Valdivia was covered in the Mapuche flag. Culture, music, chants, graffiti, and other street art were the key tools to communicate this intense desire for change. Though the protest was assumed to be triggered by yet another rise in the price of public transport, the major underlying frustrations were the ongoing legacy of policies dating back to the dictatorial regime of Augusto Pinochet, the same person that drove my brothers' father out of the country almost fifty years previously. I cried when I saw *El violador eres tú* (The Rapist Is You), the performance-protest led by Las Tesis. This Chilean feminist collective mobilized thousands and thousands of women across the world, particularly in Latin America. They would unite in groups, blindfold themselves, and chant a powerful song that includes lyrics calling out the president, the police, and the State for violating women's rights. The video went viral and countless women across the world re-enacted the performance. It was Latin Ameri-

1.

See: forensic-architecture.org/investigation/tear-gas-in-plaza-de-la-dignidad.

ca's answer to #MeToo, a way for women to express that they were sick and tired of a culture that normalizes rape. They were angry about the femicides and had had enough of patriarchy and widespread machismo. I was moved to tears to see how music, performance, culture, and art were the ways to unite the varied (sub)cultures and backgrounds of the people who joined the protests. It was peaceful yet powerful and allowed for a multitude of voices, all wanting to address forms of injustice; for different reasons and in different ways. The multitude and diversity of voices was essentially the strength of the protest, from students organizing debates, to Mapuche people who had covered the statue with their flag, to musicians and artists that filled the streets with color and sound, to the women who had blindfolded themselves for their chant. They were tying their roots together for strength. You could say this was mycelial activism: the different hyphae had merged into a powerful network.

In recent decades, we have seen many systems collapsing, from political to financial to social and environmental. People increasingly feel compelled or even forced to use their right to protest, something evident in the rising popularity of, for instance, Extinction Rebellion, a worldwide movement of peaceful civil disobedience. Anne Kervers, a PhD student in Amsterdam and one of the board members of the Green Art Lab Alliance Support, the legal entity behind the Green Art Lab Alliance, often attends these actions, which vary from occupying government buildings to blocking roads. She describes their work as acts of disobedience that come from sheer necessity—an acute fear of a future afflicted by climate collapse. It has prompted many people to join Extinction Rebellion, and from all backgrounds and ages. She describes how most of them really would prefer not to go protesting, to risk being arrested, and assures me that she has a different idea about what having a good time looks like. Yet she feels she has no other option. They are so angry and frustrated with the lack of sufficient government action to mitigate climate change. They prepare their protests well, she tells me: different groups exchange strategies and inform the press beforehand, always trying to ensure the safety of the participants and keeping the protest peaceful. Generally, protesters in the Netherlands get to choose if they leave voluntarily at some point or have themselves arrested, risking a fine. It wasn't until I spoke with activist Raquel Rosenberg in Brazil, however, that I understood the full scope of preparation that is needed in order to limit the risks of protesting. The context of Latin America is rather different, with the systematic assassination of indigenous leaders and environmental activists being the norm. Same goals, different realities.

THESE GUYS IN SUITS DID NOT GIVE THE ANSWERS WE NEEDED

I meet Raquel on a little picnic blanket in the sun in the Minas Gerais mountains. She wants the exact location to remain unknown—it wouldn't be the first time she has been chased out of her home because of death

threats. Raquel grew up in São Paulo, but has lived in many other places, from the Tapajos River and Xingu Rivers in the Amazon, to Alta Mira and the North of Mato Grosso State. She tells me she 'has seen everything you can imagine' in terms of how people are destroying and invading the Amazonian rainforest. It moves me to see how moved she is when she says this. Rosenberg worked especially in and with traditional communities; from indigenous to river communities (called *riverine*) and with *kilombolas*, the descendants of people who were forced to be slaves in Brazil. Living with these communities had been such an important learning experience for her that she decided she wanted to support their work by teaching them tools for activism. She developed trainings in how people can organize themselves and ensure their voices are heard beyond their communities, her aim being to ensure their voices are heard on an international stage: the United Nation's Conference of the Parties (COP).

When Raquel and her fellow activists first arrived at Rio+20 —the United Nations Conference on Sustainable Development held in Rio de Janeiro in 2012—still in their early twenties, it was a huge let-down. There was a space for youth, but even though they were in Brazil, it was dominated by youngsters from Europe, the United States, and Australia. Raquel: 'It was crazy because it was exactly the same repetition of what was happening inside the UN negotiations room.' Moreover, Raquel and her friends didn't really know what to do in this 'youth space' and were lost and totally disillusioned. They saw, however, how the other youngsters had prepared actions, demands, and lobby points—and knew where to take them. The young Brazilian activists quickly picked themselves up, forming an organization called Engajamundo and readying themselves for the following COP in Poland. Raquel: 'For the other youngsters at the United Nations meetings it was "all about carbon, carbon, carbon", but we wanted to talk about our direct reality: deforestation.' The mission of Engajamundo was to occupy UN spaces with Brazilian youth and address deforestation in Brazil. The following year, four young people from different parts of Brazil, including Raquel, went to their first COP, in Warsaw. 'The coldest I've ever been,' she reminisces. Cold or not, this time the Brazilians came equipped with demands and lobby points, as planned, and they knew where to occupy the youth space. They felt better, but it was still far from satisfying, Raquel admits. 'These guys in suits did not give the answers we needed.' After Warsaw, the mission of Engajamundo changed. There was a need to make these global issues more accessible to young people in Brazil and for them to understand that it was possible to change their realities by engaging politically, whether on a local, national, or international level. The COP was too far away for their realities, too abstract, and too much about men in suits and young people who couldn't relate. Engajamundo started to build local hubs, which now exist in almost every state of Brazil. The local hubs—have autonomy in whatever they want to work on, decided by the youngsters themselves. Raquel: 'I personally love working on

climate change—this is my passion—but we also have the gender working group or the biodiversity one…' Now there are different groups that go to the UN conferences, but Raquel has moved on and her main focus has become capacity-building for collectives. Engaja-mundo now offers different workshops for young people to learn strategies for organizing protests: making big banners, connecting with lawyers, writing demands and lobby points, how to make good photos and videos, how to write a press release, how to make a radio programme, how to strategically select your targets ('it doesn't make sense to target Bolsonaro; target someone local like your mayor'), occupying roads, public speaking, and how to gain media attention. Raquel: 'It's all about developing activities and methodologies they can replicate with their friends, or create something new around it and adapt it to their realities.' I can't help but think of mycelium and how this is the key to a healthy network of exchange—openness, adaptability, flexibility. She continues: 'When they have these tools on activism, strategy, and mobilization they can do their own local actions; they will have networked themselves.' The hyphae reached out further. The young activists will come up with goals and actions themselves, and then Engaja-mundo trains and prepares them accordingly. Raquel:

> Do you want to go to Brasilia to speak to the decision-maker? Then we do a role play of the meeting so they can train for it. It's not just about thinking and doing theatre, it's about actually doing it. They've learned it all; they have started their collectives and they are doing their actions, artworks, and making their videos.

I can tell she is proud of them and quite rightly so. I had come across some beautiful collages made by a young indigenous artist from Bahia, called Mavi Morais, that really struck a chord with me. The powerful high-contrast images depicted people, plants, fungi, and animals that are central figures in different indigenous communities and cosmologies. Jaguars, snakes, feathers, hummingbirds, and lotus flowers, among extraordinary images of famous indigenous leaders such as Sônia Guajajara and Célia Xakriabá (actually two huge heroes of mine). These striking collages were part of a big fundraising campaign called 'Choose Earth', a collaboration between Engajamundo and Choose Love.

I ask Raquel how she ended up here in Minas Gerais, why she left the Amazon. She tells me that one day they heard rumors that the Minister of Education at the time, Abraham Weintraub, was going to have dinner in a restaurant nearby, and they knew this was an incredible opportunity to physically confront someone in power. It had to be a spontaneous action and they had to act fast. Everyone was nervous. Though she excitedly tells me it was the best action that Engajamundo ever did, her face becomes sad when she tells me about the consequences. 'We were really persecuted

Mavi Morais, *Choose Earth*, 2021. Digital image from the campaign 'Choose Earth', a campaign powered by Choose Love in partnership with Earthrise. Courtesy the artist.

72

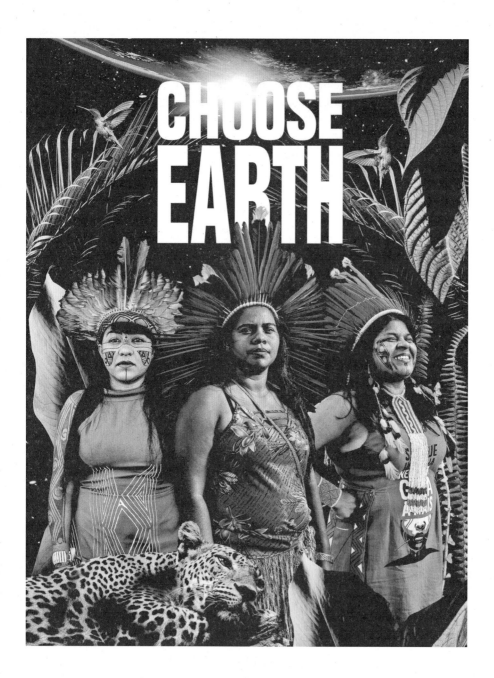

after that. There are many people in the Amazon, espe-
cially in the cities, that support Bolsonaro. The majority of the
people do, unfortunately.' Letters had been sent out from the Mayor's
Office, from the director of the local university, and from the Community
Council telling people to go after Raquel and her fellow activists, because
of this 'hostile action against the minister.' And people did. A list of their
names was sent around in a WhatsApp group. The letters stated where
they lived.

> We had to have an emergency meeting in our
> house and the next day everybody knew about
> it in the village. We left our house and went to a
> friend's house and we called everyone to warn
> them. Then the police came in the middle of this
> meeting. We asked for help but we had to leave.

The group was relieved to have found a partner, a fund in Brazil, called
Fundo Casa, that helped them. 'They literally helped us to escape.'
Once more, she underlines the importance of partnerships.

> We do everything in partnership. Even the com-
> munication. To start working somewhere we need
> to have a local partner. We need someone local
> who already has a structured group. You need
> someone also for the logistics. Logistics in the
> Amazon are crazy, you should never go there and
> think you can go to an indigenous community.
> There are no roads, only rivers; you need to be
> with people who know. Networks and partnerships
> are crucial to what we do. We couldn't do any-
> thing without them.

MYCELIAL PROTEST STRATEGIES

Engajamundo now works with many other organizations, such as Via
Campesina, Movimento dos Trabalhadores Rurais Sem Terra (the Landless
Rural Workers' Movement, MST), the Indigenous movement as a whole,
Brazil's Indigenous People Articulation (APIB), and other international
youth groups like Fridays for Future. With Fridays for Future, they have
filed a lawsuit against the Brazilian Environment Minister, Raquel proudly
shares. Engajamundo is stoking the fire: 'Now we are preparing a big
action near the Belo Sun hydro-electric dam.' Belo Sun is a big
Canadian mining corporation, and in their preparation for the action they
have connected with the people behind the famous protests against the
Dakota Access Pipeline. In 2016, their protests grew into a big international
movement led by the Native American Lakota people, whose territories
the poisonous pipeline was invading. They gathered indigenous tribes
from across the Americas and united different indigenous and non-indig-
enous groups to travel to the places where the frontlines needed to be

strengthened. The commitment was significant, at times assembling up to ten thousand people in the protest. Standing Rock symbolized the beginning of an international movement for the protection of water along areas of oil pipelines and grew into an extensive global network, into an alliance of international solidarity.

In preparation for their action—aiming to be a 'Standing Rock version in the Amazon'— Brazilian and Native American protesters shared the lessons learned with each other. The pandemic gave them more time to secretly prepare the action. On paper they are just organizing a festival in the Amazon, that being the excuse as to why they would bring so many people there. To some extent it is also just a festival as they are planning lots of cultural events and indigenous games. Though not every festival has environmental lawyers and journalists on the guest list. This networked approach between different protest groups makes all parties stand stronger against the power of the big companies they are facing, which is not an unnecessary luxury. I'm curious to hear from Raquel the exact lessons learned. She replies: 'One is to always connect with lawyers well in advance.' The lawyers have been giving the groups' advice on what is the best territory to carry out their occupation. Rosenberg:

> They confirmed we have selected a good spot for our action firstly because it is government land and, secondly, because it is a Canadian company we are targeting. If it was like Vale, or another Brazilian company, we would get too many dangerous threats.

Vale is the huge Brazilian mining company that was responsible for the Mariana and Brumadinho disasters, two huge social and environmental disasters in Minas Gerais due to dam collapse in 2015 and 2019, respectively.

And so I learn one should target international (European or Canadian) companies for fewer threats and more (potential) media attention. It makes sense. Their plan now is to take ten young indigenous people from Brazil to the United States to learn from the strategies and people of Standing Rock. They will receive training and return with ten other young indigenous people from Standing Rock. Through their decentralized mycelial approach, in which knowledge and strategies are exchanged, and in which battles and agendas are united, they hope to confront the mining company in a safer and more effective way.

POLITICAL MOMENTUM

Protesting against the constructing of dams or mines that severely damage the environment can be especially dangerous endeavors, given that the companies behind them are often wealthy, powerful, and sometimes corrupt industries which are not scared of using violence, particularly in the context of Latin America. It means protesters have to be very careful

and well-organized, using visibility and (international) media as
their shield. Artist Carolina Caycedo has broad experience in how protests
can be supported from an artistic perspective. We meet in Mexico City,
where she is visiting to install her exhibition at Museo Universitario del
Chopo, the museum of the Universidad Nacional Autónoma de México
(UNAM). Having worked on a community level with many different activist
groups across the Americas while establishing herself as a well-known and
respected international artist, she is the perfect person to ask about the
dos and don'ts of artist/activist collaborations. Sipping from her pineapple
juice, she tells me that the places where she decides to do fieldwork, the
places she visits and where she commits to work, are always places where
a certain collectivity is already thriving. That can be through political orga-
nization or through environmental struggles, or otherwise, but it's import-
ant to seek out those places that 'are really spearheading processes
of transition.' She gives an example:

> The fieldwork that I have planned for the next
> year and that I have started already and have
> been contemplating is in Northern California,
> the Pacific Northwest, where there are process-
> es of dam dismantling. These processes have
> been going on for decades and now there is some
> political momentum and that means that indige-
> nous people and non-indigenous environmental-
> ists and even politicians are helming together to
> push for this dismantling and freeing of rivers in
> the Northwest.

Her words remind me of the teachings of Raquel—the importance of
choosing your target carefully. Not only the 'who' and 'where', I see now,
but also the 'when'. When there is some political momentum. 'These are
processes that take decades, and right now we are in the heat of
the debate.' Caycedo continues:

> The other place of political momentum is Puerto
> Rico, which is the frontline of the colonial climate
> crisis, but there is so much organization on the
> ground in terms of energy transition and deco-
> lonial work, on top of all the conflict of all the
> hurricanes.

Caycedo lived in Puerto Rico for seven years and has built up a strong
network and knowledge of the country. 'It's a good reason to come
back and re-fire the commitments.' I read in her words the impor-
tance of valuing and maintaining relationships. She has also been doing
a lot of work in Colombia, where her parents are from, visiting small and
local communities doing pioneering work around the building of local en-
ergy transition initiatives, such as with biodigesters and small solar grids.

Another geography that she is very interested in is Patagonia, 'because there is already a lot of work happening on the ground.'

REFUGE IN COLLECTIVITY

When I ask her what the role of the artist is in working with these communities across the Americas, she explains it's not about being an organizer of anything but rather 'to stretch the existing processes.' She calls it her 'refuge in collectivity.' Caycedo is a 'bee to honey' to find out what she can offer to 'these already very strong and sophisticated—in political terms—processes on the ground.' She continues with a smile on her face:

> That is what brings me joy; it brings me refuge and it brings me hope. To see places where change is not in question, where it's happening and people are grinding towards it. Even in very precarious conditions, even against all odds, people are grinding towards that change and giving their all for it.

As an artist, Caycedo sees her role in these processes as a bridge and she is rather matter-of-fact about it:

> Maybe I'm the bridge between these processes that are happening in different parts of the Americas. And that's where I think I can take advantage of the institutions and status I have, to use those resources to bridge information. I'm not sure how successful I've been, but that's how I try and use the institutional opportunities that I have. And sometimes the bridge is as small as just bringing information from one place to another, and sometimes as strong as actually physically bringing people together to exchange knowledge.

I like her pragmatism and concreteness. Caycedo's work goes well beyond the artist in the context of activism/climate that is about 'raising awareness' (which, in my opinion, is a mish-mash of good intentions and debatable results half of the time). Her work is actively bringing people together, re-distributing resources, telling untold stories, providing access and a platform of visibility and grabbing momentum, alongside making stunning images, artworks, film, and other important documentation of the geographies that she is working in.

Thinking about my interview with Raquel Rosenberg, I ask Carolina about her opinion on the importance of Standing Rock. Was it really a game-changer for activism? She confirms certain nuances:

> In the United States it was the biggest and most important direct action in the last twenty years.

Yet it did make some struggles opaque. It did show that protesting is actually the way to go and probably ripened the ground for something like Black Lives Matter to happen too. What I see it did in general in the Americas is that it connected struggles of Latin America with other places. There are still some misconceptions, for instance from minority groups in Latin America that think everything is perfect in the United States. There is a lot of romanticization. But seeing Standing Rock was a way to connect to the struggles. It was indigenous, it was people of color, it stood the ground for months, it was similar tactics to what we have here in Latin America. And then it was the struggle for water. Water is life, *agua para la vida*; it was a moment for people in different countries, Brazil, Colombia, to see we have the same model.

SLIME MOLDS AND BECOMING WITH A PLACE

Call me fungi obsessed, but in learning about all these movements uniting and merging I couldn't help but think of slime molds. Slime molds are basically living decentralized networks that unite with each other. You can separate them and they will continue to live independently. Introduce them to each other again (or any other genetically compatible slime mold) and they will re-merge. Though not always visible to the untrained eye, the world is full of them. There are more than nine-hundred different types of slime molds and they grow all over the world. They are so elusive and distinct that it's even debatable if they can still even be called fungi— they're more of a category in themselves. When I ask Camila Marambio, the curator of the Chilean Pavilion at the 2022 Venice Biennale, about her favorite fungi she opts for slime molds. Marambio dived into their world while in Tasmania, when she was visiting Sarah Lloyd, an esteemed and admired naturalist who even has a slime mold named after her. Lloyd, a friend of Marambio, lives in the heart of Tasmania on a small hill, off the grid, where she and her partner creatively explore this hill that they live on, Marambio tells me over a Zoom conversation. Lloyd was studying the plants, and the birds, and at some point started to explore the place on a microscopical level, too. One day, when she was studying the nest of a bird with a hand lens, she realized there was somebody else living there: slime molds. Marambio: 'Not only were they living there, they were thriving and they were mutating and changing form. They were defying categories of kingdoms, changing from amoebal to fungal states.'

From spending time on that hill with her friend, Camila understood how to be with a slime mold:

You have to be really committed to one place and go out with your hand lens every day to see its interaction with yesterday's rain and with today's humidity, and tomorrow's drought.

To develop relationships with a place. This is how Marambio herself feels about Tierra del Fuego, the southern tip of Patagonia, Chile, where she has run a transdisciplinary research program called Ensayos since 2010. Ensayos is a nomadic residency, a collective research project focusing on topics such as de-extinction, multispecies dialogue, coastal health, and peatland protection. Marambio is passionate about all the complex layers of this territory, with its colonial history, indigenous presence, and biodiversity. Marambio: 'Even if I spend many months away from Tierra del Fuego, my commitment is eternal.'

THE ZAPATISTA UPRISING: A WORLD WHERE MANY WORLDS FIT

It was the author Alexis Shotwell who reminded me how remembering past activism is crucial in understanding how we got to where we are today. In *Against Purity: Living Ethically in Compromised Times*, she states:

> Thinking about activism and memory at this site, shows us that it matters how we remember activism of the past in remembering the present. ... When classifications become common-sensical it can become difficult to recall that they were created and sometimes, contested. Attending to contestation reminds us that what happened in the past was not inevitable. And since the past persists and consists in the present, no particular future is inevitable either.[2]

2.

Alexis Shotwell, *Against Purity: Living Ethically in Compromised Times*, University of Minnesota Press, 2016, p. 17.

And so I dived into what some perceive as the biggest indigenous-led uprising of the twentieth century: the Zapatista Uprising. This legendary protest started in the state of Chiapas, Mexico, and came into being from myriad triggers, including the lack of human rights for indigenous people in Mexico (and well beyond) and the post-NAFTA neoliberal economy, which had brought many small farmers in Mexico into poverty. NAFTA, the North American Trade Agreement, was implemented in 1994, bringing an end to economic sovereignty for many farmers, partly because of the cheap corn that came to Mexico from the United States. The Uprising started that same year, with the occupation of six towns in Chiapas by the EZLN, the Zapatista Army of National Liberation, and their declaration of war to the Mexican Government. Though this army mainly consisted of indigenous, rural people, what was interesting (and fungal!) about their approach was that they didn't want to fight just for their own Zapatista com-

munity, nor just for indigenous people in Chiapas, nor just for
the indigenous people of Mexico (and there are many: Mexico's indigenous
population accounts for 12.7 million people, who speak sixty-two different
languages!). They demanded 'work, land, housing, food, health, ed-
ucation, independence, liberty, democracy, justice, and peace'
for all who are exploited by the rich and powerful. Their manifesto, the
'Sixth Declaration of the Lacondon Jungle', which I came across in a small
feminist bookshop in Oaxaca, is written in a very clear and accessible way,
and is, surprisingly, full of dry humor. Tucked away in one of the many cute
coffee shops that Oaxaca holds, I found myself chuckling, charmed, and
disarmed with their writings. In one passage they even reach out to Europe:

> We want to tell our brothers and sisters in social
> Europe, that which is dignified and rebellious,
> that you are not alone. That your great move-
> ments against neoliberal wars bring us joy. That
> we are attentively watching your forms of orga-
> nization and your methods of struggle so we can
> perhaps learn something. That we are considering
> how we can help you in your struggles, though we
> are not going to send euros because they will be
> devalued because of that whole European Union
> mess. But perhaps we will send you crafts and
> coffee and that could help you in your struggle.
> And perhaps we might also send you some *pozol*
> (a corn and water drink), which provides much
> strength for resistance. But who knows if we will
> actually send it to you because *pozol* is more our
> way and what if it were to hurt your bellies and
> weaken your struggles and allow the neoliberals
> to defeat you.

I was blown away by how well humor and struggle go together. I also loved
this part of the manifesto:

> Perhaps we will send some organic coffee from
> our Zapatista cooperatives so they can sell it and
> make a little money for their struggle. And if it
> doesn't sell, they can always sit down and have a
> cup of coffee and talk about the anti-neoliberal
> struggle and if it's cold they can cover themselves
> with Zapatista embroidery, which, in fact, holds
> up quite well, even when laundered by hand and
> with rocks and, on top of that, the colors don't
> run in the wash.[3]

After reading this book and finishing my drink, I was ready to fight neolib-
eral capitalism with crafts, *pozol*, and coffee.

3. The Sixth Declaration of the Lacandon Jungle, Manifesto of the EZLN.

The Zapatistas remind us not only that we all struggle in different ways, but also that solidarity can be found in a humble cup of coffee, a conversation, or a warm blanket. This made solidarity and civil resistance more inclusive and more within reach, and triggered a global awakening and realization that it is indeed possible to challenge the State by joining forces.

The EZLN were also ahead of the curve in their understanding of how to use the Internet as a media weapon, for instance by playing with resistance imagery of Leftist groups from the nineteen-sixties and nineteen-seventies, such as the iconic imagery of Che Guevara. The Zapatistas acknowledged the importance and referred to these and other political movements, while also distancing themselves from them. Even though the EZLN can be considered Leftist, they were famously unpolitical in the sense that they rejected political classification. They also didn't limit themselves to their own (media)bubbles, but took a liking to unlikely allies such as celebrity magazines, featuring photoshoots with the EZLN riding horses in their balaclavas and with interviews with anonymous spokesperson Subcomandante Marcos, who ironically became a bit of a celebrity because of this. In an interview that writers Gabriel García Márquez and Roberto Pombo did with Marcos, released in the publication *A Movement of Movements*, they ask him how the EZLN differs from the traditional Left in the social sectors that they represent. Marcos answers:

> Broadly speaking, there were two major gaps in the movement of the revolutionary Left in Latin America. One of them was the indigenous peoples, from whose ranks we come, and the other was the supposed minorities. Even if we all removed our balaclavas, we would not be a minority in the same way that homosexuals, lesbians, and transsexuals are. These sectors were not simply excluded by the discourses of the Latin American Left of those decades—and still current today— but the theoretical framework of what was then Marxism-Leninism disregarded them, indeed took them to be part of the front to be eliminated.[4]

Besides the inclusiveness and openness to the like-minded, another key to the success of the EZLN was their attentiveness to new generations. By actively sharing their experiences, strategies, and knowledge with young people, they created not only a global but an intergenerational network of supporters. From their manifesto:

> New generations have renewed the entire organization. They have added a whole new strength. The *comandantes* and *comandantas* who were in their maturity at the beginning of the uprising in 1994 now have the wisdom gained in the war and

4.

Tom Mertes, *A Movement of Movements: Is Another World Really Possible?* Verso, 2004, p. 5.

5.

The Sixth Declaration of the
Lacandon Jungle, Manifesto of
the EZLN.

Through organizational leadership, young people are inspired and given
space and opportunities, allowing them to be 'dignified rebels' on their
own terms. Again, I'm reminded of the words of Raquel Rosenberg, under-
lining the importance of activities and methodologies that young people
can adapt, replicate, or re-new to correspond with their own realities and
experiences. This possibility of adaptability extended beyond younger
generations, but also applied to allies in other countries, the Zapatista
dictum being 'a world where many worlds fit'. This motto has been
inspirational for many contemporary thinkers, and still is.

FARMERS UNITED: VIA CAMPESINA AND MST

Looking into networked activism in Latin America, it started to dawn on
me that a lot of well-organized activism is somehow rooted in agricultural
worlds. It makes sense considering their work is often already entangled
with food webs and local and global communities and supply chains. Two
movements that I have found particularly inspirational in their mycelial
ways of working are Via Campesina and Brazil's aforementioned Landless
Rural Workers' Movement, the Movimento dos Trabalhadores Rurais Sem
Terra (MST). Via Campesina is an international network of small farmers
that organizes locally embedded campaigns opposing neoliberal policies
and thereby uniting against food multinationals. Brazil in particular seems
to have a rich history not so much of activism, but of interesting examples
of rural self-organizing. From the MMC (Movimento das Mulheres de Via
Campesina, the Movement of Via Campesina Women) to the MPA (Movi-
mento dos pequenos agricultores, the Movement of Small-Scale Farmers)
to the MAB (Movimento dos Atingidos por Barragens, the Movement of
People Hit by Dams and Big Energy Projects) to the MAM (Movimento pelo
soberania popular na Mineraçao, the Movement of Sovereignty for People
in the Mining Industries); basically, people were organizing themselves and
loving acronyms. I learned about all of this working on the shiitake farm in
Minas Gerais, Brazil, with the farmers Tomaz and Marília. They have a cer-
tified biodynamic farm, and over breakfast one day explained to me how
the MST had been instrumental in creating a system for eco-certification
that was affordable for farmers such as themselves. Previously, eco-cer-
tification was only possible through an external auditor and farmers had
to pay someone to come to their farm and check if everything operated
according to the rules and regulations for receiving the stamp of being
certified organic. The MST introduced another option for certification:
through a participative system. This allowed a group of farmers to form a
network among themselves and to check on each other's farms, drastically
decreasing the costs involved.

Again, this notion of organizing yourself among yourselves is key. In an
interview with João Pedro Stedile, who is on the nation committee for the

MST, he explains the importance of seeing the bigger picture:

> If farmers don't organize themselves, don't fight
> for more than just a piece of land, they'll never
> reach a wider class consciousness and be able to
> grapple with the underlying problems—because
> the land in itself does not free the farmer from
> exploitation.[6]

When I ask Tomaz and Marília what I can do to support the MST, their answer is clear and straightforward: buy their products. Tomaz adds another important point, explaining how there are many lies and misconceptions about the MST, mostly created by Bolsonaro and his supporters. Tomaz: 'You can help by explaining what they really do, as there are many prejudices about the movement.' I hope I just did.

REDES DE CARIÑHO

The question I asked Tomaz and Marília was one I asked many other interviewees. What can I and what can you the reader do? The notion of 'helping', particularly between the Global North and Global South, can be a slippery slope and hard to navigate. The forms of 'help' in the context of development are often still hopelessly colonial and patriarchal. Rich people helping poor people can have a disturbingly high cringe factor. I turned to Paulo Freire for guidance as in his book *The Pedagogy of the Oppressed* he writes about how authentic help means that all who are involved help each other mutually, growing together in the common effort to understand the reality which they seek to transform. Only through such praxis—in which those who help and those who are being helped help each other simultaneously—can the act of helping become free from the distortion in which the helper dominates the helped.[7] As someone who likes to help but finds it hard to ask for help, this was an important teaching. Why can't we be in community, rather than in transaction? When I asked artist Carolina Caycedo the same question, she told me that the teaching of reciprocity has been the most important lesson she took from all her collaborations with individuals, communities, and non-human entities. Caycedo:

> I strive all the time to be reciprocal. I've learned
> so much from others and I like to see my art-mak-
> ing as a reciprocal gesture. If we were all more
> reciprocal, everything would work better.

I ask her what reciprocity looks like without being transactional or focused on the individual, and she starts describing her work as a 'network of affections'. She elaborates:

> The work with a community against dams in Co-
> lombia facilitated the work with dam-resisting
> communities in Brazil. There is already an exist-

6. Mertes, *A Movement of Movements*, p. 20.

7. Paulo Freire, *Pedagogy of the Oppressed*, Seabury Press, 1970, p. 137.

Also known as 'the blob', this acellular slime mold can take
many shapes and sizes and loves to eat oat flakes.

Penicillium

Penicillium is a genus of fungi with over four hundred described species.
They play an important role in decomposing organic materials,
but can also produce myco-toxins.

ing network of affections that I weave myself into. Rather than organizing, I'm navigating these mycelia, these networks of affection and care, *redes de cariño*. It starts with the care for the body of water that is being affected, for the territory or the land where you are from and that community recognizes itself in other struggles across the continent. To recognize that as an artist I care, too. There is an empathy that we can build together. I weave myself into existing networks rather than providing the structure for them to become. Perhaps what my work can do is to make them stronger, temporarily at least. I see my role as an ally. As someone that could bring resources in. From money to other resources like a bank of images they can use further. Sometimes I bring in information that they don't have access to, such as satellite imagery of certain spots that I'm using in my work. Being able to share that with the community is important. And maybe a possible dialogue or their presence in other circuits that normally they are not present in, such as institutions like El Chopo, cultural institutions, museums, sometimes academic settings within the arts. Sometimes their work, community, or actions are discussed in academic settings, such as sociology or environmental studies. I can facilitate their presence in those spaces.

CONCRETE COLLABORATION MODELS

Caycedo raises an important point I find, which is the role of the facilitator to cross disciplines. Something that I often experienced myself and that frustrated me was that climate actions were too centered around 'single-issue environmentalism', meaning a protest was just focusing on one issue, such as fast fashion, or even less grand issues like plastic straws. Though I acknowledge the hyperobject size of the climate problem needs to be chopped up into bite-size pieces, what bothered me was that often these issues offered an instant solution in the shape of the 'sustainable alternative'—buy something green instead! It's a tendency we call 'green capitalism'. The solution is always instant and market-centered, and never about not buying or consuming less. Those actions don't transcend into other domains or disciplines that reveal their roots and entanglements with other social and environmental injustices.

There are already many collaboration models out there that could be the foundation and inspiration for alternatives. Models that take the values from the mycelium as a starting point, sometimes without them

even knowing they are mycelial. In my research I have come across Decentralized Autonomous Organizations (DAOs), Platform Co-ops, Temporary Autonomous Zones (T.A.Z.s) and many other contemporary examples that use the digital domain to truly become decentralized, non-hierarchical, non-patriarchal, or non-capitalist. They are collaboration models of organizations that re-think how they operate in terms of participation and commitment, legal structures, ownership, coordination and decision-making processes, financial systems, governance and power, and transnational work modes. In addition, I have come across shelves and shelves of organizational and management books that confirm that decentralized and value- and people-based organizations function better than authority-driven and hierarchical power structures. Yet what I continued to find one of the most inspirational mycelial collaboration models was the artist's residency. Residencies are spaces and programs for artists and often other creatives that create circumstances to (make) work. They are to be found across the world, in all shapes and sizes. What they have in common is that they host people and believe in the importance of creativity. Having worked for the international network of artists' residencies, TransArtists, I experienced firsthand how residencies are the nodes in international art networks. When I participated in Capacete for seven months, a residency in Rio de Janeiro, it dawned on me that not only are residencies the nodes for international connections, they are often also important nodes in local communities. They expose the artists to new perspectives, communities, people, and contexts. They have a fungal capacity to be micro and macro at the same time. They're at once an infrastructure and a host. Residencies can be considered a place of refuge, a place to regenerate. I'm a great believer in the arts as an important field to contribute to envisioning what a new paradigm might look like. After all, in the arts we can learn how to be creative and think of innovative solutions. In the arts we make, we improvise, we tell a story, and here we can use our imagination—crucial survival skills for an increasingly insecure future, with an increasing number of people, and other species, looking for refuge. They are potential alternative schools, places of learning and unlearning beyond institutional hierarchies and far from being the neoliberal moneymaking machines that some universities are. Donna Haraway described refugia as 'the hideaways from which diverse species assemblages (with or without people) can be reconstituted after major events like desertification or clearcutting' and 'refugia are where processes, ecological, mental, social, go to regenerate.'[8] I've seen many residencies and art spaces that fit this description, providing shelter, alternative education, places to escape from mental desertification.

Artist Sofía Gallisá Muriente illustrates how the art space Beta-Local took up this important social role for Puerto Rico, not just in terms of knowledge exchange, but very concretely as a community to return to and as a place that re-distributes resources. Gallisá Muriente:

Because so many Puerto Ricans leave Puerto Rico,

8. Donna Haraway, 'Anthropocene, Capitalocene, Plantationocene, Chthulucene: Making Kin', Environmental Humanities 6 (2015), pp. 159–165.

Splendid Waxcap (*Hygrocybe splendidissima*) is a bright-red capped, gilled mushroom listed as vulnerable on the IUCN Red List of Threatened Species, due to a declining habitat.

and because in the art world many people leave to
get Master's degrees or their academic education
elsewhere, Beta-Local is a very important space to
unpack all that learning from elsewhere.

It was not the first time for me to hear about art students feeling disillu-
sioned with their art education acquired elsewhere. Returning to their
home countries the Western theoretical framework and references did not
make much sense any more in their local context. She explains:

It's so hard to find a way to return after you have
studied abroad. To find a community to return to,
or a place that can help you re-connect with the
place you have been away from. How do we bet-
ter respond to our local reality, and challenge the
ideas that have been formed elsewhere about how
to do things?

Beta-Local was there for those international art students, including Sofía,
who were looking to consider what makes sense working in the context of
Puerto Rico.

One thing that is important to remember is that Puerto Rico was still
recovering from Hurricane Maria in 2017 when Hurricane Fiona hit in 2022.
Hurricane Maria's death toll was almost three thousand people and came
with an incredible amount of damage, creating a nation-wide trauma. After
Hurricane Maria, many things changed, also for the Puerto Rican art world.
Whereas before, Beta-Local had been fighting to try to obtain resources to
distribute to artists in the form of grants, fellowships, and commissions,
the hurricane opened up a floodgate of disaster philanthropy funding that
had never been available in Puerto Rico before. Beta-Local ended up being
a major re-granter of emergency funds.

Residencies and art spaces can also be important nodes in an in-
frastructure for producing new knowledge. Fundación Mar Adentro, a
foundation initially focused on nature conservation in Chile, introduced
a residency program for artists in order to include a new perspective on
conservation, alongside the perspective of scientists. The foundation,
with offices in Santiago de Chile and Pucón, provides stewardship for a
forest called Bosque Pehuén. They were studying the forest from a scien-
tific point of view, in order to turn it into a conservation project. Members
of the team, as well as the founder Madeline Hurtado, are artists, which
prompted a need to further expand these scientific explorations into con-
servation. This is how the Bosque Pehuén Residency Program came about.
It was conceived as a multidisciplinary nature research station in which
different creators and thinkers could contribute with research for con-
servation efforts. Maya Errázuriz curates the residency program and she
tells me that when they started there were very few residency programs in
Chile. Maya:

What is most interesting about a residency program is the multiple formats it can take and the ways in which a program of this nature can harbor a community of creative thinkers. It positively seeks to affect a specific territory or context. Our program is formulated in a way that it can establish a relationship of reciprocity with its residents. We do not necessarily ask for specific results, but we do hope that part of their research considers finding ways to contribute to this territory and the people that inhabit it.

The foundation's ideas about conservation are very progressive and innovative and, throughout the many years they have been active, has resulted in a significant ecological-educational impact. This is to be perceived in both the forest and the community. Maya tells me how she thinks that residencies have different layers of meaning. The more traditional understanding of residencies is that they are spaces for artists to work and create. Particularly in Latin America, where working conditions for the arts can be very precarious, this is of considerable importance. There are very few opportunities where you have time, space, and funds and most artists have to do other jobs, such as teaching, to survive. It makes residencies crucial spaces for the production of art. Fundación Mar Adentro has situated that methodology—time, space, funds for artists—in the context of nature conservation. Maya: 'For us it's key to incorporate the residency program and its methodologies within the overall management of the conservation plan.' She gives an example:

We need to study the river environments of Bosque Pehuén because there hasn't been any study on that. So it's not just convening a scientist to work on this, but also convening an artist. And perhaps a sociologist, to carry out studies revolving around the ecosystems that are in the conservation of this area.

Involving scientists, sociologists, and artists means that conservation is not only addressed from a scientific point of view. It also includes the cultural and social aspects of these eco-systems. 'Through the residency methodology we are able to immediately have a more holistic approach to conservation.' Having worked with Maya and the foundation on a few different occasions, I consider the residency to be an interdisciplinary Nature Research Station. One that convenes different perspectives, and an understanding of the forest as a social and cultural place, just as much as it being an environmental context. Maya:

For those who aren't coming to Bosque Pehuén from the arts, and also not from the sciences, it's

Mycelium is the underground rhizomatic network of the fungus,
consisting of connecting hyphae.

She continues:
> I have seen how much the residents learn in five
> weeks in Bosque Pehuén, in a conservation area.
> It's incredible. They start acquiring a language that
> they didn't incorporate before; they learn about all
> the different species that live here. They spend time
> with the forest ranger and all the other local actors
> and they get to internalize all that information.

In a way, all the residents become ambassadors of the Bosque Pehuén
conservation project.
> Before their residency they might not have known
> what a privately protected area of conservation
> means. And by the end of it they do. And that is
> already valuable as a result.

Though this sounds amazing and I'm very impressed with the work of
the foundation, my personal experience is also that collaborative proj-
ects across disciplines can be terribly challenging and the balance for an
exchange that is truly mutually beneficial is often hard to find. I've seen
art/science collaborations across the world where the scientists were so
busy with their research in the lab, on deadlines and having to come up
with results, that artists coming in and asking silly, speculative, and vague
questions were mostly annoying and time-consuming. Particularly artists
that didn't speak 'science' and didn't have a clear plan of what they were
going to do (which, honestly, most artists don't) were sometimes received
with hostility and questions were answered with deep sighs and rolling
eyeballs. Art/science collaborations can be forced. The same applies to
working with 'the community'. One of my first 'real' jobs after graduating
was to review art projects that were funded under the strand 'Community
Art' by a Dutch funding body for the arts. I interviewed project organizers
and people from the community who had participated in the art project.
The organizers almost always had big, ambitious, utopian ideas about all
the beautiful things they were going to bring to the community and the
community was, more often than not, disappointed and disillusioned with
all the unrealized promises. The biggest challenge? Continuity. A marginal-
ized community did not benefit from a one-off dinner, party, festival, or the-
atre play. What they needed was continuous support to be able to count
on, through relationships of trust, being heard. How can we ensure a posi-
tive impact or reciprocity when we don't know, or can't even understand,
what the community wants or needs? This becomes even more complicat-
ed when working with a non-human community. Errázuriz recognizes the
challenge and that continuous search for reciprocity.

We want to establish long-term relationships with the key actors for educational and community aspects, and embed the Bosque Pehuén program as a long-term and organic collaboration with schools or a cultural center. We want to understand how we could tap into the potential needs a community might have.

She emphasizes the need to not be doing 'one-off things' as there are many ways to interact with a community. And 'getting to the right form is not easy.' And not just for the community, but also for the artists participating in the residency. She describes the residency as a 'trial community', as people live in the house together, cook together, and spend quite a bit of time together. Maya:

You're very rapidly learning how to live with people that you don't know, for a very intense period. You need to establish a code of co-habitation, learn how to live with each other, so in a sense it's a microcosm of community. You have to learn how to co-habit together and then that is inserted into a natural area in which you also have to learn how to interact with more than human beings. This makes the residency a trial of a community. You have to learn how to make compatible your sleeping schedule... a lot of time spent in a residency is consumed in the day-to-day living, especially in places like Bosque Pehuén. Half of the time you are distributing chores among each other and making sure the fire doesn't go out.

It's exactly what I remember as a key activity during my residency in Chile, at Valley of the Possible, keeping the fire burning and the wine flowing. A form of necessary care that proved to be a fast-forward way into creating a sense of family and community.

SYSTEMS THINKING

Tara Rodríguez Besosa is a food justice activist in Puerto Rico who set up the organization El Departamento de la Comida, a non-profit collective that acts as an alternative agency in support of small-scaled, decentralized, local food projects. They offer a Resource Library with tools, seeds, and educational materials, and a kitchen with product-making equipment, renewable energy, and a retail point of sale. One of the things that is important to them, according to Rodríguez Besosa, is that they are supporting food projects, not just farms, not just kitchens. 'Most of the projects that we support are food projects in which the people don't identify

is.' When we speak over Zoom, we discuss how many people do not un-
derstand the different roles and the full spectrum of what food is, and how
capitalism and the separation of tasks and labor creates the disconnection
between what we're eating and who's farming it. As a collective, El Depar-
tamento de la Comida is particular in trying to support those who are not
recognized within our food system because they don't fall into known or
funded roles. Whether that's via the Department of Agriculture or non-prof-
its not recognizing these types of food projects. Tara Rodríguez Besosa:
'Some of these people are farmers, some are cooks or artists; we
just share the ways in which we work with "food projects"'. She
continues:

> Part of what we have experienced is that most
> food sovereignty is in the hands of those who
> don't necessarily farm for other people. Food sov-
> ereignty should include all the free foods that are
> abundant on the island. As a collective, we would
> like to recognize those who participate in infor-
> mal food systems and informal food economies.
> Something that I think has become an elephant
> in the room is that food is not just an industry
> or a currency. It's a system. And you can't even
> live anymore off growing crops based on the sales
> prices of crops. If we were to think about food
> as a system with different parts and different
> areas in which we can all participate, we could
> also help people that are growing food, from the
> burden and obstacles of having to participate in
> markets that will not have a return in any aspect
> of investment, be it currency or well-being. That
> part of broadening what food sovereignty means
> and what food means and where it's at—it's pretty
> much everywhere—is complex and nuanced.

Totally mycelial if you ask me!

SURVIVAL OF THE FITTEST?

In my biology class in my semi-posh secondary school in the south of Am-
sterdam, I learned about Mr. Darwin. In a nutshell, I learned that whoever
won the competition was the one that was going to survive and move
forward in evolution. Many of the interviewees, including Giuliana Furci in
Chile, Raquel Rosenberg in Brazil, and the ladies of the FIBRA art collec-
tive in Peru, spoke about the exact opposite. Not Darwin, but fungi taught
them that it is collaboration over competitiveness that defines a notion of
evolutionary success. The only way to survive and to thrive is through co-
operation and collaboration. Because we are never separate from others.

Darwin's evolution theory was also taught at the school of Lucia, one of
the three members of FIBRA. Lucia:

> We heard a lot about the survival of the fittest;
> where everyone is fighting for their own space.
> But here, in the world of fungi, we have this beau-
> tiful example of collaboration between species.
> Not only between fungi and trees, but also be-
> tween different kinds of trees, this network shar-
> ing nutrients and information with young trees
> from the same species but also other tree species,
> from the idea of the elders; a vibrant picture of a
> community that is not about survival of the fittest
> at all.

The example of fungal collaboration kindled FIBRA's interest in learning
more about mushrooms, and all the powers and teachings they carry with
them. As a collective, they are 'continuously inspired by their social
organization in equitable and sustainable ways.' The thoughts
and words of Raquel Rosenberg from Brazil's Engajamundo were not too
dissimilar:

> We learn everything from how nature organizes
> itself. There is such an interdependence. A tree
> doesn't live alone, not even a small plant or or-
> ganism; it's about collective knowledge and mak-
> ing sure that the other survives so I can survive.

These, among many other examples, demonstrated that not just for me,
but for plenty of other people, the mycelium had been a great example
of the immutable interdependence of all living things, underscoring the
importance of alliances.

TAKING STOCK OF OTHERNESS BY FINDING POINTS OF UNITY

Mycology as a discipline in itself is very much like a mycelium; it thrives
on the informal networks of amateur enthusiasts that go out into the field
identifying mushrooms and collecting data. As with mycology, small-
scale alternative systems, networks, communities, and relationships are
often already in place. It's the connecting of these systems, disciplines,
and groups that needs to be facilitated in order to create a critical mass
that integrates their potential. We need continuity and groups getting
together for the vast numbers that constitute strength for a significant
global and political impact. The examples in this chapter demonstrate
how a balance is needed between like-mindedness and the sharing of val-
ues, alongside the need for diversity and differences that spark dynam-
ics; for instance, dynamics triggered by forming coalitions across sectors
and disciplines. The Zapatistas showed like no other how one takes stock

of otherness by finding points of unity:

> We want to tell all of those who are resisting and fighting all over the world in their own ways and in their own countries that you are not alone, that we, the Zapatistas, though small in number, support you and we are going to see how we can help you in your struggles and how to speak to you in order to learn from you, because what we have learned is to learn.[9]

9.

Sixth Declaration of the Lacondon Jungle, Manifesto of the EZLN.

HOW TO RE-THINK DECAY AND DECOMPOSITION?

We Need to Talk about Death

TEACHING FOUR

Featuring:
Saprobes, *Cordyceps*, Indian pipe, Giuliana Furci,
rot and mold, Camila Marambio, *Pleurotus ostreatus*,
Teresa Margolles, Milton Almonacid, Maria Alice
Neves, Francisca Álvarez Sánchez, Olaf Boswijk
and Mirla Klijn (Valley of the Possible), Juli
Simon, *Psilocybe cubensis*, *Panaeolus cyanescens*, Sofía
Gallisá Muriente, Daniela and Lola of TEOR/éTica.

Geographies:
San Francisco Lachigoló and Santa Cruz Papalutla
in Oaxaca (Mexico), Amanalco, Valle de Bravo
(Mexico), Tierra del Fuego (Chile), Cañón del
Blanco (Chile), Puerto Rico.

TRASH MONSTERS AND VALUE-MAKERS

We woke up at the crack of dawn. It was still chilly and fresh and the air gave no clues as to how hot and sunny the day would become later on. I'm not much of an early bird (more of a night owl) and while I was cursing the friendly but forceful birdsong that I have as my alarm, I realized I had reached peak-fungal commitment: leaving my warm bed on a Saturday morning in search of mushrooms in the forest. The digital birds were chirping so early because we were going mushroom hunting with a group of strangers, out in the woods of Valle de Bravo, Mexico. I had joined a WhatsApp group called 'Shroom Hunt' through friends of friends, and we had arranged for a place to meet in the city and from there drove three hours into the mountains to a place called Amanalco. I now found myself on the back of a Vespa at five am, racing through Mexico City in the dark, with a big rucksack stuffed with snacks, raincoats, Opinel knives, hand-lenses, foraging bags, and Igor the dog in the front. In the middle, my Mexican boyfriend whom I had convinced to join the mushroom hunt. I imagined we must have been quite an endearing sight, with all three of us grabbing on to each other on the scooter, except there was no one on the streets yet to witness our cuteness. Arriving in Amanalco, Valle de Bravo, there were a few annoyances to overcome, mainly on a social level. I'm not very good with big, chatty groups in a forest and a significant amount of people had joined, shrieking with laughter and excitement with every

fungal creature we encountered. I just wanted to silently focus my gaze on the ground in search of them. Igor, my partner, and myself discretely removed ourselves from the group by going slightly off-route and were instantly rewarded. On a little side path we spotted an incredible, out-of-this-world looking thing with the appearance of an interfusion between a fungus, an orchid, and an asparagus. Bright pink and transparent. It also bore a striking resemblance to a lollipop. We learned that we had encountered an Indian pipe. Indian pipes are often mistaken for fungi, I later learned from an article in the *New York Times* called 'The Ghost of the Forest',[1] yet officially they are saprophytes.

Unlike parasites, who feed off living entities, saprophytes are plants, fungi, or other microorganisms that solely eat dead or decaying organic matter. I found it interesting that this 'feeding off death' is how they are categorized. Saprotrophic fungi are also called saprobes, although when it concerns a plant, they are always called saprophytes (*sapro* meaning rotten material and *phyte* signifying plant in Greek). Saprophytes are essentially the decomposers of this world. Without them the world would be a huge heap of trash and the flesh of all that was once alive would be lying around and piling up. Not a very attractive sight to imagine. Saprophytes, which are the majority of fungi, don't only decompose dead matter, they also create new life out of death. In the process of breaking down dead matter, they release minerals and other nutrients into the soil which are essential for the growth of plants, making them crucial in soil biology. It also makes them the kings and queens of compost; saprophytes are the organisms doing the hard labor turning our food waste into rich garden soil. Fungal life starts with something else dying, and the sequence of decomposition and recycling organic (and sometimes inorganic) matter on the planet is how fungi make sure no energy is lost and is instead transformed into new life. They thrive on waste and decay and are, in essence, trash monsters and value-makers at the same time.

ROT 'N' MOLD IS THE NEW ROCK 'N' ROLL

One of the first people I interviewed, a woman on the top of my list, was Chilean mycologist and founder of the Fungi Foundation, Giuliana Furci. Not only a pioneering mycologist but also a person blessed with charisma in abundance and an unstinting sense of humor—epitomized by her proclamation that 'rot 'n' mold is the new rock 'n' roll'. Clearly someone I wanted to meet. Furci's foundation released a short film called *Let things Rot* and rot is one of her favorite subjects.[2] She told me that for a mycologist, decay and decomposition are the beginning of many life-forms. The end of one life-form is just the beginning of another. We spoke a bit about *Cordyceps*—the fungus that enters the body of arthropods and starts controlling their behavior—and how this scenario is always framed as a kind of cruel horror film with the poor ants turning into zombies. Furci contextualizes:

The death of the ant is the beginning of a new

1.

See: Dave Taft, 'The Ghost in the Forest', *The New York Times*, July 26, 2018.

2.

Let Things Rot, www.youtube.com/watch?v=Pl_-eUOgqFI.

cycle of life for the fungus and keeps the colony of ants in check. If anything, this is a perfectly balanced cycle of life and death. Yet we are conditioned to think about death as solely the end of one life, not as the beginning of another.

That Furci thinks in terms of beginnings is clearly demonstrated when she shares her favorite moment in the life of a tree: when it falls down. When it hits the ground and starts decomposing and goes back to the soil. Furci:
Most people think the most glorious moment of the tree is when it's standing and it's visibly serving others. But when it serves invisibly, it's equally as, or even more, glorious.

She adds: 'The process of transforming energy is what we call decay and that's negative!' In the terminology we use there is a lot of connotations that inform how we relate. Furci:
The word regeneration is so trendy and fashionable now while degeneration.... There is no regeneration without degeneration. It's really necessary that we let things rot. It needs a reclaiming of the word as it has such a negative connotation. In a way fungi degenerate, but it's to enable regeneration. That doesn't mean they are degenerate beings. You can't regenerate when you don't degenerate.

According to Furci, the same needs to happen in the process of ideals and ideas: 'They need to decompose in order for new ones to arrive. It's really important to let ideas rot. Let them disintegrate and give life to new ideas.' Speaking with the curator Camila Marambio, a friend of Furci's, she tells me the story of when, 'many years ago', Giuliana and herself visited a forest in Tierra del Fuego, Patagonia. The forest was severely damaged: it had drowned because of the beaver dams that had created too much water for the forest floor to hold. Silvery dead trees were submerged in water, not looking too different, I imagined, from a flooded forest I once saw in Brazil. Marambio and Furci were dreaming about the possibility of enlivening some of that forest by making the drowned trees rot. They were talking about the possibility of manually inoculating the trees with spores from above. It couldn't be done through the ground, since the trees weren't rotting through the water. Though they didn't realize this idea (I guess they had to let the idea rot?), it was a good example of the type of mycological strategies or interventions that could be part of a creative practice.

Every year, on the first days of November, and the days leading up to that, pretty much the whole of Mexico is decorated with skulls and skeletons. The image of death is all around, yet the atmosphere is festive, amplified by an abundance of music and flowers, mostly the bright orange *cempa-suchil*. It's the time when Mexico is commemorating *Dia de los Muer-tos*, the Day of the Dead. The souls of the deceased are invited back into the world of the living and welcomed by all sorts of *ofrendas*, altars with a wide selection of objects. Photos and candles, food and flowers, and religious or other sacred paraphernalia are carefully curated to honor and remember the dead. For anyone conditioned to mourn the dead dressed in black, weeping, and with dramatic classical piano music—and who hasn't seen the Disney film *Coco*—it's a surprising sight to approach death as a celebration. With colectivo amasijo, the Mexican art collective of women working around territory and food sovereignty, we were making a huge *ofrenda* at the Museo de Arte Carrillo Gil, a museum for contemporary art in Mexico City. While collaboratively crafting a constellation of all the beautiful *maize criollo* (colorful ancestral corn), it became clear that though this had seemed festive to me, it was actually a rather serious affair. The produce we were arranging was all from Milpa Alta, to the south of Mexico City, where a lot of women traditionally grow the food. It's also a place with the highest number of femicides, the murders of women. A sad truth that is a reality in many parts of Mexico—extreme violence and murders. In an article in which the Mexican artist Teresa Margolles ad-dresses femicides, she states that men are generally murdered for things that they did, while women are murdered for being women.[3] The stories are haunting, with bodies being mutilated and endless unsolved cases of people gone missing. Margolles tackles morbidity in confrontational yet subtle ways. I will never forget seeing a work of hers in a church in Germa-ny somewhere. I entered the cold and majestic building expecting to encounter an artwork, but at first sight there was nothing to be seen. It was a quiet weekday morning, and the few people around were silently in awe, making their echoing footsteps sound excessively loud. As I started walking around, I caught a glimpse of a piece of string that was stretched throughout the space. It was very long and only parts of it were properly lit. As I came closer, I could identify that the piece of string was actually lots of shorter threads tied together, looking a bit dirty with brown and reddish stains. I followed the threads from one part of the carefully lit space to the other, becoming aware of the large number of threads tied together. The threads, I read in the curatorial text, were all used in autop-sies; they were the remains of stitches from the bodies of murder victims. The stains were blood and other bodily fluids. Margolles collected them from different morgues where she worked. She observed how the activity inside the morgues reflects the truth from the outside. '<u>Looking at the dead you see society</u>.' One way in which this was perceivable, for instance, was that the majority of the murdered people were from poorer

3.

See: www.mistermotley.nl/geweld-is-een-taal-to-craft-is-to-care/.

backgrounds. Margolles's observations in the morgues reveal so much about the injustices that are rooted in our societies: who gets to benefit and who has to pay, with their lives. The deaths of the murder victims are somehow entangled with all of us, including, or maybe even particularly, those who are in favor of class systems and maintaining and feeding the growing gap between rich and poor.

THE DEMOCRATIZATION OF VIOLENCE

While in residence with Valley of the Possible, a residency program in the South of Chile, we had a visit from Milton Almonacid. Specialized in transition design, he came round to conduct a workshop in which we, a group of international artists and curators, were to identify our inner resistances to the change needed to bring an end to global social injustices. A big part of this was de-growth in the, what he called, Western world, pointing particularly at Europe and the United States. As a Mapuche academic who had grown up in Chile and studied in Denmark, he was very skillful in navigating both ancestral cosmologies and European thinking. In a lecture, he spoke of the Western obsession with happiness. From his point of view, it was time to let go of this naive idea, as happiness and comforts are 'always at the expense of something or someone else.' He spoke about the idea of the 'democratization of violence', meaning that the direct and indirect violence that 'the West' has put on the rest of the world needs to be directed back. Listening to his words, I thought about how the murder victims in the morgue of Margolles were somehow entangled with hedonistic parties I had attended in Amsterdam in my twenties, not realizing that the coke that was being snorted off tables was connected to the infrastructure of the *narcos*, and that the *narcos* played a significant role in violent practices and corrupt power structures across Latin America and beyond. And not just with drugs; the consumption of coffee, chocolate, or avocados (three things I love) also turned out to be connected to practices of suffering, murdering, and the modern-day slavery of, for us consumers, invisible others. Though Almonacid's words 'democratization of violence' scared me, they made his point very clear. The emotional resistances to the idea of de-growth, for instance, are often to do with an unwillingness to give up certain comforts, the things you love, and the fun that a lot of people have become accustomed to. Yet without radical de-growth in the places with the highest consumption rates, and without letting go of this obsession with happiness, avocados, and cocaine, collapse is irrevocably on its way. It was hard to disagree with Almonacid on this issue of impending collapse. He explained that in historical collapses approximately eighty percent of civilization dies and that rather than obsessing over happiness, we should be preparing for the collapse. We should be making plans and changes to our lives so that communities don't end up killing each other fighting over resources, while the billionaires are hiding in their well-stocked radiation-free bunkers. I had come across people in Amsterdam who had taken up shooting lessons to prepare for the collapse.

4.

[Teresa Margolles, *Dylegued (Entierro) [Dylegued (Burial)]*, 2013. Mola on fabric permeated with blood from the body of a woman assassinated in Panama City, Panama. Created with the participation of the Rosano family, of Kuna descent, in memory of Jadeth Rosano Lopez, a seventeen-year-old teenager who was assassinated, Unique, 230 x 100 cm]

I wasn't sure if this was about learning how to shoot people over resources or to shoot animals to eat. Whatever the answer was, it was installing a fear that people were accepting that climate collapse is looming and they were preparing for it by taking measures to save their own skin. While in places that are actually suffering from floods and crop losses in the here and now, people were thinking of ways to prevent it from happening again in the future, and helping each other recover from the disasters. A Hollywood-esque climate apocalypse narrative catapults people back into the survival-of-the-fittest approach, where we have to fight each other over resources. Rather than accepting and preparing for the apocalyptic future with guns and bunkers, we could also prepare by making more fungal and collaborative communities at this moment in time.

A SPACE OF GRIEF

The 'friends with guns', Almonacid's strong words, and the haunting work of Margolles triggered a lot of sadness in me. Sadness about great injustices, grief about all the victims of murder, about (intergenerational) violence, and generally, about the state of the world. It does indeed seem to be in a state of ending, with extinction after extinction of species and disasters becoming more and more extreme. I didn't seem to be the only one who was struggling to deal with this and I could see why giving up and accepting climate collapse was easier than resisting it. The challenge seemed too big and all-encompassing. I had many friends with 'eco-anxiety' and—I guess the next stage after that—so-called climate grief. Climate grief is a term that started popping up more often in my environment, signifying a sense of loss and bereavement related to the impending climate collapse. People were mourning not only plants, animals, and people, but also lifestyles, identities, and possible futures. Dealing with death means making space for grief. I understood grieving could go beyond the death of an individual and could be about a collective state of being too. Is it time to start thinking about a funeral for humanity? I remembered the words of mycologist Maria Alice Neves who, in our interview, was talking to me about 'these weird rituals related to death and how human bodies are treated after death.' She said:

> I don't quite understand these death rituals because I'm not religious and I think we are destined to die and rot and decompose and become tree food. And the fungi help with that.

Her matter-of-factness made me feel lighter. Also, in the conversation with Giuliana Furci, right after she mentioned how the most beautiful moment in the life of a tree is when it falls down and can start, invisibly, serving others, she brought up the topic of grief. Furci:

> There is a misconception that only the visible and the shareable are important. The only thing you see about death is decay and a lot of people asso-

ciate this with a feeling of negativity or sadness,
but there's the whole invisible part that is very
powerful too. Both the invisible and the quiet are
undervalued, especially now. This is a time of hy-
per-communication so there is hyper-occupancy
of anybody's mind with other people's thoughts
and I think that's not helping very much.

We talk a bit more about the importance of making space for grief, and
what it requires. Our conversation loops back to the forest. Furci:

Nowadays it's hard to even get to your own
thoughts, to be calm and quiet. We are constantly
bombarded with what everybody else is thinking
and doing. So the forest is important there. The
forest as a place of calm or of being far away from
others.

The forest as a space for grief. It made me wonder if maybe mycologists
are the perfect people to design death rituals, involving all sorts of fungi to
help us accept death in a better way.

DYING AND RESTING

The work of Chilean artist Francisca Álvarez Sánchez often addresses
death as a cycle of life and speculates about life after the collapse. One hot
and sunny afternoon for me in Mexico and a cold and snowy afternoon for
her in Chile, we Zoomed to talk about death and regeneration. Enviously
looking at my sunshine, she told me about the last time she was in Mexico,
for a residency in Oaxaca, in a place called San Francisco Lachigoló. It was
in the middle of the pandemic, during strict lockdowns. She had a scholar-
ship for the residency, which only now was allowing one person to come
and stay because of the restrictions when the usual practice was to host a
few. On her second day, having just arrived in San Francisco Lachigoló, she
started to feel sick. And it got worse, with her illness and symptoms long
and drawn-out. In retrospect probably Covid. She felt so bad and frus-
trated because her residency was only one month, and felt like she was
wasting that precious time now that she couldn't work. But she had a fever
and couldn't do much. After a while she realized she just had to surrender
to it. Álvarez Sánchez:

I was working with this cycle of life and death and
realized in my state that an illness and fever is a
process of the body trying to get better, to regen-
erate itself. So I HAD to rest, to let that process
go on.

Rural Oaxaca is full of *milpas*, agricultural fields featuring the three
sisters (corn, beans, squash) as the main produce. Locked inside her

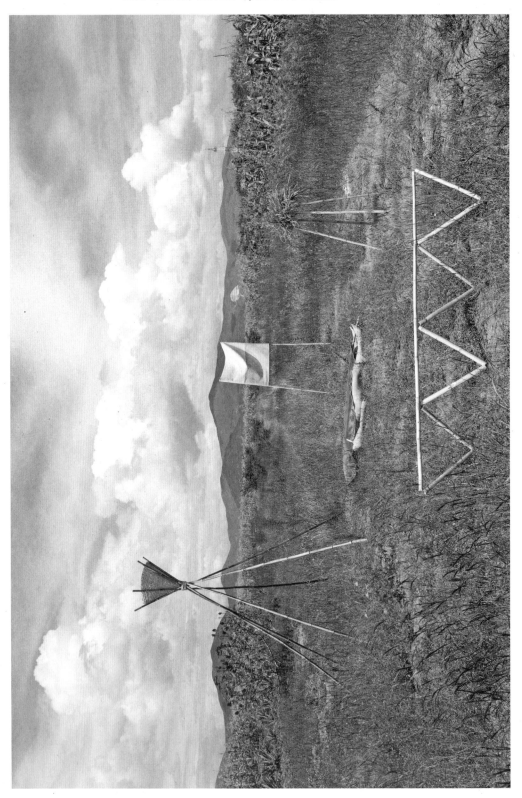

Francisca Álvarez Sánchez, *El Descanso de la Tierra* [*The Rest of the Earth*], 2020.
Installation on barren lands, Santa Cruz de Papalutula, Oaxaca, Mexico.
Series of ritual objects created with reeds, banana leaves, palm leaves,
corn leaves, fabrics dyed with earth.

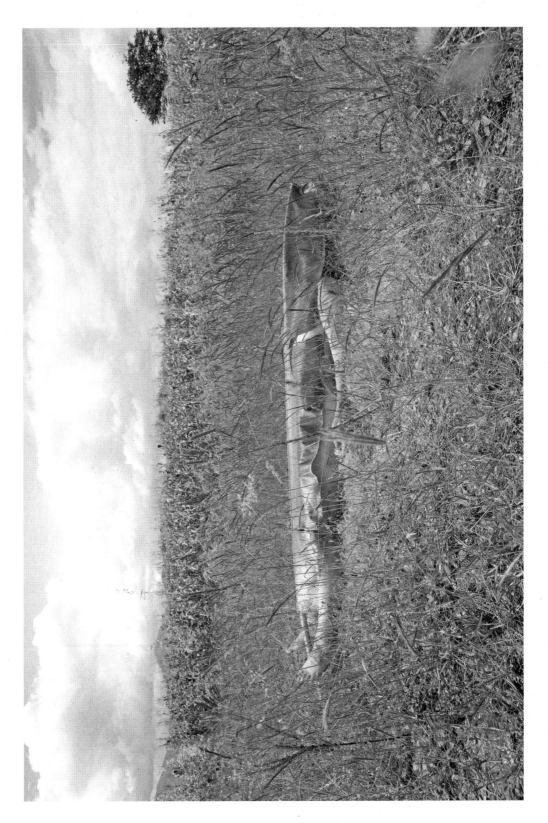

We Need to Talk about Death

bedroom, feverishly staring out of the window, she could follow the slow growth of the *milpa* and the processes of the earth. Francisca:

> In some places they had harvested and taken
> away the harvest, so the land was barren. In the
> barren places the land was resting from the har-
> vest. From here the whole cycle started again.

When she started feeling better and her PCR test was negative, she went out and started talking with farmers and neighbors. They were local farmers with small plots of land producing an equally small harvest. They told her about two phenomena that were happening there. There were the people that use the native seeds and plant these for the *milpa* and there were the others who use GMO seeds. Many people stopped using native seeds and started using GMO seeds because it means you don't have to let the land rest after the harvest. Combined with the fertilizers, they could just keep on going, keep on producing. Francisca:

> I started to see the parallel of what happened to
> me inside and what was happening on the land
> and on the earth, and seeing it on an even larger
> scale, being in the pandemic and being forced to
> rest. We were forced to stop. All these phenom-
> ena, on different scales, seeing it in the harvest,
> in my own body, in the big body of the earth. I
> was thinking about my own body, the body of the
> earth, the planet. It was really interesting for me
> to see the in-between, the process of not-doing;
> the opposite of the action part. We project the
> capitalist mentality both on our body and on the
> earth.

She started working with a local community in Santa Cruz Papalutla, where they use the *carrizo* (reeds) for basketry and other small agricultural constructions. Álvarez Sánchez wanted to build a triangular shaped struc-ture, a structure for plants to grow on. She met a family who works with *carrizo* and they were willing to help her build them. Francisca:

> I imagined an altar for the rest of the earth, with
> different objects made from materials that grew
> there. We went to the fields to install this altar
> and we were surrounded by the agave harvest and
> the *milpas*. We went to a piece of land where they
> had taken away the harvest and the land was rest-
> ing so it was full of wild herbs and weeds. Weeds
> that are sometimes called *malezas*—bad weeds.
> They were growing there and I learned about
> their regenerative role. When you take away the
> harvest, they are the first plants that will start

growing back to start regenerating the earth and
are called pioneer species. There we took the el-
ements that we had prepared. We did a ritual and
put the objects in the land that was resting from
the harvest. I also laid my own body to rest there,
it was all related. I tried to position my body like
it was one of the organic objects. Because all of
the objects were made of organic materials that
we found there. My body was one of these ele-
ments. This is where we took the photos.

With the work, Francisca wanted to question the separation between her
own body and the body of the earth, and to make a parallel. Expressing
how something that came from a micro-scale inside of her grew into a con-
sciousness about the need for rest for all natural processes. Francisca:

When you take away the harvest you might think,
because the land is barren, that there is nothing.
But a lot of things are happening in this period.
The wild weeds and the mycelium come to regen-
erate the soil.

Many farmers stopped using the native seeds that have adapted to the
specifics of each locality for decades, if not longer, replacing them with a
standard seed and adding fertilizers that chemically feed the soil so they
can produce continuously, without the earth needing rest and regener-
ation. These seeds are genetically modified with the promise of an in-
creased yield, yet in the long-term this results in infertile land. Francisca:

It's the same as what we do to our own bodies. We
can't be sick because we can't stop working and
we have to take chemicals to keep on going. It's
our mentality; it's in our minds, in our ways of liv-
ing and seeing. The altar for the rest of the earth
is a symbolic way of giving the planet and our
bodies the right to rest, honoring the not-doing,
not producing, as an important part of the death-
life cycle.

A black woman is the protagonist in many of Álvarez Sánchez's paintings.
I've spotted her many times and became intrigued by a work in which the
woman is lying on the ground. She might be dead, but Francisca suggests
she is in an 'ambiguous state'. Plants, both endemic and exotic, but
all-present in Chile, are growing from her body. The work is called *Especie
vulnerable* and she made it after having visited a Sclerophyll forest; a
forest with plants and trees that have evolved to survive in long periods
of dryness and heat. With a group of botanists and plant lovers, they were
identifying which of the plants and trees were native species of that forest.

Francisca Álvarez Sánchez, *Especie vulnerable* [Vulnerable Species], 2019.
Acrylic on canvas, 180 x 150 cm.

108

We Need to Talk about Death

They visited a place called Palmar El Salto to find La Palma Chilena, a palm species endemic to Chile. At that time, La Palma Chilena had the status of 'vulnerable species' on the Red List from the International Union for Conservation of Nature (IUCN), an international overview of which species are doing well and which species are under threat of extinction. The Palma Chilena is currently in the category prior to 'threatened with extinction'. Francisca was intrigued by this human classification of what is 'vulnerable'. After all, it's a very old plant that has existed before humans even existed in that part of Chile. Francisca:

> If we assume we humans are also a species, where
> would we be on this list? Who is more vulnerable
> really? What happens with humans when there are
> no more plants? And what happens with plants
> when humans become extinct?

DYING ART

Though death as a topic in artworks is of course nothing new (think of the profusion of historical paintings depicting Jesus on the cross, bloody war battles, or dramatic suicides), the issue of whether 'art may die' is only slowly entering contemporary art discourse now. Because a lot of art enters the art market, there is a need for it to live forever and be preserved. Understandably, most people who buy art want it to keep on existing and prefer it not to disintegrate, rot, and disappear. That would make for a rather lousy investment. At the same time, more and more artists, for different reasons, are having to, or wanting to, use natural materials in their artistic practice. With biodiversity collapsing, the air becoming increasingly polluted, species becoming extinct by the hour, the acidification and rising of oceans, extreme weather, and other human-induced disasters on the rise, more and more artists not only want their own materials to be more sustainable, but also want to address and reflect on problematic consumerist and dangerous behavior causing existential challenges. As a result, we see more plants in exhibition spaces, with the artist attempting to say something about the relationship between humans and nature. We also see the majority of these plants unhappy and dying in exhibition spaces—sterile and air-conditioned areas or heated white cubes without natural light aren't the best environments for plants to flourish. I will never forget the phone call I once received from an art space in the Netherlands that was offering to sell a load of tropical plants and trees because they made an exhibition attempting to re-create an Amazonian rainforest—an endeavor in which 'the moist, damp, sticky, and deafening wilderness of the Amazon' was supposed to take our breath away in the middle of the European winter. When I came to see what was available, my local Amazonian rainforest was a battlefield of dead plants. I did end up saving and buying a banana tree that went on to live happily ever after in the garden of the Jan van Eyck Academie and even had a copious amount of banana tree babies. If you are ever at the academy and wondering why there are so

many banana trees, there's your story. I was told by one of the employees that when the plants arrived in the art space in February, it was minus five degrees Celsius outside and the soil of the plants was frozen—a problem solved by pumping up the heat (and carbon emissions). The tantalizing forces of the jungle were clearly dreamed up with little understanding of the plants' needs, presenting us with a naive and romanticized notion of nature. Do we really want to raise awareness about the Brazilian rainforest's declining ecosystems by creating a slowly dying ecosystem in a gallery space? It would be ironic if it weren't so sad.

In Puerto Rico, the home country of artist Sofía Gallisá Muriente, the molding and rotting of artworks is a continuous battle. But what if we didn't fight that battle and instead embraced it and used it? And showed decay to communicate the impermanence of things? It's exactly what Gallisá Muriente did when she started to allow mold to grow on her film. Sofía:

> We need to recognize that these forces are all around us and totally in control of the duration of things in the Tropics, particularly in a place like Puerto Rico. The climate conditions our memory in this way. It's shaping how long things last. The duration of things influences our ability to remember, the survival of the material evidence of history; all that memory is conditioned by climate. Climate conditions memory in this way. Shaping how long things last. Welcoming decay and impermanence in my work are exercises in thinking about how we surrender to the reality of the context we live in. How do we assume the context in which we live and not live in denial of that? Why are we trying to resist the inevitable?

The work of Sofía Gallisá Muriente is a reminder to acknowledge ephemerality as a condition of the Tropics and is an important teaching for a warming world.

DEATH AND CYCLICAL WORKING

How can we include death in our ways of working? It was also a question I asked Olaf Boswijk and Mirla Klijn, the founders of Valley of the Possible. They run a residency program in the Chilean Andes that invites artists, scientists, and other creative thinkers and makers to envision alternative perspectives on our relationship with the natural world. Not by letting plants die in an exhibition space, but by offering participants a thought-provoking program of activities and reflections regarding the many local, embedded, and indigenous practices of that territory. As an associate curator of the program, I had the honor of attending the residency in May, which is the autumn for the south of Chile. I interviewed Mirla and

Olaf inside their camper van parked outside of their charming cabin house with the baby phone, so as not to wake up their toddler. It so happened to be May 8, the birthday of Mirla's father, who had passed away a few years before. Especially on this day, death was something we discussed, with Mirla expressing how strongly she felt that time is cyclical. With a hot cup of tea to warm her hands, she explained how she experienced that in their program too:

> With the first residency there was a lot of concentrated energy here. For four of five weeks, ideas sprouted, things started to grow, collaborations started, relationships formed, and then the residency ended. People left and dispersed again. But the death of the residency created a layer of humus for the next one. A humus layer from which we could build again. Not necessarily grow, not in the sense of going up the ladder, but more in the sense of creating the relationships that are reciprocal and ever-returning. We work with indigenous people and it's a principle in indigenous cultures that if you start a relationship, you keep inviting back and forth. I invite you, you invite me, and then the relationship starts growing. It's much more normal in the Western world to have the concept of the program as the main priority and from there you start looking for people who fit into that conceptualized program. From indigenous cultures, you start with the relationship. The relationship is the most important thing and it defines what you do in the program. It's really an exercise for us to think in that way and to keep doing that.

We start talking about seasonal rest and both of them agree that with the intensity of their program (hosting twelve artists for five weeks), you can't continuously be productive throughout the year. They will organize their residency program twice a year and, in the meantime, cultivate relationships and regenerate.

When talking to Daniela Morales Lisac and Lola Malavasi of TEOR/éTica, an art program in Costa Rica, they tell me that they are also familiar with embracing the idea of death in their organization, and how some of their collaborations and projects 'die'. I asked them how a dying collaboration is different from it just ending and Daniela tells me that 'if you use the word "death" it implies it was alive before. And if it's alive you're open to admitting that shapes and forms can shift.' They emphasize we shouldn't be fearful of the word death and to understand that something dying can be closure and the end of something but also a

transformation into something else. Daniela: '<u>Sometimes you</u> 113
<u>just need to let it sit for a while, a couple of years or months,</u>
<u>and after that it comes back in a different shape.</u>' Lola adds
to that:

> I think there are cycles. Humans have a hard
> time understanding that death is not necessarily
> the end. I'm not talking about the spiritual level,
> but we all go back into the ground and hopefully
> something springs from that. It might be that a
> relationship or a project ends; there is certainly
> a death there and sometimes there's even grief of
> having to let go. When you work in a collective
> it's important to recognize when something needs
> to be let go of, and when to close the cycle. Or
> else it can become more harmful.

Maybe the time of grief is also a time of rest, I wonder, and think of the
work of Francisca. The land might look barren after the harvest is taken
away, but underground, the mycelium is doing its work.

METAMORPHOSIS

Fungi are the interaction between life and death, positioning them perfect-
ly to demonstrate that the binary is not as strong as we might think. Life
and death are not opposing each other. Fungal bodies and other microbes
teach us that death is about the transformation of energy. Turning one
thing into another thing. This is most clearly visible with the microbes
that turn apples into cider, that turn grains into miso, that turn cabbage
into kimchi. Transformation is the best conservation, a metamorphosis
to extend a lifetime in a new form. Without death, there would be no new
life. It was mycologist Juli Simon who told me that mushrooms taught her
to understand death and to not be afraid as death means life being able to
continue.

> It's the cycle of life; everything still exists but in
> different forms. It's important for people to un-
> derstand that because people are always afraid
> of death, struggling so much with grief for losing
> people.

It was after Simon took hallucinogenic mushrooms that this really all
clicked.

> I took two, the *Psilocybe cubensis* and the *Panae-*
> *olus cyanescens*. When we learn in school about
> the cycle of life, the concept doesn't really enter
> your mind. With the mushroom it clicked—ah so
> that's it! It was one of the biggest lessons. I start-
> ed seeing the beauty of decay.

HOW TO UNDERSTAND THE CLOSENESS OF TOXICITY?

Resisting the Demand for 'Purity'

TEACHING FIVE

Featuring:

Myco-toxins, fungicides, Nina van Hartskamp, Jessica Segall, Aracelly Vega, rust fungus, Patricia Kaishian, pretzel slime mold, dog vomit slime mold, marine fungi, Francoise Vergés, honey pinkgill mushroom (*Entoloma cetratum*), silky webcap (*Cortinarius evernius*), witches' butter and jelly ears, Tatyana Zambrano, Felicia Cocotzin Ruiz, Fer Walüng, Maria Alice Neves, Kadija de Paula and Chico Togni, Pedro Neves Marques, Larissa Mies Bombardi, Tomaz Morgado Françozo & Marília Carneiro Brandão, Annalee Davis, Naguel Rivero.

Geographies:

Panama, Martinique, Del San Antero Coveñas (Colombia), Llaima Volcano (Chile), Brasilia and Rio Grande do Sul (Brazil).

Ping! An email comes in from an artist I had never heard of. Her tone is enthusiastic and her question unusual and intriguing. As part of her graduation project at the Rietveld Academie, an art school in Amsterdam, she wants to send me a petri dish by post that I am supposed to sleep with. I have to expose it to my 'bedroom air' for one night while I sleep and send it back to her the next morning. Upon the return of the petri dish, she will cultivate the microbial life of my bedroom and breath for seven days, photograph it, print it, and present it as a blown-up planet to hang on my wall. A work called *Worlds Within*, a project by Nina van Hartskamp. I've seen cultivated petri dishes before: they are little plastic containers treated with agar, a nutrient-rich type of gelatin which bacteria, fungi, and viruses can feed off. They are often used in labs as the controlled environment of the petri dish allows it to be closely examined under the microscope—the microscope has been of incredible importance in our discovery and growing understanding of microbial life. In 1931, the electron microscope was invented, which caused a seismic shift in, for instance, our insights into plant cells, blood cells, and even into our own bodies. The difference with the electron microscope in comparison to the first microscope is that it used electrons rather than light to illuminate research subjects. This didn't just reveal all life that was previously invisible to the naked eye, it magnified to such an extent that it allowed us to study the behavior of microorganisms, and, therefore, their relationships. New technologies that are the descendants of the electron microscope can nowadays be worth millions and can be the size of a small spaceship. I once stood next to one visiting the MultiModal Molecular Imaging Institute in Maastricht, in the Netherlands—it was part of research for an exhibition I was curating at the Jan van Eyck Academie called 'Non-Human Narratives: Stories of Bacteria, Fungi and Viruses'. One of the artists I invited to participate was Jessica Segall. For the exhibition she made a network of (button) mushrooms to create an electrical current, and this mushroom-based power source was used to gently illuminate a chandelier. It was an experiment that Segall had done before with other types of foods, having previously exhibited a chandelier powered by lemons and by root vegetables. The energy of the slowly rotting foods can be captured in the process of their transformation. At the MultiModal Molecular Imaging Institute, the work of the super microscope was completely digital. These microscopes make a visual penetration to the level of sub-cellular and macro-molecular possible, allowing not only huge leaps in scientific developments, but also opening up the potential to change our perception and relationships with the living world. A world that we are in constant relation with, including our own bodies. In the essay 'A Symbiotic View of Life: We Have Never Been Individuals', various authors make the case for understanding ourselves as systems, rather than individuals, opening up a symbiotic perspective and thereby re-thinking the (some say misunderstood) idea of Darwinism and competition in nature.[1] It also implies an end

1. Scott F. Gilbert, Jan Sapp, and Alfred I. Tauber, 'A Symbiotic Life: We Have Never Been Individuals' *The Quarterly Review of Biology* 87, no. 4 (December 2012), pp. 331–335.

Also known as fly agaric, this iconic mushroom generally
grows in symbiosis with pine or birch trees.

Amanita Muscaria baby

Amanita muscaria is known to have both poisonous
and hallucinogenic properties.

to thinking in terms of 'self/non-self or subject/object dichotomies', concepts that characterize Western thought. Central in this symbiotic thinking has been the work of Lynn Margulis, the scientist who in the nineteen-sixties also laid the foundations for what later became James Lovelock's famous Gaia theory. Her scientific research was ground-breaking in demonstrating how the idea of an autonomous individual organism is an illusion, as any organism is in symbiosis, anatomically part of, or in close collaboration with, another.[2] Margulis's important observation was that single-cell forms of life evolved to become more complex through symbiosis between organisms of different species, the result of their cells merging. This new cell, the outcome of their symbiosis, is called the eukaryotic cell. Throughout her lifetime, her work was considered to be very radical and was not always recognized and often rejected. Years later, as science evolved and more powerful microscopes and technologies such as DNA sequencing became available, her theories were proved right. One can only imagine the frustration of being a (female) scientist so much ahead of your time, trying to make the case for collaboration over competition in a male-dominated world.

THE COMPOST POLICE

When I first started experimenting with growing mushrooms myself, I started with oyster mushrooms on a substrate of used coffee grounds. I had never drunk as much coffee in my life, and each day I was awfully keen to produce fresh 'waste' to be used for my fungal babies. Overnight, these coffee grounds had transformed from trash to treasure and flipped my notion of what waste was. The same happened to me when I started composting. I started eating much more diverse fruit and veg just because I wanted to feed my compost a balanced diet—not just the usual banana peel and breadcrumbs. The compost heap became my pet and I would joyfully check on it every day to see it transform. When I started working at the Jan van Eyck Academie in the Netherlands in 2017, I also started a communal compost there, to which everyone could contribute. Unfortunately, it also turned me into the compost police. The bin was located within eyeshot of my office, so every time someone put something in there, I would go and check what it was. No cut flowers (flower industry uses a crazy amount of pesticides!), no 'biodegradable' plastics (they take forever!), no tea bags (they are bleached!). Half of it I would fish out again, mildly annoyed as I wanted to keep the compost 'pure'. After a while people stopped using it, I guess as a result of my tyrannical behavior. Over the years I have become milder and reading Alexis Shotwell's book *Against Purity. Living Ethically in Compromised Times* helped me break away from any remaining illusions of the possibility of purity. Shotwell introduced me to the concept of healthism: 'The idea that we are each responsible for maintaining our own individual well-being, even in contexts of collective harm.' She suggests public health as a web of complex interdependencies, relating both present and past. Shotwell:

2.

Lynn Margulis, *The Symbiotic Planet: A New Look at Evolution*, Basic Books, 1999.

Healthism names the tendency to think about individual health as a moral imperative; individuals are held responsible for their bodies, and obesity, diabetes, cancer, and other chronic conditions are rendered as moral failings. Without a political and collective conception of health, we fail to have an effective strategy for real health promotion.[3]

What was happening on a micro-level in my compost is happening on a macro-level with our human society. A default inability to keep/have anything 'pure' just for the fact that it was already in this messed-up world, being fed the waste of this society, breathing in the oxygen that is so deeply enmeshed with the all-encompassing and unavoidable toxicity of the system we operate in. We are complicit through the supermarkets we shop in, the clothes we buy, the plastic we waste, the energy we consume, the food we eat, and the computers and phones we use. If not today (unlikely), then through our unjust colonial past. We are entangled with the systems of toxicity one way or another. As Shotwell explains:

> The idea that we can (or should) eat organic food, drink alkalinising water from personal water filters, or take up other practices meant to manage the effects of exposure to pesticides and herbicides is a version of an individualising purity politics. Healthism as a possible practice is heavily racialised; people who live at a site of multiple vectors of vulnerability have less possibility for individually managing their health to resist the structural context that produces premature group-differentiated death.[4]

How is it possible that the cheapest and most accessible foods are snacks and sodas? High in saturated fats, sugars, and salts, they lead to obesity, diabetes, high cholesterol, and other noncommunicable diseases. An example: ever since the introduction of NAFTA, diabetes has become the leading cause of death in Mexico, creating a public health crisis. Author Alyshia Gálvez shares in her book *Eating NAFTA, Trade, Food Policies, and the Destruction of Mexico*:

> About eighty thousand Mexicans die of type 2 diabetes each year, and the number of diabetics has increased by about two percent per year every year for the last decades.

Yet these diet-related illnesses have been framed as an issue of personal responsibility in ways that deflect societal responsibility for restructuring economic, political, and food systems.[5]

3. Alexis Shotwell, *Against Purity: Living Ethically in Compromised Times*, University of Minnesota Press, 2016, p. 29.

4. Shotwell, *Against Purity*, p. 95.

5. Alyshia Gálvez, *Eating NAFTA: Trade, Food Policies, and the Destruction of Mexico*, University of California Press, 2018, p. xii.

Jessica Segall, *(Nom Nom Ohm) When Life Gives you Lemons, Make Chandeliers*, 2016. Site-specific installation at Cuchifritos Gallery in the historic Essex Market, Manhattan. Fruits, root vegetables, rewired chandeliers, Dimensions variable. Photo: Bill Massey

Nina van Hartskamp, *#51 Bedroom of Yasmine,* from the series
Worlds Within, Bodies, Bedrooms, and Breath, 2020.

122

Growing a mycelium or cultivating a microbial community on a nutrient agar yourself comes with interesting situations that tend to interrogate our ideas about cleanliness. At first, I was quite disgusted with the moldy-looking substances that had appeared in my petri dish, until I realized I wasn't intrinsically grossed out, but conditioned to be so. I had to un-learn my feelings of disgust as frankly there was nothing dirty about microbes. Estonian artist Marit Mihklepp once told me that she was cultivating a slime mold at home, a *Physarum polycephalum*. A slime mold is a single-cellular type of fungus that appears in many places, shapes, textures, and forms, in her case a yellowy gelatinous one. She fed it with oat flakes, one of their favorite foods, and it was 'loving it' and getting bigger and bigger... Up to the point that her boyfriend became a bit concerned as the slime mold started 'escaping' from the petri dish and had become rather big and 'was kind of taking over their home.' I love Marit's story of the happy, shiny slime mold as it shows that they can flourish with the right kind of care, making them ideal pets for beginners. You feed them and nurture them and you can even teach them tricks, such as finding the best routes to food. Though they are non-neural, they respond to their environments. They are able to smell food and make their way to it. They make excellent choices about what is the most efficient way to get there. They even 'remember' how they got there and where they have been, and what is the fastest way to their desired oat flakes, making them interesting research subjects for a wide range of people. They have been used in research to understand the most efficient routes connecting the Tokyo Metro System (an often-used example)but also to help understand the fastest way out of IKEA, an example that Merlin Sheldrake used in his book *Entangled Life*[6] and which remains one of my favorites as it confirms I'm not the only one who gets lost in there (and wants to get out of there as fast as possible).[7] Apart from the occasional Estonian artist, most of us generally don't keep slime molds as pets—even the word 'slime mold' sounds unappealing. Specific names for them generally don't help either: think of 'dog vomit slime mold', also known as 'scrambled egg slime' (Latin: *Fuligo septica*). It's the classic case of fungi names always seeming to sound weird and a bit yuk, from 'witches' butter' to 'jelly ears'. Though during my fungal journey I also came across the 'pretzel slime mold' (Latin: *Hemitrichia serpula*), which looks and sounds like it would fit right into a beautiful design house with its elegant and graphic pattern. Again: always some exceptions to the rule in the world of fungi.

IN-BETWEENNESS

In his book *Slime Dynamics, Generation, Mutation, and the Creep of Life*, Ben Woodward presents the dynamics of slime as the murky substance of all life. The gooey source of all life. We all came from slimy substances and circumstances, but for some reason, the humid and opaque characteristics of slime trigger not only disgust, but also a level of

6.

7. See: biodesign.berkeley.edu/2022/02/18/brainless-slime-mold-grows-in-pattern-like-tokyos-subway-system/.

Merlin Sheldrake, *Entangled Life: How Fungi Make Our Worlds, Change Our Minds & Shape Our Futures*, Random House, 2020.

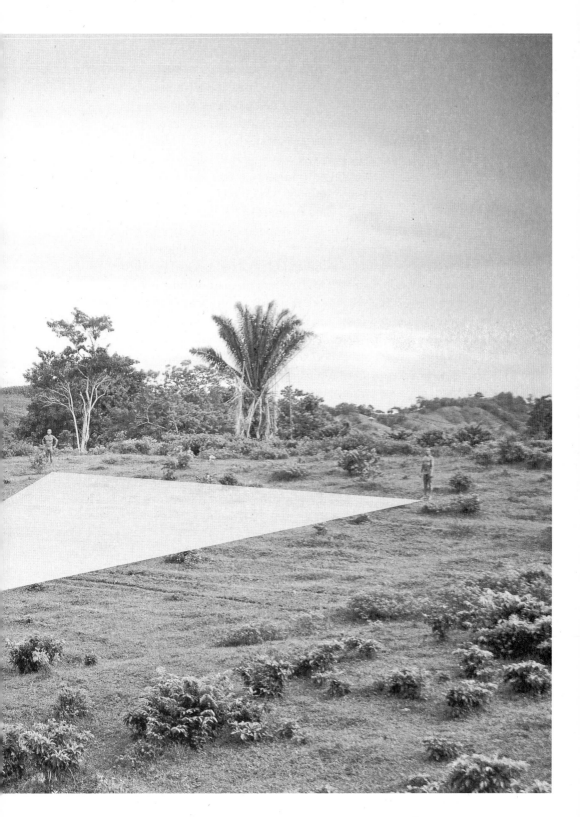

Resisting the Demand for 'Purity'

8.

Ben Woodward, *Slime Dynamics*, Zero Books, 2012.

fear, something we can see in the weirdly prominent roles of swamps and mutating slimes in horror films, video games, and graphic novels. Woodward argues that slime is a viable physical and metaphysical object necessary to produce a realist bio-philosophy void of anthrocentricity,[8] meaning that slime might be worth embracing for a better understanding of nature that is not extractive and not taking the human as a starting point of everything. Slime is teaching us about the possibility of in-betweenness—not being solid or liquid; swamps being neither land nor water. This in-betweenness, the un-boxable and undefinable, is exactly what seems to freak people out. Swamps are mysterious, dirty, and dangerous places. The draining of swamps was an important endeavor in colonial times, bringing an end to the murkiness that was cultivating mosquitos and was home to sinister animals. It happened across the Americas, where indigenous groups were dislocated because their habitat—the swamps and wetlands—were to be drained in an attempt to bring 'civilization' to the savage areas. They had to make space for infrastructures: roads and railways, mining, and other colonial industries. What the colonists were probably not aware of, however, is the astonishing ecological importance of swamps and wetlands. Wetlands and swamps are not only places of biodiversity and food, but protect against floods and droughts and are—like mycelium—crucial to storing carbon. Besides that, they are key habitats for what are called 'marine fungi'; fungi that live close to both sea or brackish water. A particularly favorite spot for marine fungi is the mangrove swamp, where wood-decaying species like to hang out on mangrove and driftwood. Typical swamp-loving mushrooms include the honey pinkgill mushroom (*Entoloma cetratum*) and the silky webcap (*Cortinarius evernius*), yet many species of marine fungi are still to be discovered. It's hard to cultivate marine fungal DNA, and most of them are only known from spores. Mycologists believe that possibly less than one percent of marine fungi have been described, making the swamp even more mysterious...What else is brewing in these murky grounds?

MODERNITY AND CLEANLINESS

The work of Colombian artist Tatyana Zambrano plays with the notions of 'primitive' versus 'civilized' in a Latin American context. For her work *Future Island*, she went back to the *pantano* (swamp) in the north of Colombia where she used to go as a child. In the nineteen-eighties and nineteen-nineties the place was a popular getaway for families and tourists who wanted to enjoy the muddy and thermal baths as a beauty retreat. Often located in the proximity of volcanoes, visitors would bathe in the mud and rub the slimy soils against their skins with the mythical promise of a youthful glow as a result. In Colombia (the north), Chile (the south), Brazil (northeast) and Mexico (around the Popocatépetl Volcano), Latin American families eagerly smeared themselves with mud or immersed themselves in thermal baths in order to obtain ancestral and magical beau-

ty. The mud and thermal waters are full of minerals that make the skin soft and shiny and flush out toxins from the body. I myself also had the chance to bathe in the steaming thermal baths in Chile, near to the Llaima Volcano. They were simple wooden baths that suddenly appeared in the forest, like in a fairy-tale, and though it did smell of rotten eggs, my skin had never felt so soft. Yet unfortunately no ancestral beauty for me; gazing in the mirror after, I looked more like a sizzling shrimp that had been cooked in a hot pot.

Zambrano mainly remembers the 'horrible stench' of sulphate and always hated going to the *pantano* as a child. When she came across archival footage of her father from the nineteen-eighties—the time when the family visited these 'primitive spas'—she decided to return to the site of the photos, to the volcano Del San Antero Coveñas on the north Colombian coast. What had once been a thriving, bubbling landscape had turned into a desolate and desiccated site. Zambrano: 'Nature was gone there; they literally had become dead places.' In her personal archive, she has photos of the discolored and peeling billboards in Coveñas, images that once featured pretty girls in bright bikinis. The visit was the bedrock of her work *Future Island,* a series of six photos that are intended to 'represent the inhabitants of a future island.' The set of photos is an ironic vision of an island's past in the future. Tatyana:

> San Antero and many other similar places are
> now dystopian, alien, dry, and dead landscapes.
> Nobody knows about these places anymore and
> nobody cares. My images are like *Star Wars*, some-
> one from the future looking back at the past.

Her work is a futuristic vision that crosses the historical. The forgotten and abandoned swampy wellness sites epitomize a farewell to 'the primitive'. *Future Islands* thus questions the idea of civilization as well as of the primitive. How can we even imagine a 'future primitive' when the volcano is dead and the swamp is drained? It brings us to the all-encompassing influence of the idea of modernity, progress, and civilization. The modern world that should be clean, sterile, and hygienic, and certainly not smelling of volcanoes and swamp.

PURITY AND RACISM

This notion of progress poses problems around who has access to modernity. Who has access to sterile spaces and polished bathrooms and in what capacity? As cleaner or as user? It became even more apparent with the Covid pandemic, which hit minorities and vulnerable people, people with less access to spaces they didn't have to share, much harder. Francoise Vergès hits the nail on the head in her text 'A Leap of Imagination':

> The notions of cleanliness and dirtiness are far
> from neutral, there is no equality in access to
> soap, water, ecological habitat. Water is inaccessi-

ble to migrants, people on the streets, prisoners, people in the Global South.

130

Another example came to me listening to a podcast with Felicia Cocotzin Ruiz. Ruiz is a curandera (healer) and indigenous food activist working on 'decolonizing our diets by re-indigenizing our recipes.' In the podcast, she speaks of what she calls 'indigenous shame', referring to indigenous communities in New Mexico that became addicted to processed foods, sugar, and/or alcohol; foods that were not previously part of their diets. In this transition they have lost their own recipes, their traditional ingredients, and often even lost access to clean water. The outside world is judgmental about this, projecting their own romantic expectations about what it means to be indigenous on to them, expectations related to being connected to the land and eating pure and organic food. Ruiz makes the point that even when you have organic food, if you have uranium in your water, what's the point? Ruiz's point is that you can only be 'sustainable', 'clean', 'pure', or 'organic' when you already have access to certain other privileges.[9] When you have the financial freedom to make these decisions about buying pure food, pure water, or creams for pure skin. Purity in itself doesn't exist, but the promise is for sale for those who can afford it.

 This concept of cleanliness and civilization is peppered with colonial, and even racist, ideology. In her book *White Innocence: Paradoxes of Colonialism and Race*, Gloria Wekker makes the very powerful point that claiming innocence is also a form of ignorance. Hiding behind not knowing can be an effective way of not being confronted with what is really going on and, therefore, not having to act on any injustices. Wekker traces the notion of innocence and purity back to Christianity. Wekker:

> While since the end of the 1960's Christian churches as institutions have crumbled, the underlying worldviews have not. Jesus is the iconic innocent man.

Wekker speaks specifically about the context in the Netherlands, the country where I'm from, though this applies to many places. What is really specific for the Netherlands, though, and sharply observed, is how the Dutch perceive themselves as innocent and not racist because they are a small country that can't do much harm, and maybe something comes across as being racist (think of the controversial Black Pete figure), but it is always just intended as an innocent joke. She makes the point of how innocence 'enables the safe position having licence to utter the most racist statements, while in the next sentence saying it was a joke or it was not meant as racist.' Ignorance claiming innocence in the face of racism. And as long as there is ignorance the problem is hard to combat. Wekker: 'It contains not-knowing, but also not wanting to know.' Just as much as 'purity' isn't desirable, 'innocence' isn't either. It's some-

9.

https://speaking-broadly.simplecast.com/episodes/indigenous-wisdom-from-the-kitchen-felicia-ruiz-zVLunta6

> We like to think that the present can be innocent
> of the past that produced it. We might like to
> think that we don't need to tell or hear the painful
> stories of the actions that created the world we
> live in. The social organization of forgetting
> means our actual histories are lost and we have a
> feeling of acceptance and normalise about living
> with a lie instead of an unforgetting.[10]

10.

Alexis Shotwell, *Against Purity: Living Ethically in Compromised Times*, University of Minnesota Press, 2016, p. 38.

It's a fact that racism is very much part of these painful stories and actions and very much entangled with our institutions and systems. The time of 'not-knowing' is over and the time of sharing the burden is here.

I met Mapuche seed-keeper Fer Walüng as part of the Valley of the Possible residency program in Chile and straight away was smitten with all her fungi-related accessories and jewelry. In the following weeks, she kept on impressing all of us with her mushroom-themed outfits. From jumpers to earrings to hats, Fer was literally embodying how to become fungal. On top of that, she was incredibly knowledgeable, casually mentioning all sorts of interesting facts about all the fungi we came across during our hikes. In a more intimate moment, with just the two of us around the table in the lodge with a glass of red wine, she told me she had been terribly bullied in her life, an example of this 'purity racism'. She was willing to share the story of her youth with me and honor what a great support her grandfather was in her life. Fer:

> I experienced a lot of racism because of my Ma-
> puche background and because I am mixed-race.
> They called me *tintre*. They said I was small and
> ugly and that my blood was dirty. It made me very
> sad and I went to my grandfather. And he said no,
> the thing is, I fell in love with your grandmother
> and that's why we had your father. And your other
> *abuelo* and *abuela* fell in love and that's why they
> had your mom. And your father and mother fell in
> love and therefore you were born, and thus, you
> came from love. And you should never feel bad,
> because all that energy and mixing in your blood
> ultimately makes you strong and diverse, in terms
> of culture, religion, in everything. We are all part
> of the great mycelium, always.

It's a moving story and I love how her grandfather described their family connections as a mycelium long before we started using the metaphor. Fer continues:

> It is important that we finally break with all prej-
> udices about purity. Pure blood is still valued and

> some people still think of *mestizos* as having dirty
> blood. All of this brings more division than unity.
> If you consider that we are all sons, daughters,
> children that arise from the same large mycelium,
> then you see that all people in the world have had
> to deal with the same problem. In some places
> more than in others, but we all need water, forest,
> land, nutrients, oxygen, access to education, be-
> longing to a community... to buenvivir.

In other words, she is also saying there is a lack of access to certain priv-
ileges. 'And who is to blame for that?' she asks. It is not a rhetorical
question and she starts to sum them up.

> The OECD, the Sustainable Development Goals,
> or the 2030 Agenda all reveal that, at least from a
> political perspective, we have come to view na-
> ture as a natural resource. Nature is essentially
> about resources. Nature is objectified, considered
> just to be environmental resources for us to use.
> People still don't see that we humans originate
> and are part of Mother Earth.

Her frustration is clear and understandable and she brings up another
important topic. 'Can only original, indigenous peoples defend
nature? Or the people with a love for nature? Or can we all de-
fend nature?' It is true that indigenous people are the biggest stewards
of nature. Even though they hardly make up five percent of the world's
population, they protect eighty percent of its biodiversity. The words of
Fer remind me of protest signs I once saw saying: 'We are nature, de-
fending herself'. It's what Fer believes in too:

> If we love Mother Earth, nature and everything
> she offers, we all have a mycelium at our disposal
> to defend her. A force, an intuition, a vital univer-
> sal energy within us, which urges us to do so.

Annalee Davis's works *Woman Wrestling with Long Annelid Para-
sites of History* and *Woman Confronts a Long Annelid Parasite
of History*, from the Parasite Series (2018), drew inspiration from a
phrase by Cuban essayist Antonio Benítez-Rojo, as written in his book *The
Repeating Island*. In the book, he describes how Caribbean history was
akin to a long annelid parasite moving through the bowels of the region.
He writes about the plantation as a model that repeats itself throughout
the archipelago. Davis's parasitic drawings are about this history of ex-
tractivism, and of being diseased—a history that shaped the entire land-
scape, wiping out Barbados's biodiversity, putting in monoculture, and
affecting the ways in which people engage with one another across class

Naguel Rivero, no title, photograph part of the editorial 'From Attire
To Ashes: Clothing Waste in the Atacama Desert', 2022. First published
in *Atmos Magazine*, September 2022. Courtesy the artist.

133

and race. Though Benítez-Rojo focuses on Cuba, he also speaks of Jamaica and Barbados, the repetition of the model of the plantation, whether it be Spanish, English, or French, as a colonial project that went across the Caribbean. It was an inspiration for Davis, who explains that 'of course there are differences in each of these places, but it's something that is repeated in terms of how it manifests.' For Annalee, it was 'an incredible description of the extractive nature of the plantation and the parasitic relationship between the colonial power and the small island state.' And more than a metaphor, people would have come across different kinds of worms or parasites that infected their bodies. Annalee tells me about how the Caribbean was once seen historically as an infected and diseased site.

> When you came out to the Caribbean in the 1700s and 1800s, medicine was poorly developed and it was an unhealthy place to live. There was also the idea of it being infected because of the idea of Creolization.

Creolization is the process through which creole languages and cultures emerge in the context of forced migration and the plantation system. Davis continues:

> There was a sense that white Creoles had been contaminated by their proximity to slavery, to the colonial project, to the black body. When they came to England in the 1700s and 1800s, they saw themselves as white but English people didn't see them as white at all because of their proximity to the black body, the way they dressed, the way they spoke, what they ate, how they ate. There was this whole notion of a lack of purity in the Caribbean because of contaminated blood, contaminated bodies, contaminated histories, and contaminated lands.

We both remain quiet for a second. It's yet another example of how the demand for purity had informed racist ideology, I realize. Time is running out and Annalee has a lot of work on her hands. She ends the conversation referring to Lloyd Best, a Trinidadian economist who stated that the Caribbean is 'one of the few places in the world where the economy preceded the society.' Annalee:

> I think this is a really powerful statement and a complex way to consider the region as a European economic-generating machine not designed for those who lived and worked here.

Chaga (*Inonotus obiquus*) appears in the shape of conks on a tree that resemble burnt charcoal. It's known for its high levels of antioxidants, vitamins, and amino acids.

Bleeding tooth fungus

Bleeding tooth fungus (*Hydnellum peckii*) is also known as
strawberry and cream. It is edible, and still undergoing studies
for its possible medicinal properties.

If we consider the ruins of our consumption, we always end up in a conversation about our trash, about our mountains of landfill. One example: we dump tens of thousands of tons of clothes, old or sometimes even unused, in the Atacama Desert in the north of Chile. It has created an actual mountain of clothes in the middle of a desert. Argentinian photographer Naguel Rivero made an intriguing series of photographs all with discarded clothes collected from this huge desert pile. Or rather mountain—we literally create mountains made of trash. And it's not just clothes; we all know that plastic has become a towering problem, filling up our oceans and soils and ending in our stomach and even blood as microplastics.[11]
For the process of making plastic we use petroleum; oil that we find in the geological formations of the Carboniferous Period. Mycologist Maria Alice Neves tells me that with the evolution on earth, fungi were important to stopping the production of petroleum. She explains how the Carboniferous Period, the geological time that spans around sixty million years, is marked by accumulated wood debris that wouldn't decompose because it contained lignin. Lignin is the hardest organic polymer of the wood of a tree and is very concentrated and, therefore, hard to decompose. At that time, fungi were only able to decompose the cellulose in the wood, not the lignin. All of those layers of lignin-containing plant fossils became carbon and, eventually, petroleum. At the end of the Carboniferous Period, fungi developed enzymes that can decompose the lignin in the wood, causing a huge shift for geological strata. Because fungi were able to decompose the cellulose and the lignin, the debris no longer accumulated. Currently, lignin is being explored again as a potential new petroleum. It's the main by-product from the paper industry and, again, without the help of fungi it doesn't decompose easily. One could say that fungi brought an end to what would (much) later become the fossil fuel industries. They were the anti-capitalists before there was even capitalism. The Extinction Rebellions before activism. For Brazilian artist duo Kadija de Paula and Chico Togni, it's a political as well as artistic anti-capitalist statement to only use trash as the material for their art work. They conducted various artist residencies whereby their methodology was to make work from the things they accumulated during that period of time; thus, they want to question the value of resources and promote consuming and buying less. The concept of de-growth is central to their practice. During their residency at Cité Internationale des Arts, for instance, they made collages out of all the packaging they collected and accumulated during their time in Paris. I visited them for their residency at Q21 MuseumsQuartier in Vienna, where they were organizing a series of gatherings and performances in which they would cook from a stove they had made out of recycled tins, using food they collected during dumpster dives. In total, they spent thirty days living and working with found food, resources, and materials. I visited them halfway into their residency and the apartment had already completely transformed. The previously sterile white flat was full of weird

11.

See: Damian Carrington, 'Microplastics Found in Human Blood for the First Time', The Guardian, March 24, 2022.

found objects, metal, cardboard, and wood, and a banana-peel stew was simmering in an improvised oven made of discarded tin. I must admit it wasn't the most exquisite meal I've ever eaten and the dish was rather chewy and fibrous, but it was not a completely unpleasant taste and the atmosphere in the flat was warm and exuberant. It was a great antidote to the literal and occasionally metaphorical iciness of Vienna. Kadija and Chico shared all their tips and tricks about accessing free food, from which days (and even what time!) which supermarkets were discarding their out-of-date stock to which foods were better to avoid eating from the trash (meat and fish). It was the work of this Brazilian duo and the work of artist Agnès Varda that taught me the practicalities of how and where to look for treasures that are misunderstood for trash. In her film *Les Glaneurs et La Glaneuse* (The Gleaners and I), Varda follows different gleaners: people who often live on the margins and collect leftover food that they get to forage after the harvest. Varda starts scavenging for food herself, too, and seeing them amid heaps and heaps of ugly looking yet perfectly fine food, you start wondering why we are still going to supermarkets, indoctrinated with the idea of purity.

Mycologist Maria Alice Neves speculates that fungi started producing the enzyme to decompose lignin because they wanted to solve the problem of accumulating piles of wood. The only organisms that have enzymes to decompose lignin are fungi; more specifically, the fungi that we call 'white rot'. White rot decomposes wood to the point that it becomes very soft and falls apart. Neves: 'I imagine these piles of wood accumulating on the land and the fungi thinking "we have to deal with that; we have to solve this problem!"' Her approach indulges in some optimistic speculation about the future:

One thing that I think maybe will happen in another million years is that maybe they will be able to decompose all the plastic. I don't know if we the human species are going to see it happening, but I think it might happen because fungi are super adaptive, variable, and because of the way their genetics work.

She continues:

Most people don't even know how big of an impact the fungi have had in the evolution of the earth. Like causing the end of petroleum. People now start learning about myco-remediation but they don't know about the past. A lot of people don't know the past. I participated at an event where I was invited to give a talk and I showed the whole geologic time on earth and pointed out every step where fungi were important and people were amazed as they didn't know any of that.

Another example that comes to mind as Neves is talking about the evolution of the earth is that fungi might be able to help us with heavy metals and even radioactive materials. Some research has been showing positive results with fungi ionizing radiation. Let's hope that Maria Alice Neves is right and that fungi feel like solving that problem too.

AGRO-TOXICS: YESTERDAY ENSLAVED, ALWAYS EX-PLOITED, TODAY POISONED, WOMEN SAY ENOUGH!

In the aforementioned essay 'A Leap of Imagination', Françoise Vergès addresses the use of chlordecone (also known as Kepone) in Martinique, the Caribbean island under French rule and so-called special territory of the European Union.[12] Chlordecone is a pesticide that leads to direct intoxication of soil and subsoil, rivers and seas, and essentially humans, and for this reason it has been banned in France since 1990. However, after the French ban it has continuously been used in Martinique and Guadeloupe for many more years. Despite the many actions and cries for reparation by the people of Martinique, this act of severe polluting has not been recognized or acted upon by the government. A very important gathering took place in Martinique in 2018, when feminists protested not only against the pollution of chlordecone, but against the roots of the problem, namely 'health, colonialism, racism, sexism, violence, environmental crimes, relationships between women and men, intergenerational solidarity and resistance.' Vergès wrote about how the members of the protest group, who called themselves #Pebouchfini, were chanting 'Start the Fire, Put the Mess in Order!' their banners stating 'Yesterday Enslaved, Always Exploited, Today Poisoned, Women Say Enough!'[13] They publicly made clear how the use of pesticide was entangled with many other systemic injustices. The use of agro-toxics (pesticides) is a big problem across the world, particularly in Latin America and the Caribbean. As the Martiniquan protesters clearly demonstrated: the use of agro-toxics is enmeshed with racism and colonialism. Next to France using up their leftover chlordecone in Martinique, there are many other examples of how Europe is feeding poison to Latin American and Caribbean soils. Brazil is a big customer of European agro-toxics that are actually illegal in Europe as they are highly poisonous. The chemicals produce headaches and cause high blood pressure. Europe doesn't seem to mind selling them to Brazil, though, as the soy that will be sprayed with it will very likely be sold to China. Europe, and to be more precise Bayer, does 'good business' providing the poison. Since Bayer took over Monsanto, it is the biggest producer of agro-toxics in the world, while Brazil is the biggest global consumer in volume, spraying twenty percent of the world's total, equaling roughly 7,1 liters per Brazilian, per year. According to the research of Larissa Mies Bombardi, who has been a leading expert on the use of pesticides in Brazil for over ten years, between 2007 and 2014, thee-thousand-one-hundred people died annually of acute pesticide poisoning. In 2017, the figure was 5,238, an increase of forty-five percent.

12.

Françoise Vergès, 'Leap of Imagination', in *Slow Spatial Reader: Chronicles of Radical Affection*, ed. Carolyn F. Strauss, Valiz, 2021, p. 221.

13.

The complete research document is called: 'Geografia do Uso de Agrotóxicos no Brasil e Conexões com a União Europeia'.

Annalee Davis, *Woman Wrestling with Long Annelid Parasites of History*, 2018.
Mixed media on paper, 188 x 152 cm. Photo: Daniel Christaldi.

140

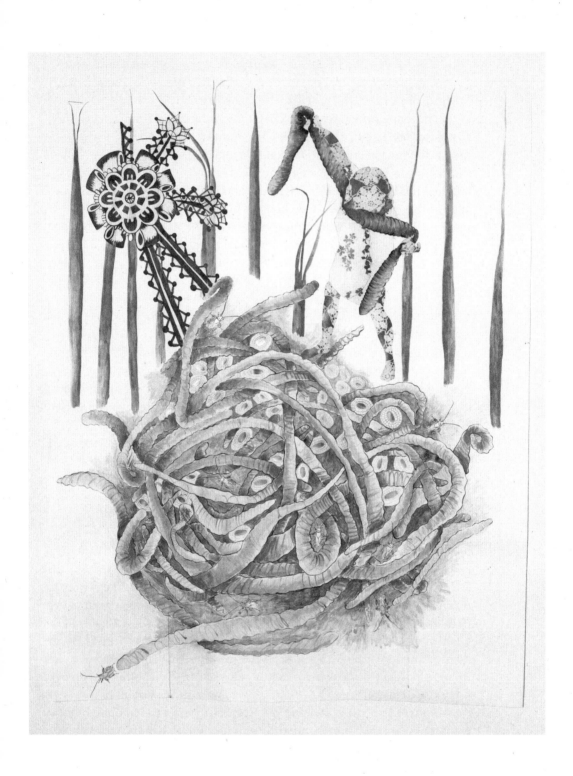

There are more and more deaths in the North of Brazil, signaling the growing presence of agro-toxics in the Amazon. Unlike in Europe, there are very few laws on the amounts of agro-toxics that may be used, they aren't taxed, and new laws allowing for more spraying are constantly being introduced. It's been this way for over twenty-five years, starting with the *agro-negocio* law of Kandir in 1996. In 2013, the distance between sprayed crops in Brazil was reduced from three hundred to ninety meters, and planes and tractors that are spraying poison can come as close as ten meters to homes and water sources. When spraying from planes, the sprayers often continue to be on when flying over (indigenous) communities, spraying a layer of poison directly over the people. From January 2019, under Bolsonaro, 467 more agro-toxics have been allowed, of which one-hundred-and-sixty are illegal in the EU. The Swiss company Syngenta alone sells fifty-two poisons that are illegal in the EU, including the popular Atrazine. Atrazine is their best-selling product, though it has been banned in the European Union since 2004. Atrazine is widely used in the United States, for agriculture as well as golf courses. In Brazil it has already been detected in breast milk, turtle stomachs, and also widely in the Xingu River, which is important to the livelihood of many indigenous groups in being used for fishing, bathing, and drinking.

Artist Pedro Neves Marques worked with Larissa Mies Bombardi on giving insights into all this shocking data. They made an Atlas of Toxicity, explained in their video *Molecular Colonialism*.[14] The video, part of the research that Bombardi has been doing as a geographer at the University of São Paulo, reveals not only a map of contamination and poisoning by agro-toxics, but also its entanglement with sex, age, ethnicity-race, and education, for instance.[15] It shows the mortgage captivity of farmers who are being made dependent on agro-toxics through initial subsidies to buy them. And possibly the saddest fact: in the state of Paraná, where the most agro-toxics are used, the amount of suicides among farmers is also the highest. Mortgage captivities and disease create desperate situations for farmers and they kill themselves by drinking their own agricultural poison. One of Neves Marques's other films, called *Learning to Live with the Enemy*, is located in Rio Grande do Sul, a state in the southern region of Brazil. The film follows the industrial process of the transformation from soy into biodiesel, from the harvest to the end result. The massive monoculture and mammoth machinery are haunting, leaving no space for naiveté about agriculture: this is the reality of transgenic soy, maize, and sugarcane. Over the film, questions are asked, for instance regarding the life that is left in transgenic seeds. Seeing this work changed my perception of biodiesel. In Brasilia, the capital of Brazil, there has been an ongoing lobby to change the term *agrótoxicos* to *defensivos* or even 'phytosanitary products'. Phytosanitary translates as the measures taken to control a plant against diseases. Whether we call a pesticide a '*defensivo*'—something that helps to defend—or a '*veneno*', a poison, makes all the difference in how a substance is perceived and used, and the

14.

Colonialismo Molecular: Uma Geografia dos Agrotóxicos no Brasil.

15.

The complete research document is called: 'Geografia do Uso de Agrotóxicos no Brasil e Conexões com a União Europeia'.

producing companies are well aware of this. There is a strong social movement in Brazil, including shiitake farmers Tomaz and Marília, that consistently uses the term '*veneno*'. Marília: 'Agro-toxics should be called poison. It's poison in your food after all. It's what it does to you and the planet; it poisons us.'

FUNGICIDES AND MYCO-TOXINS

There are also *venenos* specifically against fungi, called fungicides. They are chemical substances that prevent spores from germinating. It's a strange concept for a mycophile, yet they are used regularly in mono-culture farming, golf courses, and even inside bodies, both human and animal, to fight fungal infections. Fungi are very good at signaling environmental conditions. For instance: in temperate forests the oak milkcap (*Lactarius quietus*) is an indicator that the soil is very acid and polluted with high levels of nitrogen. Yet fungi can also have a positive message; when the lichen tree lungwort (*Lobaria pulmonaria*) is plentiful, it's a sign of clean air and old woodlands.

Rather than just focusing on their destruction using poisons, we should see these fungi as messengers and listen to what they are indicating—often the balance in the fungal community is lost, and that's why they showed up. Though fungicides are extensively used, we often don't know their impact fully. We might know they're effective in killing a particular pathogen, but we are only just finding out. When I ask mycologist Patricia Kaishian about them, she brings up an interesting point:

A tree, in the tropics in particular, could have a hundred different species of fungus living in a single leaf as endophytes. What is the impact of treating that tree with a systemic anti-fungal for a particular fungus? We don't really know what that means for the tree or the forest's health in the long term. And that is true for so many chemical interventions that we have used around the world. I don't know a ton about anti-fungal research, as I'm not involved with that, but I do know we definitely don't know enough to say anything for sure about the long term or larger impacts of these treatments. We barely know what's going on when we don't intervene, never mind about this cascade of effects that could happen when we do intervene. There are reasons to research these things, for sure, and I'm not trying to demonize any type of specific research, but it's important to reflect on what our goals are, where these questions are arising from, and the types of perspectives. I think the biggest mistake that people make is assuming that these questions and

The Veiled Lady (*Phallus indusiatus*) is a fungus in the family of stinkhorns. The protective white membrane looks beautiful, but the mushroom has an intense odor that attracts animals.

their pursuits are from objective and clear and straightforward facts as opposed to system-level questions about industrial agriculture and its failures and the massive harm it's caused around the world. Sure, I don't want a pest or pathogen to destroy our entire country's wheat supply, given that we are all so precariously dependent on industrial agriculture. We have to know what's going on; we have to research it and prevent that from happening. But I would like to also reflect on the fact that this isn't sustainable: it's a completely unsustainable way of living and something is going to bring it to its knees eventually and we are better off taking on a more ecologically sound and diverse way of feeding ourselves and interacting with our landscapes and all the other organisms that we live in a relationship with.

One of the art projects of Estudio Nuboso in Panama was about myco-toxins, molds, and spores in the air that land on food and are potentially harmful to people. It was in the first Art and Science Lab the studio organized and they invited Dr. Aracelly Vega, a scientist specialized in myco-toxins. Dr. Vega collaborated with an artist who is also a permaculture farmer. Aracelly's research focused on myco-toxins in coffee, a big problem in Panama. When small farmers produce coffee and don't follow certain steps, a toxic fungus grows on the coffee beans and this coffee is often sold anyway because there aren't enough regulations to check it all. This is not about export-quality coffee but about coffee sold locally. Dr. Vega was providing farmers with tools to avoid these myco-toxins, which was a lot about being more careful in the process of drying and storing the coffee. The artwork they produced was called *Ser Café* (Being Coffee), a play on 'you are what you eat'. The installation consisted of two human-sized triangular-shaped structures. One could lie inside these structures. One of them had a semi-transparent plastic roof for the sun to dry the coffee and yourself. Heat is the key to keeping the coffee dry, instead of cold and humidity of highlands, which trigger the growth of the myco-toxin. The other installation was the storage space of the coffee, with a short looped video inside telling the story of a coffee bean that turned into a person.

STARTING FROM THE RUINS

I grew up with the 'three second rule', meaning that whenever I dropped food on the floor, it was deemed edible as long as I picked it up within three seconds. After three seconds it was supposed to have become 'dirty'. The Mexican variation of three seconds, I learned later, involves the devil. After three seconds the food is *Ya lo chupó el diablo*, 'sucked by

the devil'. I'd usually still eat my devil-sucked food as my mom taught me it would 'boost my immune system'. I imagined my immune system was collecting small amounts of 'dirty' microbes and slowly making me stronger and more resilient. This wildly unscientific habit challenged my notion of what is clean and if 'clean' even ever existed. The mycelium is the immune system of the fungi. Thinking about immune systems was for me a helpful way to stop thinking about purity as something possible or even desirable. Not to have immunity or purity as a goal, but to understand our 'defense systems' as a collaboration between the inner and the outer world. Our microbes and our environments. The more diverse we are, the stronger we are. Acknowledging that we are living in a world full of racism, trash, toxicity, and ruins doesn't mean passive acceptance; without denying pain, death, or complicity. It means we need to cultivate practices of responsibility while collectively building our mental and physical immune systems, our mycelium. Through diversity rather than purity. Alexis Shotwell formulates it as follows:

> To be against purity is to start from an understanding of our implication in this compromised world, to recognize the quite vast injustices informing our everyday lives, and from that understanding, to act on our wish that it were not so.[16]

We need to resist the demand for purity. Purity is not only a fantasy, it's also undesirable as it is an impossible starting point. We have to start from the capitalist ruins as described by Anna Tsing in *The Mushroom at the End of the World. On the Possibility of Life in Capitalist Ruins*. Starting from waste, from the mountain of clothes in the Atacama. That involves embracing a bit of dirt, occasionally eating food sucked by the devil, bathing in a swamp, or having a slime mold as a pet.

16.

Shotwell, *Against Purity*, p. 204.

HOW CAN OUR IMAGINATION SHAPE NEW WORLDS?

De-zombifying and Re-training Our Senses

TEACHING SIX

Featuring:
Juan Ferrer (Museo del Hongo), polypores, Tara Rodríguez Besosa, *Psilocybe cubensis*, Giuliana Furci, Anicka Yi, Maria Alice Neves, Liene Kazaka, Pauline Oliveros, destroying angel (*Amanita bisporigera*), Tosca Terán, Marjet Zwaans and Razia Barsatie (CUPP Collective), Gregorio Fontén, Maya Errázuriz, green elf cup (*Chlorociboria aeruginascens*), Marion Neumann (The Mushroom Speaks), tinder fungus (*Fomes fomentarius*), *Phaeolus schweinitzii*, *Omphalotus olivascens*, white rot, Turkey Tail (*Trametes versicolor*), matsutake, shiitake, Chaga (*Inonotus obliquus*), button mushrooms (*Agaricus bisporus*), black truffle (*Tuber melanosporum*), Lion's mane (*Hericium erinaceus*), Penicillium mold, Lucía Hinojosa Gaxiola, Daniela Catrileo and Nicole L'Huillier.

Geographies:
Suriname, Borikén (Puerto Rico), Rio Cristalino, Mato Grosso (Brazil).

RE-IMAGINING THE FARM

Close your eyes and think of a farm in Puerto Rico. Just do it for fifteen seconds. Take a deep breath and try to feel some warmth on your skin. Open up your imagination, remove your shoes, and feel the grass tingling between your toes. In the distant background you might hear someone strumming the *cuatro* on the veranda, the Puerto Rican version of the guitar, played with four strings. What do you see? What's growing on this imaginary farm? Perhaps banana trees with their big floppy leaves providing a bit of shade for our *cuatro* player? Coffee maybe, with those little bright red pods contrasting with the green leaves? Perhaps you see an open field with big juicy oranges dangling? It's an exercise that food activist Tara Rodríguez Besosa has been doing with her art students to challenge their presupposed image about what a farm looks like. 'The fact is', *she tells me,* 'that most people have a fairly romanticized and nostalgic vision of a farm.' All of these crops named above, bananas, coffee, oranges, and many more, come with significant social and environmental problems. For starters, most of them are planted as mono-crops. Rodríguez Besosa explains the complexities: 'Bananas are sold too cheaply; they're a one-year crop, and the people picking those bananas most probably don't own that land and are working under really poor conditions.' She emphasizes how we are working within a food system that is not allowing complexity, and mostly people

are only working with one crop. That means knowledge on biodiversity of crops outside their labor practice is limited. 'You can't expect someone who has been growing bananas their whole life to know all of these other things.' We dive right in. Tara Rodríguez Besosa lives on a farm in Borikén, Puerto Rico, and a lot of what they have been doing concerns changing that vision of the farm, changing what that image looks like when you close your eyes, and making space to imagine new visions and interpretations of a farm. That also includes changing the idea of having to participate in the market to grow food. She tells me how in recent years more people are going back to the idea of foraging in the forest and harvesting on a smaller scale.

> Yesterday I harvested four pigeon peas—enough for me. I rescued a citrus tree that was covered in vines after the latest hurricane. That was my intervention on the farm. We are completely off-grid so we do compost toilets; we learn to wind down when the sun goes down, to live without electricity. That has forced and allowed us to eat more of what's around us. We had to identify the neighbors who have egg-producing chickens, identify how to exchange and barter crops with other people around. I do distribute and I do share food and produce for other beings—some of them are human and some are not. I'm documenting what I'm doing and sharing it so I can be an example of what farming can look like. Different from the ideas ingrained in our heads. What farming looks like when you don't have lots of resources; we are an under-researched, underfunded project that is still doing really cool stuff within a small community. I think that's important to see.

I feel Tara raised a very important point here. Many alluring artistic and agricultural projects involving people moving out of the city tend to be well-resourced and financed. While the majority of people don't have access to that, it means Tara and her community can show people a project they can identify with. Rodríguez Besosa:

> I want to show what a DIY project with no funding looks like, what that requires energetically from people, what those practices look like, and how it changes the aesthetics. When this remains invisible, kids can grow up never really connecting with the idea of growing food themselves, thinking they can get there.

Again, it comes down to imagination and opening up connections in the

brain. We formulate and envision our dreams based on our
imagination, yet imagination is also informed and triggered by the things
we experience and see. The arts play an essential role for opening up
these new connections and expanding our minds about what is possible.
Imagination allows for speculation and, from there, allows us to change
our mindsets.

THE SHARED HISTORY OF FUNGI AND ART

Some people say—and by some, I mean specifically myco-king Terence
McKenna and his following—that the genesis of imagination culture, art,
creativity, and even language was ignited by mushrooms. The hypothesis,
for which he actually has some pretty fun and convincing arguments, goes
that at some point, about two million years ago, there was a shortage of
food for the *Homo erectus* and for this reason they started migrating. In
search of something edible, they reached the point where they had to ex-
pand their diet if they were to survive. They had to try out something new.
So they started eating mushrooms and encountered a mushroom contain-
ing psilocybin, also known as a 'magic mushroom'. The *Psilocybe cuben-
sis* was possibly the beginning of the transition from *Homo erectus* to
Homo sapiens, as the consumption of this 'magic mushroom' opened
up a new part of the brain, making new connections between brain cells.
These psychedelic mushrooms literally opened the minds of the apes, cat-
alyzing a new type of consciousness and thereby allowing for a big leap in
evolution: the birth of language and culture. Though it's a hypothesis and
there are plenty of scientists who oppose it, I love the idea. A hungry ape
that gets high marks the beginning of arts and culture. Fungi and art as an
entangled history.

Two million years later, fungi and art are experiencing a revival of their
relationship, with many artists interested in mycology. This was confirmed
by all the enthusiasm I encountered from artists as part of my research.
Giuliana Furci, founder of the Fungi Foundation, verified that they are also
often approached by artists to collaborate on exhibits, biennales and even
assist in the production of paintings, sculpture, new media, and more. Out
of their many myco/art collaborations grew Museo del Hongo, a (nomadic)
museum of mushrooms. The aim of Museo del Hongo, director and curator
Juan Ferrer tells me, is to create a platform that can help bring justice to
the world of fungi using art. Their multitude of projects stimulate educa-
tion, recognition, protection, and respect for fungi. When we speak, Juan is
preparing for the exhibition 'Holy Children' that is taking place across
Berlin and is all about mushrooms. It includes art work from Mexican artist
Lucía Hinojosa Gaxiola, who made a work about the famous Mazatec
curandera (healer) Maria Sabina (more about her in Chapter Ten), and
Chilean artists Daniela Catrileo & Nicole L'Huillier in relation to the Mapu-
che cosmovision and its connection to outer space, among many other
works. Museo del Hongo promotes an engagement with mycology by
organizing art and science exhibitions that stimulate the senses. These

artistic myco-ambassadors have popped up all over the world, from the MAC Valdivia in Chile to the Ars Electronica Festival in Austria. The arts seem perfectly located to fulfil this honorable role, and increasingly have been doing so. From artists, audiences, and art institutions alike, there has been a surge of interest in microbial life, also called the bio-art movement. Many countries have their own bio-art societies, which bring together artists, scientists, hackers, and other creatives to exchange knowledge, resources, and tools to keep on pushing artistic collaboration with micro-bial life forward, making visible the processes of bacteria, fungi, and viruses through artworks and experiments. Even big Western museums such as the Tate Modern in London and the MoMA in New York have dedicated solo exhibitions to bio-artists, with Korean/American artist Anicka Yi the most well-known. Anicka Yi works with biomaterials such as kombucha, hormones, glycerin, fungi, and (cyano)bacteria. Her works are often sensorial, and olfactory in particular. Though I have to admit that when I visited 'Metaspore',[1] a 'sensorial' solo exhibition presenting over a decade of Yi's work, nine out of ten times I couldn't smell a thing, even though I was practically pushing my face into the artwork, sniffing vigorously.

It resulted in some anxious looks from the guards keeping a close eye on me. I wasn't sure if it was my zombified olfactory nerves not being able to pick up—perhaps it was the huge space (a former hangar)—a lack of scent from the works themselves, or an unfortunate combination of all three of them. I feel it's important to acknowledge this reality of bio-art, and how it often fails to do what is expected. It's important to see it as experimental and imperfect, and that's okay. The experimental aesthetics of bio-art and the friction it often creates are an entry into sparking curiosity, spreading a sense of mystery, and possibly even a deepened connection with nature. Yi herself compares the arts to a fungal process. She explains:

> Another way to think about art is as inoculation. To inoculate is to introduce something new, something viable, into a medium or into a body. Once an artwork is introduced into the world, it seems to take on a life of its own and catalyze chain reactions that we could not have anticipated. There is something truly humbling about not being able to grasp a thing in its totality.[2]

Though bio-art is not just about DIY labs in kitchens anymore and is adorning the grounds of some major art temples, Giuliana Furci points out that in the history of art fungi are wildly underrepresented. Giuliana: 'Think of all those still-life paintings full of vegetables and fruit, which rarely feature mushrooms. Even Arcimboldo used only one or two!' She suggested some redemption and a more deliberate incorporation of fungi into contemporary art:

1.

Anicka Yi, *When Species Meet Part 1 (Shine Or Go Crazy)*, 2016, shown at 'Metaspore' at Pirelli HangarBicocca in Milan, IT. Installation, acrylic pipes and fittings, faux fur, lab hardware, wire, foam, epoxy resin, paint, aquarium pebbles, imitation pearls, 183 x 183 x 183 cm. Courtesy of the artist.

2.

Anicka Yi in conversation with Merlin Sheldrake in her publication *Anicka Yi: Metaspore*, ed. with texts by Flammetta Griccioli and Vicente Todolí, Marsilio editori, 2022.

I think artists have a responsibility there be-
cause part of the role of the arts is capturing
what is not always visible. Making you feel what
is not always there to be sensed. And there aren't
many things that are as ephemerous as mush-
rooms....

For her, contemporary artists play a really important role in changing sensations around fungi. Giuliana: 'Artists have an important role in triggering reflections and presenting fungi close to other be-ings or objects or sensations.' As Covid-19 has soared over the world since 2020, many people have been sluggishly Netflixing, Zooming, and food-ordering their way through life, with technology dulling our senses. The pandemic didn't only bring loneliness, sickness, and death, it also led to a sensorial crisis. With an overdose of screens, a lack of touch, and for some a literal loss of smell and taste, it provoked an amnesia of the senses. Perhaps fungi can help us get re-acquainted with the importance and joy of the sensorial world and open up the imagination. Brazilian mycologist Maria Alice Neves thinks the goal of fungi is to educate us:

That's why they have all these crazy strategies
and behaviors and shapes and forms, textures,
and smells: to get people's attention. There is all
this mystery with the psychedelics, the biolumi-
nescence, the ones that control the minds of ar-
thropods, the edible ones. These are all strategies
to reach and attract people.

SEEING: 'HONGOJOS' AND THE EPISTEMOLOGY OF IGNORANCE

One of the books I read and loved while studying art was Berger's book *Ways of Seeing*. It was and is (and will be?) inspirational for many people because, as the title suggests, it really invites you to embark upon different ways of seeing. The main point, which he demonstrates with many practical and fun examples, is that the way we see things is affected by what we know or what we believe. For instance, when an image is presented as a work of art, 'the way people look at it is affected by a whole series of learnt assumptions about art.' Those can be assumptions concerning beauty, truth, or taste, for instance.[3] Those same assumptions about looking at art apply to looking at fungi. People look through mycophobic or mycophiliac lenses—I personally tend to see fungi everywhere, not because I'm actively looking for them, but because a switch has been flicked inside of me to see them. It confirms Berger's theory that 'we only see what we look at.' In other words, when we choose to look, we see.[4] It applies to many things, beyond fungi and art. In her book *White Innocence*, Gloria Wekker speaks of racism in the Netherlands that is embedded in what she calls the cultural archive. The

3. John Berger, *Ways of Seeing*. Penguin Books, 1972.

4. Berger, *Ways of Seeing*.

'cultural archive', according to Wekker, is located in many things.

> In the way we think, do things, and look at the world, in what we find (sexually) attractive, in how our affective and rational economies are organized and intertwined. Most important, it is between our ears and in our heart and souls.[5]

It's how we see the world. She observes an overlap between the cultural and the colonial archive and, in her book, deconstructs how the colonial archive keeps on informing the cultural archive. One of the roots of racism. She also observes how the card of 'innocence' is often played by Dutch people to 'enable the safe position of having license to utter the most racist statements while in the next sentence saying it was a joke or was not meant as racist.' Saying that you don't see skin color and thus you are not racist. Innocence and 'not seeing' is used as a shield. Wekker:

> The claim of innocence, however, is a double-edged sword: it contains not-knowing, but also not wanting to know, capturing what philosopher Charles W. Mills had described as the epistemology of ignorance.[6]

It's a different type of example to Berger's not-seeing because we're choosing to not really look. In this case, we are not looking because we don't want to see and face the consequences. Wekker:

> Loss of innocence, that is, knowing and acknowledging the work of race, does not automatically entail guilt, repentance, restitution, recognition, responsibility and solidarity, but can call up racist violence and often results in the continued cover-up of structural racism.[7]

It's time to look and really see—including the things we don't want to see—both Wekker and fungi seem to be telling us.

'To find wild mushrooms in a forest, you have to be in a state of receptiveness, a state of openness to an encounter,' Giuliana Furci of the Fungi Foundation told me. 'If I walk into a forest, and if I'm predetermined to find one shape or color, I will probably miss many species with other shapes and colors.' It's true; foraging for mushrooms requires you to use your eyes in a different way. Furci calls this 'getting your eyes' and I, in a giddy mood, called it 'hongojos' (hongo = mushroom, ojos = eyes). Learning to use your eyes differently so you see other things. For me personally this was what studying art history was about. It wasn't about remembering all the names and years of paintings and sculptures listed in Janson—the key book we used in class—though at the time it often seemed to be. Looking back, it

5. Gloria Wekker, White Innocence: Paradoxes of Colonialism and Race, Duke University Press, Durham and London, 2016, p. 19.

6. Wekker, White Innocence, p. 17.

7. Wekker, White Innocence, p. 18.

taught me to be aware of how to look, just like John Berger, how to see other things, how to read what's depicted. A painting was never just a painting but said so much about the time, the context, the values of the maker, the available materials. In this sense, the foraging of mushrooms is not too dissimilar from the arts: once you develop an eye for it, you start seeing things differently, in unexpected forms and places. Things are more than what they seem. Furci:

> An artist needs to be open to what they first set out to draw, paint, or sculpt, to be open for an encounter that might be an amazing masterpiece but it wasn't what you set out to make. There's a similarity in the state of receptiveness and the state of openness to an encounter that is common both to natural sciences and to art; finding and creating.

Perhaps more of that receptiveness to systemic injustices takes us further away from the epistemology of ignorance.

QUANTUM LISTENING, POLYPHONY, AND FUNGAL SONIFICATION

> As you listen, the participles of sound decide to be heard. Listening affects what is sounding. It's a symbiotic relationship. As you listen, the environment is enlivened. This is the listening effect.[8]

8.

Pauline Oliveros, *Quantum Listening*, Ignota Books, 2022, p. 9.

This is a quote from Pauline Oliveros that I came across while studying her *Quantum Listening* techniques. It was somehow the sonic version of resisting the epistemology of ignorance as described by Gloria Wekker, highlighting how we don't only choose to look and, therefore, see, but also choose to hear and, therefore, listen. Pauline Oliveros was a musician interested in the sensual nature of sound and its power of synchronization, coordination, release, and change. She introduced the concept of Deep Listening, a way to listen in every possible way, to hear everything that's possible to hear. This included the sounds of daily life, and also one's thoughts. In the form of a meditation, it could lead to a heightened state of awareness and connection. Oliveros, who passed away in 2016, had been training herself since 1953 to develop her listening skills. It's a beautiful story that started on her twenty-first birthday, when her mother got her a tape recorder as a birthday present. She started recording and, when listening back, noticed many sounds that the microphone had picked up but she hadn't. She decided there and then that she was going to practice listening and remind herself when she was not. She had practiced that meditation ever since. The key to her meditation is to listen in as many ways possible to everything that can possibly be heard, all the time. Only when we listen in all possible modes can we meet the challenges of the

unexpected. It made me wonder if listening to fungi could give us some insights into the unknown.

The work of Tosca Terán, who describes herself as a Latinx-feminist and bio-artist, explores the intersections between art, biology, and technology, with a particular interest in sound and fungi. Listening to the sounds of fungi using technology is a process called fungal sonification and a form of what's called bio-sonification. Bio-sonification is a process to make the biorhythms of living entities audible to human ears using synthesizers and transducers. Fungal sonification is the same process used on mushrooms, and in this case, mycelium. I became interested through *Mycorrhizal Rhythm Machine*, an installation by Terán that, using sound equipment, creates a soundscape in a dome-shaped growroom (a humid space with good conditions for mushrooms to grow), based on the translation of mycelium biodata. With the mycelium growing, the soundscape develops. This way, Terán aimed to engineer 'an ecosystem between the acoustic technology, the space, and the organisms, facilitating a conversation between nature and machine.' It's a technology that many artists have been playing with; you attach the transducers to a plant or mushroom and a new dimension to approach the species is opened using sound. If you want to hear one of the world's deadliest mushrooms talking, a big fleshy white mushroom called the *Amanita bisporigera*— also known as the destroying angel—you can find a YouTube video that gives you an idea of what that sounds like; like you are in a dark cave with echoes of water dripping, magical yet slightly scary. What's interesting is that different mushrooms make different sounds. Listening to the sounds of the oyster mushrooms and the Turkey Tail on my headphones at home (also to be found on YouTube) added a layer of understanding to how I related to them, like a new awareness of how alive and active they are, even standing still.

Curator Maya Errázuriz told me that in their Bosque Pehuén residency program they also once worked with a sound artist, called Gregorio Fontén. He translated data taken from the Araucaria into musical compositions through an algorithm he made, and used 3D scans of the tree using the XYZ set of coordinates, the coordinates of which a 3D image is made up. All these coordinates are essentially numbers that, put together, form an image. He took this set—essentially an excel sheet with all the coordinates—and assigned a musical role for the different components. Thus he 'musicalized' the sounds to make a composition. Maya explained that through the composition a discussion was triggered on whether it was a way to listen to the interior sounds of the tree, ones that otherwise we are unable to listen to, unable to see. Maya:

> I think that really opens up a lot of speculation revolving around sound and the effect it has. When you're looking at the scan of the Araucaria and you listen to this music, you can really imagine that this music is coming from within the Araucaria.

For her, it creates a sensation and a connection with the tree that you don't necessarily have in nature. 'You are not trying to rep- licate an experience, but rather you are extrapolating it into another sensation and relation with the species. And that there is the key,' according to Errázuriz. Anna Tsing, when describing her con- cept of assemblage in her book *Mushroom at the End of the World. On the Possibility of Life in Capitalist Ruins,* also refers to sound. More specifically, to polyphony and what we can learn from polyphonous music in relating to the natural world. Polyphonic music is generally un- derstood to be classical music from the late Middle Ages and Renaissance, in which there are multiple lines of melody that you can follow. These melodies operate independently from each other. They don't follow each other, yet are still collaborative. When I read her book for the first time, still unfamiliar with classical polyphonic music, this paragraph reminded me of an ex-boyfriend from my twenties, a noise DJ in Amsterdam called Hakki Takki. Freshly in love, I went to all his DJ sets, usually in smoky, dark basements with an excessive amount of wires connecting all kinds of obscure flashing devices. At least that's what it seemed to me at the time. Because of him I have had a fair amount of practice listening to somewhat non-musical music (not too dissimilar from the sounds the destroying angel makes) and have built up a relative tolerance to music that doesn't follow a stable beat or single melody. Tsing writes about how polyphonic music can teach you how to listen with multiple perspectives. Like Oli- veros, it's the practice of hearing different things at the same time. Tsing writes about polyphony:

> These forms seem archaic and strange to many modern listeners because they were superseded by music in which a unified rhythm and melody holds the composition together. In the classical music that displaced baroque, unity was the goal; this was 'progress' in just the meaning I have been discussing: a unified coordination of time. In twentieth-century rock-and-roll, this unity takes the form of a strong beat, suggestive of the listen- er's heart; we are used to hearing music with a single perspective. When I first learned polypho- ny, it was a revelation in listening; I was forced to pick out separate, simultaneous melodies and to listen for the moments of harmony and disso- nance they created together. This kind of noticing is just what is needed to appreciate the multiple temporal rhythms and trajectories of the assem- blage.[9]

A teaching that was perhaps also hidden in the unrhythmic fungal bleeps playing in the basement of DJ Hakki Takki.

9.

Anna Tsing, *Mushroom at the End of the World: On the Possibility of Life in Capitalist Ruins,* Princeton University Press, 2015, pp. 23–24.

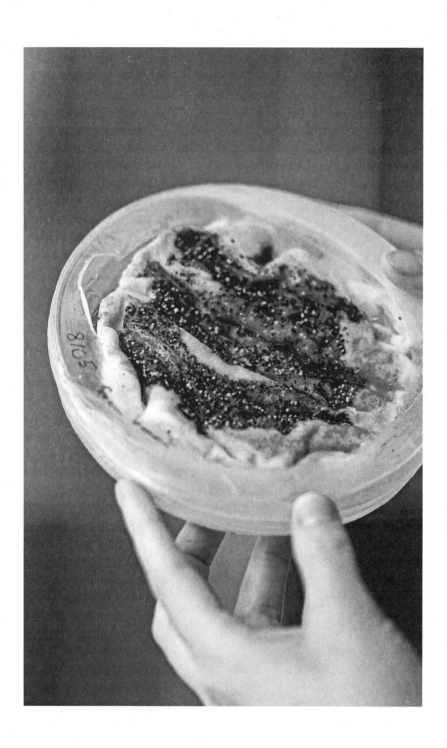

During our workshop with mycologist Fer Walüng in the Valley of the Possible residency program in Chile, we encountered different types of bright colored mushrooms. Fer also found a piece of wood that had turned completely turquoise. Speckled with tiny blue mushrooms, the wood itself looked like a bottle of ink had been poured over it. Fer explained it was the *copito de duende,* and I later learned in Europe and the United States it is known as the green elf cup (Latin: *Chlorociboria aeruginascens*). The blue color comes from the mycelium, which colonizes the wood and stains it with the luminous color. It was once, in the eighteenth and nineteenth centuries, the most expensive wood in the world, used by artisans and other woodworkers for elaborate decoration and fancy furniture for the rich. The mycelium's process of colonization can be stopped by drying the wood, and it will still keep its beautiful blue color. The green elf cup isn't that rare and can be found on decomposing wood in forests—its availability gives it the potential to add a turquoise-colored value to wood. Wood that, without the color, would be considered of lower value. In contemporary practices, the green elf cup has also been (re)discovered. In the Future Materials Bank, a platform for sustainable materials for artists, the project Myco Colour can be found. It is by designer Liene Kazaka, who uses the pigment of elf cups directly on textiles. By letting the fungus grow on the textile, it creates a colorfastness that can be compared with commercial dyes. According to Kazaka, this method has 'the potential to revolutionize not only industrial material finishing methods but also the cultural perception of color, and could renew our connection with, and appreciation of, nature.' It makes sense given that commercial dyes generally come with a lot of chemicals. Though the green elf cup definitely stands out because of its brightness, there are many mushrooms that give off great pigments that can be used to dye textiles and paper. Some examples include the *Phaeolus schweinitzii*, which gives off a beautiful deep yellow, or the *Omphalotus olivascens*, with its dark green, purple, or lavender, depending on the mordant you use (alum, iron, or none). Dyeing with fungi, using mushrooms and lichen, became popular in the nineteen-seventies, and it is enjoying a bit of a comeback now that many, both professional and amateur, artists are looking for more sustainable materials to work with. In the process of using mushroom dyes, when all the pigments are extracted, you end up with a lot of mushroom pulp. For those with true no-waste attitudes, the mushroom pulp can be made into paper. Fungi have been crucial for paper-making developments as fungi contain lignin, a type of organic polymer that is also found in wood and bark. As mentioned before, fungi figured out how to decompose wood about three-hundred-million years ago, supposedly marking the end of the Carboniferous Period. Before white rot fungus, and later other fungi, developed this enzyme to process lignin and cellulose, dead trees piled up, becoming what we now call fossil fuels. By produc-

ing this enzyme, they also brought an end to fossil fuels. White rot fungi leave behind white cellulose, while brown rot fungi leave behind brown lignin. Though the lignin isn't generally used (and is still a widely available material), the remains of the lignin-eating fungi form the cellulose base for paper. It is also possible to make chitin-paper out of fungi—the structure of chitin is similar to cellulose. Chitin is the tough organic polymer that also makes up the hard shells of most insects and that is also used for a range of medicinal, industrial, and biotechnological purposes. Polypores, in particular, are good for making paper; they don't have lamellas through which they sporulate, but are more skin-like, with pores. They are literally named after their many pores (*poly* means many). Polypores can be found on both living or dead trees, making them saprophytic—decomposing fallen branches, leaves, and tree trunks. When found on a living tree, they can be the first sign that heralds the death process of that tree. Though there are almost two thousand different types of polypores, they are fairly easy to recognize, not only because of the pores but also because they often appear in the shape of little shelves on a tree. These are not called mushrooms but conks, or bracket fungi. They are very important for ecosystems because they can break down the lignin in wood. A type of bracket fungus that has been crucial to humankind is the tinder fungus (*Fomes fomentarius* in Latin or also known as *amadou*)—a bracket fungus which, being common and widely distributed, made it possible for humans to make and transport fire. The name already says it: it's been used as tinder.

If it weren't for fungi, there would be a dearth of interesting materials for artists in this world. At the moment, there is a surge in the popularity of mycelium as a material, something I first started noticing when more and more artists were uploading their mycelium projects into the Future Materials Bank, the project I initiated in 2020 while working for the Jan van Eyck Academie. Browsing through the different materials (over three-hundred!), there were at least seventeen projects in there using mycelium as their material. Artists are hungry for alternatives and in the fungal domain there are many to be found. With a friend I was living with at the time, artist Rain Wu, we decided we wanted to try growing some mycelium too, and reached out to our local mushroom provider to source the materials needed. She started with straw as a substrate and classical Greek and Roman sculptures as mold, resulting in Julius Caesar, unintentionally (but somehow very suitable), having an oyster mushroom growing out of his nose. Growing mycelium at home is very doable and fun and there is a great diversity of substrates you can experiment with, from (sterile) rice-husk to oat flakes, straw, sawdust, shredded corn stork, or hemp, or other agricultural waste streams. Objects and shapes made out of mycelium represent an auspicious area of research, and the material has already been used for chairs, lamps, and tables, for packaging, for bags (both French fashion house Hermès and British fashion designer Stella McCartney have a mycelium bag in their collections), as coffins (a project called The Loop

Living Cocoon by Loop of Life), yoga mats, and in architecture.
Mycelium is a better isolator than Styrofoam, can provide shelter at a low cost, and is regenerative, sustainable, and can grow, rather quickly, in any form. The advantages are endless and I am yet to find a disadvantage. But then I'm probably also one of the most fungi-biased people ever.

What is interesting about working with natural, living materials is that they respond to their environment. They will grow or decay faster or slower depending on the climatic conditions. This notion was the starting point for Collective Un Prati a Patu (CUPP), a mobile workspace and exchange project between artists based in Suriname and the Netherlands and initiated by artists Razia Barsatie and Marjet Zwaans. CUPP aims to stimulate the use of natural and local materials and spark discussions that address differences in the recipes and the production of biomaterials in different localities, including the Tropics. Artists Meagan Peneux, Annemarie Daniël, Asli Hatipoglu, and Basse Stittgen enjoyed a period of dedicated material research in both the Netherlands and Suriname, experiencing and understanding the different behaviors and availability of their materials under different temperatures and levels of humidity. Departing from their own artistic practices, they have been researching, among other materials, kombucha biofilms, lignin, used teabags, eggshells, bioresins, blood, and warimbo reed. The aim of the project is not only to provide the artists with stimulating working conditions, but also to set up an actual materials research space in Paramaribo in the longer term; an open, accessible, and collective research and production facility for the community. The space should facilitate a critical reflection on materials, and the understanding that a (bio)material is never just a material. It has a spirit and is, or has been, alive. It's part of larger ecosystems, bodies, histories, cultures, and traditions. This should inform how we approach and work with them.

SMELLING: A PROUSTIAN SNIFF OF THE MOUNTAINS

When I came back from Chile, after having spent six weeks in Valley of the Possible in Wallmapu, tucked away in a creaky but charming lodge, hiking volcanoes, drinking red wine by the fire every evening, and less frequently washing my clothes, I was welcomed by a happy, big hug from my big love. The warm embrace morphed into some awkward sniffing. He raised his eyebrows in an act of confusion and concluded 'you smell different. You smell like mountains.' I wasn't sure if it was a good or a bad thing and also wasn't able to smell the mountains on myself to judge. A few days later, when I finally got round to unpacking my bag, I smelled it too. The scent was hard to describe, and perhaps 'mountains' wasn't such a bad attempt. It was like a mixture of the smell of fire, mushrooms, humidity, soil, nuts, the smell of early morning, and unwashed clothes. The strongest overtone was definitely smoke. I would have winced at the content of the bag if it wasn't for the amazing experience I had had. Now I found myself happily going back to the mountains with every deep Proustian sniff I took, holding on to the precious memory.

In a Reading Group I once organized, we read a book that had a great impact on me: the aforementioned *Mushroom at the End of the World. On the Possibility of Life in Capitalist Ruins*, by Anna Tsing. A particular fragment stood out which we ended up discussing. It was the following:

> The smell of matsutake transformed me in a physical way. The first time I cooked them, they ruined an otherwise lovely stir-fry. The smell was overwhelming. I couldn't eat it; I couldn't even pick out the other vegetables without encountering the smell. I threw the whole pan away and ate my rice plain. After that I was cautious, collecting but not eating. Finally, one day, I brought the whole load to a Japanese colleague, who was head over heels in delight. She had never seen so much matsutake in her life. Of course, she prepared some for dinner. First, she showed me how she tore apart each mushroom, not touching it with a knife. The metal of the knife changes the flavor, she said, and, besides, her mother told her that the spirit of the mushroom doesn't like it. Then she grilled the matsutake on a hot pan without oil. Oil changes the smell, she explained. Worse yet, butter, with its strong smell. Matsutake must be dry grilled or put into a soup; oil or butter ruins it. She served the grilled matsutake with a bit of lime juice. It was marvelous! The smell had begun to delight me. Over the next few weeks, my senses changed.[10]

In her film *The Mushroom Speaks,* Marion Neumann follows, among other human and non-human protagonists including Anna Tsing, mushroom enthusiast Ursula. She has been gathering mushrooms for most of her life and is incredibly knowledgeable. Now, at ninety-two, she is also going blind. Joining her on forays in the forest, Neumann noticed her eyesight was getting worse every time. Interestingly enough, she also noticed how, through smell and touch and being in tune with all the senses, she was still able to get around and identify the mushrooms. Marion Neumann: 'By touching the tree, the ground, and becoming aware of the environment like this, she was aware of where she was—I found this very beautiful.' The taste of mushrooms can be quite complex and you need to understand the taxonomy to know what you're doing. What an irony that the Covid-19 pandemic takes away your senses. Symbolically, touching has also been taken away. Marion: 'Intimacy as a subject is so interesting, particularly now. Working with fungi reminds us of these things we worry about losing in this pandemic.' The

10. Tsing, Mushroom at the End of the World, p. 47.

Alternaria is a genus of fungi with almost three hundred different species.
They are generally considered to be plant pathogens.

pandemic was not the only thing to numb, pause, or take away some of our senses. City life has too. Having moved from Brazilian farm life to Mexico City in 2021, I noticed how, in order to survive in a big city, you have to shut off a lot of the senses. Ignoring horrible smells of sewage or fumes was the first one, and the second, to try not to engage with every home-less person, or make eye contact with every person asking for money. It was not a skill I desired to have, nor one that I have mastered. But in big cities it's almost a necessity to switch off and disengage with poverty, drug and alcohol use, homelessness, and other injustices in order to not get depressed yourself while moving from A to B. Don't make eye contact in the metro, don't touch anyone or anything, cover your ears against all the honking and screaming, unsee the cockroaches, stop breathing when you're behind a truck. It's all in the starter pack for big-city dwellers.

A TASTE OF PHARMA

Mushrooms are considered to be an acquired taste, meaning there's lovers and haters. Though the taste of mass-produced button mushrooms (*Agaricus bisporus*) is hardly controversial or interesting, wild and foraged mushrooms come with strong and complex flavors. These flavorsome mushrooms, such as porcini, are also the hardest to cultivate as they are mostly mycorrhizal—living in a relationship with other plants and trees. Most of the cultivated species are saprophytes and grow easily in dead or-ganic matter. The black truffle (*Tuber melanosporum*), one of the most expensive (and some say delicious) edible fungi, is not a saprophyte and grows and produces spores underground. Truffles release a special aroma to attract animals who will sniff them up and thus help them disperse their spores. Truffles can be cultivated with a large slice of luck and alongside oak, beech, birch, and hazel trees. The majority of truffle products avail-able, however, like truffle oil, don't contain any truffle at all. It's made with a chemical called 2,4-dithiapentane. This chemical, making a synthetic truffle oil, mimics the taste and aroma of truffles. Another discovery about edible fungi is that, to keep the flavor, you shouldn't first wash them with water, a mistake I made until two years ago. Mushrooms will soak up the water, leaving very little of their own taste. For that nice 'earthy' flavor, it's best to heat them in a dry pan first and squeeze the water out, before add-ing anything else. Some people must have been doing this right though: the global market for cultivated and wild edible mushrooms is worth a whopping thirty-five billion dollars.

Reasons to ingest mushrooms don't have to be purely gastronomical since many of them have really interesting medicinal properties. Lion's mane (*Hericium erinaceus*), for instance, often used in Chinese medi-cine and quickly becoming more popular and better known, is consumed to help alleviate anxiety and depression, but also supports cognitive func-tions. In other words, it helps you to get sharper, but is also said to slow down neuro-related diseases such as Parkinson's disease and Alzheimer's. The Turkey Tail (*Trametes versicolor*) is a bracket fungus and is also

full of anti-oxidants, helping to boost immunity, and is said to **1 6 3**
help balance instable molecules, also known as free radicals. Free radicals
can increase the risk of disease, including cancer. Another fungus said to
suppress cancer progression and enhance the immune system is Chaga
(*Inonotus obliquus*), another type of bracket fungus. Chaga grows
on mature birch trees and looks a bit like burnt coal. It is also a bracket
fungus. There are many fungi that have anti-viral and anti-bacterial com-
pounds, and research on their medicinal properties is continuously mak-
ing progress. It's interesting to think about how many of these fungi can
just be found in forests and how that democratizes access to medicine.
The most famous anti-bacterial fungus is, of course, penicillin, an antibi-
otic derived from Penicillium mold. While synthetic foods and medicine
often weaken the senses, food and medicine directly sourced from the nat-
ural world wake them up. This also applies to plants. We could grow a lot
of our medicine ourselves, yet many people don't know the names of the
plants, how to use them, and what they are good for. Through our senses
and the art of noticing, we can re-learn this. Food justice activist and farm-
er Tara Rodríguez Besosa, from Puerto Rico, elaborates on the situation in
Borikén, Puerto Rico, where she lives. Borikén has an informal local food
economy that consists of many small sustainable farmers and food prod-
ucts. It has farmers' markets around the islands, agrotourism projects, and
a growing community of supporters. She adds:

> For many of us who form a part of this economy,
> Borikén is the perfect 'case study' of what agro-
> ecological, small-scaled food communities on the
> frontlines of climate change, capitalism, and colo-
> nialism can do in favor of our collective well-being.

She explains further:

> More than discovering the medicinal uses of
> plants and fungi, we need to tap into the knowl-
> edge that has been present in older generations
> and from which we have been separated. Most of
> the medicinal plants in Puerto Rico grow every-
> where. These plants really come out of nowhere,
> from sidewalks and concrete.

She gives the example of Verdolaga, a plant that just shows up on side-
walks in cities and is important in medicinal use.

> We have a type of plantain which is also abun-
> dant and free and those are just two examples of
> many medicinal plants that nowadays survive in
> the weirdest of places and that we're trying to
> rescue from our own devaluing of them in these
> post-generations.

The re-valuing that she suggests is directly connected to decolonial practices of unlearning certain things. Rodríguez Besosa explains that in the case of Borikén, there has been a lot of pharmaceuticals coming to the island, creating over-the-counter medicines.

> This is directly related to that American dream of success that equals a house, a car, and being able to afford these over-the-counter medicines that come to you in a package and that were made in a lab. That means not using the traditional remedies that our mothers and grandmothers and grandfathers and medicine-makers have been holding for generations.

Though we speak over Zoom, by the end of the conversation I feel inspired and ready to go to Borikén. I'm reminded of how much I miss being on a farm.

RECIPROCAL RELATIONSHIPS

When a friend came to visit me in Mexico from the Netherlands and asked me if I could maybe introduce her to an indigenous shaman for an interview, I almost choked on my taco. Though the intention was good and the interest sincere, in my own practice (as a Dutch white woman living in Mexico), I had become (over)careful when it came to reaching out to indigenous communities when you want something but don't know what you can give back in return. The fact that indigenous groups are the stewards of eighty percent of global biodiversity (but only manage a quarter of the earth's surface)[11] triggered a flurry of international artists and NGOs alike wanting to work with indigenous leaders, shamans, and groups. A long tradition of non-indigenous people extracting knowledge from indigenous people, however, made me anxious of making the same mistakes. I had seen people coming to the Amazon wanting to meet indigenous people and actually polarizing relationships rather than bringing people closer because of their projections and expectations. I had plenty of European friends who tried the shamanic spiritual and ceremonial medicine *ayahuasca* in Latin America and had contributed to a whole problematic tourism industry around this brew made from sacred plants. And it's not just with *ayahuasca*; the same is happening with psilocybin containing mushrooms in Mexico and other parts of the world. More about the exemplary story of Maria Sabina, and the risks involved when tourism and sacred and shamanic ceremony meet, in Teaching Ten.

I had seen and heard of one too many collaborations between European and American artists and traditional or indigenous communities that had been extractive. In my personal experience, it takes a really long time to even start scratching the surface to understand what an equal, non-extractive collaboration might look like. It requires putting in the effort to learn different languages, a form of respect to deepen your knowledge about the cosmology, and spending time with the community to understand what reciprocity might look like. Time that most people don't have, particularly on a residency. It's become a bit of a trend in the arts to want

11. See: www.un.org/en/food-systems-summit/news/indigenous-peoples-are-best-stewards-our-environment.

to work with both indigenous people and local communities,
yet few are willing to put in the time it requires to build up long-term and
reciprocal relationships when everyone comes from different worlds. At
the same time, it's so important to build a platform in order to give a voice
to people who have ancestral knowledge of the natural world. Speaking
with Maya Errázuriz from the Bosque Pehuén project of Fundación Mar
Adentro in Chile, she explained to me how the quest for the right balance
is a continuous challenge. Maya:

> Our residency program takes place in Wallmapu,
> which is Mapuche territory. This in itself is very
> attractive to many people, especially contempo-
> rary artists, and for a lot of international artists
> too. I've thought many times: 'Do you make that
> apparent and a thing in the actual open call? Or
> are you then utilizing the interculturality?'

It was a question neither of us had a clear answer to, though it was appar-
ent that ignoring this important information about the territory was not
an option, either. The territory holds a complex and problematic tradition
of universities coming in, taking information, and using it for papers and
research. Usually none of that is being taken back to the communities. It
makes it harder to establish a relationship with the Mapuche community
because they are, understandably, very hesitant toward the idea of col-
laboration. 'It means there is a dynamic of transaction, an expec-
tation to have something in return,' Maya explains. That has been a
good exercise for Fundación Mar Adentro, however, as it has given them
responsibility to think about what they can actually do in return, about
what makes sense to the community. Errázuriz is very aware of this re-
sponsibility and it's something I have often asked myself too when working
in the context of residencies.

> Am I doing something well by bringing an artist
> from Europe to introduce them to a member of the
> community and having that knowledge extracted
> and used for an artwork?

We agree it's questionable. Is there a way to even run a residency program
that is not disadvantaging animals, plants, and the community, and also
not compromising cultural and artistic production? A rhetorical question
that lingers for days after we speak. Maya ends our conversation on a pos-
itive note. She has seen how it can be beneficial for the Mapuche commu-
nity to have aspects of their culture heard and seen through a respectful
artistic collaboration. Maya: 'When something new is perceived that
makes sense to everyone, when a mutual benefit happens, that's
incredible. That's all that you work for.' The odds are that it only
happens ten percent of the time, I think, but I decide to leave it at that.

David Abram said in his book, *The Spell of the Sensuous. Perception and Language in a More-Than-Human World*, that 'we should all be students of subtle differences,'[12] a mission that I found mushroom identification the perfect exercise for. Being able to differentiate between mushrooms, of which some are close look-alikes, can be the difference between a delicious meal or serious poisoning. Another way to become students of subtle differences is to become students of ourselves, re-acquainting ourselves with our intuition, gut-feeling, and senses—the senses are our best available tools in helping us become students of subtle differences. Being able to smell the ingredients in a meal, feeling the temperature change, being able to pick up sounds that were inaudible or just sounded the same at first. It's the biggest challenge for those of us living in big cities as urban life forces us to switch off. With flashy screens bombarding us with ads, horrible stenches from sewers, traffic fumes, and the misery of our unfortunate fellow urban dwellers all around, we learn to close our eyes to our surroundings, a kind of survival strategy. Being sensitive to all of it would be unbearable, so instead we become zombies. De-zombifying (and becoming fungal) is more than an awakening of the senses. It's an end to the simplification of things, and embracing and recognizing complexity and specificity. It means becoming sensitive, literally being with your senses, being able to taste, smell, see, and touch in a deeper way, being able to notice the world around us changing. Climate change is more than disastrous floods and fires. It's also the quiet disappearance of insects and birdsong, slowly dripping ice, and stars we find harder and harder to see because of air and light pollution. Climate change has many disguises. Not only shall we de-zombify and re-train our senses, we shall use this renewed sensitivity to notice subtle differences and reforest our imaginaries about what the world could and should look like. Including a farm in Puerto Rico.

12.

David Abram, *The Spell of the Sensuous: Perception and Language in a More-Than-Human World*, Vintage Books Editions, 1997, p. 20.

HOW TO ESCAPE CATEGORIZATION?

Thinking and Being Non-binary

TEACHING SEVEN

Also known as the split-gill mushroom. This white,
fan-shaped mushroom has more than twenty-three
thousand sexual identities.

Yeast

Yeasts (*Saccharomyces cerevisiae*) are single-celled microorganisms that, through the process of fermentation, are crucial for making bread, wine, beer, and many other delicious foods.

Alternaria alternata, Giuliana Furci, Seba Calfuqueo, *Phallus impudicus* (common stinkhorn), *Schizophyllum commune*, Juli Simon, lichen, Patricia Kaishian, Tara Rodríguez Besosa, Maria Alice Neves, conidium, *amadou*, Comunidade Catrileo+Carrión, Fer Walüng, Brigitte Baptiste.

Geographies:
Wallmapu (Chile), A Brazilian mycology classroom.

A FUNGAL QUEENDOM WITH SEXY TWINS

As a self-proclaimed mycophile, yet unmistakably trained in the arts, I've often had to blag my way through interviews with true mycologists. People who study fungi deeply form a category of their own at times, not too dissimilar to a cult. They often wear fungi-related clothes (think of Paul Stamets's hat made of *amadou*, also known as tinder fungus, or *Fomes fomentarius*), have fungi tattoos, send fungi GIFs to each other (there are many), and make fungi-word jokes. I know this because the more I've learned about fungi, the more I've become like this. One of my favorite jokes that plays with fungal words came from Brazilian mycologist Maria Alice Neves, who likes to say 'Micorriza se estiver errado' instead of 'Me corrija se estiver errado'—a tad untranslatable from Portuguese, but basically slipping in a mycorrhizal network when saying 'correct me if I'm wrong'. Neves admits that she can't help herself and always plays with language, especially in the mycology classes she teaches. 'My students sometimes even feel embarrassed with all the silly jokes and don't laugh but they can't stop me from making them!' The thought of a classroom full of twenty-something mycology students not laughing at this joke was almost too much, and during my interview with Maria Alice Neves I found myself laughing hysterically. What an amazing woman.

Another thing that many mycologists have in common with each other is how they drop long and complicated Latin names of fungi with the

ease of talking about a friend in common. To not interrupt an interview
through my unknowingness and asking about which mushroom they were
referring to exactly, I would secretly, fanatically, make incomprehensible
notes. This classic case of pretending to understand left me having to
Google the guessed and cryptic names I had scribbled down. It helped if
I added '+mushroom'. Nine out of ten times I got it right. Yet dear Google
also brought me somewhere completely different, to a world that I had not
(yet) associated with mushrooms: porn. Warmed by the blush that always
catches my cheeks when I least want it, I told myself this was also 're-
search' and decided to explore more. A world of 'mushroom cocks' opened
up. A big throbbing fungus as a sexual organ appeared to be a rather
desirable thing to possess in the porn community, symbolizing masculinity
and pride. I opened another tab (also so that I could quickly click away
if needed) and searched for the common stinkhorn mushroom, in Latin
appropriately called the *Phallus impudicus* (*impudicus* being Latin for
shameless). And, yes, the resemblances were astounding! I never imagined
many points of connection between YouPorn and the Woodland Trust,
but the mushroom cocks and the stinkhorns were practically sexy twins.
I began to wonder about mushrooms and masculinity. I was aware that
there is a movement of people who are pushing to call the world of fungi
a queendom, rather than a kingdom. The first person to tell me about this
was Giuliana Furci, the founder of the Fungi Foundation. In our interview,
she referred to fungi queendom even though she was quick to add that the
term was scientifically incorrect. This simple and playful suggestion of a
name-change, however, actually opened up a lot of interesting questions. I
continued to look and came across a mycologist whose Instagram handle
was @queendomfungi. Clearly, this was the woman I had to speak to. A few
weeks later, when we manage to plan a call, Patricia Kaishian tells me that
the term queendom wasn't something that she felt had to be adopted sci-
entifically, but that she invoked as a way of making people stop and reflect
on terminologies that are 'pervasive and unquestioned'. The aim was
to give people a moment to reflect on the histories that are the foundation
of the sciences we are operating (with)in or are in relation to. More as a
moment of pause. Kaishian:

> Not only is it a masculine term; kingdom implies
> many other things. Not that queendom is better, but
> it means we are talking about ownership and a no-
> tion of control. It makes you realize it's not a totally
> innocuous word, whether or not you are intending it
> or engaging with it. It has meaning and those mean-
> ings are not simply at surface level. Especially when
> you probe further and further into foundational
> ideas within science, you find and realize there is a
> lot of legacy of social order in the ways we are con-
> ducting science. The term 'queendom' is not a cure,
> but it's a way of making people reflect.

While she is on a roll, I ask her about other terminology we need to review and she stays within the domain of gender.

> The first thing that comes to mind is notions of sex; discussions of male and female and reproductive structures. In science, outside of human discussions, organisms are not gendered. Only humans are gendered because it's a social construct. Maybe there are people that disagree with that, but these are the definitions that I'm working with.

ANARCHIST MUSHROOMS

Male and female are still loaded terms. '<u>You wouldn't see that tree as a man, but you could say that that tree is a male because it has particular structures</u>,' Patricia posits.

> I've been reflecting on this more and more, in conversation with colleagues and in conversation with some of my students, about whether it is okay to use male and female when we are not talking about humans. I don't think I have a clear answer on that, but I've basically decided I'm not just going to use those terms without describing what I mean and putting quotes around them. In literature, it's all discussing male, female, male, female in this binary way, and there are some scientific bases for obviously having two primary points on a spectrum that most organisms will pull around.

It's true that there is a lot of meaning bound up in male and female that also goes un-interrogated. Kaishian:

> Typically, when you push your conversation to figure out what we really mean when we say male and female, it's usually some sort of function and some sort of combination of structures and behaviors. But even outside of humans they become harder and harder to pin down definitionally. There's an interesting space for conversation around it. I don't think it's wrong or specifically harmful to provoke the terms male and female, but it makes you question the usage and how useful it actually is. With fungi, because they are so infrequently binary, you can have thousands of mating types within a species. Male or female, there are potentially tens of thousands of different combinations of genes that can give different

types of arrangements. But it's really common in animal biology and animal behavior to just have the male and the female. I won't say that I think these terms should be removed, but it's definitely a great place for conversation, with your students, colleagues, and other people.

The numbers she shares with me are quite overwhelming, those tens of thousands of different combinations for fungal sex. It makes our human categories of LGBTQIA+ suddenly sound ever so limiting in terms of sexual preferences. When I speak with mycologist Juli Simon, who works in the Brazilian Amazon, and who identifies as non-binary, it becomes more technical:

If you have two different mycelia trying to mix there is a system of compatibility that is not about the gender of one or another; there can be over twenty thousand compatibilities. It's got nothing to do with male or female.

Basically, Juli is saying that the mycelium teaches us that the mushroom is not binary as the mycelium can go anywhere, hook up with anyone. There is a strikingly clear lesson here that we can use as a reference, and as direct inspiration, to free our human and rather boxed-up and limited understanding of gender and sexuality. Juli continues: 'Knowing that they don't have a mating type that is binary really made me impersonate and connect with mushrooms. They are anarchists!' After having conducted a dozen interviews or so, it suddenly dawned on me that not just Juli, but quite a few of the other interviewees didn't feel aligned with hetero-normativity. Was this a coincidence or not, I wondered...?

Patricia Kaishian has a theory about this, based on having read a study that the Mycological Society in America had conducted. The MSA is one of the biggest and oldest (founded in 1932) mycological societies in the world. Though a 'Mycological Society' sounds rather Harry Potterish, it is basically a platform to bring mycologists together to exchange knowledge. Most countries have one, though some are significantly smaller than others. The Mycological Society of the United States also has a committee focused on diversity, and has initiated a survey identifying the percentage of LGBTQIA+ mycologists within their society, which consists of several hundred people. Of all the respondents, twelve percent identified as LGBTQIA+. Patricia Kaishian notes that it was maybe not a 'perfect study' but that, nevertheless, it's interesting information that could, and should, be explored more given that this percentage is a lot higher than in a regular science lab.

There is definitely research potential there, confirmed by Kaishian's funny anecdotes about being in a room full of mycologists and realizing they were all queer. It led her to write the compelling essay 'Mycology as a

Queer Discipline', in which she argues that mycology relies upon queer methodologies because of the 'non-binary, cryptic, and subversive biological nature of fungi.'[1] Fungi disrupt the binary conception of plants versus animals because they possess a mixture of qualities common to both groups. In addition, they demonstrate there is much more possibility beyond the two-sex mating system. Kaishian gives the example of the *Schizophyllum commune*, a mushroom that has as many as twenty-three-thousand mating types.

> When two compatible fungi meet, their mycelia
> will fuse into one body, sexually recombine, then
> remain somatically as one as they continue to
> live, grow, and explore in their environment.

I read in her essay. Kaishian in person:

> The *Schizophyllum* genus and specifically the
> species *Schizophyllum commune* is known to have
> the greatest number of sexes studied thus far.
> It's a wood-decaying fungus and so performs the
> critical function of breaking down and recycling
> organic matter including nitrogen, carbon, and
> phosphorus.

Patricia also has some other interesting facts about the *Schizophyllum commune*, such as how it can strangely infect humans who are severely immunocompromised.

> People can become very ill as the fungus can
> establish itself in the human body, which is also
> very interesting and sort of strange. We don't
> know much about it; the fact that it can go from
> being a wood decaying fungus to living inside a
> human body is not a very well understood phe-
> nomenon.

MORE LIQUID AND LESS SQUARE

Fungi can reproduce both sexually and asexually. Though the asexual reproduction is a slow process, there are many different fungal strategies of propagation. Asexual spores are produced by cell division and the most common type of asexual spores are called conidia. *Alternaria alternata*, which is the common black fungus that causes black spots on fruit and vegetables and can cause allergies in humans, is an example of a fungus with hypha that bears conidia. Mycologist Maria Alice Neves shares with me that ever since she started teaching about fungi in schools and universities, she has been advocating that we should all be more like fungi. 'You have to accept diversity and fungi are diverse and you can't be prejudicial, especially with that which we don't know.' When I ask her what the most important lessons from fungi are for her, she also agrees

1. Also further articulated in Mushroom Hour's podcast: www.welcometomushroomhour.com/blogs/podcasts/ep-101-queendom-fungi-mycology-as-a-queer-discipline-feat-dr-patricia-kaishian.

Seba Calfuqueo, *Simbiosis*, 2021, 100 x 67 cm. Photo: Diego Argote.

1 7 6

that this is probably regarding sex or gender, or as Neves calls it 'to not see as square as we always tend to see.' She too reiterates the incredible number of different combinations that we can consider sexes or genders in terms of pairings for fungi. Neves:

> If we think of that as a way in which nature is stopping interbreeding and making fungi prosper, it is such a good example of how we could see ourselves. Being less black and white about our sex, as it is much more liquid and really not so square. I think that's a way fungi teach us to become less prejudicial and more inclusive.

EPUPILLAN

2.

See: Walter L. Williams, The "Two-Spirit" People of Indigenous North Americans', *The Guardian*, October 11, 2010.

Being non-binary is nothing new. Also for humans. In fact, in many indigenous cultures the people of 'two spirits' means that they are doubly blessed, the most spiritually gifted and, therefore, highly respected.[2] They often have the role of the shaman, a teacher, or spiritual or religious leader, or other special duties within the community. It was the colonists—the Spanish in Latin America and the English in North America, and later the conservative Christian Church—that introduced the homophobia, discrimination, misogyny, and stigmatization of the so-called fluid third gender. Non-binary people were condemned by the Church as sinners and sodomites. In Mapuche cosmology, people who did not inhabit one gender used to have a very special status, and the ability to connect with both male and female forces. They were called *epupillan* (also literally meaning a person with two spirits), referring to a type of spirit that is a higher entity than a human, a spirit that is infinite. I learned that *epupillan* can not only move between the feminine and the masculine, but also between animate and inanimate life connected to the earth (the *Mapu* in Mapudungun). That means that they can help people connect with biodiversity (*itrofil mongen* in Mapudungun). The work of artist Seba Calfuqueo, non-binary and of Mapuche origin, is auto-biographical, poetic, and performative, telling stories of what it was like to grow up being bullied over having a Mapuche background and for being non-binary. The work I went to see was part of the exhibition 'Árboles torcidos' at the Art Gallery of the Universidad Católica in Temuco and illustrates the strong environmental dimension of issues around gender and culture. In a series of photographs, Seba's beautiful long hair is braided with the lichens of the forest. In a video work they bathe in the river and leave a long trace of deep blue textile. In my attempt to learn more about *epupillan*, however, I had little success. This part of colonial history is sparsely documented and largely erased. Besides more general information about the two-spirited, a lot of archival information and other historical documents about *epupillan* have been destroyed. The colonists left a hole in the documented history. A key source of stories and knowledge is Comunidade Catrileo+Carrión, a queer/trans/nonbinary Indigenous epupillan

Comunidade Catrileo+Carrión, *kiñe lafken, ngelay afpun / One ocean, no borders / Un océano, sin fronteras*, 2021. Film still from full HD video-essay, 11.16 min. The work is a recording of a ceremony/performative work in which two textiles are offered to the great body of water of the Pacific Ocean that connects the members of the collective living in Pikunmapu /Qullasuyu (Valparaíso, Chile), with the other members that currently live in Kumeyaay land (in San Diego, California).

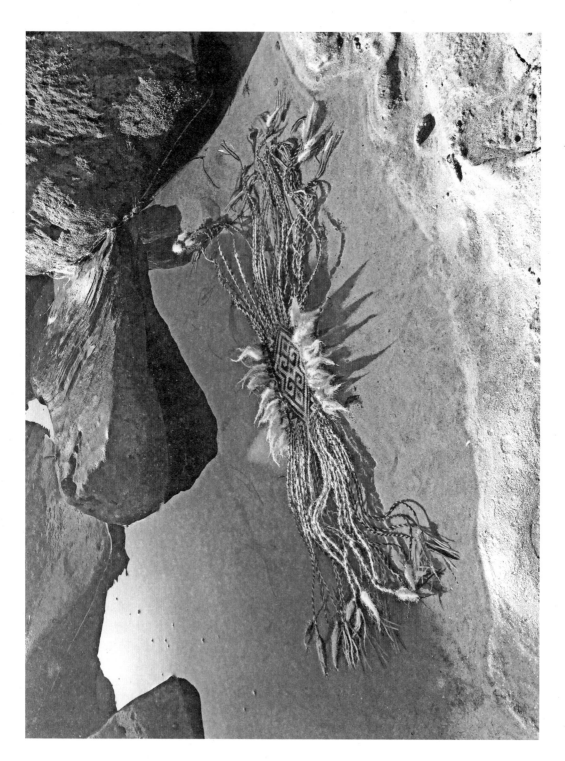

(two-spirit) community comprised of five artists. They dedicate their research to the tradition of *epupillan* beings in Mapuche society. Their artistic research 'seeks to form social and artistic relationships that transcend a hetero-patriarchal regime.' As a collective, they protect knowledge about *epupillan*, which for them is a way to keep the ancestors' memory alive. The term is not solely descriptive of people who identify as non-binary, they explain in a text written for *Terremoto* magazine, but for people who do not identify with heteronormativity, who position themselves as free beings, 'sexual dissidents', and those who refuse the violent repression of coloniality. In the article, they describe how 'it's not just a category of gender and/or sexual preference', but much more than that. It's entangled with anti-colonial and anti-racist values. Antonio Catrileo Araya, Constanza Catrileo Araya, Malku Catrileo Araya, Alejandra Carrión Lira, and Manuel Carrión Lira, the members of the collective, are actively retrieving and documenting stories and memories of *epupillan* using the language of the arts, and particularly through Mapuche weaving, a source of ancestral knowledge.[3]

3. See: terremoto.mx/en/revista/utopias-epupillan-para-el-presente/.

Speaking with Mapuche mycologist Fer Walüng about non-binarity, she of course mentions the diversity of fungal genders, but also brings up the Pehuén, the Araucaria tree that is central to Mapuche cosmology. She explains to me how, depending on the necessity or the place, the Araucaria is able to change sex. In order to reproduce, the trees first produce a lot of *piñones*, the seeds, for two or three years. After a year or two, the process of self-fertilization takes place, in which time the tree does not yield *piñones*. Fer also explains how the mycelium can have a remarkable diversity of forms, from polymorphous to homogenous, and how it is constantly changing. Fer:

> If you observe the sexuality of plants, animals, mushrooms, insects, you will see that gender is imposed by us, by the system, by the ideology of capitalism. This deprives us of liberties. As with our own preferences; as soon as you are born things are already fixed; you are given a name; your gender is determined and that includes a color such as pink or blue, and often even the role you are expected to play—as a man or a woman— is fixed.

Fer thinks that Chile, her home country, is particularly backwards when it comes to the inclusion of different gender identities, the result of a lack of education about it, and generally conservative thinking. 'There is no acceptance of the idea that we are non-binary beings and that social sexual gender is imposed by ideology.' She explains that often men are far removed from their female consciousness, from their feelings, because they are taught from birth to conform to certain patterns

that constrain them emotionally and spiritually. Fer:

> And then feminism comes in and demands re-
> spect for many important, valuable things that
> are essential in life. But they hit a wall because
> many men have never learned to express their
> emotions. As a result, women get blamed for the
> problems.

GENDER POLITICS IN LANGUAGE

Moving to new countries and having a nomadic life, I've had to learn new
languages, which I considered to be both a joy and a pain. A joy in theory;
being excited about that hypothetical moment at some undefined point in
the future that I would perhaps master the language, and a pain in reality
as the learning process was always much slower than I wanted and imag-
ined it to be. Something that was very present in both the languages I was
learning, Spanish and Portuguese, was how everything had to be either
male or female. Quite different from the articles 'de', 'het' and 'een' in my
native Dutch language. As I was mumbling my way through these bina-
ries, often embarrassed with my mistakes, I noticed many people in my
environment, many interviewees, were actually not bothered about main-
taining these male/female structures. I was introduced to using *cansade*
for the word 'tired', rather than using *cansado* (for a male) and *cansada*
(for a female). *Amigos* or *amigas* were *amigxs*. Among my interview-
ees, I observed a desire to make language less binary. Puerto Rican queer
food justice activist Tara Rodríguez Besosa connects binary language
with agriculture.

> A lot of what I've experienced as a queer identi-
> fied person is how binary language translates into
> the language of agriculture and growing food. Not
> only heteronormative practices and monocultures
> are homogenizing everything, but also the way we
> speak about plants and about farming is very much
> affected by the effect of binaries in our language.

It is true that the articles *él* and *ella* are everywhere in Spanish and Tara
and myself wonder what would happen if we stopped separating both.
Would this also allow us to stop separating ourselves from nature? No
more us and them? It's something I've been practicing ever since, covering
up my linguistic mistakes in the desire to emancipate language.

FEAR OF THE UNBOXED

The point of many languages and sciences is generally to seek clarity and
functional objectivity in binaries and boxes. Yet objectivity is more often
than not a political fiction, an impossibility, especially when it comes
to gender and queerness. Though the idea of categorization is useful, it
doesn't always work—and not in science, either. In her mycology classes,

mycologist Maria Alice Neves explains that her students are often confused and want to put the fungi they are studying into boxes of categorization. Neves:

> I don't really follow the ecological rules for fungi because the students are always obsessing about them: 'Is this a decomposer?' 'Is this a mycorrhizal?' 'Or is it symbiosis? Or what type of symbiosis?'

Maria Alice Neves's answer usually is:

> They are what they are. We can try to put tags on them, but it can be a mycorrhizal fungus that is connected to a root and that can also be predating and killing *collembola* (a soil-dwelling arthropod; a small invertebrate animal with an external skeleton that lives in the soil) to give animal nitrogen to that plant. How do we define that organism?

Neves had to repeat that sentence for me to fully understand it, and then I got her point: fungi can have contradicting behaviors and there are many exceptions to every rule. Does it make sense to obsess over taxonomies, or should we be focusing on the relationships between species instead?

To not be so easily boxed and categorized is a quality that seems to be hard to accept for some people. This fear of the unboxed could be the root of both myco-phobia and queer-phobia. People have a hard time dealing with fluidity and things that don't fit in their boxes. In 'Mycology as a Queer Discipline', authors Patricia Kaishian and Hasmik Djoulakian trace this binary thinking to Christianity. As explained in the text, scientists were strongly influenced and sometimes even financially supported by the Church. Even philosophers like Descartes were loyal to the Church in their 'supposedly objective pursuits of knowledge'. The influence of the Church was all-encompassing, even projecting Christian values concerning domestic and marital structures on to agriculture. Kaishian and Djoulakian refer to this as 'agro-heterosexuality'.[4] In the book *New Perspectives on Environmental Justice*, edited by Rachel Stein, what this term refers to exactly is described more extensively. In a nutshell, the seeds of the crops were considered to be male and the land that had to be fertilized was supposedly female. Anything outside of this Christian binary wasn't natural. Any contemporary scientist, however, can confirm that this is far from the reality. 'Nothing is more queer than nature' is one of the great pearls of wisdom of Colombian scientist Brigitte Baptiste. In 2018, I attended a talk by this transgender scientist who is an advocate of both gender and biodiversity. The talk took place in Amsterdam, inside the framework of the 'Louder than Words: Global Leaders on the Frontline of Culture' seminar by the Prince Claus Fund. Baptiste arrived on stage in a spectacular dress with big butterflies and turquoise-dyed hair, making an

4.

Patricia Kaishian and Hasmik Djoulakian, 'The Science Underground: Mycology as a Queer Discipline', *Catalyst: Feminism, Theory, Technoscience* 6, no. 2 (2020), p. 6.

unforgettable impression, and not just because of her appearance. Her powerful statement that cultural diversity is part of nature's diversity has stayed with me ever since that day. In clear and powerful terms, she explained how biodiversity and cultural diversity are linked and en-twined in a dance with each other. After all, diversities are the result of change and the world is constantly changing. This also implies that we have to build a cultural view of biodiversity. Because of the constant change, we are forever losing perspective, according to Baptiste, and simplify and become detached from the natural world. Science tends to look at nature as something separate, while science is a product of culture. Baptiste suggests we understand the living variety of the world in its totality, including humans and non-humans—biocultural diversity—advocating that, and this is how she ended her talk, 'nothing is more queer than nature.'

READY TO TRANS-FORM

Fungi teach us that nature is queer indeed. They challenge narratives about binaries and resist against being boxed and categorized. It's the fear of the unclear, the non-normative, the fear of change, the inability to keep up with change, and the fear of not knowing that lures us into boxed and binary thinking. Though of course it is helpful in science to categorize, fun-gi show us there are always exceptions to rules and always more options than you think. This is demonstrated by how they challenge the idea of hetero-normativity with their mind-boggling number of genders and sexual compatibilities. Whether informed by Christianity, coloniality, or agro-het-erosexuality, we live in a society ridden with queer/homo-phobia, sexism, and racism, all based on binaries. Ironically, it's exactly the non-binary, the unclarity, the instability, the change, the not-knowing that will become more prevalent in a future dealing with climate collapse. The speed of change will increase and the behavior of the natural world, including the weather, will be increasingly erratic. We already see the genders of frogs changing as a result of pesticides and have no idea which other conse-quences await us. It's the mutability and adaptation that we see in fungi that are the crucial survival skills for the instability ahead. By being and thinking less binary, we prepare ourselves to trans-form.

WHAT ARE FUNGI TEACHING US ABOUT MULTISPECIES MODELS OF COLLABORATION?

Collaborating with the More-than-Human

TEACHING EIGHT

Featuring:
Termitomyces titanicus, Camila Marambio, Tara Rodríguez Besosa, Renata Padovan, Lilian Fraiji, *Marasmius Yanomami*, Maya Errázuriz, *Metarhizium*, *Përisi* fungus, molds, Brandon Ballengée, Sofía Gallisá Muriente, Ursula Biemann and Paulo Tavares, Maria Alice Neves.

Geographies:
Tierra del Fuego (Chile), Rio Cuieiras (Brazil), Balbina (Brazil), Wallmapu (Chile), Nangaritza River valley in the Cordillera del Condor region, Lago Agrio oil fields (Ecuador), Cabo Rojo (Puerto Rico).

LEAFCUTTER ANTS

One sweaty afternoon, tired from an intense hike through the dense and humid tropical rainforest and on our way back to the boat, I thought I was hallucinating. I had been focusing my gaze on the forest floor to avoid tripping over the rocks and branches and suddenly saw hundreds of little pieces of leaf dancing in my path. The leaves, about half a centimeter in size, were swaying like they were moving to a banging beat that was inaudible to me. Then, for a split second, I thought I was dizzy, until I realized nothing was actually wrong with me. I stopped to have a closer look at this ant party.

The boat was moored further down Rio Cuieiras, an affluent of Rio Negro, the largest blackwater river in the world. We had travelled for days downriver from Manaus to get to this impressive dense part of the forest. We, a group of artists and scientists participating in the Labverde residency program in the Amazon, were learning about the forest, the carbon cycle, dendrochronology, the different types of landscapes within the forest, the cosmologies of people living in the forest, forest fires, and the domestication of the rainforest, among other things. We even visited a flooded forest, a horrific consequence of the Balbina hydro-electric dam and a nightmarish sight I will never forget. For hours we cruised in a little motorboat through what was basically an eerie liquid-forest graveyard with endless dead branches sticking out of the water. It was warm and

without a breeze or any sign of life in the water, except for the occasional pirarucu, a monstrous-looking fish I had encountered in an aquarium at the INPA, the Institute for National Amazonian Research, and ate grilled on my plate a few days before. The all-round feeling of despair and discomfort made it the perfect setting for an alarming artwork by Brazilian artist Renata Padovan, one of the participating artists in the Labverde program. She painted branches red using food coloring, almost like they had been dipped in blood, and photographed them. The world needs to see what had happened to this area, a haunting spectacle that would otherwise stay out of sight, just like the people who had previously lived in this forest before the dam was installed. Before they had all been displaced. With no guardians left to raise awareness about the devastating consequences of the hydro-electric dam, Padovan shared this apocalyptic image of what had happened, and what is planned to carry on in Brazil.

Before my trip, I had naively romanticized the Amazon as this paradisiacal and serene place. Being there, the forest kept on revealing herself as a rather busy place: buzzing with energy and constant activity, always full of surprises (oh hello tarantula!), and everything in communication and relation to each other. On closer inspection, the dancing leaves that had caught my attention were carried by hundreds, if not thousands, of ants. Our local guide Ricardo Perdiz explained that these ants were at work for a fungus. The ants can't actually digest the leaves themselves, but were delivering this food order to a fungus nearby. The ants are picky and thus excellent delivery folk, only choosing leaves that the fungus likes most, even carefully treating them with homemade antibiotics when there are too many bacteria on them. In exchange for their hard labor zealously cutting, dragging, and delivering the leaves in bite-size pieces, the fungus breaks down the cellulose and converts it into sugars and proteins upon arrival; a well-deserved reward for the ants. When they have to pack up and leave to find a site with fresh leaves, the ants carry the fungus to the next location on their backs. This collaboration is not only a beneficial deal for both parties, but a matter of life and death. The ants need the fungus and the fungus needs the ants. There is mutual exchange and a symbiotic relationship.

Spending time in the forest made me see things differently. It taught me to look, and to look again, calibrating, tuning into details. After every hike, I started to see more co-dependencies, complexities, and layers between all the more-than-human actors. Initially distracted by the heat and damp of the forest, what first looked like trees became intricate webs of relationships and communication. Everything came alive; nothing was identical anymore. Every leaf had a different pattern; some of the bark had been gnawed on, and I now saw insects, fungi, and small (and occasionally big!) animals in all colors and shapes everywhere. It is mind-blowing to realize that only a very small percentage of these complexities and interrelations are visible to the human eye. Even more of it happens on a microscopic level, or changes will only be visible over the course of a decade.

Lion's Mane (*Hericium erinaceus*) is an edible mushroom
known to improve brain functions.

Turkey Tail

Turkey Tail (*Trametes versicolor*) is a polypore
mushroom full of antioxidants. The colors of this bracket
fungus are variable.

Morel and baby Morel
(Classic Morel)

Recognizable by their distinguished honeycomb caps,
morels (*Morchella esculenta*) are wild edible mushrooms with
an earthy and nutty flavor.

Morel (Classic Morel)

Labverde is an incredible residency program to get immersed in the forest and, in more recent years, they have developed a program called Fungi Cosmology, a transdisciplinary research project by a group of artists, scientists, curators, and anthropologists. The idea is to develop new knowledge and languages from the observation and analysis of the symbiotic relationships of fungi. The residency program is held in both Patagonia and in the Amazon and is dedicated to building narratives about the multispecies landscapes of the two reach territories in order to disseminate the importance of the fungi kingdom and its relevance to the future of the planet. Lilian Fraiji, one of the curators of Fungi Cosmology and founder of Labverde tells me that it's important for us to all get out of our bubbles; the mycologists, the artists, and all the other scientists. She set up the program because she felt it was important that we start working with the forest across our disciplines. After years of bringing together international artists and scientists in the Amazonian rainforest, Labverde is now moving toward bringing environmental content to festivals and working with local artists. Lilian: 'Music, dance, sound... we reach bigger audiences, the people are young, and the atmosphere is fun!' I get her point.

COLLABORATING WITH THE FOREST

The Amazonian rainforest accommodates species of trees that host up to more than two thousand creatures and critters, all feeding off each other. The forest presents itself as a place of hyper-specificity and entanglements to those who open their eyes. Smells and sounds are amplified by the forest. Whether it is the absence of the air pollution and fumes we have become so accustomed to or the continuous buzzing of traffic and other forms of urban noise pollution, my ears and nose experienced a feeling of relief in the forest. But don't be mistaken: not because of a peaceful tranquility—the opposite was true! You hear and smell an abundance of life. The various sound artists that were part of the Labverde program were in for a phonic treat in the Amazonian rainforest, which allowed for incredible recordings. Artist Simone Moraes de Barros was recording the sap running through trees, others the mysterious underwater bubbles, or the haunting calls of the howler monkeys and an overwhelmingly loud dawn chorus. Drummer Lisa Schonberg made music compositions based on her recordings of leafcutter ants on the move. She started working with a myrmecologist (an ant expert) from the Federal University of the Amazonas, which resulted in a collaborative research project encompassing bioacoustics, field recordings, behavioral ecology, taxonomy, music composition, and acoustic ecology. The forest proved to be the place par excellence to investigate soundscapes and biophonies, forming beautiful collaborations across species and contributing to a less anthropocentric perspective.

The forest itself is a generous collaborator, storing a multitude of knowledge, voices, stories, and secrets that go far beyond human histo-

ry, beyond the natural sciences, beyond the arts, going further back in
time than we can imagine. We risk losing access to an understanding and
a sense of the rhythm that revolves not around clock-time, but is driven
by other forces. However, the decisions we make in the here and now
regarding our forests are decisive for a deep future, including deforesta-
tion, species extinction, and the loss of habitat. Though this is alarming,
human intervention in the forest doesn't have to be destructive. There are
thousands of years of good examples of sustainable modes of co-existence
between people and forest in the Amazon, emphasized by the existence
of anthropogenic dark earth; highly fertile soil full of biodiversity, and
created by the compost heaps of indigenous people. The people living
with, collaborating with, the forest have always known how to turn a dump
heap into a garden, making good use of ash and charcoal as fertilizers. It
demonstrates that there is no such thing as the 'untouched forest' and
perhaps it's not even something desirable. Humans can create, contribute
to biodiversity, and construct beneficial environments, just like all other
species, and like Robin Wall Kimmerer's example of the flourishing sweet-
grass living among people. Anna Tsing also contextualizes the possible
impact of humans on nature in her book *The Mushroom at the End of
the World*:

> Making worlds is not limited to humans. We know
> that beavers reshape streams as they make dams,
> canals, and lodges; in fact, all organisms make
> ecological living places, altering earth, air, and
> water. Without the ability to make workable living
> arrangements, species would die out. In the pro-
> cess, each organism changes everyone's world.
> Bacteria made our oxygen atmosphere, and plants
> help maintain it. Plants live on land because fungi
> made soil by digesting rocks. As these examples
> suggest, world-making projects can overlap, al-
> lowing room for more than one species. Humans,
> too, have always been involved in multispecies
> world making. Fire was a tool for early humans
> not just to cook but also to burn the landscape,
> encouraging edible bulbs and grasses that attract-
> ed animals for hunting. Humans shape multispe-
> cies worlds when our living arrangements make
> room for other species. This is not just a matter
> of crops, livestock, and pets. Pines, with their
> associated fungal partners, often flourish in land-
> scapes burned by humans; pines and fungi work
> together to take advantage of bright open spaces
> and exposed mineral soils. Humans, pines, and
> fungi make living arrangements simultaneously for
> themselves and for others: multispecies worlds.[1]

What Are Fungui Teaching Us about
Multispecies Models of Collaboration

1. Anna Tsing, The Mushroom at the End of the World: On the Possibility of Life in Capitalist Ruins, Princeton University Press, 2015, p. 22.

Renata Padovan, *Irreversible Series*, 2018. Natural food color on tree. Intervention at the Balbina Hydroelectric Dam, Amazonas, considered one of the biggest reasons for ecological disasters in Brazil.

193

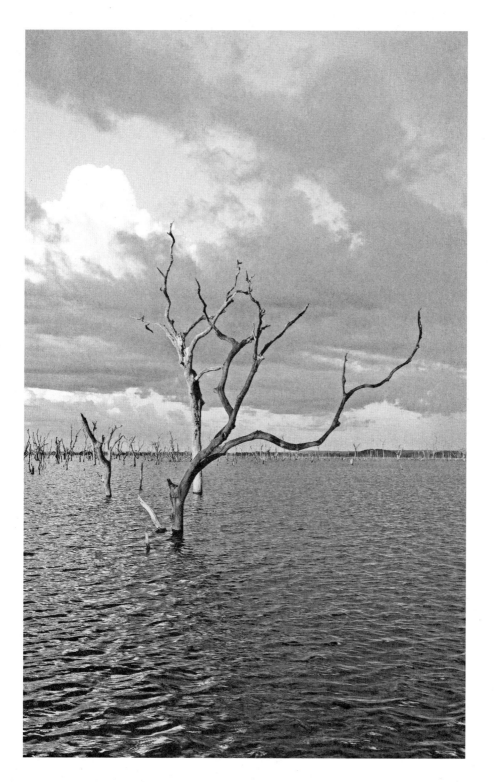

There is a role for humans as co-creators of abundance and collaborators with more-than-human life. However, the narrative of the human as destructor dominates, often informing our notion of nature conservation. When I speak with Maya Errázuriz, curator at the Fundación Mar Adentro residency program in Bosque Pehuén in Chile, she explains to me the different approaches to conservation. The foundation actually started as a conservation project, as a privately protected, 882-hectare natural reserve located between the Villarrica Volcano and the Quetrupillán Volcano in Araucanía Andina (Wallmapu). Maya Errázuriz:

> When you're working in a conservation area, nature is your prime focus and you are constantly working to make the conditions available for the more-than-human species. When you think of it from a research perspective or a residency perspective, it definitely sets the mood very differently.

We discuss how the idea of conservation is generally conditioned by putting plants, trees, and animals first, so it predisposes you to already have a lot more respect for other beings. Maya analyzes how in a residency, when you come in without this context,

> you aren't immediately that aware or internalize the idea that you are interacting with the species and that you are affecting a natural space from the moment you enter it.

It's true, your impact is generally not the first thing you think of when you enter a forest or national park. We often see forests as something there for us to enjoy. Think of *shinrin-yoku*, the idea of forest bathing to increase our own well-being. But what about the well-being of the forest? Maya Errázuriz:

> Many times, I feel people have this idea of nature around how you have the right to be in nature, you have the right to enjoy nature, and with conservation in particular sometimes, that's really difficult because in a sense you prohibit certain human circulation, prohibit access to certain spaces, and people have a hard time dealing with that.

Conservation can be controversial when it's about prohibiting access to certain spaces. She continues:

> I think with the residency program, as well, we've been really working and focusing on seeing how the zoning plan in the conservation area is respected by the residency participants. They won't

be aware that going all the way to the waterfall
and then to touch the waterfall is not the best for
the water. It's only good for them. Being there is
super difficult, I would say; it's not easy to see
what's the limit of being in a mutually beneficial
relationship when you're working with more-than-
human species and living beings. Being in the
forest helps you have more respect for it. At the
same time, your very presence in that forest is
already having an effect. All of that is super inter-
esting, thinking about how you work with nature.
Everything that you do has a potential rippling
effect.

A similar thing had come up in my conversation with artist Sofía Gallisá
Muriente, who at one point was co-directing an artist-run space in Puerto
Rico called Beta-Local. Beta-Local was founded with a clear mission to
be rooted in the local. As a place for artists to work from the context of
Puerto Rico. Gallisá Muriente acknowledges that the context is, of course,
always shifting, and never singular or static, particularly in the case of
Puerto Rico, a place where 'everything is falling apart', and where the
tropical climate and nature 'are constantly eating away at things and
are impossible to ignore.' Central questions in her practice include:
'What is memory, what is preservation, and what is archive in a
place where things don't last?'
 To collectively start thinking about these questions, she once orga-
nized a symposium for which she had invited an archivist and a mycolo-
gist to have a conversation with each other. She asked them to elaborate
on the question of whether preservation was about maintaining materials
intact or more about making materials accessible? In other words: Is it
more effective to preserve something in a vault forever or to have people
know about it and use it so that it continues to be known and spread? The
opinion of the mycologist was that if you wanted things to survive, you'd
be better off taking them out of Puerto Rico. A biologist in the audience
made an important remark aligned with Gallisá Muriente's thoughts:
'What if we considered those animals and molds that attach
themselves to historical documents as additional information?'
After all, they also contain information about a place.
 With the all-encompassing hurricanes, heat, and humidity on the
island, the conservation and preservation of things, including art, remains
an issue. Tony Cruz, one of the founders of Beta-Local, even commented
to Sofía once that 'all art in Puerto Rico should be ephemeral.' This
influenced her thinking a lot and in her own art work Gallisá Muriente has
really embraced the workings of the elements. She likes images to be creat-
ed outside of her control. It's an exercise in surrendering control. Sofía:
 There are all these other things at play. From light

and the camera, to the environment. I wanted to allow for those things to also have a hand in crafting the image.

A great storyteller, she recounts to me a compelling anecdote of when Hurricane Maria hit Puerto Rico and how she embraced working with humidity, salt, and molds.

Sofía:

Years ago, years before Hurricane Maria, I went to visit the herbarium of the University of Puerto Rico. When we got there, the director of the herbarium was manically moving big boxes full of specimens in and out of big meat freezers. He said 'Give me ten or fifteen minutes. I can't help you right now.' He was so busy. He later explained to us that he had to perform this laborious ritual every two weeks; he had to rotate specimens in and out of these freezers to make sure they didn't get any pests or any mold or insects would go into them and eat them. That really struck me and made me think a lot about all of the ways in Puerto Rico we are constantly fighting against climate, fighting against the reality of the place that we are in. We do it mainly through air conditioning, but it's just a losing battle. It's uncontrollable and totally beyond our grasp, to deal with humidity and this amount of salt in the air. It wasn't until Hurricane Maria passed that the presence of that humidity was really overwhelming. The power was out, it was flooded, mold was growing everywhere... You could just see it everywhere. Things that are usually invisible were right there, all these climatic forces of degradation were visible. And me as an allergic person I was so susceptible to it, with all these allergies. I felt like there is this thing that is invisible that is eating away everything now, and how do we make that visible? I had a bunch of film in my freezer and when the power went out, I was so aware of the fact that all of this film was rotting in my freezer and that I should do something with that. I started asking myself: How can I make this deterioration, this decay, visible on film? That's where it started. I was so lost and confused in many ways and was wondering what art-making still makes sense after everything that had happened. I was committed to

participating in an exhibition six months after the hurricane. I was supposed to be producing something. It made no sense to produce what I had been meaning to produce initially. I was uncomfortable on the photographer's side of the camera, because so many people were making so many images of destruction and pain and people suffering. All of these things combined led me to think that what I really want to do is to make all of this decay visible. I started talking to Kathryn Ramey, an American filmmaker whom I had been collaborating with at the time. She had been making a film in Puerto Rico and I was assisting her. She is very knowledgeable about hand-processing techniques and she knows a lot about chemistry. I asked her how to make molds and decay visible on film. One of the first things she explained to me is that the film has to be shot and exposed already. She also explained that black-and-white film, since it has a silver base, responds to salt. While color film, which has a gelatin base, an organic base, responds to humidity and mold. I decided I was going to experiment with each. Fortunately, at home, I had one roll of black-and-white film that I had shot previously and one roll of color film. I began working with the black-and-white film and the salt. There is a lot of salt in the air where I used to live in old San Juan because I lived really close to the water. I lived right between the Atlantic Ocean and the San Juan Bay so the salt water there corrodes everything. However, it is a very slow process. I was fascinated by the fact that salt also absorbs humidity. It is used to dry things. I started reading a lot about the history of salt, just out of curiosity, and it's really interesting. The history of salt and the chemistry of salt are tied to colonialism and imperialism. Whoever could control salt could navigate furthest because food could be preserved on the ships. The chemistry is so fascinating because it soaks up humidity but it also releases heat, and that's why you can melt snow with it. When I was reading about the chemistry of salt, I found this line that said that when salt was eating away at the film and creating crystals on the film, what it was doing was breaking apart the larger molecules to

turn them into smaller molecules and assimilate them. Not an assimilation in the sense of cultural assimilation, like a form of erasure, but much more about digesting something, like assuming and internalizing. To me, this idea that destruction and assimilation can be parallel processes that can support each other really blew my mind. Particularly in the face of all the destruction caused by the hurricane. What are the things that can be best assimilated now that this destruction has happened? What kind of images need to be destroyed in order to be assimilated? It was a little scientific fact that I really felt I had to hold on to. So that whole series of works that I made around bio-deterioration is called Assimilate and Destroy. It was like finding poetry in a science book; this scientific fact could open up other forms of understanding.

2.

Sofía Gallisá Muriente collected her salt in Cabo Rojo, a natural reserve where salt has been produced since pre-Hispanic times. It's a federally managed natural reserve—the United States Federal Government controls most of the natural reserves in Puerto Rico. Salt has been produced for so long that is has become a part of the ecosystem. The Federal Agency of Fish and Wildlife needs to make sure there is commercial salt production happening in order to support all of the animal and plant species that live there. This idea, that an extractive industry, a capitalist industry, becomes part of the ecosystem blew Sofía Gallisá Muriente's mind, and mine. Extraction that has become entangled with conservation.

NATURE AS ARTISTIC INSPIRATION

There is a long tradition of artists using nature as their inspiration, from the Romantic paintings of landscapes to the Land Art movement in the nineteen-sixties and nineteen-seventies. Land Art was considered the first entry into artists working with nature as a collaboration partner, sculpting the landscape by making interventions and using natural materials. One of the most famous Land Art works must be *Spiral Jetty*[2] by Robert Smithson, for which he re-organized black basalt rocks and earth into a giant coil shape in the Great Salt Lake in the United States. In the light of the current art/ecology movement, this is not perceived to be exactly collaborating with nature anymore. How does it benefit nature to be re-shaped like that? Can we still even use nature as romantic inspiration or does a collapsing climate demand collaboration with nature that is meaningful, mutually beneficial, regenerative, reflective, or critical? Curator Maya Errázuriz from Fundación Mar Adentro has noticed that for many artists that apply to their program at Bosque Pehuén, art has really taken a turn

Robert Smithson, *Spiral Jetty*, 1970. Mud, precipitated salt crystals, rocks, water, at Great Salt Lake, Utah, US. 45.720 x 460 cm. Courtesy Holt/Smithson Foundation and Dia Art Foundation. Photo: Soren Harward, photo taken from atop Rozel Point, mid-April 2005.

because of the climate crisis. 'Artists are not thinking about what nature can give to them, but thinking about how their work can visualize something that is not being visualized.' We both agree that contemporary art is placing the emphasis more on research, community, and education. The projects that we discuss are very different from what Land Art was doing and go far beyond the idea of understanding nature as a material. Maya:

> To some extent it continues as there's still a lot of artists who just use nature purely as their material, without any further reflection. It goes hand in hand with the idea of bio-art, for instance, and using fungi in your art, but that's a whole other discussion about how we can be more sustainable as a sector in our materiality.

We pause for a second. She struck a sensitive chord. It's a lot of big topics that she just brought up, topics that lie very close to my heart. While working at the Jan van Eyck Academie from 2017 to 2020, I set up the Future Materials Bank, an on-and-offline inventory of materials for artists that could be considered sustainable. Though the Future Materials Bank has been a huge success with regard to its visibility and artists looking for—and finding—alternatives to toxic or chemical materials they have been using, I understand the point Maya is making here. We need to stop seeing nature just as a resource or material, whether that's in terms of energy, food, water, or artistically. Though that doesn't mean that there are huge improvements to be made in the cultural sector in terms of the materials being used, in sculptures, paintings, and also decors and exhibition design. Errázuriz is interested in what she calls the 'critical reflection of the human and non-human relation to art' and 'artists using new media or other traditional media to speak for nature or about nature, and speculate about what nature is thinking.' This idea of speculation and speculative futures is a huge proclivity in the arts, bridging with science fiction. 'Contemporary artists are really assimilating this language of science fiction,' according to Errázuriz. It's something that I've definitely observed, too. Over the last decade or so it seems every other artist is referencing the science fiction works of Ursula K. Le Guin and Octavia E. Butler. They are both incredible authors, but it certainly seemed remarkable how popular their work became again in the light of the climate crisis, speculative futures, and the context of contemporary art.

EXHIBITION DESIGN

Maya briefly mentions the recycling of decor and exhibition design, and I try to steer the topic back to that. I used to work for an organization in London called Julie's Bicycle, who advise the cultural sector on how to reduce their environmental footprint. Besides important work regarding

reductions of water, waste, and energy, I was always very excited to see cultural organizations forming mini-networks to exchange, recycle, and up-cycle walls and other exhibition structures among themselves. Besides the materials that the artists use, there is a whole system and infrastructure of materials needed to share these works with the public that often remains undiscussed. Back at the topic of exhibition design, Errázuriz once again brings up a very interesting case study: the Chilean Pavilion at the 2022 Venice Biennale, curated by Camila Marambio. The Pavilion, called *Turba Tol Hol-Hol Tol*, is about the importance of the peat bogs of Patagonia. Peatlands are not only incredibly important for storing carbon (even more than forests!), but also regulate water cycles. Simultaneously, they are vulnerable to climate change and poorly researched. Mining, wildfires, and drainage are very concrete threats, and peat is also often harvested to be added to commercial compost as it's so fertile. For this reason, one should always check and buy peat-free compost. The name of the Pavil-ion, *Turba Tol Hol-Hol Tol*, means 'heart of the peatlands' in Selk'nam. The Selk'nam are one of the indigenous groups of the Patagonian parts of southern Argentina and Chile, including Tierra del Fuego. The aim of the exhibition is to re-create the material and ancestral experience of these Patagonian peatlands by bringing in these peat bogs and making an instal-lation using natural materials—the screen for the projection, for instance, was made from a bio-based film called agar-agar. A central narrative to the Pavilion is the significant relationship between the peatlands and the Selk'nam people. The peat bogs are the main ecosystem of their ancestral lands, where they lived for over eight thousand years before the territory was colonized and many people were killed. Thus, the myth was created that it signaled the end of the culture and the language. The Pavilion tells a different story, presenting the Selk'nam as a living culture, with people learning the language. Marambio herself is part of a group that is learning to speak Selk'nam, she tells me when we speak over Zoom. Marambio: 'Language might disappear but it's not lost. Stories sometimes disappear but they are not lost; they can be found and re-narrat-ed, re-inscribed.' She recalls one of the things the leader of the group, Hema'ny Molina, a Selk'nam lady, said to her in the first session. 'There is no right or wrong way to do this. We're just doing this and that's what's important.' When I ask her what drove her to learn the language, Marambio shares how:

> It's to do with the emerging responsibility of being in Tierra de Fuego. The myth of the ex-tinction of the language was just that—a myth that had been instituted by anthropologists and Western academic thinking. It was very import-ant to find the ways to gnaw away at that myth, without knowing how, or without really under-standing the tools that were available to do that, or the protocols necessary to really engage in

what today is called de-colonial work. But back then that wasn't a term that was available. It was much more based on sentiment, on the feeling that Selk'nam culture as was known to us mainly through the books of two white anthropologists, might not be any longer in the way that they had depicted it. Surely it changed, mutated, went underground, and assimilated. Unlike some other colonized countries in Latin America, we (Chileans) are *mestizos*; we are profoundly mixed and confused. And with the confusion the process began of peeling away the layers of ignorance and that Selk'nam culture is still alive— subjugated, obviously, but it remained in many forms.

It is clear that Marambio is very invested in and committed to both the culture and the territory, making the Pavilion a really interesting example of the complications one comes across when collaborating with the more-than-human in an art context. Maya Errázuriz thinks the Chilean Pavilion for the 2022 Venice Biennale is a good case study as it's an example of both the good and the bad when working with the materiality of nature. 'You're essentially taking peat bogs out of their natural system and putting them into an exhibition.' I tell Maya about the work *Ice Watch* by Icelandic artist Olafur Eliasson, who took around fifty huge blocks of natural glacier out of its natural habitat in Greenland and transported them to various locations in Europe, in order to let them melt on the Place du Panthéon in Paris, outside the Tate Modern in London, and in the City Hall Square in Copenhagen. The aim was to raise awareness about climate change. Sure, it was a powerful sight and received a lot of positive (social) media attention, but I kept on wondering if all of that validated the fact that the glacier was sacrificed and now non-existent in nature. Errázuriz:

I think in this specific context with the peat bogs they were very careful and conscious; they didn't extract them from a place where it would be too damaging, but rather from a quite domesticated form into the space.

As a curator, Maya often has to make decisions regarding exhibition design, including the materials that are used. And she acknowledges it's not always possible to choose a sustainable option. Errázuriz:

Exhibitions create a lot of waste; you build a lot of things, and they are very rarely reused and repurposed for other exhibitions. Many places don't attempt to recycle them and they get destroyed afterwards. It's interesting to think about which recyclable or biodegradable materials are

available to integrate in artistic structures or installations. But it's definitely a controversy when you are taking nature outside of its natural space. You are sending out a message, and people are seeing something they will otherwise never have the chance to see. And it's true that in the grand scheme of things that artwork is not the cause of climate change—just because you extracted from this glacier or peat bog or this plant. You're not destroying a whole ecosystem like with mining or other extractivist practices. But you are still creating a trap within your practice. I think the intentions are always good behind these projects but it's really hard to not trap yourself in these things. That's the thing with climate change and sustainability, essentially nothing is net zero carbon in the end. Everything has an emission, everything has an effect; it's just more genuine when you're not preaching. When you're just being conscious that this work is also always somehow conflictive.

We both sigh with the thought that maybe it's better to not do anything, not make art, not make exhibitions. It's the main thing that would reduce our footprint. Though I like the idea of doing less, the idea of doing nothing seems highly unsatisfying. A couple of months before the opening of the Biennale in Venice, I actually interviewed Camila Marambio, though we didn't speak about the Pavilion at all. She did say something about doing less that really resonated with me. She said about her work and research in Tierra del Fuego, Patagonia:

The more time passes, the more I see; the more I see, the more responsibility I have; the more responsibility I have, the more I learn. The more I learn, sometimes the less I do. The less I do, the more I see and it's like an endless cycle of becoming with a place.

I ask Maya if she can give me a concrete example of a situation where she found herself in what she previously called 'a trap'. She mentions the exhibition 'Árboles torcidos' that I saw in Temuco and that travelled to Valparaíso after. She explains that for this exhibition they didn't have a lot of resources for the exhibition design and ended up having to use pine, the cheapest wood, because they couldn't afford anything else. Errázuriz:

Even if your whole exhibition is about extractivist practices, you find yourself forced to use the structure made out of the same materiality you

Chilean Pavilion of the 59th Venice Biennale 2022, *Turba Tol Hol-Hol Tol*, 2022. Installation view. Curated by Camila Marambio, Courtesy Turba Tol and the Chilean Ministry of Cultures, Arts and Heritage. Photo: Ugo Carmeni.

203

are criticizing in the works. It's very metaphorical of what our lives are like, because it's so entangled with everything in the end. It's always a work in progress and there are a lot of traps in the residency that we do. On the one hand, we have this ambition—what many spaces now are striving for—that is multi-disciplinarity, bringing together different practices. Bringing together someone from the humanities or scientists working together with artists. In practice, I would say a full-on collaboration only happens one third of the time. It's important to say that because it's not easy. It's easy to say we are bringing together artists and scientists and bringing people from all parts of the world, but it can be very forced too; if you as a host or organizer don't facilitate a very concrete connection, and kind of commission it, it's very dependent on the people that you are working with. We started this residency program in 2015. We always had groups of scientists working in this area. They were doing very specific research on conservation; creating inventories of all the species. The were very focused on what their labs and universities and research institutions are looking for in the forest. In parallel we had this idea of running an arts residency program. We thought: Why don't we prompt them to talk? At first it was simpler and we had scientists give talks about research they were doing and we'd see how artists absorbed this. But there is another trap: How do you make it less of one discipline at the service of another? And what I feel with the residency that has been very conflicting for me, and maybe it's something that just I feel, is that sometimes it can become very extractivist. A residency program can be very extractivist: you come, you grab information, you use it for your own research, and then you go and you do your art and show it elsewhere. I don't know if I was that aware of this until members of my team who are not from the art world kept asking me about what it was for. Why are the artists asking this question? What are they doing with this information? How does this contribute to the conservation of this area?

Maya admits that most of the time she does not have an answer to these

questions. For her, the residency is more about being a form of
communication. A way to spread a message about conservation and how
the awareness of a conservation area could be internalized by an artist or
any practitioner who hasn't had the chance to live in such an area. After
all, not many people get the opportunity to live in an area of conservation
for five weeks.

THE PARADOX OF NATURE CONSERVATION

There is an interesting tension at this intersection of art and nature
conservation, creating space to narrate people back in. Not only for
humans to re-connect with nature, but possibly by being regenerative,
stewards of nature, seed-dispersers, creators of biodiversity, and by being
at the center of the solution. Nature conservation, by fencing off and
taking the human out, can lead to complicated clashes between what
could be seen as environmental justice versus social justice. The liveli-
hood of a community might depend on access to the forest for food and
materials, and some nature conservation has resulted in the displacement
of people. People are forced out of areas that are actually their homes,
having to make way for nature reserves or national parks. This is not just
the case in Latin-America, but a major problem for indigenous communi-
ties from different countries of the African continent. For instance: indige-
nous minorities such as the Hadza, Pygmies, and Bushmen in South Africa
are displaced to make space for game reserves for elephants and other big
animals that foreign tourists like to see from their Land Rovers.[3] It can turn
the conversation about nature conservation into an either/or discussion.
Either we 'save' the forest and the animals or we 'save' the people. Why
wouldn't this go hand in hand? Do humans and nature really have to oppose
each other? Fungi teach us that this isn't the case and there are endless
benefits in collaborating with the more-than-human.

MULTISPECIES FUNGI COLLABORATIONS

Not only leafcutter ants have a symbiotic relationship with fungi; termites
also have a very sophisticated collaboration pact going on with some
fungal species. The most astounding 'best practice' example I came across
was with the *Termitomyces titanicus*, which, as the name already hints
at, is a giant mushroom. The cap of this spectacular edible mushroom can
reach a diameter of one meter, more than enough to feed a whole family.
These mushrooms grow from termite mounds and both the termites and
the mushroom completely depend on each other for their survival. The
fungus digests wood and other plant matter and makes it edible for the
termites, while the termites make sure a solid supply of plants is being
brought to the fungus. Fungi relate to practically every form of life. They
always find groups of beings that they connect to, without prejudice.
Mycologist Maria Alice Neves tells me that even birds use a specific fungus
to weave their nests with. The example that she gives me concerns the
golden winged cacique (*Cacicus chrysopterus*), a beautiful black bird

3.

Robert K. Hitchcock, *Kalahari Communities: Bushmen and the Politics of the Environment in Southern Africa*, International Work Group for Indigenous Affairs, 1996.

with bright yellow feathers on its wings. Their nest hangs from the trees, normally above rivers. Neves tell me:

> It's a nest that usually hangs from trees above rivers and is made of the rhizomorphs of the *Marasmius* species that you find all over the forest. It's all black and it's beautiful. I found one in the reserve that we have a few hours from here.

As she speaks, I remember seeing some beautiful baskets when I was in Manaus woven with a *Marasmius* species by the Yanomami people. I couldn't believe they were mushrooms when I first saw them, the thin red and black material looking so shiny, sturdy, and durable. Two women, Floriza da Cruz Pinto Yanomami and Maria de Jesus Lima, part of the Associação de Mulheres Yanomami Kumirãyõma (the Kumirãyõma Association of Yanomami Women), are known to be the first to 'identify and name' this fungus which was unknown to traditional and Western science. It was named the *Përɨsɨ* fungus, the denomination the Yanomami had been using for it, and the Latin name became *Marasmius* Yanomami.[4] Though both a type of *Marasmius*, the type the Yanomami use for their baskets differs from the one the golden winged cacique uses for its nest. The one used for the nest has a much thinner rhizomorph, Neves explains to me.

> It's all above ground and grows on top of the trees; the rhizomorph grows over the plants and you can really see them climbing. They will go all over the branches and then eventually you see a little mushroom somewhere. And there's a lot of it! It's a lot of material for the bird.

The list of collaborations goes on. Being a mycophile and a bee lover, I was particularly excited to learn about the research shared by myco-king Paul Stamets showing how bees appear to be medicating themselves with fungi.[5] For instance, the *Metarhizium* fungus helps against varroa mites, a big problem in honey bee colonies, causing Colony Collapse Disorder.[6] The varroa mite feeds off bees, making them vulnerable to viruses, weakening their immune system, and sometimes killing up to fifty percent of the hive per year. Many beekeepers use pesticides ('miticides') against the mites yet they are reportedly becoming more and more resistant. Though the research on Metarhizium conducted by Washington State University, is still a work in progress, the results are promising.[7] Also exciting is research showing that extracts of the mycelium of some polypore mushroom species, such as *amadou* and *reishi*, can reduce viruses in honey bee colonies. The need for this fungal medication for bees is urgent as the chemicals and pesticides we are using on our plants, including neonicotinoids, are killing them rapidly.

Bees alone make an incredibly interesting case study, with a social or-

4. See: medium.com/social-environmental-stories/we-yanomami-have-presented-scientists-with-a-great-discovery-94697eec280d.

5. paulstamets.com/news/new-bee-fungi-research.

6. www.nature.com/articles/s41598-021-89811-2.

7. news.wsu.edu/press-release/2021/05/27/fungus-fights-mites-harm-honey-bees/.

Spores

Spores are the reproductive units of the fungus and they appear in
many shapes and sizes, depending on the mushroom species. Spores are
practically everywhere.

Mycelium is the underground rhizomatic network of the fungus,
consisting of connecting hyphae.

ganization that we humans can learn a lot from. They are the masters of making collective decisions, which are particularly important when they are swarming. Bees will swarm when they have outgrown their hive and are all on the lookout for a suitable new home. This can be several hundreds of bees house-hunting alongside their dear queen. What I read in the (amazing) book *Where Honeybees Thrive: Stories from the Field*, by Heather Swan, is that when the house-hunting bees find good quality real estate, they will come back and dance the map to the rest.

> The other bees will then go and check out the new location and return with their impressions. It is not until a majority of the bees decide in favor of one spot, which becomes evident in the fact that they are doing identical dances, that they make their move. That the queen was not making authoritarian decisions was ground breaking news. The queen is obviously still essential as she's the sole babymaker in the hive, but bees live in consensus communities.[8]

8.

Heather Swan, *Where Honeybees Thrive: Stories from the Field*, Penn State University Press, 2017, p. 50.

Apparently bees love to dance. They don't only dance these maps to future homes, but also to flowers. This book is actually full of incredible examples of human and non-human collaborations with bees. One story that struck me tells of an agricultural village in rural South Africa. The village was located on the route of migrating elephants, causing some problematic encounters: hungry (or thirsty) elephants would pass through the village and destroy the gardens, farms, and even properties in search of juicy crops. Desperate farmers and other villagers tried many things, from electric fences to more extreme scare tactics (shooting), but all without solving the problem. In her book, Heather Swan writes about scientists Ian Douglas Hamilton and Fritz Vollrath who, in 2002, introduced the idea of using bees to scare off elephants in a non-violent way. I loved this idea of using one of the smallest animals to scare off one of the biggest. Swan writes:

> While an elephant skin might seem rough and tough, elephants are, in fact, extremely sensitive creatures. The skin on an elephant's belly and behind her ears is much thinner than that on her back. In those areas they're susceptible to tick bites and bee stings. The eyes and inner trunk are also very sensitive to bee stings. The elephant's trunk is loaded with nerve-endings which give it a keen sense of smell. A bee sting on the inner trunk is terribly painful, and elephants will go out of their way to avoid it. Knowing this, Vollrath and Douglas Hamilton designed an experiment in which they put beehives into trees that would

normally be tasty to elephants. The elephants left
these trees alone.[9]

The project was such a success that lines of dangling beehives have been
installed in many other places, not only increasing pollination and bringing
a peaceful end to the crop-raidings of the elephants, but also providing a
delicious flow of honey (and income) to the villagers.[10]

OBSERVING ANIMAL TEACHINGS

We are more used to observing mammals in order to start learning about
our environments, simply because their behavior is more accessible to wit-
ness than the underground mycelium or the ephemerality of mushrooms.
In addition to that, we tend to look at animals with aesthetic criteria—
many of them look cute or interesting and with their blinking eyes we can
project ourselves on to them. I once read somewhere that the cutest look-
ing animals (read: fluffy) also get the most research funding, though some
marine mammals also have a very high cute factor—just think of smiling
dolphins and, ever since the nineteen-nineties, Greenpeace campaigns and
Free Willy, orcas, (baby) seals, and whales, all much-loved creatures. I was
pleasantly surprised and totally inspired by the book *Undrowned: Black
Feminist Lessons from Marine Mammals*, by Alexis Pauline Gumbs,
a beautiful equilibrium between poetry and concrete teachings from the
ocean. She writes about what she calls 'ancestral listening' and how we
are not bound by the human species' limitation for listening to ancestors.
'Some animals are our ancestors; they are also relatives.' She
focuses on marine mammals and I love these five lessons:

> The white bellied/short-snouted dolphins who
> travel in groups of hundreds, sometimes thousands
> (lesson one: roll deep) and welcome several 'other
> species' of dolphins and whales to swim and eat in
> community (lesson two: better together). Though
> they swim across the entire planet, no scientist (or
> no one willing to tell a western scientist) saw one
> alive until 1971. In fact, it seems to be a coordinat-
> ed movement to be recognized because there were
> several 'first sightings' of the species on different
> parts of the planet. All somehow in 1971 (lesson
> three: we can be seen on our own terms). The only
> requirements to be part of this massive oceanic
> family are that you gotta be willing to dive deep,
> because they eat at a thousand feet below the
> surface (lesson four: do your depth work) and
> flock because they collectively change direction
> abruptly to keep humans from following them, and
> also move thousands of miles to stay current with
> the ocean (lesson five: be ready to transform).[11]

9. Swan, *Where Honeybees Thrive*, p. 50.

10. Swan, *Where Honeybees Thrive*, p. 50.

11. Alexis Pauline Gumbs, *Undrowned: Black Feminist Lessons from Marine Mammals*, AK Press 2020, p. 55

Needless to say, I saw many parallels with the teachings of fungi.

Many years ago, I saw the exhibition 'Ecovention Europe: Art to Trans-form Ecologies', curated by Sue Spaid, and I remember a work by artist Brandon Ballengée catching my eye. I knew that amphibians are so-called indicator species, meaning they can tell us something about the changes in our environment, the things we can't see or understand yet. For instance, they show the results of pollution at an early stage. In this exhibition I saw the true meaning of what indicator species meant: Ballengée showed images of deformed frogs that he had found in nature while doing field research in the Americas, Australia, Asia, and Europe. Some had an extra leg, shortened hind limbs, or other terminal abnormalities. He managed to capture this by:

> using biological enzymes to make their tissues transparent, and inject colored dyes into their bones and organs. The specimens are then imaged with a high-resolution scanner. These image files are then printed using water-based inks on water-color paper to recall the palette of a nine-teenth-century painting.[12]

The reasons for these malformations include predators and parasites but also environmental degradation and being exposed to pesticides.

RIGHTS FOR NATURE

If we start to think of fungi, animals, the forest, and plants as our collab-oration partners rather than our materials, we are more likely to think about their rights, needs, and wishes. Though it is often impossible to really know how a non-human entity feels, we do know it's to the benefit of the water to not be polluted and to flow freely, and to the benefit of any animal to have a habitat and access to food. Artists Paulo Tavares and Ursula Biemann developed a project that researched the possibility of a forest law. The project sprouted from research they had conducted in the oil and mining frontier of the Ecuadorian Amazon, resulting in a two-channel video installation and small publication called *Forest Law*. The project researched the indigenous Sarayuku people and their quest for self-determination and environmental protection in Ecuador, seeking to make environmental crimes also crimes by law—with large-scale ex-traction threatening their forests, homes, and livelihoods, the aim was to give nature legal rights. Not genocide, but ecocide as a recognized crime. In the *Forest Law* publication I read a bit more about the context that is starting to sound awfully familiar:

> In between the two military regimes that governed Ecuador—from 1963 to 1966—a series of develop-ment/colonization programs were deployed in various regions in Amazonia in order to stimulate migration and expand agricultural and cattle

12. Sue Spaid, *Ecovention Europe: Art to Transform Ecologies, 1957–2017*, Museum Hedendaagse Kunst De Domijnen, 2017.

What Are Fungui Teaching Us about Multispecies Models of Collaboration

frontiers. These initiatives were especially robust in the Nangaritza River valley, in the Cordillera del Condor region along the Peruvian border, and around the Lago Agrio oil fields, taking advantage of the infrastructure built by Texaco. Roads carved out in the middle of the jungle to connect refineries, production stations, and oil wells opened up routes for colonists, loggers, ranchers and land speculators. Dispossessed by enclosures or displaced by severe weather events that hit the drought-prone regions of southern Ecuador, hundreds of thousands of peasants and poor farmers migrated in search of a better life and occupied the margins of the oil-road network, building precarious houses in between pipelines and hundreds of toxic-waste pits. Pioneer settlers were followed by large-scale wood industry and mono-crop plantations, accelerating deforestation, landscape fragmentation, and consequent loss of biodiversity.[13]

13. Ursula Biemann and Paulo Tavares, *Forest Law – Selva Jurídica*, Eli and Edythe Broad Art Museum at Michigan State University, 2014, p. 51.

In their work, artists Biemann and Tavares explore the forest as a physical, cosmological, but also legal entity based on their encounters and dialogues in the Ecuadorian Amazon. It contextualizes a series of landmark legal battles that eventually led to legal rights of nature in Bolivia and Ecuador, pioneered by the Sarayaku people. It grew into a wider movement of people across the world—with the aim of including rights of nature in legal frameworks—called the Stop Ecocide International movement. And it makes a lot of sense: though a river might not have a voice to make this case, it's alive and entangled with the well-being of many human and non-human species.

Speaking with Tara Rodríguez Besosa, the problematics of law and non-human justice also come up. It started over a personal issue. As a queer-identified person that bought land and who has no technical or biological children, Tara had to really research inheritance laws and other structures that allowed her to leave the land to chosen family. Rodríguez Besosa remarks that the legal system is a human-written system in which language plays an important role. It comes from a lot of definitions of property and prioritizing development or conservation. But these terms are legally defined and need to be revisited if we are to practice differently.

Something I've been very interested in is how the practice of law can begin to protect non-human species and ecosystems. Whether that be in agriculture fields or inheritance laws, it goes in different ways.

This interest in the protection of non-human species and ecosystems is clearly demonstrated in the project Tara developed for the Food Justice Bi-

Ursula Biemann and Paulo Tavares, film still from *Forest Law*, 2014.
Multi-channel video installation (38 min.) and photo-text assemblage.
Courtesy the artists.

2 1 6

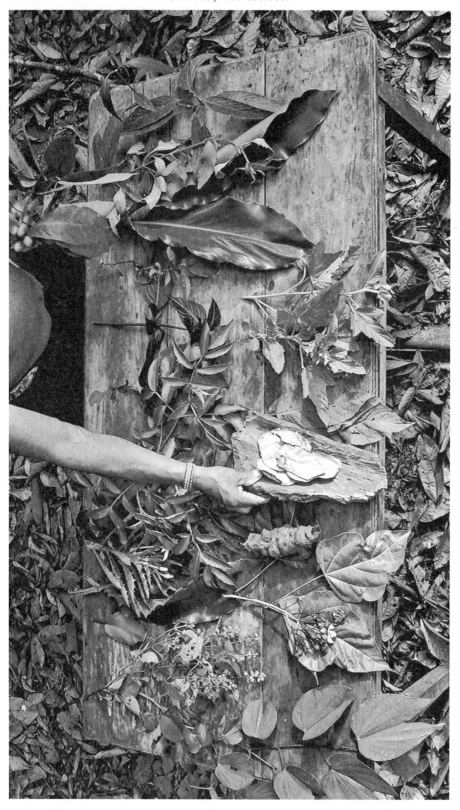

TEACHING EIGHT What Are Fungui Teaching Us about
 Multispecies Models of Collaboration

Collaborating with the More-than-Human

is: Food Justice for who? Rodríguez Besosa explains:

> Is it about food justice for us humans? Because we are calling it food justice. Have we included the non-human species? One thing is about defining what food is, the other thing is: Will this food justice apply to non-human species? Is this a multispecies movement and approach? How as a queer person am I approaching land and how am I approaching the term of food justice on that land? Which practices take food justice for all into account? What is my role on the land? Through a food justice approach, which decisions do I make? How am I bringing this into food environments as an example that demonstrates that food justice needs to be much more about the more-than-human species? Let's prioritize food justice for birds. Let's prioritize food justice for trees. Let's prioritize food justice as a way humans can support other species through the exchange of picking and leaving and composting, growing, planting... What does it mean? What is the role of humans in farming, in making food more readably available for themselves, and how is that connected to what I think is an important role in protecting biodiversity? Is it possible to do both? I feel that within the definition of food justice we have a lot of work to do. The takeaway for most people is that food justice is about making food more accessible to minorities and marginalized communities and having access to land, and, yes, it's not about if/or but AND. Maybe this tree doesn't give me food, but it actually gives all of the birds food. That would be me voicing food justice for the birds or the bees. I think that there's a lot of work still, because a lot of people entering into the term of food justice are not taking these things into account. I'm learning about the complexities of what my role is in the food justice of non-human species and what food justice for non-human species means. I think that's really important. I will be focusing specifically on four sites on our land. One is the creek, one is the forest, one is the human house with the domestic animals, and the other is the field where the cows and bees and birds are. We're going within each site and under-

standing we cannot see or treat the space as one and must go deeper and more site-specific. I'll be creating a path to connect different areas. We will use observations and meditations and listening and other interventions to start learning about the specificities of each mini-ecosystem. The path will be for humans that visit the space to then also have a way to deepen and reflect on that, without needing me to explain it or me being the only one that knows. Who feeds off this water? Where does it come from and where does it go? I want to understand my roles and responsibilities as the creek passes the river and the land that I live on. To be able to offer sanctuary to the water, the birds, the different bees that are passing through. By me gaining a better understanding, I think I can advocate for them better.

Tara gives a very specific example:
In our forest, there is a wild passion fruit vine. It's one of my favorite fruits and I didn't plant it; it's there. I harvest from it and so do the birds. I'm sharing the food with other non-human beings, and I'm not the only one who loves it and I'm not even the one who brought it. So how do I engage in someone else's food source? What does that mean? Should I maybe plant more passion fruit in the forest for the birds? Maybe that could be a beautiful intervention that will support the birds in the forest.

Tara shares her final teachings with me before we end our call:
I can be very rigorous and I've learned from other non-human beings that our knowledge brought us to a certain point and now I need to embrace things I don't even understand sometimes.

UNDERSTANDING PLACE AS A RELATIONSHIP

The history of humans and the forest has been a process of true interdependence, in which plants are key actors when it comes to our nutritional and medicinal choices. A significant difference with contemporary times is that the majority of people live in a city, not in a forest. We don't tend to think of urban environments as places with a lot of nature, yet even cities are places of both human and non-human co-habitation and, possibly, collaboration. The trick is to start understanding place as a relationship. Start noticing the small changes in the tree that you walk past every day,

recognize which other species depend on its existence—fungal, microbial, insects, or other. Most species intuitively maintain some system of ensuring the well-being of the collective, from the leafcutter ants to the honey bees to the termites; they all act in favor of the collective and the individual is subordinate to the species. Yet the human species doesn't act like this intuitively. We can learn how to make cross-species friends, even in an urban environment. It requires listening and acting upon the needs of our local non-human co-habitants. This may concern multi-species food justice, safety of habitat, medicine, or reproduction—or a process of de-colonializing the species. Alexis Pauline Gumbs pointedly raises the question: 'How can we listen across species, across extinction, across harm?'[14] This type of listening or observation might need some tuning in and quieting down. It demands repetition and careful attention to start noticing the small changes. Only then can we recognize that conservation is not about 'saving nature' but about repairing our bond. We can recognize our symbiosis in collaboration, the potential of mutually beneficial exchange with both human and non-human actors. And here starts our trans-species communion, with a sustained awareness of interconnectedness and feeling part of a wider community of nature.

14.

Gumbs, *Undrowned*, p. 19.

HOW TO MOVE THROUGH DIFFERENT NOTIONS OF TIME?

On Invisibility, Silence, and Non-linearity

TEACHING NINE

Davi Kopenawa, spores, *Ionomidotus*, Ela Spalding, Maria Alice Neves, puffballs (*Lycoperdon perlatum*), lichen, Patricia Kaishian, shiitake, Cristian Parra, morels, Laboulbeniales, oyster mushrooms (*Pleurotus ostreatus*), fungal air jets, bird's nest fungus, Milton Almonacid, FIBRA, Yina Jímenez Suriel, Claudia Martínez Garay, Sofía Ureña, TEOR/éTica, colectivo amasijo, Mirla Klijn.

Geographies:
Wallmapu/Araucanía (Chile), Puelmapu (Argentina), Mantiquera Mountains in Minas Gerais (Brazil), Amazonas (Brazil), Lima (Peru), Pampas (Argentina), Arrimadero (Panama), Pico Duarte (Dominican Republic).

PUELCHE

Though winter had been on her way for a few weeks now, this particular Sunday was warm. Hot and stormy, like a giant hairdryer was being switched on and off repeatedly. It was mid-May, but for this central-south part of Chile, the Araucanía/Wallmapu region, that meant the transition from autumn to winter. Every single day the colors of the trees turned a deeper red, orange, and yellow, while the contrasting eternal green pines and eucalyptus made their alien presence even more peculiar by revealing they were not coloring alongside the native trees. The hot wind announced itself spectacularly on Saturday night as a group of international artists and Chilean locals were enjoying a night of poetry reading and live music around the barn fireplace, the *fogón*. The storm was so strong that the people were singing and playing guitar with their eyes closed, avoiding the aerial ashes. It somehow made it even more magical; without looking, the energy felt stronger. Even though my musical contribution was simply tapping a rhythm on a wooden box with a wooden stick, I too tapped with my eyes closed to protect them from the dust. We listened to the charismatic Cristian Parra, the owner of the valley, singing the stories that for generations had been shared around this fireplace. We listened to one of the artists in the program, Paz González, singing the songs of Violeta Parra that I knew from my mother, a remnant of the days when she was still married to a Chilean revolutionary in the nineteen-seventies. I didn't re-

member the lyrics exactly, but knew the melodies by heart. With my eyes closed and smelling the fire, hearing the songs and memories, feeling the hot storm sneak through the cracks of the wood, tucked away in the snow-capped mountains, I had lost my notion of time and had entered a portal into timelessness in which I was both my mother and myself, the fire and the mountain.

The next morning, slightly hungover from the pisco but energized by the time portal I had passed through, I learned the hot wind is called *puelche* and that it comes from the Pampas in Argentina. It's named after the Puelche people, an indigenous group inhabiting the eastern slopes of the Andes, a place called Puelmapu for the Mapuche. A lot of the Puelche people died in colonial times when invasive newcomers brought a different kind of wind with them: a wind of invisible disease. They were not resistant to the pests and epidemics that quickly circulated around their communities. It is a very sad story that occurred historically in many different places and still happens today: outsiders enter an indigenous community and introduce alien bacteria and viruses that cause extreme illness and even death to the original inhabitants. It reminded me of a passage in the book *The Falling Sky*, by Davi Kopenawa, a Yanomami shaman in Brazil. I had read it while I was living in Brazil, a few years before. With a group we had travelled to the Amazon and passed through different indigenous communities. At the time I had already felt slightly uncomfortable with my own presence in their territory, even though we were there to collaborate, not colonize. What was I actually bringing these people? Aren't they much happier left alone? In his book, Kopenawa describes what happened to the Yanomami after 'the white people' (the colonizers) entered their forest:

> Much later, once I had become an adult, I had begun to ask myself what these people had come to do in our forest. I came to understand they wanted to know it and plot its limits in order to take possession of it. Our elders did not know how to imitate these outsiders' language. This is why they let them approach without hostility. If they had understood their words as well as they understood ours, they probably would have prevented them from coming into our forest too easily. I also think these strangers duped them by flourishing their merchandise with good words: 'Let's be friends! See, we offer you so many of our goods as presents! We do not lie!' This is always how the white people start talking to us. Then the *xawarari* epidemic beings arrive in their footsteps and we immediately start dying one after another![1]

In the cosmology of the Yanomami, minerals, metals, ores, and fossil fuels have been buried underground by *Omama* to keep them away from peo-

1. Davi Kopenawa and Bruce Albert, *The Falling Sky: Words of a Yanomami Shaman*, Belknap Press, 2013, p. 177.

ple. *Omama,* the ancestor spirit, hid them away in the ground
to protect us because they come with toxic smokes. They are buried for
Za reason and we shouldn't be digging them up as it's dangerous. Kopena-
wa warns:

> These things from the depth of the earth are
> dangerous. If white people were to reach *Omama's*
> metal one day, the powerful yellowish fumes of its
> breath would spread everywhere like a poison as
> deadly as the one they call an atomic bomb. ... So
> *Omama* did not bury iron, gold, cassiterite and
> uranium without reason, only leaving our food
> above ground.[2]

The Yanomami have known for over five hundred years that mining and
geo-engineering are a bad idea. The invisible toxic fumes of the non-native
'white people' don't just come in the shape of disease; they also come as
carbon emissions creating air pollution and climate change. The danger-
ous fumes of the non-natives are multiple.

On that same trip to the Amazon, I learned that the rainforest feeds off
dust that arrives by wind, blowing all the way from the Sahara Desert—lat-
er confirmed by NASA online.[3] The tiny particles are actually crucial
nutrients for the forest, something that scientists only discovered in recent
years. Ever since this trip I've tried to be aware of the invisible things we
might unknowingly be instigating or bringing with us. All winds and wafts,
emissions, all breathing; it's something invisible after all. The pandemic
years obviously reinforced this realization. As I felt the hot *puelche* wind
blowing in my face, making my eyes narrow, I took a deep breath of it,
letting it circulate through my lungs, and imagined that it was maybe
the Puelche people reminding us of their continued and endless pres-
ence. They might have been invisible at that moment in time, but their
energy was felt.

Wind is essential to making spores, the reproductive cells of fungi,
fly far and wide, and to start a new life elsewhere. If you think about it,
however, mushrooms are rarely suitably located to catch much wind given
that they stand close to the earth and are sometimes even hidden behind
logs of wood or other potential wind obstacles. That's why, as inventive
as they are, some fungi have learned to produce their own wind to spread
their spores. It's an incredible skill which they perform by evaporating
water, giving the spores a lift of up to ten centimeters, from where they can
catch the wind and travel further more easily. This phenomenon is called
a 'fungal air jet'. In the two largest groups of fungi (*Ascomycota* and *Ba-
sidiomycota*), the spore-producing cells come in a protective structure.
For *Ascomycota*, the spores are formed inside little sacs called asci and
for *Basidiomycota* they are produced inside basidia. Basidia are formed
on gills below the caps of mushrooms. The diversity of fungal spores is
mind-blowing in terms of shapes and textures, and ranging from slimy to

2.

Kopenawa and Albert, *The Falling Sky*, p. 285.

3.

See: www.nasa.gov/content/goddard/nasa-satellite-reveals-how-much-saharan-dust-feeds-amazon-s-plants.

dry. They can be sexual or asexual and tiny (a few micrometers) or huge, meaning they are actually visible to the naked human eye. The diverse and advanced dispersal strategies of fungi cause spores to be practically everywhere. With every breath you take, you are very likely to be ingesting them. Spores are in our fridges, on surfaces, and in our lungs, and even in outer space they can survive, forever patiently waiting for the right circumstances to come along. We are constantly surrounded by an invisible cloud of spores without even being aware of it. Over Zoom, I speak to mycologist Maria Alice Neves about spore dispersal strategies. Through the camera I spot some embroideries on the wall behind her. When I ask about them, she brings them closer to the camera so I can see—they're actually spore dispersal strategies that she has embroidered herself. Only a mycologist could have picked this as a theme to depict for an embroidery, I thought to myself. With infectious enthusiasm, she brings the camera closer so I can see the dispersion of the spores through water from the *Cyathus striatus*, also known as bird's nest fungus. It's a beautiful type of fungus that can be found on mulch and compost in gardens. These cup-shaped fungi look like a little bird's nest, including a couple of mini-eggs in there. These mini-eggs (officially called *peridioles*) are splashed out of the nest when it rains and thus the spores are dispersed. Most cup fungi are spore shooters, meaning that water splashes in and carries the small balls with spores upwards.

Another embroidery depicts the phalloid fungus that has a strong smell to attract flies or bees, for instance the *Staheliomyces*. The gooey spores stick to the feet of visiting animals attracted to the smell, who then do the rest of the work by carrying them around and spreading them. I ask her about the famous puffballs (*Lycoperdon perlatum*), the cream-colored mushroom balls that you can squeeze and which then sporulate spectacularly and endlessly with spores being released by the millions. 'Oh yes! people love *gasteroid* fungi. I always have a *gasteroid* fungus to show in my classes.' She is referring to their genus; puffballs are a type of *Gasteromycetes*, which is a group of fungi that depends on an external factor, like a passing animal, to release the spores. 'People are also good dispersers because they love to touch them,' she shrieks. Though I have learned by now that it's very hard to try to categorize fungal behavior, I still ask Neves if she dares to categorize the spores' dispersal for me. She opts for two big categories. Neves:

> One is the spores that are produced over the time
> that the mushroom is growing. For example, when
> the gills of a mushroom start to mature, spores are
> maturing at different times and are released at all
> times, as long as the mushroom is not rotting. In
> this sense, spores are more dependent on the wind.

She continues with the second category:
> The second type we see, for instance, in the *gas-*

Lichen are an association between fungi, algae,
and cyanobacteria, living in a mutualistic relationship.
They come in many colors and sizes.

Lichen

Maria Alice Neves, *Natural History Embroideries*, 2020-21. Series of three: *Phallales, flies and bees*, 2021; *The Fungal Tree of Life*, 2020; *Golden-winged Cacique in* Marasmius *nest*, (based on photo by R. Rizzaro).

231

Maria Alice Neves, *Natural History Embroideries*, 2020-21. Series of three: *Phallales,*
flies and bees, 2021; The Fungal Tree of Life, 2020; Golden-winged Cacique in Marasmius *nest,*
(based on photo by R. Rizzaro).

2 3 2

teroid puffballs, where they depend on a mechanical action. That can be either a fly, water, or a person—a mechanical external factor that needs to touch or stimulate the spores and then take them somewhere else.

I understand Maria Alice Neves's enthusiasm; there is something utterly magical about the creative capacity of the spores to spread and to be omnipresent in time and space. The incredible patience they show to wait for decades until the right conditions come along. I see a clear teaching here: no more FOMO because when we are more like spores, we are everywhere. No more immediacy, running, and chasing as we just have to be patient and wait for the right conditions, making use of the wind, flowing in the right directions.

In a workshop by Pedro Drapela back in Chile with Valley of the Possible, we learn that fungi are not the only ones who sporulate. Pedro is passionate about bryophytes; different types of mosses, liverworts, and hornworts. Bryophytes are non-vascular plants, meaning that they do not have a system of roots to take up nutrients and water from the ground. They don't transport nutrients internally, like vascular plants do, but externally. Their cells are open, so when you touch them, you are directly touching the cells, their insides, I learn. Drapela, a true enthusiast, shows us different drawings of how bryophytes absorb through their whole body and get their minerals and water from the wider environment. Like fungi, bryophytes have spores. Unlike fungi, the spores are held in a kind of bag called the sporophyte. If they find a substrate and right conditions, they can sporulate. 'Though they lack the main survival skills of plants, such as having roots or flowers to reproduce, bryophytes are still more resistant than most plants,' he says proudly, as if he himself is the loving father of all mosses (maybe he is?). They grow in harsh conditions such as the Antarctic (in Antarctica there are two vascular native plants, yet one hundred and thirty non-vascular ones), and can be without water for decades, waking up again the moment they are re-hydrated. It makes them immune to death by drying; desiccation is simply a temporary interruption in life. Though they may lose up to ninety-eight percent of their moisture even after forty years of dehydration in a musty specimen cabinet, mosses have been fully revived after a dunk in a petri dish. The trick is patience. They don't try to keep their own temperature; they just adapt and wait. If Pedro Drapela is the father of mosses, then surely Robin Wall Kimmerer is the mother. In her book *Gathering Moss*, she lovingly writes about the natural and cultural history of mosses. Kimmerer:

> The mosses begin their time of waiting. It may be only a matter of days before the dawn returns, or it may be months of patient desiccation. Acceptance is their way of being. They earn their freedom from the pain of change by total surrender to the ways of the rain.[4]

4.

Robin Wall Kimmerer, *Gathering Moss: A Natural and Cultural History of Mosses*, Oregon State University Press, 2003, p. 35.

Because of their openness, bryophytes are also more susceptible to pollution, making them good bio-indicators, providers of knowledge about the environment. They hold information about the health of the air and water, and the fact that they are susceptible to pollution is not expressed by a lack of abundance of them, only by lower levels of biodiversity. You can still see a lot of them in polluted areas, you just find fewer types of them, fewer species. How is it possible to be so open and vulnerable, yet so resilient? Perhaps the answer lies in cranking up the patience and tuning in to that different time frame.

DIFFERENT NOTIONS OF TIME

Working on the shiitake farm in Brazil was the first time I experienced, up close and personal, how mushrooms operate in a different dimension of time. Every morning I would methodically harvest them from the entrance of the space, the mushroom greenhouse, following each section from bottom to top. For the lower shelves I had to squat down or sit on my knees, whereas to reach the shiitakes on the top shelves I had to climb a wobbly ladder. The mushroom house looked a little like an old bakery, the mycelium blocks vaguely resembling loafs of moldy bread. It happened to me on multiple occasions that just as I thought I had finished the harvesting and reached the last shelf, I would look behind me and see that new shiitakes had popped up. Had I not seen them before? It was as if they were joking with me, hiding, maybe even giggling, and appearing whenever they felt like it. The first few times this happened to me I thought I was going crazy. In my interviews with mycologists and other people working with fungi, I started asking about this mysterious phenomenon. It turned out that I wasn't the only one to have experienced this and learned: fungi operate in a different dimension of time. They decide when they pop and when they want to be seen by you.

When I spoke with the three women from the FIBRA collective in Peru about this, they also confirmed that in their extensive experience working with mushrooms that they are both really slow and then suddenly exponentially fast. If I had experienced the really fast in the shiitake greenhouse, then what was the really slow? Lucia from FIBRA had an answer:

The processes of fungi teach us about a different way of perceiving time. I'm thinking of mushrooms as medicine or mushrooms in myco-remediation or even in making sculptures. People are surprised that it takes months to grow a mushroom sculpture, when you are used to plaster that sets in half an hour. But also in terms of medicine and remediation; medicinal mushrooms you don't take in the form of a pill and then the pain is over. It's really about a long process that requires nurturing.' It was clear to me that this process of nurturing to get your medicine was the very opposite

of Western expectations of how things work; our solutions need to be immediate. With fungi gaining in popularity, many people, including many companies, are looking at mushrooms for all sorts of 'solutions'. In recent years, fungi have acquired a promising aura of being able to save the world, marketed with ambitious slogans varying from how 'mushrooms will cure cancer!' to how 'mushrooms will clean up our oil spills!

Though they are all, to some extent, true, I understand FIBRA is trying to make a different point here. Yes, fungi may contribute to solutions to some of humanity's pressing problems, yet the expectation of immediateness is unrealistic and, more importantly, does not address the root of the problem. Once more, it's trying to make fungi work for us. It's like the mushrooms are trying to escape extractive systems by moving between different speeds to fit—and not fit—our time frames. It's hard to describe fungi's different notions of time and I often struggled to describe what I meant in interviews, like the right words weren't quite there. Until I came across a term that describes what I failed to express. My savior is—as is so often the case—Robin Wall Kimmerer, who in both her books *Gathering Moss* and *Braiding Sweetgrass*, mentions the term '*Puhpowee*'. She writes about how, as a biologist, she could not find the equivalent term in science, yet found it in Potawatomi, the indigenous language that she is learning, being a Potawatomi citizen. '*Puhpowee*' signifies an energy that animates:

> My first taste of the missing language was the word *Puhpowee* on my tongue. I stumbled upon it in a book by the Anishinaabe ethno-botanist Keewaydinoquay, in a treatise on the traditional uses of fungi by our people. *Puhpowee*, she explained, translates as 'the force which causes mushrooms to push up from the earth overnight.' As a biologist I was stunned that such a word existed. In all its technical vocabulary, Western science has no such term, no words to hold this mystery. You'd think that biologists, of all people, would have words for life. But in scientific language our terminology is used to define the boundaries of our knowing. What lies beyond our grasp, remains unnamed.[5]

Though I feel hesitant to use the term publicly as I don't want to take it out of the cosmology in which it is so entangled, I allow myself to take the term into my heart and write it down in my notebook, as a message from the fungi, a confirmation that I'm not crazy (at least when it comes to this) and that they do operate in different dimensions of time. I also note that we need to let go of our extractive mindset toward fungi. When we don't

5.

Kimmerer, *Gathering Moss*, p. 34.

try to control them, they happily pop into human time frames. The fact that they do not like to be controlled makes the majority of mushrooms very hard to cultivate. Though there are some exceptions, such as the oyster mushroom or the shiitake, which are relatively easy to grow, most mushrooms prefer to roam around freely, popping up on their own terms, remaining ephemeral. When foraging for mushrooms in the wild, it's helpful to tune in to that different sense of time since finding them requires a specific type of patience, attention, and openness. Over the years, we have managed to cultivate two dozen types of mushrooms, while there are millions of species that we know very little about.

> While some fungi, like some species of morels, can be reliably found in the same place on more or less the same calendar day every year. Other species, such as members of the genus *Ionomido- tus*, may be seen once in a given location and then never again. But is its mycelium still present in that spot? We often do not know.[6]

The mycelium might still be there, leaving an invisible presence that makes us wonder if that even counts as 'being present'.

Cristian Parra, sitting by the *fogón* and reminiscing about his younger years, told me that his first job, as a young agriculture student, was to export morels from Chile to France. He saw a fax from a French company that was on the lookout for these delicious mushrooms and knew where to find them in the valley. With a sly smile he admits it was 'very good business'—not surprising for a mushroom that is considered a delicacy yet has been hard to cultivate. People have loved morels for thousands of years, and we are only starting to figure out how to cultivate them in the twenty-first century. There has been some careful success with cultivating these hollow honeycombed-shaped mushrooms in indoor farms all year round in the United States, and I came across two Danish brothers who devote their lives to the cultivation of these mysterious creatures. All on a reasonably small scale. Mushrooms defy our capacity to dominate them completely. Perhaps that is what has also contributed to our fear of them. It's a likely theory that Patricia Kaishian shares with me:

> We fear what we do not understand, and we fear what we can't control, and fungi very much embody this capacity for subversive materialities. They are not really committing to any one type of being, a way of being that is very legible to our social laws that are very prevalent within capitalism, which is extractive and standardized and on demand.

Her theory is aligned with my personal experience; though some varieties are more consistent, when we try to interact with fungi their behavior is

6.

Patricia Kaishian and Hasmik Djoulakian, 'The Science Underground: Mycology as a Queer Discipline', *Catalyst: Feminism, Theory, Technoscience* 6, no. 2 (2020), p. 3.

generally rather erratic. Kaishian seems sure of her case:

> Essentially, we are working for them, and not the
> other way around. I think that they just refuse, in
> many cases, to be as extractable as other crops. I
> think that that is their power, but also sadly within
> the context of capitalism and climate change, why
> they are so vulnerable to extinction right now.

Their unexpected behavior makes them mysterious and on top of that
they are not being studied well. Kaishian:

> The people who are studying them are doing a
> great job, but there is just very little funding
> for it. And there is very little support for our
> research. It's starting to change and the recent
> interest in mycology is definitely helping garner
> interest, but I have yet to see that translate into
> material support. Right now, we are definitely in
> this phase of people just getting really excited
> about what they can put in their mouth, but not
> really taking the step forward towards steward-
> ship and activism. It's more about 'what can this
> fungus do for me,' either in food or in clout on
> social media or whatever it is. I'm supportive of
> all these things as long as it's done with an actual
> concern for the organism itself. I see people who
> are like that for sure, but I also see a lot of people
> who are just demanding knowledge from people
> who have been laboring around these organisms
> or with the organisms themselves. And that's very
> capitalistic, even though that person might not be
> a capitalist themselves. It's a logic of capitalism
> that is like: 'here perform for me and let me con-
> sume you.' As a transaction, not a relationship.
> That's where I hope to see mycology grow, more
> towards this other side. For the people outside
> of mycology, specifically being a researcher, ad-
> vocating for them in ways that are beyond their
> own interest.

She suddenly stops and becomes a bit shy and apologetic, though I feel
she has just eloquently formulated the essence of what mushrooms teach
us, the most important lesson from our conversation. Kaishian: 'I always
feel a little preachy when I say that, but it's important that we
actually embody the lessons that are being taught to us by the
mushroom here.' I couldn't agree more.

The comparison between mushrooms and anti-capitalists, anarchists, or deviants of the system was made in several of the interviews I conducted. The research that really solidified this comparison is, of course, *The Mushroom at the End of the World. On the Possibility of Life in Capitalist Ruins* by Anna Tsing. This book has been influential for me and many others on so many levels. One part that clearly demonstrates how mushrooms can be allies in our subversiveness is when Tsing describes how mushrooms were supplementing the diets of farmers in Eurasia at the time when they had to give away significant portions of their yields to the ruling class. The mushrooms were growing on the margins of their farms, unnoticed, as the grains were the central crops the ruling classes sought. The mushrooms quietly remained off the radar. This subtle silence, flourishing by staying unnoticed, keeping a low profile to do your own thing the way you like it, seems to be a strategy we can all learn from. The antidote to fame and bling, to continuous judgement and the luring potential of exploitation. When I ask Patricia from which specific organism we really need to learn, she proposes insect parasites. It's not the answer I would expect from many people, but somehow I'm not surprised to hear it from her. This incredible woman is really one of a kind. She explains that she likes them precisely because they are so unknown. Kaishian:

> They are the most diverse lineage of fungi that are in symbiosis with insects. Only a handful of people in the world study them. Like five or six people really have labs dedicated to their research. Their taxonomic order is called *Laboulbeniales*. There are probably seventy-thousand species of them thought to exist in the world, but we have only described about fifteen-hundred. They live quietly on arthropods, —mostly on beetles—but also on daddy longlegs.

We both giggle for a moment, realizing what a funny name these spiders actually have. She continues:

> They live on all sorts of groups but they've been in really close proximity and co-evolution with their hosts for millions and millions of years, quietly diversifying, spreading around the world, not causing much harm to their host. Sometimes there has been a quantifiable amount of damage that scientists have detected, but often you can't detect any real damage they are causing. That's why it's a question of whether it's appropriate to call them parasites.

Basically, what she is describing is how these quiet fungal organisms that

we call parasites have been living on insects since time imme-morial, surviving by taking just a little in terms of food and energy, but not really causing their host any harm. Though they also don't benefit the insect. It's impossible not to think about how we humans could and should be more like these parasites with the planet as our host. Could we take food and energy without causing our host, the planet, harm? Yet parasites are the ones we humans tend to despise. How ironic. Kaishian describes how the *Laboulbeniales* are actually very beautiful in unexpected ways, ways that are not flashy. Kaishian:

> They have no charisma, but once you put them under the microscope they are amber-colored and really delicate and have these beautiful cellular arrangements like glass. They have helped me form a commitment to organisms that have no po-tential for application to human society; they are diverse and quietly exist whether or not you look at them. It sounds obvious, but it's not such an obvious idea that things have gone on for so long before humans or animals were involved. It's the culture of the quiet power. Yet they are resolute and determined to exist. I find a lot of inspiration from those lessons. No obvious beauty, but beau-ty nevertheless.

Her words are a breath of fresh air after all the fungal attention that seems to pivot around their solutions for us humans. A stimulating new wind that, for a change, is not about how mushrooms should work for us, clean-ing up our messes and diseases, but the other way around. How we should be humbler and more attentive towards them.

GEOLOGICAL DEEP TIME

When I speak with Ela Spalding, an artist and the founder of Estudio Nuboso, a nomadic artists' residency program born in the cloud forest in Panama, she also brings up the importance of quiet and invisible life and how that can be done through the arts. Ela:

> Our art projects are about telling the stories we overlook in the ecosystems we live in. They may not have human voices, but their histories and stories are so important to tell. I like to learn from other holders of knowledge that don't neces-sarily need to be human.

In their Art and Science LAB, they work with artists to make the efforts and research of scientists more visible. Though Ela also half-jokingly admits that 'the arts in Panama are not always that visible either,' she is quick to add that they are 'working on that!', and I understand her point.

She explains that in Panama science institutions have been their main
source of funding, despite being an art organization.

> It's interesting working with scientists who are,
> on the one hand, bound by the restrictions of
> their field yet very Catholic, on the other, and
> have a level of superstition or spirituality that
> they can't express openly in their work. The same
> goes for creativity, in fact.

Estudio Nuboso's LAB provides a space for these scientists to explore
this openness, flexibility, and creativity more freely through dialogue and
collaboration with artists. Various views on life are welcome in Estudio
Nuboso, including science, creativity, and spirituality.

> The first art-science exhibition we did in 2015
> was called 'Serendipity'. There were so many
> unexpected results and 'coincidences' as part of
> that process, simply because we were really ob-
> serving carefully. You might have an assumption,
> you might have a hypothesis, but then something
> surprising happens or a series of mistakes hap-
> pen that lead you to a revelation. And therein lies
> the mystery and the inexplicable, even for some
> scientists. Our practice of facilitating people from
> different fields of knowledge and different walks
> of life to come together is about allowing the mag-
> ic to happen. We want to address the complexi-
> ties of the world that we are living in with a focus
> on the soft and deep power of nature. This, of
> course, includes spirit and a diversity of perspec-
> tives and beliefs around that.

Another project by Estudio Nuboso, one that Ela has been working on for
a few years now, is called *Suelo*, Spanish for soil. *Suelo* as a project has
many different layers and is in part about articulating the natural and cul-
tural value of rural places and their inhabitants, particularly the ones that
are being rendered invisible by so-called development. Through different
exercises, from guided meditations to composting and walking the land,
participants are invited to connect with the soil underneath their feet and
start understanding it on various levels—sometimes quite literally. Spalding:

> When you bring up the geological history of a
> place and talk about geological deep time, it takes
> us out of our anthropocentric view of existence
> and history and why we're here. It's like look-
> ing at the stars in the night; it gives you a sense
> of perspective, proportions, and sizes and this
> longer timeline which says 'humans have only

been here for a day' in relation to the whole life of the planet. And look at all the impact we have made. How such a small thing can have such a great impact. What potential lies in those realizations!

In one of the *Suelo* projects in Panama, they had a geologist explain the rising of the Isthmus and the role of the small beach town where they did the project, a place called Arrimadero. The group gathered at a site where a seventy-million-year-old pillow lava rock had been extracted, to be installed in the (then) new Museum of Biodiversity designed by Frank Gehry (his first design in Latin America). Yet no one had really taken the time to share this story with the Arrimadero locals. The rock, characteristic of the area, was placed in the Biomuseo as the first sample in the geological gallery. As the Panamanian Isthmus is one of the world's richest ecosystems, thousands of international visitors come to the museum to learn about Panama and its geological history. And so during *Suelo*, the geologist Dr. Anthony Coates gave a solar-powered PowerPoint presentation at night in the beach restaurant, highlighting the Arrimadero pillow lava in the story of the formation of Panama and its implications for the entire globe. Ela: 'The locals were fascinated by the story and by the expansion of time. There was this sense of wonder growing in the room.' The audience in this case were not the international visitors admiring the Gehry architecture. Rather, it was the locals learning and sharing about the history of their territory. After the story of how the rocks arrived (they collided into other tectonic plates that were emerging as they formed the Isthmus), the people told their own stories of how they arrived there. Symbolically in Arrimadero, the currents bring up a lot of driftwood which gathers ('*se arrima*') on the beach, hence its name. The rocks, the driftwood, and the people had all gathered there. Ela:

> Hearing them weave their stories with the remote and more recent past was beautiful; to have that multi-layeredness and talk about the importance of the personal and the environmental, the micro and the macro. It's the zooming in and out of perspectives on different scales that is essential to the *Suelo* methodology; from deep time to recent times, to current issues and into possible futures. And then there are the scales of existence or spheres of engagement of soil in our lives: from the personal to the planetary. These are all tools to help make this shift of consciousness, this shift that we are working towards.

The aim of Estudio Nuboso is to convey the message of how interconnected we are with all of life—within ourselves, with others, and with

Claudia Martínez Garay, *mujer vende queso con su vaca, detail of casita and mujer con vaca* [Woman Selling Cheese with Her Cow], 2019. Ceramics on painted base, 10 x 25 x 25 cm. Installation view at GRIMM Amsterdam, 2019. Courtesy the artist and GRIMM, Amsterdam | New York | London. Photo: Sonia Mangiapane.

242

How to Move through Different
Notions of Time?

our surroundings; how our actions matter, our attitudes, our beliefs, philosophies, and practices. They strive to convey this message in a way that is not preachy or heavy, which is why they use art as a medium, space, or approach to engage with other perspectives. The idea is that by shifting our awareness, we might change our minds, and so too our bodies and actions.

In their programs they encourage people to use the Experiential Expertise Exchange (Ex Ex Ex) approach. In this way, the person sharing is asked to think of ways of offering an embodied way of getting their thoughts across, and the participants are invited to engage other senses, cells, and 'minds' in their bodies in order to receive and process that information in a more holistic way. At times, this is difficult for some people and it is in dialogue with other participating artists or designers that unusual experiences are created to complement or integrate the knowledge shared. Working collaboratively or even symbiotically is at the heart of this approach.

For instance, also during the *Suelo* Arrimadero experience, one designer offered to guide them through a hypnosis or visualization based on our daily composting practice (led by artist Claire Pentecost) and another based on Dr. Coates's geological story. Participants slowly had to become compost—all the participants were different elements of the compost and their ideas were collectively composting. In the next session they went deep into the soil, deep into the ground, into the seventy-million-year-old pillow lava rock. Then the hypnotist took them back to where that rock was made near the Galapagos, to the underwater volcano, and to how that tectonic plate moved towards Panama and collided with the other tectonic plates that slowly formed the land bridge. Ela: 'That practice and visualization was key to our experience of the place and of each other.'

Rocks are useful metaphors to start thinking about deep time and to visualize the tiny time frame in which us humans have been on the planet. The longevity of their lifetimes puts ours into perspective. And what is it that breaks down a rock over time? You will not be surprised to hear that yet again the answer is a fungus. Though not completely. The answer is actually a lichen. Lichen 'eat' rocks, sometimes even live inside rocks. They appear in various forms, shapes, and colors, with some looking more like seaweed or stringy rope, others sharing more similarities to a slab of extremely dry peeling skin, and others more powdery. Lichens are ninety-five percent fungal, yet have no mycelium, which makes it debatable if we can call them fungal at all. Because they don't have a mycelium, they produce their own nutrition through photosynthesis. They can become extremely old, but also grow extremely slowly, from less than a millimeter to a few centimeters per year. They protect trees while they release acids and minerals that break down rocks. Can you imagine crushing rocks with a body that is as light as a feather?

Claudia Martínez Garay, *mujer vende queso con su vaca* [Woman Selling Cheese with Her Cow], 2019. Ceramics on painted base, 10 x 25 x 25 cm. Installation view at GRIMM Amsterdam, 2019. Courtesy the artist and GRIMM, Amsterdam | New York | London. Photo: Sonia Mangiapane.

2 4 4

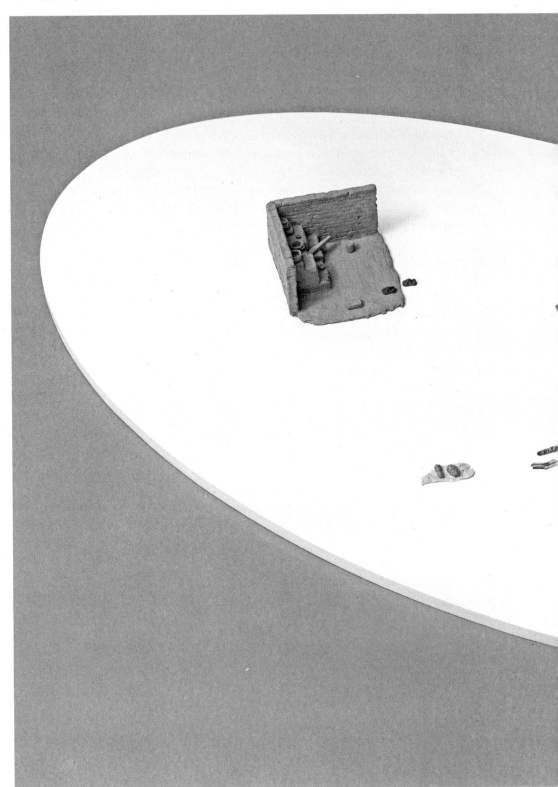

How to Move through Different
Notions of Time?

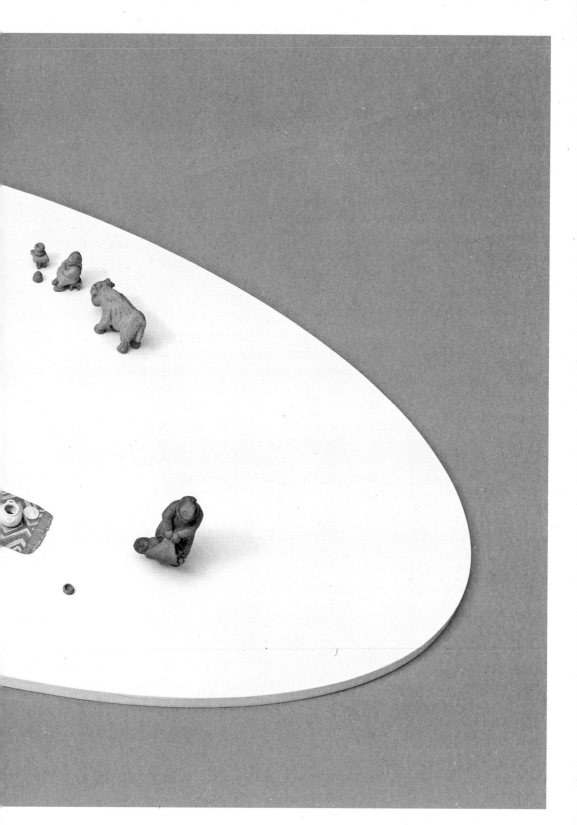

Next to the portal into timelessness at the *fogón* and the patient bryophytes of Pedro Drapela in the valley, there was another experience at the Valley of the Possible residency program in Chile that questioned our understanding of time. This time it was Milton Almonacid, a Mapuche academic, who challenged the notion of linear time and connected it to a Western idea of growth. In linear time we are born and expected to accumulate things over our lifetimes and end with more than we were born with. This is the general idea of progress. You'll have a better life than your parents. This idea comes with many problems. Milton: 'In linear time frames we have accumulation as the main orientation of life. To realize that accumulation for everyone we would need at least nine planets.' Come to think of it, it's true; our teenage dreams about our futures were more often than not connected to growth, not to de-growth. There is a linear financial expectation. A house, a growing income, maybe a car? None of these expectations came true in my life. Almonacid calls it the ontological dualism, the idea of linear time and growth, dying with more than you were born with. Through various exercises the group had to identify their dreams, hopes, and expectations and, particularly, their resistance to breaking with them. Which dreams are we not willing to give up? The illusion of a peaceful future? In the Mapuche cosmovision, like most other indigenous cosmovisions, time is a dynamic and non-linear process. This does not chime with the dominant temporality of Western linear time that is connected to the idea of not only accumulation and growth, but also speed and efficiency—time is money, after all. Even time is political when we adhere to the globally synchronized time in which the Standard+ time zones take the West as the center of the world. What about the other rhythms, other heartbeats, and temporalities? We should make desynchronizing from linear time a political act, an act of resistance, an anti-colonial act even. In the exhibition 'No Linear Fucking Time' organized by BAK in Utrecht, in the Netherlands, artists were invited to unsettle these dominant temporalities and look for anti-linear counter ideas and 'model alternate forms of liveable time'. One of the participating artists was Claudia Martínez Garay, whose work pivots around Andean cosmologies. Her family comes from a town in the Andes called Ayacucho, where traditions are very connected to and rooted in the calendar, she tells me over Zoom. It's an agricultural calendar that became entangled with a religious calendar due to colonialism and an influx of people moving to the capital. Martínez Garay:

> The continuation of knowledge had to adapt in
> order to survive. It's one of the most important
> issues and complexities to share. It's not just
> about being brown or white; it's not just ador-
> ing *Pachamama* or adoring Jesus. It's much more
> mixed and complex. It is and it isn't at the same
> time. It's related to the fact that Andean families

Mycena cristinae is an Amazonian bioluminescent
mushroom that glows at night.

Koji

Koji (*Aspergillus oryzae*) is a mold that is key
in the making of many East Asian foods,
such as sake, soy sauce, and miso.

that could grow economically sent their chil-
dren to study in Lima, in the capital. Peru is really
centralized; you wouldn't live in any part other
than the capital because there is no access to
anything. Outside of Lima there is no education or
hospitals, no roads, no airport. Many places don't
have basic things such as electricity or water.
People didn't want to lose their culture, but also
wanted to be able to develop. Many people ended
up moving to Lima. This also happened to my fam-
ily. With this move many traditions are lost. But
the most important celebrations in the calendar
are in relation to the sowing of seeds. Different
moments of the year continue to be celebrated
but are related to religion.

In the agricultural calendar things always re-occur, but slightly differently.
According to Claudia, the best way to try and understand this is to visual-
ize a cyclical pattern not as flat circles, but as spirals with different levels.
Many things will keep on repeating themselves and though they will be
similar, there will always be a difference. Martínez Garay:

The celebrations are continued but shifted because
people weren't able to continue their culture in
the same way they could in their towns. But they
tried to continue with certain celebrations. I never
thought about this calendar that much, but it was
a very important part of everyone's life. For most
of the people whose family comes from the Andes,
they know about these things.

Claudia Martínez Garay points out that linearity is directly related to
Western time, industrial time, and modern society and adds that 'in some
other places that still have indigenous or native cultures, there
is a different point of view.' She tells me about the Aymara and the
Quechua people and how she was reading a book about native culture in
Hawaii and saw that they all have a similar approach to understanding
ideas of future and past. Claudia:

For example, for the Aymara people say that you
will never know the future, so that's why it's in
the back, behind you. In front of you is the past,
because you know that. The idea of having the
future behind you is also a metaphorical reference
to the carrying of the baby on your back.

When I speak with curator Yina Jiménez Suriel from the Dominican Repub-
lic, we also talk about portals and non-linear time. The Dominican Repub-

lic is an island with the highest mountain peak of the Caribbean region, called Pico Duarte, as well as the lowest point of the region, the giant Lake Enriquillo. While the Pico Duarte is over three-thousand meters above sea level, the biggest lake of the Caribbean is forty-six meters below sea level. It's interesting that Yina describes the concept of non-linear time, or rather parallel time, by talking about altitudes. She explains that if you want to feel colder you don't have to wait for the winter to start or for it to become night. It's always colder, at the same time, at a higher altitude. She continues to speak about parallel worlds happening at the same time and how you're not able to see it when you don't know it. She tells me about a guy in the market that sells *empanadas*. What you don't see, and what you don't know unless your reality is different, is that the *empanada* guy also sells marihuana. For most people he is the *empanada* guy, yet for some he is the marihuana guy. It's parallel worlds happening at the same time, but you only see one.

Thinking about people selling things in different notions of time reminded me of the work *mujer vende queso con su vaca* (Woman Selling Cheese with Her Cow) by Claudia Martínez Garay, a small and humble ceramic piece that I encountered amid big colorful murals of corn, flowers, and cacti for the exhibition 'Revolutions, like trees, are recognized by their fruits' in GRIMM Gallery, in Amsterdam. The murals depict many clichés of what you might think a Peruvian artist or Peru is like. I was more interested in the small pieces, representing scenes from the town where she is from, Ayacucho. 'The things that you don't want to see or discuss,' according to Martínez Garay. One shows a scene with a woman selling her cheese on the road. She tells me she came across this woman when she visited her hometown and saw that she wasn't selling anything for hours. Claudia: 'That's a very different way of time passing for a person on the road in the middle of the mountains.'

NON-LINEAR ORGANIZING

When I ask Mirla Klijn, one of the two founders of Valley of the Possible, if their residency program could be organized in a non-linear way, she explains that it was definitely the ambition for the program to somehow be circular. Mirla:

> We had an ambition for a cyclical way of thinking. Ideally for the next program I'd like the start of the residency to be more related to sprouting seeds or ideas that are sprouting, and then incorporate the meditation and the connection to the earth and soil and feminine energy. And maybe the 'end' of the residency would be more about relating to the soil, dying in a way and becoming the earth again.

Our conversation takes us to the topic of dreams as I had gifted her a book

of Carlos Castaneda that I had been reading myself previously. The book, from 1968, called *The Teachings of Don Juan: A Yaqui Way of Knowledge* had given me wild and vivid dreams. In the book, Castaneda becomes the apprentice of Don Juan, 'a man of knowledge' who introduces him to the world of sorcery. It's a true story that sits between anthropology and creative non-fiction. The main character, besides Castaneda himself, is Don Juan, who describes his sorcery as moving between the 'ordinary and unordinary reality'. The idea that there are different realities that operate in different times is as true as anything else is and isn't for Don Juan. While reading the book I became more and more aligned to this idea. My colorful dreams became a portal into the non-ordinary reality, a way to travel through different notions of time, and also to start seeing the non-ordinary reality as a form of reality in which time is warped. Dreams are very important in many indigenous cosmovisions. Fer Walüng once told me that Mapuche people say that the dreams of the grandparents come true in the lives of the grandchildren. Can time be cyclical if the future is the past and the past is the future? I looked up more information about this in the book *Thunder Shaman* and found that the

> Mapuche do not experience multitemporality as de-historicized. For them, multitemporality is a historical process linking the 'before time' with 'today time'. Particularly for the machi, the spiritual leader, it is important that they are able to embody and transform the spirits from this 'before time' and the historical past of 'today time' in order to gain power in the present and create a better future for the collectivity.[7]

7.

Ana Mariella Bacigalupo, *Thunder Shaman: Making History with Mapuche Spirits in Chile and Patagonia*, University of Texas Press, 2016, pp. 100, 101.

I think of my own grandmother and how I wished she was still alive so I could ask her about her dreams. Would she have ever dreamt of a world ending and collapsing, of climate change? How do we build the future based on the past using the dreams of our grandparents? It's not only a potent reminder to take our dreams more seriously but also of the importance of intergenerational relations.

UNDERSTANDING OURSELVES AS NON-LINEAR PROCESSES

Some of our (ordinary) realities have become so non-stop, busy, rushed, and overwhelming that it is hard to slow down and see what surrounds us. When we calm down and take a deep breath, we activate our senses, and suddenly start seeing colors, hearing birdsong, or start smelling the rain. The mushrooms seem to tell us just this, and that wisdom and power are to be found in those things that are hardest to perceive: that which is off the radar, that which is in the non-ordinary reality or in the quiet underground. Invisibility, patience, dreams, and silence are the humble heroes in a society constantly seduced and distracted by loudness, immediacy,

and result. For fungal life, they have been the key strategies in survival and avoidance of exploitation. Art, fungi, and knowledge are processes rather than results. Perhaps we should also understand ourselves as non-linear processes. Stuart Hall, born in Kingston Jamaica in 1932, once wrote:

> Identity is not a set of fixed attributes, the unchanging essence of the inner self, but a constantly shifting process of *positioning*. We tend to think of identity as taking us back to our roots, the part of us which remains essentially the same across time. In fact, identity is always a never-completed process of becoming – a process of shifting identifications, rather than a singular, complete, finished state of being.[8]

Carmen from colectivo amasijo illuminated the importance of valuing the process with the example of how the collective loves to make *tamales* together, the delicious traditional meso-American dish that involves a lot of wrapping and tying together of ingredients in a corn husk before steaming it. One night, at their house, all women around the table, we must have made almost a hundred of them. My initial clumsiness was received with kindness, humor, and generosity and I quickly learned. Giggling and chatting while wrapping and tying, we could connect at this particular moment. Carmen:

> When we make a separation between labor and leisure ('like gringos do'), the danger lies in trying to make the process of labor as short as possible. It needs to be really efficient to have a fast result and to have as much time as possible for 'leisure'. But what if exactly that process is the crucial ritual of learning, of understanding the richness of what we do, of connecting over something? What if actually the process is equally as enjoyable as the result? The result is the excuse for the process and the process is the excuse for being together.

It makes me think that we are really overrating efficiency.

SLOWING DOWN

So how can we implement these different notions of time in our practice as artists or art organizations? Lola from TEOR/éTica, in Costa Rica, tells me that it all starts with talking about how we understand time. Lola:

> We did two small exhibitions last year about what we can learn from nature's times and we constantly go back to this discussion as, of course, time is a structure that somehow determines every-

8. Stuart Hall, *Familiar Stranger: A Life Between Two Islands*, Duke University Press, 2017, p. 16.

thing else based on production, capitalism, and imperialism. The imperialism of time. There is this idea that we have to follow that. And when we question it and create our own times there is always a struggle, but we do believe it's more generous and more coherent than what we are trying to do. We worked with this amazing artist who works with bacteria, Sofía Ureña. She creates a material that resembles leather. But it takes a lot more time than if she just went out to buy leather or something made from plastic. It's a creative process from bacteria. She is always saying that the bacteria are the artists. What can we learn from that when it comes to doing all this managerial work in cultural institutions, which I believe are the spaces that allow for a little bit more flexibility? Spaces like ours don't have to fit into this whole production-time-quantity-results framework. We are allowed to work more closely to how nature works, with extended periods, in which the time that something takes is more diluted. More than just slowing down, it's understanding that time stretches out. It's not that you're not doing anything, and you have to resist this question of 'what are you doing?' and making that constantly visible through social networks. We're trying to resist that and be more generous with ourselves and the time we are given.

In practice, that means slowing down and reclaiming spaces of socializing and working, and having some fun with the thinking process. Lola:

We had to reclaim the fact that *that* is work and that it deserves its time, it deserves its care, and it's probably what makes the rest of what we do more interesting and enriches it a lot. Besides slowing down, we can start valuing the process as an artwork rather than 'the finished piece'.

HOW TO DEAL WITH INSECURITY?

Embracing Mystery and Surprise

TEACHING TEN

Featuring:
Mycena cristinae, oyster mushrooms (*Pleurotus ostreatus*), veiled lady mushroom (*Phallus indusiatus*), *Psilocybe mexicana*, *Psilocybe cyanescens*, FIBRA, TEOR/éTica, Lilian Fraiji, Inti Garcia Flores, Juli Simon, Fer Walüng.

Geographies:
Manaus, Amazonas (Brazil), Ucayali, Amazonas (Peru), Huautla de Jiménez, Oaxaca (Mexico), Wallmapu/Araucanía (Chile), Valle de Bravo (Mexico).

<u>LOOKING FOR MYCENA CRISTINAE</u>

As I prepared for my first ever trip to the Brazilian Amazon, as part of an art-science research residency called Labverde, there were two items in my bag that I felt increasingly embarrassed about. I'd got overexcited in the Decathlon store a few weeks previously, but now that I was actually travelling it felt ridiculous to bring the full mosquito net hat that made me look like a beekeeper and the head torch with five light settings that made me resemble a miner. I had this horrible scenario in my mind of me being the clumsy 'all the gear, no idea' gringa, wearing the said torch and hat, huffing and puffing behind the athletic indigenous guide wearing not much more than a loincloth. This image was so cringey I kept on taking the items in and out of my bag, weighing up which was worse: me in a full reflective and protective Decathlon outfit, or me looking like me but scratching a million red, and possibly deadly, insect bites.

My arrival in Manaus, the capital of the State of Amazonas, was pleasant. I stayed in a little place around the corner from the Teatro Amazonas, a central landmark of faded glory. This famous theatre in the heart of the Brazilian Amazon opened in 1896 as the cherry atop the cake called the rubber boom, the time of economic flourishing due to the large-scale extraction and commercialization of rubber. The Teatro has a spectacular ceramic dome painted in the colors of the Brazilian flag, while the building itself is more like a Versailles pink. It hosted major opera singers in the

past, though I knew it mostly from the opening scene of one of my favorite films, *Fitzcarraldo*. This Werner Herzog film is about an aspiring rubber baron that wants to do the impossible: hoist a steamship over a mountain in the Amazon basin when blocked by part of the river. The story is not even that unrealistic, as the promise of great rubber wealth had indeed made people do crazy things. The rubber boom had even attracted the attention of Henry Ford. The capitalist-at-heart that he was, he too wanted to ride the wave of rubber wealth and bought a large piece of the Amazonian rainforest ('twice the size of Delaware') to start growing rubber for tires for his cars. Ford, however, also had a rather megalomaniac dream to bring 'civilization' to the rainforest and, alongside rubber plantations, started building modern houses with electricity, golf courses, cinemas, and ice-cream parlors in the middle of the Amazon. It became a social, environmental, and cultural disaster, with horrible and violent clashes with the indigenous groups whose territories and cultures he was invading. The remnants of the abandoned *Fordlandia*—as this ambitious project was called—can still be found in the Amazon. While in Manaus, I was reading this whole story about Ford in the Amazon, amazingly narrated by Greg Grandin in his book *Fordlandia: The Rise and Fall of Henry Ford's Forgotten Jungle City*. The book demonstrates how the worlds, values, and visions of the capitalist American and the forest communities could not be more different. How was I going to navigate the colliding of worlds? I obviously still had a wildly romantic idea about what the forest was. All of this I was contemplating as I sat with my book in a little restaurant next to the Teatro, where I ate pirarucu for the first time in my life—the enormous, monstrous-looking and ancient fish from the Amazon waters.

On my first day in Manaus I visited INPA, the National Institute for Amazonian Research, where I was delighted to meet a team of excited young female mycologists who showed me around an exhibition about the *Marasmius yanomami*, a black fungus that the Yanomami people use to weave their baskets. The fungus is like a hard piece of string, almost like plastic, and used to create beautiful patterns in their craftwork. I was told this mushroom was 'described' by Jadson Oliveira, who was doing post-doctoral research at INPA. I asked what it means to 'describe a mushroom' and was told that at INPA there are several people doing mushroom taxonomy, like Jadson. They go out into the forest and bring back mushrooms that might be new species to science. To describe a new species, the mycologists first check the references to understand to which genus the mushroom belongs. This is based on its characteristics. Then they start looking to see if anything from the files matches the description, which can be challenging because some of the descriptions are very old and not very detailed. In addition, they use DNA sequencing, which helps a lot. Usually, they use both the sequencing and the references to find out if the mushroom had been undocumented.

Initially, I was utterly amazed by this describing of unknown mushrooms, but quickly found out that the discovery of a new mushroom is a

fairly regular occurrence at INPA. Juli Simon, a mycologist there, casually told me she had already described about ten new species! Simon: 'It sounds like a lot but anyone that studied mushrooms in the Amazon would find a lot of new species just because there is so much diversity.' Simon was also the first person to bring back the bioluminescent mushroom, the glow-in-the-dark mushroom, to INPA. Jadson and his colleague Noemia Ishikawa were both very excited as they had spent some time looking for it. Ishikawa helped with funds for research to fully support Jadson and Tiara Cabral, another colleague, who did the molecular work. This newly described luminescent fungal species entered the world of science under the beautiful name of *Mycena cristinae.*

I was immediately obsessed with the idea of seeing *Mycena cristinae* with my own eyes. She sounded so magical; shy and silent by day, a glowing party princess at night. When I spoke with mycologist Maria Alice Neves she told me one of her students was researching the bioluminescent *Mycena* for her PhD. 'They are thinking there might be some that are ectomycorrhizal.' When a fungus is ectomycorrhizal, it means that the hyphae of the mycelium do not enter the individual cells inside the roots of the trees or plants they are associated with. Most ectomycorrhizae are associated with 'woody' species such as eucalyptus, pine, rose, and oak and take up nitrogen. Only two percent of plants form associations with ectomycorrhizal fungi and a large majority form mycorrhizal relationships with arbuscular mycorrhizas, which absorb phosphorus from the soil. The four different types of mycorrhizal relationships are arbuscular mycorrhizas, ectomycorrhizas, ericoid mycorrhizas, and orchid mycorrhizas.

Fortunately, one of the hikes as part of the Labverde programme was to take place at night, in the dark. Juli Simon warned me to lower my expectations.

> As a mycologist, you sometimes go to the forest
> and all the conditions are perfect and your ex-
> pectations are high and then there's nothing! Or
> sometimes you think 'Oh I'll just do a little trail
> with some friends' and you don't bring anything
> to collect and then you find so many mushrooms!

It sounded like my best chance of meeting *Mycena cristinae* was to NOT expect I would meet *Mycena cristinae*. In a kind of reversed psychology attempt, I swapped expectation for faith. I would have to leave it up to the party princess if she wanted to meet me.

We had been on the boat for four days since the visit to INPA, moving deeper and deeper into the forest. I shared a bunk bed with a Japanese curator whose outfits and gadgets were so high-tech that all my head-torch and mosquito-hat shame vanished. I was nothing compared to her. The head torch was actually a complete blessing in disguise as this was an essential piece of kit on our night hike. With a small group, we left the

boat just after midnight, in the full darkness of night, and it was like a whole new world had opened up. Different smells and different sounds, and, of course, everything looked different and mysterious, with only the head torches and moon guiding us. The sound of the frogs rose loud above everything else, and when I accidentally encountered one I saw why: they were about the size of a puppy! It felt like everything in the rainforest was more alive, more vibrant, bigger. This definitely also applied to the tarantula hanging out on a tree trunk I grabbed hold of to keep my balance. I only saw him when I looked towards the tree and my head torch followed my gaze. I had placed my hand only twenty centimeters or so away from him and though my heart was pounding with both fear and excitement, my first thought was that I couldn't wait to tell my mom I almost touched a tarantula—she has arachnophobia and would be suitably impressed. We stopped at two different places where we had to switch off our torches and wait for ten minutes to see if any bioluminescent mushrooms would light up. Every ten minutes felt like an hour but everything surrounding us stayed pitch-black. I thought of Juli's words and accepted it would probably not happen. Deeper in the forest, our guide suddenly stopped again and took a few minutes to identify the place. 'Let's try again.' Everyone switched off their torches and after the tarantula incident I decided to stay standing up rather than squat like the previous two attempts. Within minutes my eyes adjusted to the dark and it was clear that this was the spot. Several patches magically started glowing. My immediate response was to reach out and touch. I picked up a leaf and I couldn't believe my eyes. It was so bright. I held the leaf up like a mini lantern. Not only leaves, a whole trunk on the forest floor was colonized by the bioluminescent fungi and was radiating like it had magical powers. We all stayed there marveling but soon it was time to leave as we still had to hike back to the boat. I remember I had crazy dreams that night, yet I don't recall the details.

Mushrooms teach us to embrace surprise, to minimize expectations, and when something does happen, enjoy the beauty of the ephemeral. It's a magical idea that something underground is heaving up unthinkably heavy loads of soil without us knowing and then suddenly something beautiful appears. We don't know where they are going to come up, how they're coming up, what they can do, or what they will look like. There are endless possibilities of powers and appearances and colors. Or as Juli said:

Mushrooms come up so fast and might only stay for a few hours, and then maybe it takes another year before you can see them again. Or sometimes they spend years without popping up. This ephemeral state really brings you to the present. It teaches you to be thankful for what is happening right now.

CONTROL IS AN ILLUSION

Speaking with the three ladies that form the art collective FIBRA in Peru, we discussed what attracts them to fungi. They also brought up the

There are several types of false morels, mushrooms that resemble classic morels but are potentially poisonous look-alikes.

importance of wonder and surprise in their appreciation of fungus. Lucia described this 'perfect here and now feeling,' something she experienced when she encountered an exquisite veiled lady mushroom (*Phallus indusiatus*) for the first time. The veiled lady is a spectacular-looking mushroom that wears a delicate white veil around it that functions as a protective membrane. It's a type of stinkhorn and the lovely white dress doesn't cover up the fact that it smells foul. Lucia:

> It was the first time I saw it in the flesh, after seeing it in books so many times. I just went crazy because it was right there! And I remember, I was walking with someone from the area—this was in the Peruvian Amazon—and they said I was really lucky to see it complete because immediately everybody else in the forest was going to come and interact with it, eat it, such as ants. It's very rare to see it intact.

The mushroom gave her the feeling of a perfect intersection of time and space, being right there, at the right time.

FIBRA has been working with mycelium sculptures for a few years, mostly inoculated with the *Pleurotus ostreatus* (oyster mushrooms). In that process, they have experienced first-hand how controlling a mushroom is an illusion. FIBRA member Gabriela tells me one of the lessons they learned when they first started working with mushrooms also applied to her own life:

> We needed to build some mycelium sculptures for an exhibition. But the mycelium is a natural body. We expected control but I don't think we can control the body of the mushroom. You have to learn how to deal with them. We try to control not only the mushroom, but also our life and our decisions. But there are other conditions, other factors, that you can't control. Dealing with letting go of control is an important lesson for my life from the mushroom. You trust; you learn how to deal with it. I think it's trust, not only in the mushroom but in something beyond yourself.

Their words strongly resonate with me.
Lucia adds:

> As we make the right conditions for fungi to grow, we are creating the right conditions for others to grow as well. We are humans, yet we are trying to de-center the human. It's really hard to make that decision about who you are nurturing to grow, and who you are not. I think it's hard to escape



some of the human biases we have. Working with mushrooms is a great way to practice our ideas of how we want to be in the world.

Gianine, the third member of FIBRA, continues:

We have been friends forever and we always share a lot about our work. Our interests have always somehow been connected in different ways. Lucia was interested in plants and I've been interested in rocks and what was happening under the soil— not necessarily the roots but more the minerals.

But then they started to collaborate on the 'Desbosque' project, an exhibition and series of events about socio-environmental issues related to the Peruvian Amazon and commissioned by the Museum of Contemporary Art Lima (MAC Lima). For this exhibition they used biomaterials (namely mycelium) to tell the story of the deforestation in Ucayali, one of the five regions with the largest amount of forests in Peru. This is quickly changing due to the illegal timber trade, land trafficking, and an increasing amount of monoculture plantations such as the oil palm, used for palm oil. They made their mycelium sculptures using the molds of communication artefacts such as megaphones, radios, and headphones. Next to the mycelium sculptures, FIBRA used sound and light design in the show with data from Global Forest Watch and GEOBOSQUES, two platforms that monitor data on forests against deforestation—the data includes, for instance, changes in vegetation cover over the last ten years and sends weekly alerts that are designed for the early detection of deforestation.

Gianine:

When Lucia told us about the work with mushrooms and fungi she was doing, we got really excited to see these networks and the possibility of connecting. This is the bit I love the most. This component of surprise, always getting to know something new. With mushrooms it's not always completely new but it's always amazing: there are so many shapes and colors. But if you don't look closely, or if you don't pay attention, you're not going to see it. That's also an important lesson.

There are so many parallels between the fungi and our own lives, about paying attention, about how you treat each other, about surprise. Even how the start of the collaboration between the women of FIBRA was fungal. They had been friends for a long time, and the network, the mycelium, had always been there, but then suddenly, a few years ago, it sprouted into FIBRA. The mushroom decided to pop.

Speaking with Lola and Daniela of TEOR/éTica in Costa Rica, they also

bring up the importance of letting go of control, even in an (art) institutional context. Daniela:

> Within the institution it's very rare to let go of
> control. We are taught to be aware of everything,
> and in control of everything; from the budget, to
> people, to results. But there is no way. Even if we
> really tried, there is no way we can be in control
> of everything. The moments where we let go the
> most have been the moments we enjoy the most,
> the more fruitful ones, the ones with more fun and
> that people come closer to because it flows in a
> more natural way. When we finally started doing
> the things we wanted to do, instead of what we
> thought we had to do, that's when we started hav-
> ing a lot more fun.

And, as Puerto Rican artist Sofía Gallisá Muriente in a separate conversation points out to me, art is actually perfectly located to claim a space in no-control:

> Art can be conveniently confusing. We can always
> say: 'It's research, I don't know what's going to
> come out of it; I can't foresee what the final prod-
> uct is going to be!'

Fungi teach us we have to be ready to transform, embrace change, and tolerate insecurity. We need to improvise, be flexible, and ready to ma-neuver if we are to face the times ahead of us. Translating it in our times, we could perceive the pandemic as just another dress rehearsal. A re-hearsal of collapse. Anna Tsing, in her book *Mushroom at the End of the World. On the Possibility of Life in Capitalist Ruins*, already taught us we need to start practicing precarity like the mushroom does. She is an important touchstone for contemplating life without the promise of stability and in her book writes about precarity as 'the condition of being vulnerable to others.' She continues:

> Unpredictable encounters transform us; we are
> not in control, even of ourselves. Unable to rely
> on a stable structure of community, we are thrown
> into shifting assemblages, which remake us, as
> well as our others.[1]

A challenge that needs to be addressed when talking about 'practicing precarity' is that as a decision, as a 'lifestyle choice', it comes from a po-sition of privilege. There is a difference if the precarity is being practiced by choice or not. Practicing precarity as a choice requires recognizing, acknowledging, and coming to terms with your privilege and, therefore, shame. And acting from this acceptance. Only then can we start seeing

1.

Anna Tsing, *Mushroom at the End of the World: On the Possibility of Life in Capitalist Ruins*, Princeton University Press, 2015, p. 20.

the beauty in that which we don't understand, appreciate the
ephemeral, recognize the importance of the here and now, and find hope
for the future, in the possibility of surprise.

DIAMONDS ON TO THE EARTH

As I became more fungi obsessed, bringing them up in practically every
conversation, I noticed some of my social circles had slowly adopted a
new identity for me: the 'crazy mushroom girl'. Though I wore it as a badge
of honor, I did pick up on the stigma and something about it didn't feel
quite right. As I was genuinely inspired and enlightened by the teachings
I was encountering in the mycological world, the responses of the world
around me sometimes jokingly suggested my excitement came from trip-
ping on magic mushrooms. Magic mushrooms contain a compound that
we call psilocybin. More than two hundred different mushroom species
carry this compound, including the *Psilocybe mexicana* and *Psilocybe
cyanescens*, two types I had indeed consumed.

The consumption of psilocybin mushrooms had been a very helpful
exercise in letting go of control and embracing the mystery. Rather than a
funny experience, it instigated a profound connection with nature. When
we speak about so-called magic mushrooms, mycologist Juli Simon con-
firms this feeling. She herself studied and uses them too. I was interested
to hear how her scientific knowledge of psilocybin mushrooms influenced
her trip. Juli:

> When I had psilocybin mushrooms for the first
> time, I really felt that connection with nature.
> All the things you try to explain with words
> and methodologies scientifically, you then feel.
> Through science we now know about the mycor-
> rhizal networks and exchanges but when we take
> the mushroom, we can understand that through
> another type of awareness and understanding.
> You just know that it's real.

When we consume a mushroom that has this compound, we embark upon
a journey in a mysterious world. Tripping with a psilocybin mushroom can
thus be a magical experience that allows you to connect with nature and
the universe on a deeper level. The consumption of these mushrooms has
been vilified since the nineteen-seventies, however, because there have
been many cases of people taking them in the wrong way, with negative
and traumatic experiences as a result of that. Psilocybin mushrooms are
no party drugs, I learned from the Mazatec people in Oaxaca, Mexico. The
Mazatecs are an indigenous community who mostly live in Oaxaca, Puebla,
and Veracruz. In an interview for the Fungi Foundation,[2] Inti Garcia Flores,
a key person in his community in Huautla de Jiménez, Oaxaca, explains the
importance of approaching the mushroom with humility and respect. The
mushroom is sacred and the Mazatecs have known this from the beginning

of time, using the psilocybin-containing mushrooms in sacred ceremonies called *Veladas*. It's a spiritual process to communicate with the being that created the earth and universe. Various elements are very important for the *Velada*, such as a candle (*vela*), the copal, an egg, and cacao or tobacco. The ceremony happens according to the Mazatec calendar, which is aligned with the seasons and the agricultural cycle of twenty days. In those days rain and thunder come down as 'diamonds on to the earth'. From those diamonds the mushrooms will grow, Inti explains. They have to be cut, with permission from the mushroom, at dawn and with the full moon. The mushrooms have to be cut by a child, accompanied by someone from the Mazatec culture. The mushrooms are never consumed alone, but always in pairs, and they are eaten whole, starting at the top and finishing at the bottom. You have to prepare for the ceremony by, for instance, not eating meat, not drinking alcohol, and not having sex (don't even think of it!) for four days before the ceremony, and four days after. It's quite the opposite of how many people, including myself, have used magic mushrooms. Inti adds that the Mazatec ceremony is not the only way to consume them respectfully and that everyone who needs it should have the chance to heal or be cured by mushrooms. The most important thing is to treat the mushroom with respect; it is sacred, and, when used in the right way, can be a portal to the ineffable.

The use of magic mushrooms became popular in the United States and Europe in the nineteen-sixties, with their popularity triggered by an article published in *Life Magazine*, in which the *Velada* of Mazatec *curandera* (healer) Maria Sabina was featured. She was the first to allow Westerners to participate in the ceremony. At some point her ceremonial song was recorded without her knowing or without her permission, and more and more Western tourists flocked to Mexico, searching for this magical experience with the famous Maria Sabina. It created an appalling culture clash, with the tourists popping the mushrooms at parties shocking the Mazatec community. Some people became very angry with Sabina for revealing the secret of the mushrooms, to the point where her house was burnt down. It's a sad story that needs to be told again and again so we can all be reminded not only to treat the mushroom with care, but also how to navigate cultural differences carefully and have more respect toward the knowledge and rituals of indigenous people.

Nowadays, psilocybin mushrooms are again being appropriated and misused, but by a completely different invader. Not so much by overexcited party-hippies but by greedy big pharma. More and more lab research is being conducted on the beneficial effects of psilocybin for people with mental health issues, including by prestigious Western institutions such as Harvard University and John Hopkins University in Baltimore. In a world in which an increasing amount of people are popping pills and suffering from depression and Post-Traumatic Stress Disorder, there is a flicker of hope in the shape of a mushroom. Pharmaceutical companies have quickly picked up on this potentially very lucrative business and have already started

The Veiled Lady (*Phallus indusiatus*) is a fungus in the family of stinkhorns. The protective white membrane looks beautiful, but the mushroom has an intense odor that attracts animals.

Darwin's Fungus

Darwin's fungus (*Cyttaria darwinii*) is a parasitic fungus named after
Charles Darwin, who collected it in Tierra del Fuego. It's eaten by the
indigenous Fuegian people and it looks a bit like an orange golf ball.

patenting some of these psilocybin mushrooms. For-profit pharmaceutical company COMPASS Pathways, for instance, has been doing some of the largest investigations into psilocybin's potential for treating depression.[3] It's the ultimate example of the problematic perversions of capitalism. This medicine, which could help heal a lot of people, should not be monopolized. And it's not only happening with psilocybin. It's a sensitive and complex subject as it addresses 'the dark side of science,' Fer Walüng, a Mapuche seedkeeper, tells me in Chile. Over the course of three weeks spending time together I slowly gained her trust. Though she is very well informed and not shy, her experiences, her Mapuche background, and her intricate inside knowledge of what is going on in what is essentially her territory—Mapuche territory—makes her vigilant and selective about whom she speaks to regarding this matter. In quick Spanish peppered with Chilean slang—which my mother later translated for me—she addresses the Green Revolution in Latin America, the push for technical agricultural 'advancement' and 'modernization' through pesticides, fertilizers, mechanization, and so-called 'high-yielding varieties' (HYVs), manipulated crops that could produce bigger quantities of food. It started after the Second World War as a project developed by the Rockefeller Foundation, and Mexico in particular was going to be 'the lab for the social, economic, and technical experiments.'[4] This 'revolution' actually led to many complications for farmers as part of these new agricultural policies were patents on seeds and there were strict rules around which seeds could be used and which couldn't. It was a big disaster for small farmers, including the indigenous communities, who suddenly weren't allowed to use their own seeds anymore, but were forced to use hybridized seeds that needed matching chemicals and irrigation to grow. Fer:

> Many seeds have been patented and have changed composition because of this, for instance in the case of Chile; the *Maqui* (a plant with purple berries), the *Murta* (also a berry), and quinoa.

Of course, these big companies also had their fingers in the science pies, including relationships with universities. Fer tells me that this is also the root of what is happening in Wallmapu, where currently a lot of academics, university researchers, and scientists are entering this Mapuche territory. Fer:

> They enter our forests and steal genetic material of endophytic fungi that haven't come to fruition yet. It's very important for the regeneration of the soil that they are not picked before they are fully grown. The same happens with the genetic material of medicinal mushrooms, which is then taken to gigantic labs outside of Chile, often the United States, and patented. In 2016, Wallmapu was

3. See: psilocybinalpha.com/news/compass-pathways-announces-positive-topline-results-from-groundbreaking-phase-iib-trial-of-investigational-comp360-psilocybin-therapy-for-treatment-resistant-depression

4. Alyshia Gálvez, *Eating NAFTA: Trade, Food Policies, and the Destruction of Mexico*, University of California Press, 2018, p. 76.

visited by a researcher from Stanford University who 'discovered' an endophytic fungus that can degrade plastic. A small mushroom whose genetic material was immediately patented. After that, if you wanted to do any type of research, you first had to be granted permission by Stanford.

Fer emphasizes the hypocrisy of this situation as the researchers also never asked for permission to enter, let alone take material, from Mapuche territory. Fer:

Now people say about the Mapuche: 'Why are they always so closed? So inaccessible? Why don't they want to share their knowledge?' Anyone who knows a little bit about the history of Chile knows that the colonial history against the indigenous cultures was very violent, from the moment Columbus arrived.

After colonialism there was neo-colonialism, when the Chilean government expropriated a lot of the territory of the Mapuche. The settlements and traditional communities saw the surface of their land reduced to such an extent that they could no longer even keep livestock. The Mapuche lost nine and a half million hectares of land. The state originally sold the Mapuche's fertile land to European settlers known as *colonos*, who established *fundos* (large farms), and more recently land has been sold to transnational forestry companies.[5]

The native forest has been cut down, which is their home, the central and most important part of their cosmology containing all the knowledge that had been passed down through generations. The government perceived the forests to be 'unused land' and perceived the Mapuche to be lazy, claiming they didn't till their land. Fer explains to me why this is not true: 'The Mapuche just want to live according to *buen vivir*.' *Buen vivir* is much more than well-being. It's an indigenous concept that is hard to translate. It's a collective, environmentalist, Andean-Amazonian culture of 'living well' with nature. But it's about being nature, not about protecting nature. And so there are areas that cannot be exploited, not for wood, trees, or water because they protect nature as a whole. The global epidemic of depression has created a rush for psilocybin. 'With the popping of anti-depressants', Fer tells me, 'people never get cured.' Quite the contrary, they lose neuro-communicative capabilities and get addicted to the pharmaceuticals. With psilocybin the process is cyclical and deeper. Fer:

It's not about getting rid of dark feelings; it's about connecting with your heart and spirit, in which the mushroom can help. You have an active role to play in it yourself too, to trigger endorphins (by sports for instance) and through

5.

Ana Mariella Bacigalupo, *Thunder Shaman: Making History with Mapuche Spirits in Chile and Patagonia*, University of Texas Press, 2016, p. 18.

Basically, to approach depression with psilocybin is to take the holistic approach that involves the whole body, heart, and spirit. Another great advantage: it's not addictive.

The teachings of the *Mycena cristinae*, *Pleurotus ostreatus*, and the different species of psilocybin mushrooms all show us, in their own ways, how embracing mystery and surprise is the antidote to frustration, fear, assumption, and attempting to control. Mushrooms show us the tools, and are the tools, to understand this and demonstrate how it can only be done in a holistic way that takes the whole system into account. The patenting of pharmaceuticals loops back to Henry Ford trying to control and exploit the human and non-human inhabitants of the Amazon. A disaster from which the scars are still visible and felt more than one hundred and twenty years later. I hope that the 'control' that the pharmaceutical industry is trying to attain by applying for these patents will turn out to be an illusion too. A change in mindset might save us from the horrific capitalist desire to want to patent everything, rather than sharing the knowledge needed for healing. Now that would be a rather pleasant surprise.

HOW CAN LANGUAGE HELP GUIDE US INTO THE FUNGAL PARADIGM?

Communication Is Constant and Infinite

TEACHING ELEVEN

Featuring:
Cyttaria darwinii, FIBRA, Maria Alice Neves, Giuliana Furci, shiitake farmers Tomaz and Marília, Camila Marambio, Raquel Rosenberg (Engajamundo), Carolina Caycedo, Maria Alice Neves, Patricia Kaishian, Juan Ferrer (Museo del Hongo), TEOR/éTica, Marion Neumann (The Mushroom Speaks), Tara Rodríguez Besosa, Jorge Menna Barreto, Ela Spalding, Sofía Gallisá Muriente, Luciana Fleischman, Lina Meija, Annalee Davis, Claudia Martínez Garay.

Geographies:
Santiago (Chile), Tierra del Fuego (Chile), Amazonas (Brazil), Puerto Rico, Amsterdam (Netherlands), Costa Rica, Barbados, Tasmania (Australia), Ayacucho (Peru), Taiwan, Gondwanaland.

UN-LEARNING

When I was in secondary school, maybe even in primary school, my teacher told us exciting stories about adventurous Dutch people setting off on grandiose sailing boats to explore the world. I loved these stories because they fueled my imagination about undiscovered lands, jungles, and other exotic unknowns. This great time, the seventeenth century, was called the Golden Age. It's where my love for the arts was born as I visualized myself in old paintings wearing elegant robes among still-lifes depicting oysters and half-cut lemons. I was born and grew up in Amsterdam and the Golden Age signified wealth and well-being for my country and city, accomplished by noble endeavors we should all feel appreciative of, my teacher assured me. The big ships from the VOC, the Vereenigde Oost-Indische Compagnie, returned laden with endless amounts of spices and other treasures, powering the economy and the arts and enabling the flourishing of cities like my own. Multiple (even recent!) prime ministers of the Netherlands have praised this so-called Dutch 'VOC mentality' as something to which we should still aspire. This education infused me with a weird sense of pride, something that dramatically crashed the moment I started spending more time outside of Europe in my early twenties. Very quickly, pride was bashed out of me and made way for a deep sense of shame unfolding on account of how this so-called 'Golden Age' had been a violent colonial undertaking, attainable by exploitation, slavery, and theft across the world.

How could this be called a 'Golden Age' when it's one of the most shameful and horrible times in history? This is what education, language, and storytelling can do. Three beautiful things that can also be used for ugly purposes. Nothing I had learned had prepared me for the scope of things that needed to be unlearned.

SILENCE

In retrospect, it dawned on me that some of the crucial teachings in my life had happened in silence. After my epiphany about needing to unlearn, I spent a year living in Taiwan, re-educating myself and often feeling alienated as I wistfully attempted—but never learned—to speak Mandarin. This did not stop me, however, from attending conferences and other gatherings conducted in Mandarin. I would often be with a friend who would translate a thirty-minute-long lecture in three sentences. 'She thinks it's important that so and so happens.' Aha. Still, something magical happened between the lines of me desperately trying to grasp the situation. I learned to understand Mandarin without understanding Mandarin. I learned to read eyes, sounds, atmosphere, intonation, temperature, and breathing. On top of that, I learned it's not a given that everything is always in English—and why that's the way it should be. I learned not to expect an interpreter. I learned to shut up and listen anyway. It was about living an old Confucian saying without me knowing: 'Unify your attention. Do not listen with your ears, but with your mind. Do not listen with your mind but with your essence.' It was the beginning of my path of unlearning and listening, a path that I have been following gratefully ever since. Later I read an essay by Isabelle Stengers, in which she writes about a conversation she had with writer David Abram about our modern enchantment with the written text,

> the alphabetic text, the only text that presents itself as self-sufficient, as able by itself to have us hear spoken words, witness strange scenes or visions, even experience other lives.[1]

My feeling, sitting in that Taiwanese conference room, was that we are not only enchanted with the written alphabetic text, but also only tend to listen and expose ourselves to the languages we master. When we listen to the languages we don't speak (fluently) more carefully, whether that's Mandarin or the language of, let's say, a forest or a mushroom, there is always a gateway to tune into and relate to. Just like there was with Mandarin. Abram: 'Only as our senses transfer their animating magic to the written word, do the trees become mute, the other animals dumb.'[2] Communication is constant and infinite and often silent. Now who is dumb?

A PORTAL FOR CONNECTION

Many authors, some even more amazing than others, have introduced new

1. David Abram, *Spell of the Sensuous*, Vintage Books, 2017, p. 131.

2. Abram, *Spell of the Sensuous*, p. 82.

terms that could help us understand the scope of the environ-mental and existential crisis we are in. From 'hyper-objects' to 'solastalgia' and a variation on a whole bunch of '-cenes'; from 'Symbiocene' to 'Planta-tionocene' and from 'Chthulucene' to 'Anthropocene', all have been helpful tools to assist us in comprehending these complex concepts. It's like a new generation of words now that 'sustainability', 'global warming', and 'climate change' have been appropriated, hollowed out, and hijacked for economic benefit and PR material by multinationals, making these terms interchangeable and, to some extent, redundant. As a consequence of this appropriation is that we might be using the same words—eco, green, environmentally friendly—but we don't mean the same things. My understanding of sustainability is most definitely not the same as Nestlé's, but it's not as a remote off-grid forest community, either. The size of this spectrum of understanding makes it hard to speak of something in a general way. We need to start being more precise. Playing with words and languages, and trying to me more precise, is a portal for closer connection, just as knowing the names of certain plants and mushrooms creates a form of intimacy, like encountering a friend on the street. Knowing its name comes with an immediate sense of familiarity. I liked the words of Subco-mandante Marcos, of the EZLN, who said: 'We have to become con-scious of language, not as a way of communicating, but as a way of constructing something.'[3] Learning a word sharpens the focus; it changes how you see it by honoring its uniqueness. And here the arts can assist: the arts can help enrich the understanding of the natural world, create language, and perhaps even express that which is not written.

At art space TEOR/éTica in Costa Rica they have been keenly aware of the need to create a common language to find common ground. They even wrote a whole glossary with terms that were important to them. Lola at TEOR/éTica explains:

> For us it was important that we were all speak-ing this language that is sometimes difficult to translate to other processes or to people who haven't been as involved. That's why we wrote the glossary; we thought it was a good way to share with people who are interested in this to begin to understand it from language. We have many words and phrases that we use a lot. Words and phrases that don't typically come from cultural manage-ment or curatorial worlds; it's more something that comes from a vernacular of how we speak. *Buchaca* is one of those words, *alter* as well—for us the *alter* is important as it's something that represents another way of doing something. Opac-ity and transparency are really important. We talk about entanglement as well; we can get entangled with other agents. We have two funny ones that

3.

Tom Mertes, *A Movement of Movements: Is Another World Really Possible?* Verso, 2004

relate to the budget. They're called *chelines nomadas* and *chelines mágicos*. *Chelines* in Costa Rica means loose change. *Chelines nomadas* is money that was budgeted for something but that we can move to somewhere else. Like nomadic quarters, mobile coins that can travel from one place to another. *Chelines mágicos* is when there is not enough but, somehow, we have to find the money to do it. It's magical money that needs to appear.

Chilean curator Camila Marambio tells me that she would still like to come up with a word for the connection between Tierra del Fuego and Tasmania. Two geographies that she has worked in extensively and found that there are a number of connections between them. Marambio:

Some are very tangible and some are more ephemeral. Connections have been severed, damaged, forgotten, displaced, misunderstood, but one that gives material means to me and Greg Lehman, an aboriginal Tasmanian man whom I work with and care for and spend time with, gives both of us a vessel for what we feel and what we know to be true. A vessel that we can show and we can share.

The vessel she is referring to is called Darwin's fungus (*Cyttaria darwinii*). It's a fungus that resembles an orangey golf-ball and they like to gather in groups in beech trees. It's called Darwin's fungus because Darwin came across them during his journey on the HMS Beagle to Tierra del Fuego. In Spanish they call it *Pan del Indo* (Indian bread) as indigenous people eat it. Curiously, this fungus only grows in Tierra de Fuego and Australia and New Zealand, places that seem so far away from each other. This fungus hints at the possibly of these continents once being connected. It could be a fungal memory of Gondwanaland. Gondwanaland, also called the supercontinent, is a scientific understanding of what part of the world would have looked like around four-hundred-twenty million years ago. Several continents, including South America, Africa, Antarctica, Australia and New Zealand, would have been attached to each other, later separated by the movement of tectonic plates. Camila and Greg felt the fungus was an ancestral vestige of that connection between two places and, in their case, two people. Camila: 'I'd love to come up with a word for that, as Greg and I talk and write about this connection, but we haven't given it a word yet.'

JUSTICIA PARA LOS HONGOS

During my interviews, it became clear that there was quite a bit of linguistic fungal reclaiming to do and that the myco-literacy of the general public was rather poor. Juan Ferrer, curator at the Chilean Museo del Hongo, even

told me that their artistic platform was established 'to bring justice to fungi.' *Justicia para los hongos*. The reclaiming of words with connotations, asking for language to be used in the correct way, was at the base of reaching this justice. It prompted me to ask all of the people that I spoke with for the research to share words that they wanted to introduce or reclaim. The amount of negative, or simply incorrect, words used to describe fungi and other natural processes demonstrated the damage that language can do. In her book *On Immunity: An Inoculation,* Eula Biss writes about how the microbial lexicon is peppered with metaphors that are often gastronomic or educational. 'Cells ate or digested pathogens' *or* 'instructed other cells.'[4] This is often the case when the behavior of fungi is described. Because the fungus is neither plant nor animal, a lot of terminology is borrowed from other spheres, which leads to misunderstanding and misrepresentation. This is nothing new; language is often brought up as a disturbing factor between humans and nature. It doesn't just create misunderstanding and misrepresentation; it helps us objectify; it helps us create distance. It has the potential be 'conquistadorial', using language to take ownership of entities that aren't belongings but beings. Language is more than representation; it's alive, in movement, and is being used to shape and understand the world surrounding us. It can act like a prism and influence our understanding of something. I wondered: To what extent is the language, or rather the translation of concepts responsible for our inability to see and react to the present environmental crisis?

4.

Eula Biss, *On Immunity: An Inoculation,* Graywolf Press, 2014, p. 59.

Many of the interviewees, including farmers, mycologists, and artists, shared the words they wanted to (re-)introduce, correct, or reclaim. Here's a selection:

FUNGARIUM

is an important word. Fungi aren't stored in herbariums. The repositories of fungi aren't herbaria, but rather fungaria.
(Giuliana Furci)

SPOROME

is one that I would like to reclaim. Many people use the term 'fruiting bodies' but, in my articles, I always use the term 'sporomes' or just mushrooms. Anything that relates fungi to fruits or to plants is not helpful.
(Maria Alice Neves)

FUNGICIDAD

like felicidad, is a word we made up to signify that amazing ecstatic state of elation and excitement when you encounter a fungus. A state of fungal awe. The word was born in a festival that we founded here called the Fungi Fest.
(Giuliana Furci)

QUEENDOM

The term fungi 'queendom' (rather than kingdom) gives people a moment to reflect on the histories that are at the foundation of the sciences we are operating (with)in or are in relation to. For me it gives people a moment of pause. And I've observed that people stop and go 'oh yeah, kingdom, okay...' It makes you realize it's not a totally innocuous word, whether or not you are intending it to be or engaging with it. It has meaning and those meanings are not simply at surface level. Especially when you probe further and further into foundational ideas within science you realize there is a big legacy of social order in the ways we are conducting science. The term queendom is not a cure, but it's a way of making people reflect.
(Patricia Kaishian)

For the book *Caribbean Cautionary Tales* we were
telling each other these stories and others would
respond to it with another story of similar things
happening in other Caribbean islands. The publica-
tion opens with the psychiatric evaluation of a man
wrongfully imprisoned who chooses to plead insan-
ity and pretends to be crazy. It says in his verdict
that the man is 'unboardable'. It's a beautiful word,
and it's a very Caribbean word; it's very much
about a ship that you can't board. How can we
become unboardable for the system, impossible to
capture, unapproachable to the punitory system?
(Sofía Gallisá Muriente)

WAVY

We use the word 'wavy' a lot, from waves. Wavy
horizontality shows how things will flow in differ-
ent ways. It's allowing ourselves not to think that
we have to be in a constant pace or constant flow
of creativity and production that goes upwards.
Sometimes we will find ourselves going back to
things that we thought were done, or that we had
already figured out. Institutions are the people
that work in them, not the buildings. And people
have histories, traumas; they have good days and
really bad days, and that has been key for under-
standing that all of the processes will go back and
forth and will loop and go in circles.
(Daniela, TEOR/éTica)

RESPIRA FUNGO

Breathe fungi. Since I started teaching, I have
been using these words—instead of '*respira fun-
do*' (take a deep breath). I made it into a hashtag
and now everybody uses it in Brazil! When we did
the Congress here in 2016, one of the students
drew a beautiful watercolor as a background to
take pictures and I put the hashtag there and it
was all we saw all over Instagram. Now everyone
is using it and it's really cool to see what people
are posting. It really spread like spores. I think
it's interesting how spores have an ability to be
omnipresent, to be everywhere and wait for the
right time to thrive and grow.
(Maria Alice Neves)

I heard the term 'biocultural diversity' from Luisa
Elvira Belaunde from Peru and it makes so much
sense for me because culture is referred to as as-
sociating with humankind. Biodiversity associates
with everything except the human in classical
thinking, and for me to try and separate the diver-
sity... I guess it refers to understanding the spe-
cifics of a place. It has to do with what I believe,
that nature and humankind have never been sep-
arated and have always been together, and when
a place is as biodiverse as it is, it's because the
humans that have been interacting with that place
have also supported that biodiversity and that
has to do with a culture too, in relation to a place.
The Amazon Rainforest is the garden of the indig-
enous people; there is this amount of biodiversity
because of their cultural practices. For me, a river
is not just a body of water but has to do with the
communities that live with that river. Places that
are either really thriving or on the frontlines of
environmental justice are that way because of the
tie between the human and the non-human—the
multispecies tie is the strongest. The biocultural
diversity is the richest.
(Carolina Caycedo)

BERÇO AND CAIXA CONVITE

Farmers Tomaz and Marília introduced a lot of
new (Portuguese) linguistic approaches to me in
their attempt to change the language that we use
to something more truthful and deserving. For
instance: in Portuguese, when you dig a hole to
plant a seedling you call it a grave (*cova*). Tomaz
and Marília call it a crib (*berço*) instead. Marília:
'You are planting something new and it hopefully
has a whole life ahead; it doesn't make sense to
call it a grave.' The couple also keep bees and in
this field have also been introducing alternative
terms. For instance, for the boxes that are usually
called 'bait boxes' (*caixa isca*). The couple call
them 'invitation boxes' (*caixa convite*).
(Tomaz and Marília)

DÙTHCHAS

It's a Gaelic word that is very difficult to trans-

late into English but it's about soil, land, and belonging. It's not necessarily about the ownership of land but a connection to land through tradition, memory, ritual, spirit, and feeling the sense of connection to soil and landscape in a very profound way. It's a word that acknowledges the place where you feel you belong and that you understand. In my work for the National Trust of Scotland, I became curious as to whether people banished to Barbados had ever felt a sense of *Dùthchas*, or connection to this foreign land so far away. Many of them died shortly after because the working conditions were difficult and many couldn't afford the passage back home. I was reading some wills in Barbados written by very small landowners on the East Coast where the Scotland District is located and I noticed they were using the term 'my place'. I wondered whether the Gaelic *Dùthchas* had become 'my place' in English, suggesting that some eventually felt an affinity with this land.
(Annalee Davis)

ENVIRONMENTAL HISTORICAL MEMORY

In the more specific context of Colombia, I would say: 'environmental historical memory'. To understand what that is and how it can be used as a tool has been very important for me. As an artist, how can I contribute to environmental historical memory, to build environmental historical memory, and also how do you unpack these terms in the art world and inspire others to think about that term?
(Carolina Caycedo)

SUSTENANCE

I don't like the term sustainability—that's another word that I always battle against. I prefer to use 'sustenance'. In academic or art contexts, sustainability by definition means to maintain the production at a certain rate, to maintain the rate of something. I don't want to frame my work in these terms; first of all, because art-rate production is crazy and sometimes I even fall into it myself. But the word sustenance means nurturing, making sure something is living and thriving: How can my work be sustenance for people on the front line?

Be sustenance to the audience that come to see
the show?
(Carolina Caycedo)

ARTISTEAR

We often learn from artistic processes, like the
example of the project with the bacteria. We have
this word, '*artistear*'. We turned 'art' into a verb.
We are not necessarily artists ourselves but 'we
art' as a verb. We find that art is our common
space for learning and studying, for coming to-
gether with other people.
(Lola, TEOR/éTica)

RESILIENCE

I prefer to use the word 'resilience' over sustain-
ability. I think it describes a lot better what we
want to say; it thinks about the limits of the plan-
et and the survival of not only humankind, but of
all biodiversity, all kinds of life on the planet.
(Raquel Rosenberg)

EL BUEN VIVIR

The reason for existence is *el buen vivir, buen
conocer*. Reconnecting with the communication of
our birth, or the intention of this whole ecosys-
tem. Doing that was so fertile for our participants
and all the others we are nurturing.
(Lina Meija)

CAJAMPA

is a word that needs to be reclaimed. It's exclusive to Chile; it's a word that in Quechua means mushroom and, only in Chile, we use the same word for penis.
(Giuliana Furci)

PARASITE

What is a parasite? What is a pathogen? It's not so much the term itself but what the term is trying to communicate. I think so often in science we, for good reasons, try to be as clear and concise as we can. But we are talking about things that are extremely fluid and dynamic. We make our boxes smaller and smaller to accommodate those differences and get precise definitions. But I think when you're resting on ideas that have been around for a long time and have become uninterrogated, you suddenly realize those terms might be striving for something that is not really accurate and potentially harmful.
(Patricia Kaishian)

MALA HIERBA

The first thing I think about when it comes to the role of language is one of the concrete practices we have been working on over the past few years in the name of unlearning: unlearning the bad habit of identifying certain plants as weeds. In Spanish, we have *mala hierba, una hierba mala*. In Puerto Rico most of the identified *hierbas malas* are medicinal plants with very specific and present medicinal uses within our culture. A lot of these things called *hierba mala* are actually medicines that our ancestors used to use. It's not a situation where we necessarily know what they are; it's a situation where we have been programmed to not value them anymore and call them bad weeds.
(Tara Rodríguez Besosa)

NATURAL DISASTERS

In terms of all the hydro-electricity issues, for example, we need to understand these are not natu-

ral disasters; they are man-made disasters. These are environmental crimes. All of these dams that have fallen in Minas Gerais, for example in Mariana (2015) and Brumadinho (2019), is really 'dam terrorism'. Even the increased hurricanes aren't natural disasters.
(Carolina Caycedo)

FUNGI-EATING WOOD
I met a child that asked me why fungus was on wood and I answered 'because it's decomposing the wood. It's turning the wood into smaller and smaller materials.' Another person that heard me said that I should just say it's eating the wood. But that's not true! He said 'but she doesn't know what decomposing is.' And I said: 'But now she knows.' Or at least if she hears it again it will not be the first time. Introduce new words and people learn. If they want to. It needs to be a two-way thing, of course. Terminology is very important, because that's how we can understand fungi as fungi and not as plants. That change is not going to happen fast, but the more people learn, the faster it will go. Anybody can learn words, new words, at any point of their lives. But it's about how you do it. You can't expect people to memorize all of these new technical terms but you can always have a conversation about it.
(Maria Alice Neves)

MUSHROOMS
This morning I was in a meeting about revising a website about the kingdom of fungi and all I saw were photos of mushrooms. It's like having a website about the kingdom of animalia and only having birds; it's not representative. So that's why the word mushrooms is also not representative at all. It's a type of fungus, just as a bird is a type of animal. Fungi are really a whole kingdom with yeasts, lichens, molds... just like the animal kingdom has mammals, amphibians, reptiles, fish, insects, or birds.
(Giuliana Furci)

SPIRITUALITY
I don't use the term 'spirituality' directly, even

Black fungus (*Mucormycosis*) is a fungal infection
spread by spores of mold.

Black Fungus

Satan's bolete, or the devil's bolete (*Rubroboletus satanas*), is a poisonous mushroom. Ingestion can cause diarrhea and violent vomiting.

Amadou

Amadou (*Fomes fomentarius*) is also known as tinder fungus
as it can start and keep a fire going. It typically grows in the
shape of a horse hoof.

though I would definitely say it is a part of our practice at Estudio Nuboso. I also didn't use the term 'climate change' openly for a very long time because it was very alarmist for Panama. Panamanians are quick to judge and lose interest. Now that it's more widespread, we do mention climate change, but actually talk more about biodiversity loss or environmental collapse. What we mention more is our relationship with nature and with others—we focus on respectful, reciprocal, and healthy relationships and foster interconnection across disciplines and cosmovisions. We are very careful with language as we want to address a diversity of people, and we also want to continue getting the funding and support.
(Ela Spalding)

COLONIZING

Mushrooms don't colonize—we can use other words, to start growing, to arrive at a place, and changing the language can be very powerful. I think language is the first step to re-imagining the relationships that we have with fungi and that we understand the relationships that they have with other living beings.
(Lucia, FIBRA)

CONTAMINATING

Naming things a certain way affects things in a manner you don't always want; we need to question, for instance, the word 'contamination'. Something is not contaminated but has opened up for other living beings; you are in the same space. You learn that words that are not necessarily positive can change the way you see things. It's good because we are contaminated all the time with the other—you get in touch and connect with others and that's contamination because you are not pure. It has a negative connotation.
(Gianine, FIBRA)

CLIMATE CHANGE

The term 'climate change' is problematic because it means we have to put all our troubles under this very broad bag of climate change, while there are so many nuances and different ways that

communities are experiencing climate change.
Questioning something as climate change has
also united us in a way, but we need to look at the
nuances: How do women, teenagers, and kids sur-
vive climate change?
(Carolina Caycedo)

ACTIVIST

I also don't like to use the word 'activist' for what
I do, for many reasons. One: in Colombia, or the
whole of Latin America, they kill activists and I'm
not even close to being on that front line. And
also, as a woman it was such hard work to claim
identity as an artist, to be respected as an artist
in a white male context, that I'm not willing to
give that up. As an artist, you are able to partic-
ipate and contribute to activism processes and
processes of resistance. I think the word activist
takes agency from all of us: as in, if you're not
an activist, you can't do anything and that's not
true. You can do anything, even if you're, let's say,
a taxi driver, or the person that gives us juice;
anyone can contribute to these collectivities, to
these shared dreams. These dreams that I also
share with those on the front lines. I'm not there
but I share their dreams. We all need this change;
we need it urgently. So yeah, the word activist is
not a word I identify with or claim.
(Carolina Caycedo)

THE THREE PILLARS OF SUSTAINABILITY

This is the worst word and concept that we need
to break with. They always say there are three pil-
lars of sustainability: social, environmental, and
economic. This is so wrong! You have the whole
planet as the environment, and then inside one
part is the social and then the economic is only a
small part of exchanging between the social and
the environment; it's such a tiny part of it... How
can you say three pillars? The limits of the planet
need to go before everything because it's the big
globe that incorporates everything. The social is
smaller and the economic even smaller. It would
have to be proportionate.
(Raquel Rosenberg)

We need to switch the term natural resources for
'common goods'.
(Carolina Caycedo)

AGRICULTURE

A lot of what queer practices and communities
have been able to contribute toward is better lan-
guages and more inclusive languages and know-
ing that plants don't work in terms of how we are
describing them. Health and food production and
farming and being on land cannot continue to
be described in highly colonial terms and that's
something I think is very important. If you were
to look up the history of agriculture in Puerto
Rico—the culture of food—what you find is about
the agro-industry. What you'll see in the history
books is a story that says that Puerto Rico was
really big in agriculture. There were so many
sugar plantations. Sugar and tobacco and coffee
were the main crops. But that's not a full or valid
or even correct description of the food culture
on our islands; I think that's very particular to
describing a market. A lot of people that want
to learn about the actual food culture in Puerto
Rico find themselves being directed towards the
wrong places. A lot of the work is to find out how
language can support finding and connecting to
other stories that are about feeding people, that
are about passing on knowledge and skill sharing
and don't necessarily participate in exploitative,
slave-based practices or injustices that continue
to this day.
(Tara Rodríguez Besosa)

MASS EXTINCTION

I don't like the apocalyptical discourse and how
Extinction Rebellion speaks about 'mass extinc-
tion'. It doesn't really mean the same here in
Brazil, especially when you speak with the forest
people. It scares; it doesn't empower. If they don't
have the same tools and access as people in Eu-
rope, the words won't make sense. With Engaja-
mundo, we always focus on the solutions; we say
we are part of the solution; we focus on what we
should do and not make young people scared about

Penicillium mold can be found on rotting fruit and grains,
but also produces the important antibiotic.

(Raquel Rosenberg)

FUNGA

The best example, by far, of the impact of fungal language must be the endeavors pioneered by the Fungi Foundation and introducing the word *funga*. As an advocate for fungi for well over twenty years, director Giuliana Furci took note of how fungi were not acknowledged as relevant organisms in decision-making spheres for conservation. This became clear as her foundation, which formally came into being in 2012, was excluded from most funding opportunities because of the terms of reference to apply. They usually only mentioned fauna and flora—or plants and animals—but never fungi. There was a blind spot in conservation and climate agendas and Furci saw a need to construct a framework for fungi, among other ways, by using language. Up to that point, there was no language that could speak for them. Furci initially saw two options for her foundation:

> One was to accept that you are formally excluded and the other was to adhere to the old notion that fungi are plants, even though they are more related to animals than to plants.

Neither option was particularly attractive or even acceptable to her. Furci:

> There are still organizations, like CITES (the Convention on International Trade of Endangered Species), that consider fungi as plants in their regulations. What was happening there was that language on the forms and terms of reference was automatically excluding fungi. This had advantages and disadvantages. It was a disadvantage in that it was hard to attract any funding, yet the positive side effect was that there were few rules and regulations. For instance: when you're filling in a form for customs and it says 'are you bringing any plants or animals to the country?' You can say 'no' and have your suitcase full of fungi that you are taking for science or to eat. They are automatically excluded. Basically, in all types of forms when there was a mention of fauna and flora or plants and animals it was exclusive to fungi.

Despite this very handy advantage, which I too learned to use strategically while traveling across Latin America (particularly bringing mushrooms from Chile to Mexico and the other way around), I understood the disadvantage of fungi not being included in any policy frameworks for funding and how it didn't outweigh the advantages. Giuliana got a group of colleagues together (including Juli Simon, also interviewed for this book) to

do something about it. They started by researching etymologies to understand where the terms 'flora and fauna' come from. As a result of this research, they published a paper in 2018 that introduced the term *'funga'*, explaining why this term is the correct one to refer to the fungal diversity of a given place. They launched a campaign called FloraFaunaFunga, which had a major trickle-down effect into policy frameworks, essentially leading to acknowledged conservation status, jobs, and education. Furci:

> What the word *funga* has done, really, is that it has proven that just by adding that language, adding that word, we were able to include fungi in national legislation. As a result of that, more jobs are created, an eco-systemic view toward nature; there is funding for education, for research, and for conservation. Ultimately, when you change language in a hierarchical system, you change language at the top of the pyramid and it trickles down into a series of changes that depend on language—written language and spoken language. Our whole society is based on written language and legislation.

INDIGENOUS LANGUAGES

How our enchantment with the written word came about is beautifully narrated in David Abram's *The Spell of the Sensuous*, a book I decided to read after coming across it in Stengers's essay. Abram writes about how written language, to some extent, detaches us from the senses and from the natural world, while oral cultures are based on storytelling. Abram: 'In hearing or telling the story we vicariously live it, and the travails of its characters embed themselves into our own flesh.'[5] In addition, he writes about how we tend to think that language is 'the special provenance of the human species,' yet, as he points out, 'the natural world has many voices' and that if 'human language arises from the perceptual interplay between the body and the world, then this language belongs to the animate landscape as much as it belongs to ourselves.'[6] In his book, he refers to many indigenous cosmologies that come with languages that are connected to sounds, smells, shapes, and stories of the landscape. There is so much potential in how indigenous words and concepts could guide us in our re-connection with the animate natural world. Yet I felt conflicted about non-indigenous people learning indigenous languages. Wouldn't it be cultural appropriation? Can one ever do justice to a language without being part of the cosmology in which it is embedded? And weren't indigenous languages connected to the landscape specific to their locality and ecosystems? Curator Camila Marambio gave me some new perspectives on the matter. She told me that she dedicated two chapters of her PhD to two Yaghan (Yámana) words. One in each chapter. Yánama is one of the

5. Abram, *Spell of the Sensuous*, p. 120.

6. Abram, *Spell of the Sensuous*, p. 120.

How Can Language Help Guide Us
into the Fungal Paradigm?

Fuego. Fuegian languages were officiated by the silence the Fuegian people were pushed into to avoid being killed during colonialism. Everyone thought that indigenous languages in Tierra de Fuego had disappeared. Now, she tells me, people are teaching and re-learning Fuegian languages again. She is quick to admit that she got a bit weary using the two words, as she didn't really know how to pronounce them correctly. Marambio:

> I have always, since the beginning, used them
> with a tensed pronunciation, but that has always
> been fictional. I'm a great believer in eco-fiction as
> a way to create a future, a world that we want to
> live in, for everyone to be justly considered. For
> many years that was enough for me: using those
> words and mobilizing them. They are words that
> when I use them, I see they do so much to people.

It's clearly not enough for her anymore. Marambio tells me that she does believe in mobilizing language for a more just world. She explains:

> I use these words to push back a lot of the scientif-
> ic literature on the early 'discovery' of Tierra del
> Fuego. One of these words was used by Darwin in
> a very derogatory way and I pick that description
> apart and suggest a different way to understand it.
> One of these languages also has a gesture. It's not
> just the word; it's also a hand gesture.

She reaches her hand toward the camera of her computer and opens it. It's the gesture we've become accustomed to understanding when asking for something, when begging. She continues:

> It was a misunderstanding of the hand gesture,
> something that he (Darwin) read as a plea, a give
> me, give me, give me. Darwin arrived in a big
> boat, and the Yaghan people he encountered were
> in small canoes. Certainly from that perspective
> it might look like someone is doing this (and she
> holds up her hand again), but it's just saying 'hi',
> giving you a hand and in a handshake so much is
> said. You're acknowledging the other and you are
> also saying 'I'm not going to hurt you; you are not
> going to hurt me. We are both here.'

Quite the intercultural misunderstanding, shaping how a whole community of people was perceived for years.

When we spoke, Camila had just started learning another Fuegian language herself: Selk'nam. Marambio:

> I know two words; I've been practicing pronounc-

ing for the past short period of time. It's a three-
year process; we got a grant to do it, and we've
invented the method—this is part of the 'there
is no wrong or right way' because it hasn't been
done before, but I can say it's already chang-
ing my relationship. The first word that we are
working with is the word for Tierra del Fuego in
Selk'nam. Just what you call this place, this land.
And it's a language that is very much about geolo-
cation. How things are pronounced is where they
are, what kind of effort you need to be able to say
things responds to temperature, wind currents, so
many things, taboos, or what are called taboos.

I ask Camila if she is willing to say the word for Tierra del Fuego in
Selk'nam for me. She seems a little bit shy all of a sudden but focuses,
closes her eyes, and produces a kind of clicking sound with her throat with
an open mouth.

I'm practicing because to be able to say it I need
to use my throat like I have never used it before,
which is widening the tract and allowing for my
vagus nerve to bounce. It relates back to your
body: that you are a body in a place.

It dawns on me that this connection between language and place doesn't
always need to be the landscape. Place is also within your own body.

DIGGING DEEPER: GENEALOGY AND ETYMOLOGY

For many populations, the Portuguese, Spanish, French, Dutch, or English
languages remain the languages of colonizers. The concepts they intro-
duce to global culture stem from the school of thought of colonial times.
Researcher and artist Jorge Menna Barreto taught me that the etymology
of the word *florestas* (forests in Portuguese) is likely derived from *forī
s*, meaning 'outside, out there, out of sight.' For a forest community, this
concept would not make sense. When our mother tongue is taken away,
the diversity of language, and therefore of concept, specificity, and com-
plexity, diminishes. That means that the simplification of language equals a
(potential) loss of plurality of concepts. Our words haven't kept up with the
ever-expanding complexity of our world. If anything, it has become more
simplified due to it becoming more mono-cultural: think of the dominance of
the English language. There are many beautiful and ugly truths to be found
when we start digging into the genealogy of words. The etymology of the
words 'pesticide' and 'herbicide', for instance. The suffix that marks these
as deadly is from the Latin *cida*, which means slayer, killer, or cutter.
Robert Macfarlane wrote in his book *Underland* about how an aversion to
that which is under the ground is already buried in our language:

Spores are the reproductive units of the fungus and they appear in many shapes and sizes, depending on the mushroom species. Spores are practically everywhere.

In many of the metaphors we live by, height is celebrated but depth is despised. To be 'uplifted' is preferable to being 'depressed' or 'pulled down.' Catastrophe literally means a 'downwards turn', 'cataclysm' a 'downward violence.'[7]

Camila Marambio pointed me towards the Latin *curare*, which means to take care. It is also the root of the word 'curator', a term I've personally been grappling with. Though I curated exhibitions and wanted to be called a curator, I also felt this word had been hijacked, especially by shops 'curating' their shop windows and personal shoppers 'curating' your dream wardrobe. I was ready to embrace the term again after Camila pointed out how curating, curing, and caring are linguistically connected. Marambio:

> My aunties were all curators in ways that are very different than from how I'm a curator. Not all of them worked within what's called the visual arts. But it's a long lineage of women doing curatorial work or practicing care in that matted and mycelial way; where it's very difficult to point to what's going on and to which direction care is flowing.

Robin Wall Kimmerer writes in her book *Braiding Sweetgrass* about linguistic imperialism and how in the English language something is either a human or a thing. The natural world, an animal, the ocean, a fungus, the planet, or a stone are all an 'it'. This builds in a distance between the human and the other being. Kimmerer: 'In English, we speak of the land as "natural resources" or "ecosystem services," as if the lives of other beings were our property.'[8] She explains how European languages often assign gender to nouns but that in Potawatomi, the Native American language she is learning, masculine and feminine are not divided. She writes:

> Pronouns, articles, plurals, demonstratives, verbs, all those syntactical bits I could never keep straight in high school English, are all aligned in Potawatomi to provide different ways to speak of the living world and the lifeless one. Different verb forms, different plurals, different everything apply depending on whether what you are speaking of is alive.[9]

Yet it seems the 'itting' as we know it in the English language is rather functional in extractive systems. The linguistic distance makes it easier to kill, extract, exploit, or do damage. You can objectify through language. Shiitake farmer Marília, with whom I worked on the farm in Minas Gerais, is, alongside farming, also studying to become a gynecologist. She gave me haunting examples of how objectification through language can work and

7. Robert Macfarlane, *Underland: A Deep Time Journey*, W.W Norton & Company, 2019, p. 13.

8. Robin Wall Kimmerer, *Braiding Sweetgrass: Indigenous Wisdom, Scientific Knowledge and the Teachings of Plants*, Milkweed Editions, 2015, p. 390.

9. Kimmerer, *Braiding Sweetgrass*, p. 66.

why the reclaiming of words or re-naming things is an import-
ant part of the process of healing and doing justice. She is part of a wider
movement of people who want to re-name parts of our bodies, given that
many parts of the sexual system are named after white males who en-
slaved women to do experiments. Marília: 'These body parts don't be-
long to these men.' She gave me the example of the Bartholin's glands.
Marília:

> Bartholin was a physician who opened the bodies
> of a lot of enslaved African-American women and
> 'discovered' the glands. He claimed he was the
> first person to know of this, and he put his name
> to it.

Marília is involved in the Anarca project, whose mission is to re-name
the glands. Marília:

> Anarca was a woman who was opened up many
> times for 'research' for Western medicine. The
> doctors used to cut these women without an-
> esthesia, as they used to say that black women
> had more resistance to pain so they didn't need
> it. The doctors traveled with the women and cut
> them open multiple times… In the Anarca project,
> the proposal is to change the 'Bartholin's glands'
> to the Lucy and Betsey glands, named after two
> women who were abused as part of this 'medical'
> research.

Artist Claudia Martínez Garay tells me about how in her hometown in Peru
the Communist Party started their revolution, which became an internal
war. The communists never exposed themselves, hiding among the indige-
nous population. Claudia:

> The brown bodies were in the middle, in be-
> tween the military, who came from Lima and also
> couldn't recognize who was and who wasn't a
> revolutionary. During that time, around seven-
> ty-thousand people were killed and they did a lot
> of forced sterilizations to women—without con-
> sent. The indigenous women couldn't understand
> Spanish, so their sterilization was just not com-
> municated to them. Even now there is no recog-
> nition that this happened to the Quechua, while
> everyone should learn about it. But it was not
> considered important because if it's not Spanish,
> it's not important.

How can we overcome all these obstacles, from misunderstandings to the dominating and objectifying ways in which language is used? 'We should be focusing on communication, not language', Raquel Rosenberg tells me, and she illustrates her point by explaining the ways of working in the Amazon, where often there is no Internet, or no phone reception (or phones) and many people only speak their own (indigenous) language. Rosenberg: 'We had a group of fifteen indigenous people and they had six different languages. Sometimes they didn't understand each other.' Still, Rosenberg was adamant that it was exactly these people—young, black, and indigenous and who had never spoken English—that had to be heard on international stages. Her organization Engajamundo ended up bringing them to the United Nations Conference of the Parties (COP); from the Amazon perspective to the global movement. How did they do it? Rosenberg:

> The solution that Engajamundo maintains for this language issue is to always work in pairs. If someone doesn't speak English, they will always work in a pair with someone who does. The activists always go to conferences or workshops together. With indigenous people that don't speak Portuguese, they would work in a pair with someone who does and also speaks their local language. They would do everything together so we don't have simultaneous interpreting in six languages at the same time.

Even the thought of this makes my head spin. But she continues: 'For this reason, we speak slowly and we stop so that the pairs can translate to their friends.' This is what inclusion looks like. Raquel:

> People in Brazil don't really speak English. It's not like in other countries where people learn to speak English. Here they don't. If you want to work with indigenous and black people, you will have to deal with that. The ones that do speak English are very dedicated to doing so, helping with the translation and making sure that their pair is understanding everything. In the conferences only indigenous people that speak Portuguese went, paired with someone who speaks Portuguese and English. In the workshops we have the same thing with their native language and Portuguese. This was the way for us to overcome this barrier of languages. And it works on these two different levels. This is something that has everything to do with friendship and love and caring. The one that speaks English has the main challenge and

the task of the day is to make sure the other un-
derstands everything. You need a lot of care and
love for that—it's the opposite of being selfish.
Sometimes we have Latin American meetings and
even then we speak in English. For us it's already
really hard as Portuguese is never the chosen lan-
guage. We have to speak Spanish! But then they say
'oh but there's the Caribbeans'... . But they should
work on their Spanish as we do on our English. It's
always the discussion between Latin Americans.

Camila Marambio also shared some interesting strategies and communica-
tion exercises to find a common language. Camila:

I'm very invested in the ways language changes us
and why we use the language that we use. When
I started Ensayos, we had our first interdisciplin-
ary fieldwork period. There were scientists, there
were artists, there were park managers and local
activists, there were indigenous peoples, and
economists within our group. There were nineteen
of us. We were in Tierra del Fuego for two weeks.
The thing that we did the most was talk about lan-
guage. When I say art, what do you think is meant
by it? What do you think art is? When I say beau-
ty? When I say fieldwork? When I say research?
When I say outcome? When I say future? When I
say past? We did that continuously, every day.
And it was through that exercise that we began to
build common ground. If not a common language,
at least a common ground where we acknowledged
our differences. Rather than those making it im-
possible to communicate, this was our power.

Both Camila's and Raquel's experiences make it very clear how common
ground is more important than common language.

SPEAKING IN SPORES

In her film *The Mushrooms Speaks*, Marion Neumann shows how the
mushroom speaks to us, and how, in order to understand, we need to tune
into a different pace and a different way of listening. When we speak over
Zoom, she is in lockdown in Switzerland and I'm in a not-so-strict, but still
careful, lockdown in Barbados. She tells me how important fungi became
in her life through making the film. Though she had grown up in the forest,
picking fruits and mushrooms, it wasn't until *The Mushroom Speaks*
that she started understanding their language and became very passionate
about them. Neumann:

The mushroom became a passion and I tried to integrate this mushroom knowledge more profoundly into my ways of living; the idea of recycling, the idea of community, of efficiency in a spiritual manner, how to relate to something—whether that's philosophically or with work—or in how I communicate. By communicating symbiotically with plants to survive, fungi inspire me to think about my own relationships differently.

Her words resonate a lot with me, and I feel like I have been through a similar process—not through making a film, but through this book. The teachings of fungi are more than a metaphor and, if we listen closely, we know how to apply them. We speak about language, a big subject in her life. She tells me she has been practicing Zen meditation and she came across a sentence that inspired her. 'Sounds come and go, but the silence remains.' We both look at each other in the camera and are unintentionally silent for a few seconds. It was in those seconds that we connected.

Language is the first step to implementing changes and teachings into our own lives. When we differentiate with language, we acknowledge something might look similar (a plant is a plant, a mushroom a mushroom) but it has a uniqueness that should be celebrated and cherished. It's the basis of biodiversity and cultural diversity. The beauty of noticing and knowing names can manifest into a genuine love for something; it's at the beginning of 'getting to know' something. With so many new complex concepts that are in need of knowing and understanding, we need not just more language-keepers, but also language-makers; new images, concepts, and other languages and cosmologies that can address these issues altogether. Language-makers that can go beyond words. Our world is a complex web of interrelationships that needs holistic, multisensorial, and multidimensional concepts to re-connect to landscape, flora, fauna, *funga*, and each other. It requires a translative curiosity as well as a playfulness that seduces us into thinking of sensory communication that goes beyond language. I guess we need to learn to 'speak in spores', in multitude, in different wavelengths, in silence.

HOW TO IMPLEMENT THESE TEACHINGS INTO OUR LIVES?

Find Your Fungal Alter Ego

TEACHING TWELVE

There are several types of false morels,
mushrooms that resemble classic morels but are
potentially poisonous look-alikes.

Fuzzy Sandozi

Fuzzy sandozi (*Bridgeoporus nobilissimus*) is an endangered
fungus that produces large conks that can weigh up to
a hundred and thirty kilos!

IMPLEMENTING FUNGAL WAYS ON A PERSONAL LEVEL

Writing this book was my myceliated education into the ways and workings of fungi. Page by page, foray by foray, interview by interview, I started to familiarize myself with the little creatures, mesmerized by their behaviors, preferences, and differences. I hope this book has started to scratch the surface and sparked your curiosity. For every plant in the world, there are six fungi. The diversity is endless. Speaking with many mycologists, and always asking them what their favorite mushroom was, my experience revealed that hardly anyone was able to pick one. They all spoke with so much passion and love about fungi, and had their own research specialisms, yet someone compared it to having to choose 'your favorite child'. Though I couldn't identify with these maternal sentiments, I did recognize the feeling of not being able to have one favorite. I figured it made more sense to understand which (type of) fungus you identify with most, to create a more intimate relationship and stronger resonance. The fungal flowchart should be able to help you find your fungal teacher, and from there you can continue your self-study. You can start learning what kind of weather it prefers and what kind of symbioses it has with other entities, if possible; observe its growth. Rather than trying to know all mushrooms, find a few to know deeply. In addition to the flowchart, you can be in your local natural living world to find them. Develop a relationship with your

fungal alter ego and things will start changing. The more you work with them, the more they require you to change.

My personal fungal teacher turned out not to be a mushroom, but a mycelium. A mycorrhizal mushroom to be precise. I realized this because I have always worked and thought in networked ways, yet never had the right metaphors and references to frame it. My professional mycelial ways started in 2008, freshly hired by TransArtists, the international network for artists' residencies. While working there, I set up another network called the Green Art Lab Alliance, gala for short. The aim of the network was for knowledge and tools on environmental sustainability in the arts to flow more equally. It was clear that there was a lot of knowledge, tools, science, and data out there, but it needed to be connected to an infrastructure of dissemination for people to have access to it. Gala was that formal and informal infrastructure, reaching out to art organizations from Sweden to Georgia. This network, or 'knowledge alliance' as we called it, grew organically with fifteen new partners in Asia between 2015 and 2017 and fifteen more partners in Latin America from 2018 onwards. We grew slowly, building relationships of trust, support, and solidarity, and now comprise fifty art organizations, collaborating in different constellations and continuously extending our hyphae. We have become a web of support, influence, and interaction between different organizations, a fluid dialogue that empowers us all, a platform that gives access to knowledge, inspiration, feedback, interaction, and projects. It's a sounding board, where we can work in a 'more-than professional' context, outside of competition. With more-than professional we mean they are actual relationships of trust and solidarity. We like to take a long time over things, like a hearty soup that simmers slowly but tastes real. A context of meaning that is international and enriches the conversation. We are talking about the same thing, but come from different realities and temporalities.

IMPLEMENTING FUNGAL WAYS IN YOUR (ART) ORGANIZATION

I always understood gala to be capable of producing theory while implementing it in our praxis. In 2020, I had the privilege to apply for, and receive, funds from the Mondriaan Foundation in the Netherlands to research this alliance as a model for a mycelium-like network for the arts. My plan was to make a blueprint for a support network that maintains creativity as its main currency and shares strategies on how to implement these values of alliance into your organization. To this end, I interviewed many gala partners about how our gala collaboration model could be adapted to different contexts and what kind of teachings they could share. What were their needs, wishes, and expectations from a network? Based on their responses about a rhizomatic model for international collaboration, I came to the following:

— *Understand your organization to be part of different systems.*
It might be a political system, or a funding system, or any other system

which you don't have much influence over. Rather than being part of monetary systems, try to become part of value systems, for instance by joining a network of like-minded organizations. This will motivate your organization to keep your ethos in check by benchmarking based on values. As a value-based network you can push each other and collectively imagine what alternative futures might look like and how to collectively organize toward it.

— *Understand the actors in your mycelium as knowers.*
Understand your partners, artists, and audiences as knowers who bring together different types of knowledge. Let this inform how you communicate. Value that knowledge as equal to yours. Understand the importance of the plurality of knowledge. If you perceive and treat them as being part of your rhizomatic relations, they will grow in importance and, through that trust, feed back into things you have never been aware of, or considered to be important. This 'outside' knowledge might be crucial for the survival of your organization. In the rhizome, all participants are givers *and* receivers. Don't overlook what's right underneath your feet; your mycelium, your roots, your soil.

All this talk of inclusivity, yet very few art organizations have proper wheelchair accessibility or someone available to talk to you. Have a place to sit, be open for a chat, be able to offer a glass of water or a coffee; make time and space for others. Open your doors properly if you value your knowers. Camila Marambio:

Mycelium teaches me that communication is not just one way or back and forth and back and forth. The back and forth is happening all the time, layered and on top of each other and around in ways that are impossible to visualize even, at least from the naked eye. And that it's underground so it's happening even though nobody sees it's happening: it's there and it's holding us. And these are the things that I maybe most relate to my curatorial work. Because it's constant, continual, infinite, never ending, in all directions: so much more than multiple. Multiple somehow doesn't sum it up.

— *Don't be afraid to move in the space between the formal and informal.*
It's totally possible to operate in a space of genuine care, collaboration, and kindness, becoming friends while staying miles away from any kind of #MeToo scenario and power play. Break down the structures and conditions that allow for hierarchies of power. There is no hierarchy or center in the mycelium and kindness and care will be rewarded. Lina Meija (Platohedro):

Platohedro started out as a horizontal organiza-

tion and we really wanted the participants to lead the way and to be autonomous. But to get there you have to undo all of this plastic garbage that we have on top of ourselves; medicated and mediated, conditioned and false. After letting that go you can come to the truth of the materials. Then when you go to silence and to deep listening skills you start to micro-listen into things that are not said in words.

—*Decentralize when and what you can.*
Decentralize power and decentralize funds; the time of having your eggs in one basket is over. Include thinking about decentralizing in terms of place; cities are centralized and the countryside offers many possibilities. Decentralizing power can manifest itself as collective directorship and horizontal organizing that builds the capacity of those without power. That also means questioning the authority that gets to decide what is valid or not, who is given a voice, who is able to curate, and who gets to have their names on the wall. Lola (TEOR/éTica):

> Collective directorship meant asking deep questions about how this affected us personally, because it was going to move a lot of things in relation to authority, power, and division of tasks, not only the beautiful things about collectivity. It could make us uncomfortable in certain areas because we also have to relate to other people outside of TEORéTica and to artists, which also ended up transforming a lot of projects.

—*Reading, socializing, and having fun are part of your job.*
There is this great misconception that we are only working when we are behind a computer or are in very serious or boring meetings. We are supposedly not working when we are relaxed, reading a book, or having a conversation over a coffee. On top of that, we feel guilty when we are not working. This perception is outdated and wrong; we get the best ideas and best energy from good books and interesting conversation. The most fruitful collaborations sprout when we are relaxed. Lola (TEOR/éTica):

> Looking at Beta-Local in Puerto Rico showed me the different layers of the work that we do; like going for coffee with an artist. It seems so casual, yet this is also work. Being available for conversations, as casual as they may be. That is work. And making sure we allow ourselves to have fun, even when we're working. Not to take everything so seriously. Beta-Local was here in 2018 doing an organizational residency in TEOR/éTica and it was

a great match for us in that period of questions and being subconsciously very stressed about the heavy load of holding this space for Central America, the Caribbean, and what all of that meant. Watching them talk about work and allowing themselves to make space for having fun, learning from each other, from not having to do everything alone, was really important. It removed us from this place of having to know and having to answer to a lot of people, instead of just being generous and gentle with ourselves as well.

—*Review your ideas about currencies.*
Include modes of exchange that are not monetary and might not survive in a capitalist system. Understand creativity and improvisation skills as currencies. Start growing an infrastructure for the exchange of stories, food, tips, knowledge, contacts, and skills outside of your bubble and discipline. We need to start building an alternative economy for the things we want to reject. That often means you still need to invent them.

—*Start from within.*
Go beyond discourse and put things into practice within your organization. It's not enough to just be exhibiting art on feminism, or social justice, if in your organization there are still issues with the same things that you're trying to be critical about. Start to revise the hierarchical structures, institutional racism, sexism, and inherited colonialism that is still so often part of institutions. Lola (TEOR/éTica):

Why should an independent art space, founded by an artist in Costa Rica, in the tropics, in Latin America, operate in the same way or with the same rules as a museum in the United States or Europe? That doesn't make sense. We were trying to fit into a logic that came from an art world that was not our art world.

—*Remain mindful that we have to constantly change form to remain useful.*
Make your ways of working fungal by constantly building, connecting, de-constructing, exchanging, and re-wiring. The mycelium never has one form. Your organization will be of no use in the future when it is static. Allow yourself to question and not think that everything is static; work in a structure that is mobile and flexible.

—*Renew and expand on your willingness to do something for someone else.*
Keep believing in the abstract promise that the exchange will somehow,

sometime, be mutually beneficial. You are not an individual and doing some-
thing for someone else will always (indirectly) benefit you too, even when it's
not always visible. Mycelium is all about reciprocity and mutuality. Recog-
nition of interdependence is a great motivator for action, but requires trust.
Daniela (TEOR/éTica):

> In Alter Academia we developed a program with
> younger people that also included sharing keys
> to different houses so that they would open and
> close the doors. I remember starting to prepare
> for this project and thinking 'what happens if they
> don't set the alarm?' That implied a level of trust
> between TEOR/éTica as an institution but also us,
> as a team, and other people that were in unknown
> territory. It was kind of scary!

— *We need allies outside of our bubble and allies with political
will.*
Carefully and genuinely cultivate relations outside of your discipline. Feel
compelled to ask and invite questions. Though the arts have an important
contribution to make for a transition to new systems, we shouldn't overes-
timate the potential of our sector; it's in an insufficient condition for sys-
temic change. There is a particular need to unite with those who are (also)
not the beneficiaries of the system. They make for a majority of the people
and they also need you. We need to build alliances so we can organize and
act collectively, not as individuals. A coordinated society that can create
vast change and plurality is the best strategy for resilience, particularly
when multiplied globally

— *Work with food and at an agricultural practice pace.*
Food is our common language and connects everything. Food is a lan-
guage that we all understand, and it can act as a mediator inside a group
and propose different ways of understanding something. It's heavily
entangled with both our personal health and bodies, as well as plane-
tary health and bodies, and, therefore, is a great entry into meaningful
exchange with people from all walks of life. If you want to take it a step
further, align yourself or your organization with the pace of an agricultur-
al practice—that means, work with the seasons, think about when you
harvest, when you rest, when you sow, when you nurture. Maya (Fun-
dación Mar Adentro):

> When we are working with artists and scientists
> and we want to work with the community, we
> shouldn't forget that we are actually introducing
> two cryptic languages to them. The language of
> the arts and the language of science. Art doesn't
> make science easier or the other way around.
> That's why food and cooking are so important

Chi-Ngulu-Ngulu (*Termitomyces titanicus*) is a big mushroom that is symbiotic with termites. Its cap can grow up to a meter in diameter.

because they are things that don't need words; they are the common ground between scientists, artists, and the community.

—*Fail better.*
As mentioned before, fungi throw up questions, never answers. That translates into your art organization and means we shouldn't just be doing things we know we can do, just speaking languages that we master, but trying things that we don't know how to do yet, and figuring them out in the process. That means allowing yourself to fail and try again, and to be able to say 'I don't know' to questions. Daniela (TEOR/éTica):

> One of my favorite sections in the magazine we called '*fracasar mejor*', meaning to fail better. For me that was key as it was important to show other people that there were also things that were not working. It wasn't something to be embarrassed about, or hide, but let's talk about it, as there is a big need to recognize that some things just don't work for different reasons. It's a learning opportunity. What does it mean for an institution to also sometimes admit that some things didn't work?

—*Understanding where someone is coming from.*
Not for comparison, but to be mindful about differences regarding cultural references, and who decides which language is spoken and who masters those languages and who doesn't. How does that impact power dynamics? Be mindful of where someone is at in their (sustainability/awareness) journey and why. Sustainability is easy when you can afford it. When you can drive a Tesla and go to the local organic supermarket for your vegan sausages and have smart technology to assist you in reducing your energy bill and when there is an infrastructure to support your recycling. When you have access to knowledge on how to be sustainable. Without this, sustainability can also be the least urgent of your concerns. It's a never-ending process, for everyone. Improve in your own journey and don't compare—it might tempt you to think you are doing better and as long as you think like that, you are most definitely not.

—*Embrace complexity.*
The arts are an excellent gateway into complexity. For your organization to still be of use in the future, it will need complex adaptive systems like fungi. We cannot simplify the problems of our time. Don't just allow it, seek it. Situations are complex and people are complex. Claudia Martínez Garay:

> When I think of my artworks it concerns a lot of things that are not so easy to discuss. It makes people feel rejected, because of politics or the war, or because of other uncomfortable things

that are related to injustice. Sometimes I feel
there is a wall, making it very hard to discuss
these things. But for me, these are the only things
I want to discuss. I need to find ways to talk about
them through my work, but in a way that's ap-
proachable at first glance. At the second glance,
you can see the more difficult things. For exam-
ple, colonialism in the Andes and this idea that
you just have to accept colonialism to keep on
surviving and having to resist your own culture.
That this acceptance is demanded. But it's unac-
ceptable; it's a forced culture, a forced change in
beliefs and religion.

—*Embrace precarity as a new condition and reality.*
In the light of the climate collapsing and more zoonotic diseases to come,
as art organizations we need to increase our flexibility and maneuverabil-
ity to withstand the changes ahead of us. Traps are having too much faith
in better times. Don't grow too fast, if at all. Don't commodify your poten-
tial. Fungi always find a way in fragile and challenging circumstances. This
means taking resourcefulness to the next level. Daniela (TEOR/éTica):

In Latin America—particularly in comparison with
Europe—we work with so little. So few resources
or support from governments or institutions or
even individuals that you learn to get really cre-
ative. You realize that capitalism is not going to
work for you if you want to survive. You end up
un-learning from that and realizing that it's much
simpler slowing down, doing less but doing it bet-
ter, building bridges and connecting and network-
ing with people and working on building relation-
ships and strengthening bonds with people rather
than producing and producing.

—*It's high time to let go of Eurocentric colonial fictions.*
The climate crisis will not be solved with science, technology, and innova-
tions, with raw materials sourced from an invisible and exotic elsewhere.
Radically alienate yourself from everything you thought you knew and
start educating yourself informally, through conversations with human
and non-human others, through a sincere willingness to learn and a desire
to peel off your layers of ignorance. Relate to colonial legacies, not just as
people and countries but as landscapes. Recognize coloniality in plan-
tations, monocultures, damaged forest, and other extracted landscapes.
Don't fall into the trap of 'eco-colonialism' and the judgement of others
who are not acting 'sustainably' to your standards. Remain aware that
environmental justice is inextricably tied to social justice and the need

for restorative justice. Don't lose sight of racism and social inequality in systems and combat it. Make it the end of obliviousness.

—Do the (metaphorical) dishes.
There is no job too dirty for you or not worthy of your labor. Not if you're the director and particularly if you're a man. Doing the dishes can mean many things; it can mean cleaning a toilet, picking up the chairs after an event, sending round your notes, or cooking for a group. Do what's needed for the collective to function well. Lola (TEOR/éTica):

> A very simple example of something we came across was that we always talk about who does the dishes. Everyone just assumes that someone will do the dishes. That's usually the person who cleans. And it's usually a woman, and in our case it's Esmeralda, who has been with us for many years. She is the oldest member with us at TEOR/éTica and has been there practically from the beginning. But we all have to do the dishes somehow. And that really reveals some of the attitudes toward labor, toward how we understand our job.

LET'S BECOME FUNGAL

I hope I have been able to make a case for fungi as species par excellence to demonstrate non-dualistic thinking, looking, and being. They embody and defy supposed categories and binaries. Whether that's between plant and animal, life and death, male and female, pure and toxic, black and white, culture and nature. They show us the grand and powerful space of in-betweenness, impurity, timelessness, and messiness, of the sensorial and the silent. They show different ways of relating to the other; in symbiosis, in collaboration, in solidarity, in reciprocity, and in alliance. They demonstrate how to collaborate and exchange, and how there is no separation of the individual from the whole. An individual doesn't exist; we always live in, on, and with other beings. We all depend on our substrate and allies. Recognizing fungi as teachers, as modes of intelligence, in their multiplicity and oneness at the same time, might lessen our current estrangement with the natural world. Some teachings have been more poetic, about lifting the illusion of separation from each other and the natural world, changing how we relate to more-than-human entities, each other, and to ourselves. While others have been very concrete, about things we can change in our lives immediately, in the way we organize, in the way we work and collaborate. Fungi have been pulling out all of their party tricks to get our attention, from spectacularly colorful outfits to glowing in the dark and making us enter new dimensions when we ingest some of them. And like Fer Walüng said:

> Fungi communicate with us, but we are unable to understand what they are trying to convey to us.

Not because they don't know how to make contact, but because we're not listening.

315

Anna Tsing wrote in *The Mushroom at the End of the World* that we need to notice the world as a practice of responsibility: to carefully observe and attempt to understand the life around us is perhaps the most important thing we can do for nature—including humanity. Writing this book certainly helped me to notice, observe, smell, and recognize fungi more often, but more interestingly, it made me visualize a wider rhizome of relationships between entities. The intimate mycorrhizal relationship between the chanterelle and a birch bolete. The mutual dependency between the *Termitomyces titanicus* and the termites. The golden winged cacique and their carefully engineered *Marasmius* nests. The *huitlacoche* and the corn. I learned to see the subtle differences between the morel and the fake morel, and once you know, they don't even look like each other anymore. David Abram said that 'non-human nature can be perceived and experienced with far more intensity and nuance than is generally acknowledged in the west,'[1] and this intensification of perception is what occurred to me when I started paying more careful attention to the diversity of plants and species around me. The senses opened and, moreover, love arose. Love for the natural world, a love for the weird and wonderful critters and creatures. By rewarding me with stories, giggles, surprises, and, mostly, more questions, they proved really worth my love, close attention, time, and all those words that I was pondering late at night. About one thing I had no doubt: fungi are worthy of more attention. My attention became intention and started informing my thoughts and decisions, triggering a shift in my behavior. Rather than trying to answer the questions, I started to live the questions,[2] of which some are very existential, about the impending climate breakdown, social injustices, violence, and death, and about the end of humanity. A healthy world for humans and non-humans seemed so far away. Alexis Shotwell beautifully wrote: 'We practice the world we don't have yet in the present and in that practice, we bring it to being.'[3] It's exactly what fungi do with their many teachings, and it's exactly what we could be doing too. Embrace the teachings as potential gateways into new perspectives about how we could live. Let's live the questions and become fungal.

1.
David Abram, *Spell of the Sensuous*, Vintage Books, 2017, p. 27.

2.
Rainer Maria Rilke, *Letters to a Young Poet*, W.W. Norton & Company, 1993, p. 35.

3.
Alexis Shotwell, *Against Purity: Living Ethically in Compromised Times*, University of Minnesota Press, 2016, p. 179.

FUNGAL FLOWCHART

How to Find Your Fungal Alter Ego?

OYSTER MUSHROOM
(*Pleurotus Ostreatus*)

Yes: or to be precise, I can be
trained to eat cigarette butts,
but I'm also able to help
clean up oil spills

PENICILLIN
(*Penicillium chrysogenum*)

I like cigarettes!

I am antibacterial and help
against infections. And yes,
I was first discovered on a
rotting cantaloupe!

LION'S MANE
(*Hericium erinaceus*)

I will make you smarter

Because I will solve
environmental disasters
with myco-remediation

Because I am medicinal

I'M OPTIMISTIC ABOUT
THE FUTURE

How Do You Feel
About the Future?

WHAT DO YOU MEAN FUTURE?
TIME IS NON-LINEAR AND CYCLICAL.

TEONANÁCATL
(*Psilocybe mexicana*)

TURKEY TAIL
(*Trametes versicolor*)

I might cure your cancer

REISHI
(*Ganoderma lucidum*)

Some say I make you live forever

Because of the power of fermentation

I'm more of a foodie

I like alcohol

YEAST
(*Saccharomyces cerevisiae*)

KOJI
(*Aspergillus oryzae*)

Because we will collaborate our
way out of this climate disaster

Because of my
symbiosis with termites

Because of my
ectomycorrhizal network

CHI-NGULU-NGULU
(*Termitomyces titanicus*)

SATAN'S BOLETE
(*Rubroboletus satanas*)

BLACK FUNGUS
(*Mucormycetes*)

ALTERNARIA
ALTERNATA

MATSUTAKE
(*Tricholoma matsutake*)

I'm very dangerous to
humans and I'm known
as Covid-19's evil cousin

I don't mind the flood.
I flourish with extreme
humidity

I do well in poor air quality
and excessive dust in cities.

I don't mind wildfires. I
do well in disturbed and
charred landscapes

BRING IT ON! I CAN DEAL WITH
SEVERAL ENVIRONMENTAL DISASTERS.

How Does the Climate
Collapse Effect You?

THE CLIMATE COLLAPSE WILL
MAKE US, AND MANY OTHER SPECIES,
GO EXTINCT.

I need old and mature
forest hosts and they
are becoming rare

Because of all the pesticides,
I'm going extinct

People love me and know me,
but I'm challenging to cultivate

Beware of the toxic
look-alike twin sister

FUZZY SANDOZI
(*Bridgeoporus
nobilissimus*)

SPLENDID WAXCAP
(*Hygrocybe splendidissima*)

MOREL
(*Morchella esculenta*)

Fungal Flowchart

BLEEDING TOOTH FUNGUS
(*Hydnellum peckii*)

VEILED LADY
(*Phallus indusiatus*)

I'm spectacular and edible, but rather bitter

I'm spectacular and delicious

I'm more of a dancing on the volcano type of mushroom, as long as I can look spectacular!

I'm spectacular but also pretty toxic

I'm curious and nomadic and will creep my way out of any situation

SLIMEMOLD
(*Physarum polycephalum*)

FLY AGARIC
(*Amanita muscaria*)

I'm basically a survival kit myself!

I'm antiviral, nutritious, and medicinal

I can be used as kindle and to transport fire

I can be used to build a shelter

SHIITAKE
(*Lentinula edodes*)

AMADOU
(*Fomes fomentarius*)

MYCELIUM BLOCK

BIBLIOGRAPHY

Associação das Mulheres Yanomami Kumirãyõma. *Marasmius yanomami: O fungo que as mulheres yanomami usam na cestaria.*

Abram, David. *Spell of the Sensuous. Perception and Language in a More-than-Human World.* Vintage Books Editions, 1997.

Bacigalupo, Ana Mariella. *Thunder Shaman: Making History with Mapuche Spirits in Chile and Patagonia.* University of Texas Press, 2016.

Ballengée, Brandon. *The Occurrence of Malformation in Toads and Frogs: An Art/Science/Ecology Investigation.* The Arts Catalyst, 2009.

Benítez-Rojo, Antonio. *The Repeating Island.* Duke University Press, Durham and London, 1996.

Berger, John. *Ways of Seeing.* Penguin Books, 1972.

Biemann, Ursula and Tavares, Paulo. *Forest Law-Selva Jurídica.* Eli and Edythe Broad Art Museum at Michigan State University, 2014.

Biss, Eula. *On Immunity: An Inoculation.* Graywolf Press, 2014.

Castaneda, Carlos. *The Teachings of Don Juan: A Yaqui Way of Knowledge.* University of California Press, 1968.

EZLN. The Sixth Declaration of the Lacandon Jungle.

Freire, Paulo. *Pedagogy of the Oppressed.* Seabury Press, 1970.

Gálvez, Alyshia. *Eating NAFTA. Trade, Food Policies, and the Destruction of Mexico.* University of California Press, 2018.

Gilbert, Scott F; Sapp, Jan; Tauber, Alfred I. *The Quarterly Review of Biology.* The University of Chicago Press, 2012.

Grandin, Greg. *Fordlandia: The Rise and Fall of Henry Ford's Forgotten Jungle City.* Picador, 2010.

Gumbs, Alexis Pauline. *Undrowned: Black Feminist Lessons from Marine Mammals.* AK Press, 2020.

Hall, Stuart. *Familiar Stranger: A Life Between Two Islands.* Duke University Press, 2017.

Haraway, Donna. Haraway, Donna. 'Anthropocene, Capitalocene, Plantationocene, Chthulucene: Making Kin'. *Environmental Humanities* 6 (2015).

Hitchcock, Robert K. *Kalahari Communities: Bushmen and the Politics of the Environment in Southern Africa.* International Work Group for Indigenous Affairs, 1996

Kaishian, Patricia and Djoulakian, Hasmik. 'The Science Underground: Mycology as a Queer Discipline', *Catalyst: Feminism, Theory, Technoscience* 2, no. 6 (2020).

Kimmerer, Robin W. *Braiding Sweetgrass: Indigenous Wisdom, Scientific Knowledge and the Teachings of Plants.* Milkweed, 2020.

Kimmerer, Robin W. *Gathering Moss. A Natural and Cultural History of Mosses.* Oregon State University Press, 2003.

Kopenawa, Davi and Albert, Bruce. *The Falling Sky: Words of a Yanomami Shaman.* Belknap Press: An Imprint of Harvard University Press, 2013.

Macfarlane, Robert. *Underland. A Deep Time Journey.* W.W Norton & Company.

Margulis, Lynn. *The Symbiotic Planet: A New Look at Evolution.* Basic Books, 1999.

Mertes, Tom. *A Movement of Movements: Is Another World Really Possible?* Verso, 2004

Oliveros, Pauline. *Quantum Listening.* Ignota Books, 2022.

Paxson, Heather. *The Life of Cheese: Crafting Food and Value in America.* University of California Press, 2012.

Rilke, Rainer Maria. *Letters to a Young Poet.* W. W. Norton & Company, 1993.

Sheldrake, Merlin. *Entangled Life: How Fungi Make Our Worlds, Change Our Minds & Shape Our Futures.* Random House, 2020.

Alexis Shotwell. *Against Purity: Living Ethically in Compromised Times.* University of Minnesota Press, 2016.

Simard, Suzanne. *Finding the Mother Tree: Discovering the Wisdom of the Forest.* Knopf Doubleday Publishing Group, 2021.
Solnit, Rebecca. *A Field Guide to Getting Lost.* Canongate Books, 2005.

Spaid, Sue. *Ecovention Europe: Art to Transform Ecologies, 1957–2017.* Museum Hedendaagse Kunst De Domeinen, 2017.

Swan, Heather. *Where Honeybees Thrive: Stories from the Field.* Penn State University Press, 2017.

Tsing, Anna Lowenhaupt. *Mushroom at the End of the World: On the Possibility of Life in Capitalist Ruins*. Princeton University Press, 2015.

Vergès, Françoise. Essay: 'A Leap of Imagination', in *Slow Spatial Reader: Chronicles of Radical Affection*, ed., Carolyn F. Strauss. Valiz, 2021.

Viveiros de Castro, Eduardo. *The Ends of the World*. Polity, 2016.

Wekker, Gloria. *White Innocence: Paradoxes of Colonialism and Race*. Duke University Press, 2016.

Woodward, Ben. *Slime Dynamics: Generation, Mutation, and the Creep of Life*. Zero Books, 2012.

Wynter, Sylvia. *Novel and History, Plot and Plantation. Savacou* (a journal of the Caribbean Artists Movement), 1971.

Yi, Anicka. *Exhibition Catalogue of Anicka Yi: Metaspore*. Marsilio editori, 2022.

BIOGRAPHIES

Interviewees

Francisca Álvarez Sánchez
ARTIST (CHILE)

Francisca is an artist who studied Industrial Design and graduated in Visual Arts, majoring in Painting. She also completed a postgraduate degree in Illustration at Universidad Finis Terrae in Chile. She has participated in residencies in Oaxaca (Mexico) and Chiloé, Santiago, and Valparaíso (Chile) and in solo and group exhibitions in both countries. Moreover, she has worked in artistic-pedagogical projects, theatrical design, stop-motion animation, and editorial illustrations. Francisca is the creator of the micro-publishing company Caracol, which publishes fanzines and books in small formats, and of the virtual store Una rama azul, where she creates objects in painted wood. She actively participates in fairs and events related to graphics and culture.

Carolina Caycedo
ARTIST/ACTIVIST (UNITED STATES/ COLOMBIA)

Carolina participates in movements of territorial resistance, solidarity economies, and housing as a human right. Carolina's artistic practice has a collective dimension to it in which performances, drawings, photographs, and videos are not just an end result, but rather part of the artist's process of research and acting. Her work contributes to the construction of environmental historical memory as a fundamental element for the non-repetition of violence against human and non-human entities, and generates a debate about the future in relation to common goods, environmental justice, fair energy transition, and cultural biodiversity.

Annalee Davis
ARTIST (BARBADOS)

Annalee is a visual artist, cultural instigator, educator, and writer with a hybrid practice. She works at the intersection of biography and history, focusing on post-plantation economies by engaging with a particular landscape in Barbados. Her studio, located on a working dairy farm, operated historically as a seventeenth-century sugarcane plantation, offering a critical context for her practice by engaging with the residue of the plantation. In 2011, Annalee founded Fresh Milk, an arts platform and micro-residency program, and in 2012 co-founded Caribbean Linked, an annual residency in Aruba, cohering emerging artists, writers, and curators from the Caribbean and Latin America. In 2015, she co-founded Tilting Axis, an independent visual arts platform bridging the Caribbean through annual encounters.

Maya Errázuriz
CURATOR, FUNDACIÓN MAR ADENTRO (CHILE)

Maya directs the Art and Publication Projects at Fundación Mar Adentro, a non-profit organization founded in 2011 and dedicated to creating collaborative experiences between art and science to develop knowledge, awareness, and action for nature. Their multidisciplinary team works together with a network of collaborators within three areas of work: Conservation, Creation/Research, and Experiential Learning Dissemination. One of their core programs is Bosque Pehuén, a privately protected area of 882 hectares located in Araucanía Andina in the south of Chile, between the Villarrica and Quetrupillán Volcanoes. Their work is dedicated to the conservation of temperate rainforests and conceived as an experimental outdoor laboratory, exploring nature stewardship strategies and human-nature relations with a local and international perspective.

Juan Ferrer
CURATOR, DIRECTOR, MUSEO DEL HONGO (CHILE)

Juan is the director and curator of Museo del Hongo, an unconventional nomadic museum space dedicated to re-signifying the Fungi Kingdom. Through the combination of contemporary artistic practice and scientific research, they design immersive experiences in which a variety of interdisciplinary works are displayed, raising awareness on the ecological relevance of fungi and encouraging research by way of its disciplinary dimensions. Through his work, Juan questions disciplinary boundaries by proposing new concepts of scientific engagement through artistic, immersive, and interactive experiences in a museum space.

Lilian Fraiji
CURATOR, FOUNDER, LABVERDE (BRAZIL)

Lilian is a curator and the founder of Labverde, created to strengthen the limits of art through a broad array of experiences, knowledge sets, and cultural perspectives involving art, science, and nature. The program's main goal is to promote artistic creation through a constructive debate on environmental issues generated by both theory and life experiences in the Amazon Rainforest. Developed in association with Manifesta Art and Culture and The National Institute for Amazonian Research, Labverde promotes an intensive experience in the rainforest mediated by a multidisciplinary team of highly qualified specialists in art, humanity, biology, ecology, and natural science. In collaboration with Maria Luisa Murillo of CAB in Patagonia, Lilian curated the residency program Fungi Cosmology. A special thank you goes out to Lilian Fraiji

for hosting the author of this book in the Labverde residency in the Brazilian Amazon in 2019.

Giuliana Furci
MYCOLOGIST, FOUNDER, FUNGI FOUNDATION (CHILE)

Giuliana has been the biggest promoter of the study and protection of the Fungi Kingdom in Chile in recent decades. She is the founder and CEO of the Fungi Foundation, and the first female mycologist of non-lichenised mushrooms in Chile, starting her career in 1999 as a self-taught amateur. Under her leadership, Chile became the first country in the world to include the Fungi Kingdom in its environmental legislation, thereby allowing Chilean *funga* to be included in the study and evaluation of environmental impacts throughout the country through its incorporation into the Law of General Bases of the Environment, and also mandating its incorporation into the National Inventory of Species, among other obligations.

Sofía Gallisá Muriente
ARTIST (PUERTO RICO)

Sofía is a visual artist who works with multiple approaches to documentation, exploring the subjectivity of historical narratives and examining formal and informal archives, popular imaginaries, and visual culture. She has been an artist-in-residence at Museo La Ene (Argentina), Alice Yard (Trinidad and Tobago), Solar (Tenerife) and Catapult, as well as a fellow of the Flaherty Seminar at the Smithsonian Institute, TEOR/éTica, and NALAC. From 2014 to 2020, she was co-director of Beta-Local, an organization dedicated to fostering knowledge exchange and transdisciplinary practices in Puerto Rico.

Yina Jiménez Suriel
CURATOR (DOMINICAN REPUBLIC)

Yina is a curator and researcher. She obtained her Master's Degree in the History of Art and Visual Culture, with a focus on Visual Studies, from the University of Valencia. She has collaborated with different institutions, among them Casa Quién and the Museo de Arte Moderno of Medellín. She is part of the curatorial team at Centro León in the city of Santo Domingo, Dominican Republic, where she lives and works.

Patricia Kaishian
MYCOLOGIST (UNITED STATES/ARMENIA)

Patricia is a mycologist and visiting professor of Biology at Bard College. Her research focuses on fungal taxonomy, diversity, evolution, symbiosis, and ecology, particularly of the less-studied fungal groups, such as the insect-associated *Laboulbeniales*. Patricia also studies Philosophy of Science and Feminist Bioscience, exploring how mycology and other scientific disciplines are situated in and informed by our sociopolitical landscape. She is a co-founder of the International Congress of Armenian Mycologists, which seeks to jointly protect Armenian sovereignty and biodiversity.

Mirla Klijn and Olaf Boswijk
FOUNDERS, VALLEY OF THE POSSIBLE (NETHERLANDS/CHILE)

Mirla and Olaf are the founders of Valley of the Possible, located in Cañon del Blanco, a remote and secluded valley in Araucanía Andina, Chile, surrounded by ancient volcanic landscapes with a high level of biodiversity and a strong indigenous presence. They are an independent, cultural non-profit that offers artists, scientists, and other thinkers and makers a place to connect with nature, time for research, and space for artistic development. Through open calls and curated programs, they encourage interhemispheric, intercultural, and interdisciplinary exchange, offering a platform to investigate an inclusive and community-led model for the rewilding and regeneration of nature and specifically this remote valley in the Chilean Andes.

A special thank you goes out to Mirla and Olaf for hosting the author in the Valley of the Possible residency program in Chile, and to the group of VOTP participants from April/May 2022, the test audience for reading the first fragments of this book.

Lola Malavasi and Daniela Morales Lisac
CO-DIRECTORS, TEOR/ÉTICA (COSTA RICA)

Maria Paola Malavasi Lachner (aka Lola Malavasi) is currently one of three co-directors of TEOR/éTica, an independent contemporary art space, located in San José, Costa Rica, dedicated to the research and diffusion of contemporary artistic practices. It has consolidated itself as one of the most dynamic and purposeful cultural projects in the region, with an emphasis on Central America and the Caribbean. From 2016 to 2020 Lola curated and facilitated Alter Academia, a residency program focused on guiding young artists from Costa Rica. Daniela, who formally trained as a photographer, has been part of TEOR/éTica since 2013, coordinating communications, fixing electronic equipment, painting exhibition rooms and organizing collective lunches, among many other things.

Martina Manterola and Carmen Serra
CURATORS, FOUNDERS, COLECTIVO AMASIJO (MEXICO)

colectivo amasijo comprises women from different parts of Mexico (Veracruz, Oaxaca, State of Mexico, Mexico City) united in their

desire to actively reflect on the origin and diversity of our food. The collective was born in 2016 and has since provided a platform for non-dominant voices: the narratives of women close to the land with stories of the real cost of climate change who show us the way toward regeneration. Their projects grant visibility to the interdependence between language, culture, and territory and can take the form of gatherings, dinners, research, actions, ceremonies, exhibitions, markets, seminars, film, and talks to build structures to form a community, whereby taking care of ourselves and the territory we inhabit is the priority.

Camila Marambio
CURATOR (CHILE)

Camila is the director of Ensayos, a nomadic research program that focuses on ecological issues in Tierra del Fuego through experimental inter-disciplinary practices. She founded the program in 2010 in order to integrate artists and humanities scholars into the existing scientific research teams in the region, working in partnership with Wildlife Conservation Society's Karukinka Natural Park. Ensayos considers Tierra del Fuego and its climate and cultural concerns as a laboratory where issues of global importance are considered at a hyper-local level. In 2022, she was the curator of the Chilean Pavilion for the Venice Biennale.

Mariana Martínez Balvanera
CO-FOUNDER, COCINA COLABORATORIO (MEXICO)

Mariana runs Cocina Colaboratorio (Colaboratory Kitchen), a transdisciplinary platform that gathers creatives, farmer communities, scientists, and chefs around the kitchen table to exchange knowledge and design and to take action toward sustainable food futures. Cocina Colaboratorio is a testing ground for ideas that conciliate land restauration, food production, and better livelihood in rural and natural areas. Started in 2016 as a collaboration between Cascoland, the Autonomous University of Mexico, and Wageningen University, the project today involves a continuously growing group of creatives, academics, and practitioners, establishing long-term residencies within three sites in Mexico: Xochimilco in Mexico City, Santo Domingo Tomaltepec in Oaxaca, and Marqués de Comillas in Chiapas.

Claudia Martínez Garay
ARTIST (PERU)

Claudia lives and works between Amsterdam and Lima. She studied at the Pontificia Universidad Católica del Perú in Lima, and her work deals with the sociopolitical memory and history of Peru and its relationship with propaganda, iconography, and official and unofficial visual archives. From 2012 to 2013,

she had a residency at the Cité Internationale des Arts in Paris, and between 2016 and 2017 she participated in the Rijksakademie van beeldende kunsten art residency program in the Netherlands.

Lina Meija and Luciana Fleischman
PLATOHEDRO (COLOMBIA)

Lina is the founder of the residency at Platohedro, a collaborative and creative innovation platform based in Medellín. Luciana coordinates the artistic residency program and is a lecturer at EAFIT University in Medellín, Colombia. Since 2004, both have investigated contemporary issues and the defence of Human Rights through the liberation of knowledge, exploration, and autonomous and collective reflection. Through artistic experimentation, the appropriation of technologies, free communication, and alternative pedagogies, they tackle problems that affect their context through workshops, collective actions, public interventions, content generation, and networking. They offer permanent support to life projects of children, adolescents, and young people, working to disassociate them from the dynamics of generalized violence and establishing a close link with the community.

Tomaz Morgado Françozo and Marília Carneiro Brandão
SHIITAKE FARMERS (BRAZIL)

Tomaz and Marília live and work on a certified organic farm near Gonçalves, Minas Gerais, Brazil, situated in the beautiful Mantiqueira Mountains. Besides their biodynamic farming practice using beds, they grow biodynamic shiitake in the mushroom house, keep bees, take care of chickens, and look after their food forest. They are a registered farm on Work Away and can receive volunteers who like to learn about shiitake farming and other biodynamic agricultural practices.

Marjon Neumann
FILMMAKER (SWITZERLAND)

Marjon is the writer and director of *The Mushroom Speaks* (2021), a film that goes on a walk alongside parasites, symbionts, and decomposers, offering ideas of both interconnectedness and collaboration. Driven by a vision of resistance, the encounters seek possibilities of renewal and question what connects us when the world seems to be falling apart. Driven by her love of curious encounters, Neumann is an intuitive filmmaker. Her work is rooted in personal experience, navigating between documentary and experimental approaches and weaving narratives between science, poetry, and contemporary social issues, and aspires to create a sense of wonder to reflect on ways of being in this world.

Maria Alice Neves
MYCOLOGIST (BRAZIL)

Maria is a mycologist and professor in Florianópolis, southern Brazil. Her research focuses on mushroom taxonomy and the study of ectomycorrhizal fungi native to Brazilian ecosystems. She is a professor of Mycology on the undergrad and graduate programs at Universidade Federal de Santa Catarina in Brazil, and has a Bachelor's Degree in Biology and Master's Degree in Biotechnology from the same university, and a PhD from the City University of New York and the New York Botanical Garden. Her team works with fungi outreach and school teachers to plan fungi classes and activities for children and the general public. To help spread knowledge about *funga*, she mixes art and science in embroidery and sewing projects, papermaking, and fabric dying.

Tara Rodríguez Besosa
ARCHITECT, FOOD ACTIVIST (PUERTO RICO)

Born in Santurce, Puerto Rico, Tara is an architect building a world where agro-ecological concepts and queer practices are used to create resilience through food sovereignty. She is the founder of El Departamento de la Comida, a project born in 2010 as a multi-farm CSA (community supported agriculture), and then as a storefront, and a local, sustainably sourced experimental kitchen, restaurant, and workshop space in Puerto Rico. She is also the co-founder/co-director of El Fondo de Resiliencia de Puerto Rico, which came into being in the aftermath of Hurricanes Irma and María. This twenty-four-month action campaign is dedicated to impacting 200 sustainable food projects while focusing on five pillars: Renewable Energy, Reforestation, Rainwater Collection, Seeds and Soil, and Community Wellbeing.

Raquel Rosenberg
ACTIVIST (BRAZIL)

The life mission of Raquel, an activist and social entrepreneur, is to work with people and organizations that seek the convergence of ideas and purposes for balance in social relations, respect for the environment, and the formation of solid solidary citizens. A co-founder of the youth-led organization Engajamundo, she has extensive experience in youth mobilization, project development, and the coordination of non-hierarchical teams. Rosenberg has represented the organization in several international conferences in defence of climate justice, with an emphasis on speeches at the COPs, the United Nations climate change conferences.

Juli Simon
MYCOLOGIST (BRAZIL)

Juli is a Brazilian biologist who works at INPA, the National Institute for Amazonian Research (Instituto Nacional de Pesquisas da Amazônia). She studied for her Master's Degree in Mycology in Manaus and since then has described many new species of mushrooms in the Amazon. She is interested in studying the relationship between mushrooms and music, particularly in the work of John Cage who was, as well as an artist and musician, an amateur mycologist who wrote many things about mushrooms. Juli loves doing fieldwork and the basic taxonomy of mushrooms and believes they are the key to a better understanding about life and death, interconnectedness, and learning to be in the present by embracing the ephemeral.

Ela Spalding
ARTIST, FOUNDER, ESTUDIO NUBOSO (PANAMA)

Ela is an artist-facilitator who founded Estudio Nuboso, a nomadic platform for exchange between art, ecology, culture and society. The studio stems from her family history and connection with a nature reserve in the cloud forest of Panama, and it aims to reconnect people with nature, as well as generate and share knowledge that promotes resilience and sustainability for individuals, communities, and the environment. To do so, they design a range of formats for knowledge exchange and multidisciplinary encounters in different ecosystems, from residencies and short workshops to publications and audiovisual projects. They believe that sustainability lies in a strong network, which is why they work in partnerships and cherish alliances with individuals and organizations in Panama and the rest of the world.

Gianine Tabja, Gabriela Flores del Pozo, and Lucia Monge
ARTISTS, FOUNDERS FIBRA COLECTIVO (PERU)

FIBRA is an art collective of Peruvian women founded in 2018 by the artists Gianine Tabja, Gabriela Flores del Pozo, and Lucia Monge. They understand knowledge production as a collaborative process and are particularly interested in interdisciplinary collaboration as a methodology for artistic research and practice. FIBRA focuses on environmental issues and seeks to interweave disciplinary, traditional, and embodied knowledge on research-based projects. Their focus on collaboration and ecology leads them to explore and use sustainable materials that are sometimes created hand in hand with other species.

Fer Walüng
MYCOPHILE, SEEDKEEPER (CHILE)

Fer Walüng is the director of Wallmapu Seeds

and Fungi Huerta and is wholeheartedly dedicated to safeguarding traditional seeds and the cultivation and regenerative collection of edible and medicinal mushrooms and fungiculture. Through the revitalization of Mapuche knowledge and agroecology, she develops multimedia projects made up of lectures, workshops, and forays.

Tatyana Zambrano
PUBLICIST AND ARTIST (COLOMBIA)
Tatyana holds a Master's Degree in Digital Art and IT from UNAM Mexico. Her projects mix art and advertising, creating political fictions from a female perspective in a Latin American social context. Created on websites or TikTok, or through video, merchandising, props, jewelry, 3D printing, and photos, they use parody, humor, absurdity, and irony. She teaches Multimedia, Humor in Contemporary Art, Photography, and Video at the Universidad de Antioquia and Universidad del Bosque in Bogotá, and is currently part of the collective Nmenos1. Her work has been recognized at Les Rencontres Internationales New Cinema and Contemporary art in Paris/Berlin, the Official Selection of Latin American Video Art by the Getty Research Institute, among others.

About the author

Yasmine Ostendorf-Rodríguez
RESEARCHER/CURATOR (MEXICO/
NETHERLANDS)
Yasmine founded and runs the Green Art Lab Alliance, a network of fifty art organizations in Europe, Latin America, and Asia which pursues the fostering of relationships that contribute to social and environmental justice. The alliance, which acts like a mycelium, is the fruit of over a decade of research she has conducted across (East) Asia, Latin America, and Europe on artists proposing alternative ways of living and working—ways that ultimately shape more sustainable, interconnected, and resilient communities. She has extensively worked on international cultural mobility programs and on the topic of art and ecology, working for expert organizations that include Julie's Bicycle (United Kingdom), Cape Farewell (United Kingdom), Labverde (Brazil), and TransArtists (Netherlands). She is the founder of the Nature Research Department at the Jan van Eyck Academie (Netherlands), the Van Eyck Food Lab (2018), and the Future Materials Bank (2020). Furthermore, she has been curator-in-residence in various art institutions, including Kunst Haus Wien (Austria, 2017), Capacete (Brazil, 2019–2020), Valley of the Possible (Chile, 2022), Bamboo Curtain Studio (Taiwan, 2015–2016,) and with colectivo amasijo (Mexico, 2021). She is a self-proclaimed 'mycophile' and interested in using a mycological lens to define sustainable and fair models of collaboration and organization.

About the designer

Andrea Spikker Lemus
GRAPHIC DESIGNER & CREATIVE DIRECTOR
(MEXICO/GERMANY)
Andrea focuses on graphic design within the creative and cultural field. With experience in Germany, the Netherlands, Austria, Spain, and Mexico, she focuses on editorial design, photography, visual identities, exhibition design and creative direction. Her practice is defined by a conceptual and research-driven approach, interweaving several disciplines. Andrea's work mirrors history, literature, archeology, and foreign cultures.
Finishing her studies in 2013 at HTW Berlin (DE) and EASD Valencia (ES), she moved to Amsterdam (NL) and worked at Studio Remco van Bladel. Selected projects are the identity and publication for the Dutch Pavilion during the Venice Biennale 2015, and the redesign of *Metropolis M* magazine. In 2017 she moved to Mexico City and worked at SAVVY Studio (MX/NY), focusing on visual identities. Since 2018 she lives and works moving between Austria and Mexico, leading the Creative Direction at Studio davidpompa, a Mexican design brand that she reimagined and strenghtened its position in the international design industry. Selected exhibitions are 'Magmatic Parallelism' and 'Stone Archive' at Alcova during Milan Design Week.
andreaspikker.com

About the illustrator

Rommy González
DESIGNER, ART DIRECTOR, VISUAL ARTIST
(CHILE/GERMANY)
Rommy studied Graphic Design at DUOC UC, Santiago, Chile. As an art director specialized in fashion, she worked for seven years for global advertising agencies in Chile (Wunderman, Prolam Young & Rubicam and Dittborn & Unzueta from the Mcann Erickson Group). Since 2010, she has expanded her personal and artistic horizons abroad, studying Motion Graphics at the School of Visual Arts in New York (SVA) and Photography Direction in Films at Escola Superior de Cinema i Audiovisuals de Catalunya (ESCAC) in Barcelona in 2012. Moreover, she has worked on the creative direction of independent projects, including *Fragmentos Magazine* and the magazine *Stgo B.* Rommy has lived and worked in Berlin since 2014.
rommygonzalez.com

The Green Art Lab Alliance (GALA) is a mycelium-like network of art organizations contributing to environmental sustainability through their creative practice. GALA acts as an informal knowledge alliance among art organizations seeking to connect over issues of climate justice and environmental sustainability. It started as an EU-funded project in 2012 and today networks institutions in Europe, Asia, and Latin America.
greenartlaballiance.com

Valiz is an independent international publisher on contemporary art, theory, critique, design and urban affairs. Our books offer critical reflection, interdisciplinary inspiration, and often establish a connection between cultural disciplines and socio-political questions. We publish these books out of our commitment to their content, to artistic and social issues and to the artists, designers and authors.
Apart from publishing Valiz organizes lectures, debates and other cultural projects in which certain topics in contemporary art are explored.
valiz.nl

Let's Become Fungal! Workshops
Let's Become Fungal! is more than a book. It's a methodology and a way of thinking that can be activated in communities, networks, and organizations. The author offers a program of twelve collaboratively crafted mycelial workshops to activate each Teaching with a group.
From mycelial meditations to Reading Groups to biomimicry exercises, the workshops are suitable for anyone who, after reading this book, wants to become fungal. In addition to the author, the workshops are guided by guest mycologists, (bio)designers, architects, artists, and community organizers. Workshops last one full day and groups can be between ten to thirty people.
More information:

INDEX
Humans

Funga, Flora, Fauna

Geographies

Human Projects/ Collectives/ Organizations